PRINTMAKING

Gabor Peterdi

PRINTMAKING

METHODS OLD AND NEW

REVISED AND EXPANDED EDITION

MACMILLAN PUBLISHING CO., INC.
New York
COLLIER MACMILLAN PUBLISHERS
London

Macmillan Publishing Co., Inc.
866 Third Avenue, New York, N.Y. 10022
Collier Macmillan Canada, Ltd.

Library of Congress Cataloging in Publication Data
Peterdi, Gabor.
 Printmaking.
 Bibliography: p.
 Includes index.
 1. Prints—Technique. I. Title.
NE850.P4 1980 760'.28 80-12888
ISBN 0-02-596060-1

Revised and Expanded Edition 1980

Printed in the United States of America

ACKNOWLEDGMENTS

THE AUTHOR wishes to thank the following institutions for permission to reproduce prints from their collections: The Brooklyn Museum, The Metropolitan Museum of Art, The Meltzner Gallery, The Museum of Modern Art, New York; The New York Public Library, The Washington University Collection, St. Louis; The Yale University Art Gallery, and The Weyhe Gallery.

For the great help received during the preparation of this book, the author is grateful to Mr. Walter Bareiss, Mrs. Virginia Griggs, Mr. Theodore J. H. Gusten, Miss Una Johnson, Mr. Karl Kup, Mr. William Lieberman, Mr. Hyatt Mayor, Mr. Ken Purdy, Mr. Thomas Sharp, and The Print Council of America.

FOREWORD

An artist, influenced by the pulse beat of his own time, must be able to impart his heightened perceptions to a receptive public. Working within the disciplines of a chosen medium, he must still communicate his personal convictions or disenchantments. Depending on his particular temperament, he may express his ideas in satire or wit, as did Goya and Daumier, or through the brooding tone of tragedy, as did Rouault. He may also convey his observations in deftly spun fantasies, as did Paul Klee, or through intellectual, often ruthless, objectivity, as does Picasso.

A true artist may employ any method that lends itself to his own creative concepts; nevertheless, in printmaking, sheer manual facility may become an end in itself. Not to minimize technical skill and virtuosity, it must be remembered that in nearly every instance the great printmakers have also been great artists in other media as well.

During the present century a few well-known artists have written about their craft, but rarely, within the strict confines of a textbook, have they been able to project an

unquestioned professional authority together with enthusiasm and warmth of personality. Gabor Peterdi, painter, printmaker, and teacher, has achieved such a book. At the peak of his career he surveys the myriad techniques of modern printmaking.

This is a book by a highly skilled artist-craftsman who participates in the splendid tradition of the painter-printmaker, and delights in it. He himself has often remarked: "Even if I could pull only one print from each of my plates, I would still make them." Thoughtfully presented and vastly informative, this superb treatise answers a grave need for the artist who embarks on another form of creative work. Peterdi discusses and analyzes the problems and the technical solutions inherent in this severely disciplined art expression.

His understanding and appreciation of the great printmakers of the past and his interest in the work of his contemporaries have added to his own stature. He discusses the contributions of many artists with the ease of a brilliant craftsman and the zest of a storyteller. Peterdi, despite the fact that he is only forty-three years old, has in the past twenty-five years completed over one hundred and fifty engravings, etchings, and woodcuts, many of which are in color and of sizable dimensions. He has explored every facet of intaglio and relief printmaking. His own integrity of purpose and fine craftsmanship have inspired a wide circle of fellow artists and students. The text and the carefully integrated illustrations present twentieth century methods and ideas, and also portray the accomplishments of painter-printmakers through past centuries.

Gabor Peterdi has astutely summed up his own working philosophy: "As an artist I believe that the great creative spirit lives in the present and creates the future. I also believe that no one should, as no one can, define or dictate in art what is the right or wrong way to create a work of art. The artist should follow his own conscience. . . . Graphic art is just another form of expression in the vocabulary of an artist. The technique of performance for its own sake is meaningless unless it serves to express content. In contemporary graphic art there is a living and exciting movement. Out of this feverish production of images and inventiveness of expression something has emerged already, that represents the creative spirit of this century."

UNA E. JOHNSON

The Brooklyn Museum
October, 1958

CONTENTS

FOREWORD: BY UNA E. JOHNSON *vi*

INTRODUCTION TO THE REVISED EDITION *xxi*

INTRODUCTION *xxiii*

GLOSSARY *xxvii*

One · LINE ENGRAVING *1*

 Introduction *1*

 Tools and Materials for Engraving *5*

 The Burin *7*

 The Scraper *10*

 The Burnisher *11*

 The Plate *13*

 Drawing on the Plate *14*

 Conception and Technique *18*

Corrections on the Plate *39*
The Wax Proofing *42*

Two · DRY POINT *45*

Tools and Materials *46*
The Plate *46*
The Needle *47*
Electrical Engravers *48*

Three · STIPPLE ENGRAVING AND ETCHING *57*

Tools *57*

Four · CRIBLÉ (DOTTED PRINT) *61*

Five · MEZZOTINT *65*

Tools *67*

Six · ETCHING *73*

Introduction *73*
Tools and Materials *82*
Beveling the Plate *83*
Cleaning the Plate *86*
The Etching Needle *87*
Working with Flexible Shaft Electric Drills and Engravers *88*
Etching Grounds *89*
Liquid Hard Ground *89*
Hard Ground, Solid Form *90*
Application of Liquid Hard Ground *91*
Application of Solid Hard Ground *91*
Smoking a Hard Ground *105*
Transferring a Drawing on Hard Ground *105*
Working on a Hard Ground *106*
Stop-Out Varnish *110*

Asphaltum Varnish *113*
Soft Ground *114*
Aquatint *118*
Materials and Equipment *126*
Dust Boxes *126*
Dusting Bags *127*
Flour-of-Sulphur Method *133*
The Salt Method *136*
The Sand Ground *136*
Stopping-Out the Aquatint *137*
Handling Acids *137*
The Acid Tray *140*
Etching Zinc Plates *142*
Etching Copperplates *145*
Etching the Aquatint *148*
Lift-Ground Etching *150*
Relief Etching *154*
The Router *161*

Seven · PRINTING EQUIPMENT AND TOOLS *163*

The Etching Press *163*
Motorizing the Press *165*
Setting the Pressure *167*
The Hot Plate *169*
Wiping Materials *170*
The Inking Roller and Dauber *171*
Felts *172*
Papers *174*
Printing Inks *175*
Inking the Plates *177*
Wiping the Plates *177*
Printing *181*
Storing the Plate *183*
Plaster Print *183*
Printing on Textile *189*

Eight · COLOR PRINTING *193*

 Introduction *193*
 Intaglio Color Printing *195*
 Offset Printing with Stencil *205*
 Stencil Printing Directly on Paper *210*
 Combination of Silk-Screen and Intaglio Printing *212*
 The Technique of Silk-Screen Printing *215*
 Intaglio and Surface Color with Relief Etching *223*
 Combination of Wax Intaglio Overprinted with Oil Colors *226*
 Intaglio Color Printing Combined with Other Surface Media *227*
 Metal Graphic *232*
 The Cellocut *239*
 Collagraphy *241*
 Printmaking and the "New Look" *244*

Nine · WOODCUT AND WOOD ENGRAVING *257*

 Introduction *257*
 The Wood *260*
 Tools for Woodcutting *266*
 Wooden Spoons for Rubbing *267*
 Sharpening of the Tools *267*
 Working on the Wood Block *269*
 Texturing *275*
 Correcting the Wood Block *276*
 Printing the Wood Block *277*
 Color Woodcut *288*
 The Colors for Woodcut *297*
 Wood Engraving *301*
 The Tools *302*
 Gesso or Casein Engraving *305*
 Linocut *305*
 Press Printing of Wood Engraving and Linocut *307*

Ten · NUMBERING AND RECORDING AN EDITION *313*

Eleven · MOUNTING PRINTS *315*

Twelve · THE WORKSHOP *319*

Thirteen · MORE TECHNIQUES IN COLOR PRINTING *323*

Fourteen · HEALTH AND SAFETY IN PRINTMAKING *333*

BIBLIOGRAPHY *371*

SOME POPULAR PRINTING PAPERS *373*

SOURCES OF GRAPHIC SUPPLIES AND EQUIPMENT *375*

INDEX *379*

ILLUSTRATIONS

MAJOR PRINTMAKING METHODS *xl–xli*

ENGRAVING WITH THE BURIN *2*

THE CORRECT POSITION OF THE FINGERS ON THE BURIN *3*

ANTONIO POLLAIUOLO, *Battle of the Naked Men.* ENGRAVING *4*

ANTONIO POLLAIUOLO, DETAIL FROM *Battle of the Naked Men* *5*

MARTIN SCHONGAUER, *St. Anthony Tormented by Demons.* ENGRAVING *6*

SHARPENING THE BURIN *8*

SHARPENING THE BELLY OF THE BURIN *9*

CUTTING A BURR WITH THE SCRAPER *10*

BURNISHING *12*

PABLO PICASSO, *Combat*. ETCHING AND ENGRAVING *15*

GABOR PETERDI, *La Grande Bataille*. ENGRAVING *16*

GABOR PETERDI, DETAIL FROM *La Grande Bataille* *17*

ANDREA MANTEGNA, *Battle of the Sea Gods*. ENGRAVING *19*

ALBRECHT DÜRER, *Knight, Death, and Devil*. ENGRAVING *21*

ALBRECHT DÜRER, *The Prodigal Son*. ENGRAVING *24*

ALBRECHT DÜRER, DETAIL FROM *The Prodigal Son* *25*

GIULIO CAMPAGNOLA, *Battle of the Naked Men*. ENGRAVING *26*

JEAN DUVET, *The Angel Sounding the Sixth Trumpet*. ENGRAVING *27*

LUCAS VAN LEYDEN, *The Milkmaid*. ENGRAVING *28*

LEE CHESNEY, ENGRAVING *29*

WILLIAM BLAKE, FROM DANTE's *Inferno*. ENGRAVING *30*

FREDERICK G. BECKER, *Scaffolding*. ENGRAVING ON DOWMETAL *31*

MAURICIO LASANSKY, *Self-Portrait*. ENGRAVING *32*

WALTER ROGALSKI, *Scorpion and Crab*. ENGRAVING AND EMBOSSMENT *33*

DANNY PIERCE, *Wild Boar*. ENGRAVING *34*

H. G. ADAM, *Anse de la Torche*. ENGRAVING *35*

GABOR PETERDI, *Landscape of Death*. ETCHING, ENGRAVING, AND DRY POINT *36*

ANDRÉ RACZ, PLATE VIII FROM *Reign of Claws*. ENGRAVING *41*

ALBRECHT DÜRER, *St. Jerome by the Willow Tree*. DRY POINT *44*

MASTER OF THE AMSTERDAM CABINET, *Dog*. DRY POINT *50*

EDVARD MUNCH, *The Sick Girl*. DRY POINT *51*

MAX BECKMANN, *Portrait of Dostoevsky*. DRY POINT *52*

JACQUES VILLON, *Self-Portrait*. DRY POINT *53*

HANS HARTUNG, *Composition*. DRY POINT AND ETCHING *54*

LOVIS CORINTH, FROM *Am Waltchensee*. DRY POINT *55*

GIULIO CAMPAGNOLA, *Venus Reclining*. STIPPLE ENGRAVING *56*

ILLUSTRATION FROM *Encyclopédie de Recueil*. *59*

GERMAN, XVTH CENTURY, *The Mass of St. Gregory*. CRIBLÉ *60*

MASTER OF THE CLUBS, *Calvary*. DOTTED PRINT *63*

RICHARD EARLOM, *A Concert of Birds*. MEZZOTINT *64*

YOZO HAMAGUCHI, *Coupe de Raisins*. MEZZOTINT *66*

MARIO AVANTI, *Les Coquillages d'Amagansett*. MEZZOTINT *71*

REMBRANDT VAN RIJN, *Three Crosses*. ETCHING AND DRY POINT *72*

GABOR PETERDI, COPPERPLATE. RELIEF ETCHING, LINE ETCHING, AND ENGRAVING *74*

JACQUES CALLOT, DETAIL FROM *Two Masked Figures*. ETCHING *76*

FRANCISCO GOYA, *Disaster in the Arena at Madrid*. ETCHING AND AQUATINT *77*

EDWARD HOPPER, *American Landscape*. ETCHING *78*

GEORGES ROUAULT, *Face to Face*. AQUATINT, DRY POINT, AND ROULETTE *79*

PABLO PICASSO, *Weeping Woman*. ETCHING AND AQUATINT *80*

RUDOLPHE BRESDIN, *The Forest of Fontainebleau*. ETCHING *81*

BEVELING THE PLATE *82*

WORKING ON A PLATE WITH HAND REST *87*

GABOR PETERDI, *The Black Horn*. ETCHING AND ENGRAVING *92*

GABOR PETERDI, DETAIL FROM *The Black Horn* *93*

PAUL KLEE, *The Hero with the Wing*. ETCHING *94*

GIORGIO MORANDI, *Oval Still Life*. ETCHING *96*

PABLO PICASSO, *The Rape*. ETCHING *98*

PABLO PICASSO, *Minotaur and Reclining Woman*. ETCHING AND DRY POINT *99*

JOAN MIRÓ, *Composition*. ETCHING AND DRY POINT *100*

HENRI MATISSE, *Charles Baudelaire*. ETCHING *101*

JACQUES VILLON, *Equilibrist*. ETCHING *102*

GABOR PETERDI, *Apocalypse*. ETCHING, ENGRAVING, SOFT-GROUND ETCHING *103*

THE AUTHOR SMOKES A HARD GROUND *104*

REMBRANDT VAN RIJN, *The Three Trees*. ETCHING *107*

GIAMBATTISTA PIRANESI, *Gli Carceri*. ETCHING *109*

EDGAR DEGAS, *Self-Portrait*. ETCHING *111*

ROBERT BIRMELIN, *Monkey*. ETCHING AND DRY POINT *112*

JAMES ENSOR, *The Entrance of Christ into Brussels*. ETCHING *115*

PIERRE BONNARD, *Renoir*. ETCHING AND DRY POINT *117*

PETER MILTON, *Julia Passing*. ETCHING *119*

KARL SCHRAG, *Lonely Heights*. COLOR ETCHING *120*

PABLO PICASSO, *Ass from Buffon's "Histoire Naturelle."* AQUATINT *121*

HERCULES SEGHERS, *The Rocky River Landscape*. ETCHING *122*

STANLEY WILLIAM HAYTER, *Tarantella*. ENGRAVING AND SOFT-GROUND ETCHING *123*

GABOR PETERDI, *Despair I*. SOFT- AND HARD-GROUND ETCHING AND ENGRAVING *124*

JACOB RUYSDAEL, *The Traveller*. ETCHING *125*

LAYING AQUATINT GROUND WITH DUST BAG ON A RELIEF-ETCHED PLATE *128*

FRANCISCO GOYA, *Ensayos from Los Caprichos*. ETCHING *129*

JAMES ENSOR, *Stars at the Cemetery*. LINE ETCHING AND AQUATINT *130*

JOHN PAUL JONES, *Suspension*. AQUATINT AND ENGRAVING *131*

PABLO PICASSO, *Head*, FROM GONGORA'S *Vingt Poèmes*. AQUATINT *134*

MARC CHAGALL, *Self-Portrait with Grimace*. LINE ETCHING AND AQUATINT *135*

RICHARD ZIEMANN, *Edge of the Clearing*. ETCHING AND ENGRAVING *139*

GABOR PETERDI, *The Nervous Lobster*. ETCHING WITH GOUGED WHITES *141*

LOUIS MARCOUSSIS, PLATE FROM *Planche de Salut*. ETCHING 147

JAMES WHISTLER, *Nocturne, Danse Russe*. ETCHING 152

GABOR PETERDI, *Arctic Birds*. MIXED MEDIA COLOR, RELIEF ETCHING, ENGRAVING, MOVABLE PLATES 155

GABOR PETERDI, *Swamp III*. LIFT-GROUND AQUATINT, ENGRAVING, GOUGED WHITES, TWO COLORS 156

MICHAEL MAZUR, *Confrontation Across Two Shadows*. ETCHING, CUT-OUT PLATE 157

GABOR PETERDI, *Dark Visit*. RELIEF ETCHING ON ZINC PLATE 159

WILLIAM BLAKE, FROM THE *Songs of Innocence*. RELIEF ETCHING 160

CHARLES BRAND ETCHING PRESS 162

CHARLES BRAND MICRO-DIAL INDICATOR GAUGES 166

CHARLES BRAND ELECTRIC THERMOSTAT-CONTROLLED HOT PLATE 169

RAG WIPING WITH TARLATAN 171

HANDLING OF FELTS AND PAPER 172

INKING THE PLATE WITH DAUBER 178

HAND WIPING THE PLATE 180

JOHN FERREN, *Carved Plaster Print* 184

STANLEY WILLIAM HAYTER, *Carved Plaster Print* 185

OMAR RAYO, *Water, Please*. EMBOSSED INTAGLIO ON PAPER 187

HERCULES SEGHERS, *Rocky Landscape with a Plateau*. ETCHING 197

STANLEY WILLIAM HAYTER, *Centauresse*. ETCHING, ENGRAVING, STENCILED COLOR *Facing 200*

MAURICIO LASANSKY, *My Boy*. COLOR ETCHING AND ENGRAVING 198

GABOR PETERDI, *Germination No. 1*. AQUATINT, LINE ETCHING, SOFT-GROUND ETCHING, ENGRAVING, AND EIGHT STENCILED SURFACE COLORS 206

GABOR PETERDI, *Sea & Land & Moon*. COMBINED MEDIA COLOR. ETCHING, RELIEF ETCHING, ENGRAVING, FIVE MOVABLE PLATES 213

GABOR PETERDI, *Studio*. ETCHING, ENGRAVING, INTAGLIO WITH STENCILED COLORS
Facing 216

GABOR PETERDI, *Still Life No. I*. ETCHING, ENGRAVING, TWELVE STENCILED COLORS *214*

JOHN VON WICHT, *Icarus*. STENCIL PRINT *216*

VICTOR VASARELY. EMBOSSED SERIGRAPH *217*

NORIO AZUMA, *Interior*. SILK SCREEN ON CANVAS *224*

GABOR PETERDI, *Angry Gulf*. DRY POINT WITH ELECTRIC GRAVER *225*

GABOR PETERDI, *Miracle in the Forest*. FIVE-COLOR LINOLEUM CUT OVERPRINTED WITH IN-
TAGLIO PLATE, ETCHING, ENGRAVING, AQUATINT *229*

KRISHNA REDDY, *Wave*. INTAGLIO AND RELIEF COLOR *Facing 232*

GABOR PETERDI, *The Massacre of the Innocents*. ETCHING, ENGRAVING, AND TWO LINOLEUM-
CUT COLORS OFFSET ON METAL PLATE *231*

ROLF NESCH, *Wind*. METAL GRAPHIC *235*

MICHEL PONCE DE LEÓN, *Entrapment*. COLLAGE INTAGLIO *237*

BORIS MARGO, *The Wall*. CELLOCUT, EMBOSSMENT ON PAPER *240*

GABOR PETERDI, *The Vision of Fear*. ETCHING, ENGRAVING, FOUR-COLOR INTAGLIO, AND
SURFACE COLOR PRINTED FROM RUBBER CAST *242*

ANDREW STASIK, *Round Landscape, Summer*. LITHOGRAPH OVERPRINTED WITH ETCHING,
COLOR *245*

GABOR PETERDI, *Red & Blue Eclipse*. COMBINED MEDIA COLOR *Facing 248*

RONALD T. KRAVER, UNTITLED. FOLDED THREE-DIMENSIONAL INTAGLIO IN COLOR *247*

JUAN GOMEZ-QUIROZ, FOLDED FIVE-COLOR INTAGLIO IN PLEXIGLAS *249*

J. L. STEG, MIXED MEDIA INTAGLIO WITH PHOTOENGRAVING *250*

ANNE YOUKELES, *Square Dance*. FOLDED SILK SCREEN *251*

GABOR PETERDI, *Bloody Sky*. TWO-COLOR INTAGLIO *253*

ARTHUR DESHAIES, *Engraving on Lucite* *254*

GABOR PETERDI, *Arctic Bird I*. COMBINED MEDIA COLOR. CARDBOARD AND ZINC PLATES. RELIEF, SOFT-GROUND, HARD-GROUND ETCHING, ENGRAVING, INTAGLIO, AND SURFACE PRINTING *255*

TOSHUSAI SHARAKU, *Azaiki Rijkuse*. COLOR WOODCUT *256*

HANS BALDUNG GRIEN, *The Groom Bewitched*. WOODCUT *259*

EMIL NOLDE, *Prophet*. WOODCUT *261*

ERNST BARLACH, *God Over the City*. WOODCUT *262*

LEONARD BASKIN, *The Anatomist*. WOODCUT, BLACK AND RED *263*

KATSUSHIKA HOKUSAI, *Storm*. WOODCUT *265*

CUTTING WITH JAPANESE KNIFE *270*

CUTTING A LINE WITH A BROAD BASE *271*

CUTTING WITH A LARGE GOUGE *273*

HEIGHTENING OF WOOD GRAIN WITH WIRE BRUSH *276*

VASILI KANDINSKY, *Abstraction*. WOODCUT AND WOOD ENGRAVING *278*

JOSEF ALBERS, *Encircled*. WOODCUT *280*

ERNST LUDWIG KIRCHNER, *Head of L. Schames*. WOODCUT *281*

HENRI MATISSE, *Seated Nude*. WOODCUT *282*

PABLO PICASSO, *Head*, A FRAGMENT. WOODCUT *283*

LYONEL FEININGER, *Cathedral*. WOODCUT *284*

KATSUSHIKA HOKUSAI, *Lightning at the Foot of the Fuji*. COLOR WOODCUT *285*

RUDY POZZATTI, *Venetian Sun*. WOODCUT *286*

RUBBING A WOODCUT WITH SPOON *287*

GABOR PETERDI, *Spawning III*. WOODCUT, FOUR COLORS *289*

GABOR PETERDI, WOOD BLOCKS NO. II AND NO. III FOR *Spawning III* *290*

EDVARD MUNCH, *The Kiss*. WOODCUT *294*

PAUL GAUGUIN, *Changement de résidence*. COLOR WOODCUT *295*

ANTONIO FRASCONI, *Night Work*. COLOR WOODCUT *298*

SEONG MOY, *Classical Horse and Rider*. COLOR WOODCUT *299*

EDMOND CASARELLA, *In a Moment of Panic*. PAPER CUT *300*

LEONARD BASKIN, *Man with Forsythia*. WOOD ENGRAVING *303*

NORMAN GORBATY, *Talmud*. CASEIN CUT *306*

PABLO PICASSO, *Toros Vallauris*. COLOR LINOLEUM CUT *309*

ROBERT E. MARX, *Snared*. COLOR LINOLEUM CUT *310*

MISCH KOHN, *Untitled engraving*. CHINE COLLÉ *327*

MICHAEL MAZUR, *His Running, My Running*. MONOTYPE, HIGH-VISCOSITY BLACK WITH THALO BLUE *328*

INTRODUCTION TO THE
1980 EDITION

Printmaking was published in 1959 and revised in 1969; this is its second revision. Thus *Printmaking* has survived twenty years and has been used by artists all over the world, as far as Africa and India.

When I wrote this book there was hardly any up-to-date literature available on printmaking. I considered this book an extension of my teaching, and hopefully it reflects both my teaching and aesthetic philosophy.

This book is primarily addressed to artists who are interested in the creative possibilities of printmaking and who don't mind digging into printer's ink up to their elbows. It is not for those who consider printmaking a business, and the print only a commodity. There are workshops with clever craftsmen to serve them with the most sophisticated print technology.

The revisions in this edition fall into two categories: the amplification of already existing information, and the addition of new material. Although the changes are not many, I feel they substantially contribute to the clarity and completeness of this book. I hope this new edition will serve my readers well.

I dedicate this book to young artists, and to the memory of my wife, Maria.

INTRODUCTION

I BEGAN to write this book nearly five years ago. From time to time I wrote a few pages and set them aside because I was much more interested in making prints than in writing about them. Outside pressure, however, finally convinced me that it was time to finish this book on printmaking.

The outside pressure came mainly from two sources: first, from my students, who need a reliable reference book that covers both traditional and experimental methods in printmaking; second, from fellow artists who have written to me from all over the country to get technical information that obviously was not available in any existing book.

When I first planned this book, I intended to cover all the major printing processes, including lithography. As I started to lay out my material, however, it became clear that

unless I compromised on the thoroughness of my descriptions the size of the book and the expense of publishing it would become prohibitive. For this reason I have chosen to omit discussion of lithography. Good books on this technique are available.

My main subject is work on metal in its pure form and in combination with other media. Woodcuts and work with plastics are discussed individually and in relation to intaglio printing. Silk-screen stencil and linoleum and rubber cuts are covered in relation to mixed media color printing.

Printmaking is about five hundred years old in the Western World and a few hundred years older in the Orient. Yet I can safely say that the last twenty-five years have brought more technical innovation than have all the previous centuries.

The development of contemporary printmaking parallels the evolution of modern painting. The cubist preoccupation with dynamic space, picture plane and texture, and the present dominance of color have their equivalents in the evolution of the graphic arts.

The graphic workshop is one of the few places where artists leaving the isolation of their studios can work together in a collective atmosphere. Technical experimentation and innovations are passed on and carried further immediately. This, together with the availability of prints for distribution on a wide scale, made it possible to spread new developments throughout the world in a few years.

In the past twenty-five years adventurous artists with a healthy disregard for the taboos of the graphic arts have tried just about everything that can be used or abused for printing. We have used every texture that can be pressed in a soft ground. We have printed every color of the rainbow. We have used every material, new and old, that either nature or science could provide. We have pushed the size limitation of the print to the breaking point, where it starts to compete with mural decoration. Now I feel that we have reached the crucial turning point; the period of experimentation for its own sake is over. Now we have to digest what we know in order to express what we are.

I should not like to be misunderstood as advocating or foreseeing a complete end of experimentation. As long as creative people handle tools and materials, unexpected things will happen. Artists invent, not by intent, but by necessity.

My experience with the graphic arts began with engraving. I fell in love with it and I engraved for several years before I made my first etching. This self-imposed limitation had no reason other than the fascination of exploring thoroughly this pure and powerful technique. When I began to work with the various methods of etching, I became aware of the immense range of this medium, and plunged into a period of feverish experimentation. Today I think I can say without much exaggeration that I have made prints with practically every known major process in graphic art. Obviously, some of these are more suited to my temperament and working method than others, but I discovered this only

by trying them. Procedures that did not seem very useful at first proved to be invaluable on many occasions later on. I am against the idea of specialization, even in technique.

I am also convinced that the more you know about your craft, the freer you can be from it. My interpretation of freedom has nothing to do with sloppy or careless technique that is a caricature of freedom. To me real freedom arrives when the artist's creative instinct can function without limitation and without consciousness of technical means.

I respect and love the materials I use. Each material has its own character, its assets and limitations. Our choice of materials is wide enough to accommodate any problem. You may fight your material but you can never cheat it.

In writing this book one of my problems was to decide how much information I should include. I decided that for my purposes a general description of the various methods would not be enough. My feeling is that most of the books written in recent years on printmaking take too much for granted in expecting the reader either to have the missing information or to know that it is available from other sources. I have had enough experience both as a teacher and as a printmaker to realize that even if one knows the basic principles of a method, many particular problems can arise in their practical application. Therefore, as far as possible, I have tried to anticipate such problems and to suggest their solution.

The other problem that I faced was how to arrange the material with directness and simplicity, in order to avoid confusing my readers. I felt that the best procedure was to follow fairly closely the same method I use in teaching. I begin the book with the simpler direct methods and proceed toward the more complex techniques, concluding with the new experimentations. In relation to materials and equipment, I try to give adequate information—where they can be obtained and, in many cases, how they can be made by the artist himself. I feel that this is important for two reasons: first, because to do so generally provides higher quality for a lower price; and, second, because I assume that some of my readers live in areas where such materials aren't easily obtainable. Some of the formulas, like that for the liquid ground, for instance, are not available commercially.

To conclude my introduction, I should like to say a few words about my own feeling in relation to printmaking as an art. Unquestionably, we are now witnessing a great renaissance of printmaking. There are many reasons for this. One of them is that an ever-increasing number of people are becoming actively interested in art. They want to see works of art and they want to own them. Many of these people cannot possibly afford the price of an original oil painting. Because they do not want to put reproductions on their walls, they prefer to buy original prints. Printmaking is on the way to becoming a great popular art, as it was in Japan in the time of Hokusai and Utamaro.

There is no doubt that the production of a great number of original prints from a

plate is an economic and social asset. This aspect, however, has very little to do with my interest in printmaking. I make prints because in using the metal, the wood, and all the other materials available, I can express things that I cannot express by any other means. In other words, I am interested in printmaking, not as a means of reproduction, but as an original, creative medium. Even if I could pull only one print from each of my plates, I would still make them.

GLOSSARY OF GRAPHIC TERMS AND TECHNIQUES

AQUATINT A porous ground for etching tonal areas into metal.

BENCH HOOK A wooden board built to hug the working table's edge; its function is to hold wood blocks in place while cutting.

BITE The action of acids or corrosive agents on metal.

BLEEDING The oil seepage around a printed line, or blotching of a printed line.

CELLOCUT A method originated by Boris Margo. A surface, design or texture built up with liquid plastics on wood, metal, cardboard or plastic support. It can be printed in intaglio or relief.

CHIAROSCURO WOODCUT Developed in the early sixteenth century. First printed color woodcuts in Europe. Simulated drawings on colored paper with touched-up white highlights. It involves two or more separate blocks.

CLICHÉ VERRE Developed in the nineteenth century on the principle of photography but without the tonal variations of the photograph. A piece of clear glass is covered with an opaque pigment or emulsion. The design is scratched into the protective coating with a sharp stylus, then placed on photosensitized paper and exposed.

COLLAGRAPH A fairly recent method of building up a printing surface. The printing plate is created by gluing all kinds of textures (sawdust, wood shavings, ground walnut shells, wrinkled paper, sand, etc.) to a support (cardboard, Masonite, etc.). The textures have to be imbedded in a tough and nonabsorbent adhesive like Elmer's Glue, Lucite or Epoxy. The plate can be printed in intaglio or relief.

COUNTER PROOF After a plate or wood block is printed, a clean sheet of paper is placed on the wet proof and run through the press or rubbed by hand. The resulting offset image from the wet print on the second paper is the counter proof.

CREEPING BITE Etching in stages by the gradual submersion of the plate in the acid. Generally used with aquatint when a subtle transition of tone is desired.

CRIBLÉ OR DOTTED PRINT A dotted print is made by punching hollows and making incisions into a metal plate. Generally printed on relief, the design appears as white dots on a black background. This is the earliest European metal print.

DOUBLE RUN The running of a plate through the press twice in order to get a heavier impression.

DROPPING OUT Cutting out, scraping out, digging out, eliminating from the printing plate or wood block.

DRY POINT An intaglio method of creating a design by scratching lines into metal plates (copper, zinc, soft steel, etc.) with hard steel- or diamond-point needles.

EMBOSSED PRINT (GAUFFRAGE, BLINDPRESSING) A print with a three-dimensional, sculptural effect created by pressing paper into the lowered areas of a plate or wood block. All intaglio prints are embossed, but in this case the lowered or incised areas are uninked.

ENGRAVING Cutting a design into metal with a graver or burin.

ETCHING Working a design into metal by the corrosive action of acids.

ETCHING GROUNDS Acid-resisting coating applied on metal plates. The design is scratched into the ground, then etched. There are two major ground types. Hard ground is a solid protective coating used mostly for controlled linear work. Soft ground is essentially the same as hard ground with grease added to keep it in semi-hard or tacky condition. It is used mostly for taking impressions of various textures.

FEATHERING Removing or stirring with a feather or brush the bubbles produced by the action of nitric acid on zinc or copper plates.

FOUL BITE The accidental etching of an area.

INTAGLIO COLOR PRINT Overprinting several color intaglio plates on the same paper.

INTAGLIO MIXED METHODS The combination of several intaglio methods on the same plate.

INTAGLIO PRINTING Printing from the crevices and grooves engraved or etched into the plate.

KEY PLATE OR BLOCK The plate or block used to serve as a guide to register other plates or blocks in color printing.

LIFT-GROUND ETCHING The main principle is to etch a positive image on aquatint by drawing with a water-soluble paint. Lift ground is a washout principle. A viscous liquid (India ink, gamboge or ordinary poster paint mixed with sugar syrup, glycerin, etc.) is used to paint on the plate. After the painting is finished and dried, it is covered with thin-liquid hard ground. After the ground dries, the plate is washed with lukewarm water that dissolves the paint and exposes the plate to the acid where the paint has been lifted.

LITHOGRAPHY (PLANOGRAPHIC PROCESS) Invented by Aloys Senefelder in 1798. This method is based on the principle that water and grease do not mix. The image is drawn or painted on a stone or zinc plate with greasy litho crayon or ink (tusche). Once the drawing is finished it has to be fixed with an etch to prevent the spreading of the grease. The term "etch" is rather confusing because most people immediately identify it with metal etching, in which the result is a drastic alteration of the printing surface. In lithography the etch is a syrupy mixture of gum arabic mixed with a small quantity of nitric acid. This is used basically to protect the

drawing from water and to desensitize further the undrawn areas to printing ink.

After the stone is properly etched and thus the design fixed, it can be washed out with turpentine. Now all the visible aspect of the design disappears, but it is locked into the stone by the grease. After the cleaned stone dries, it can be wetted with a sponge and rolled up with litho ink. The ungreasy areas of the stone retain the water and reject the printing ink. The greasy parts attract the ink; thus the image reappears. It is ready now to be proofed or printed on a dampened, fairly smooth rag paper.

The litho press consists of a steel bed traveling under a leather-faced scraper. The scraper exerts the printing pressure and can be adjusted.

Lithography lends itself well to a great range of drawing techniques. Tones can be achieved by rubbing the stone or plate with soft crayons, or by washes and dry brush. Scratch techniques are made with needles, razor blades or sandpaper. Textures can also be spluttered or transferred from various materials with an offset technique. Lithography is well suited for color printing. Outstanding examples: Toulouse-Lautrec, Bonnard, Vuillard, Munch, Picasso.

MEZZOTINT (MANIÈRE NOIRE) An intaglio method of creating a dark surface by roughing up the plate with a tool called a "rocker" and working back toward the light tones with scraping and burnishing.

MONOTYPE OR MONOPRINT A print in an edition of one; a unique print. Actually it is a printed painting or printed drawing. The artist can paint on various surfaces such as metal, plastic, and glass, and then print either by rubbing or on an etching press.

MIXED MEDIA A combination of techniques on the same print.

OFFSET PRINTING OR OFFSETTING Indirect printing, by depositing an image from one roller or plate to another and then printing it on the paper.

PAPER, PRINTING PAPERS The development of papermaking had an important role in the history of printmaking. No invention had greater influence on human culture than paper; yet most people know so little about it. Certainly everyone interested in the graphic arts should have at least a superficial knowledge of its history and manufacture. The word "paper" itself is the source of a great deal of confusion. It is derived from the Latin "papyrus"; therefore most people think papyrus was an early form of paper, a mistaken notion.

Papyrus was made from the pitch of a sedge growing in abundance in the Nile valley. The Egyptians and other Mediterranean peoples used it to write on. Papyrus

is made by laminating strips of the sedge pith. Paper is made by macerating fibers to form a watery solution of pulp.

There is also a great deal of confusion with the term "rice paper." This inaccurate term is generally identified with most papers made in the Orient. The so-called "rice paper" is made of the pith of a plant growing in Formosa. This sheer, white substance, used to make artificial flowers, is not a paper, nor is it made of rice. Rice cannot be used to make paper.

Paper was invented in China, approximately in the second century A.D. The system was amazingly simple. Leftover silk strips were soaked in water and beaten until they became a fibrous pulp. This pulp was then spread evenly on a screen (mold) to allow drainage of the excess water. Dried, the thin layer of fibrous pulp became paper. It is worth noting that the basic principle of handmade paper is still the same all over the world. The mechanics of the mold were improved, the preparation of the pulp became more efficient, but the fundamental process remained the same.

The most primitive method of pouring the pulp on a stretched woven-grass screen is still practiced in some areas in the Orient. The more sophisticated method is dipping the mold into a pulp-filled vat, shaking it for even distribution, and drying it. The modern paper mill is a mechanized application of these principles.

It is fascinating to follow paper's long journey from China to the West.

A.D. 105 Paper invented in Leiyang.
A.D. 610 Paper introduced to Japan from Korea.
A.D. 751 Paper made in Samarkand.
A.D. 793 Paper introduced in Bagdad.
A.D. 900 Paper made in Egypt.
A.D. 1100 Morocco learns papermaking from Egypt.
A.D. 1151 First paper mill at Xativa, Spain.
A.D. 1276 Paper manufacturing begins at Fabriano, Italy. This paper mill is still in existence.
A.D. 1348 Paper mill in Troyes, France.
A.D. 1390 Paper mill started in Nuremberg, Germany.
A.D. 1690 First American paper mill in Germantown, Pennsylvania.
A.D. 1757 First English paper mill in Hertfordshire.

In Japan, paper is made of vegetable fibers. Kozo, gampi, and mitsumata are the three most commonly used plants for this purpose. The most popular mulberry paper is made of kozo. In the Orient, the preparation of the vegetable fibers is considered the most important step in papermaking. Most oriental craftsmen still prefer to do it by hand in order to produce fibers of the correct length.

The West used linen and cotton rags instead of raw vegetable fibers as its basic

material for paper. The water-soaked rags were rolled into large balls and fermented for weeks. When fungi appeared on the surface of the balls, the rags were ready for making the paper. Some experts think that the "foxing" or discoloration of old papers is due to excessive fermenting in the manufacturing process.

The distinction between various types of paper often relates to the mold construction. The mold is a wooden frame inside which a wire screen is stretched. The "chain" lines run up and down the short dimensions of the paper, one-half to two inches apart. The "laid" lines run the long way, twenty to forty to the inch.

The deckle is a removable wooden frame that is placed inside the mold to determine the size of the paper. Therefore, deckled paper is associated with handmade paper. The term "laid" or "woven" paper refers to the screen impression on the paper and has nothing to do with its manufacturing. Woven paper doesn't exist.

Pressing and sizing are the last important steps in papermaking, as they determine the surface characteristics. The more pressure exerted on the paper, the harder is its surface. For instance, water-color papers come in cold pressed or hot pressed variety; the hot pressed is the harder. The last step is the sizing. This is the application of a thin layer of glue or gelatin. The quantity of sizing will determine the absorbing qualities of the paper; without sizing, all papers would be as absorbent as blotting paper. For printmakers the amount of sizing in the paper is critical as it determines how long the paper has to be soaked before it prints well.

Papermaking became such a big industry in the West that eventually a shortage of rags developed. All kinds of laws and regulations were enacted in Europe as well as in America to conserve the raw materials essential to papermaking. In England a law was passed forbidding the burying of anyone in clothing usable for the manufacture of paper.

From the eighteenth century on, there was continual experimentation to replace rags as the sole source of papermaking. The turning point came when at the end of the eighteenth century in England Matthias Koops started to manufacture paper in large quantities made of wood pulp. From that point on wood-pulp papers gradually replaced rag papers in commercial use. Wood paper was cheap and its raw material was plentiful. Unfortunately, this paper is not durable and in time becomes brittle. It also has a tendency to yellow with age. Another disadvantage of wood-pulp paper lies in its manufacture. In order to reproduce a white paper, strong chemical bleaches, sulfites, have to be used. So far no way has been found to remove all traces of these chemicals. Thus, on extended contact, the remainder of sulfuric acid in the pulp paper stains and burns other materials. These are the reasons why this type of paper is not suitable for fine art work and why it is so dangerous to mount fine prints with cheap cardboards.

PARCHMENT The inner side of sheepskin, separated from the outside. After special treatment of its surface it was used for writing. In Europe it was in wide use before the introduction of paper manufacture. After that it was used mostly for important documents.

PLANOGRAPHIC PROCESS See Lithography.

PLASTER PRINT It can be either a print made by casting plaster on an inked intaglio plate, or a relief print made from an inked plaster plate.

PRINTING À LA POUPE A color printing method developed in France. Instead of using separate plates for the various colors, the different color areas are individually inked and wiped on the same plate. The inking is made with a specially folded pointed tarlatan "poupe." This is a rather tedious process, admirably controlled by expert Parisian printers.

PROCESS PRINTS (PHOTOMECHANICAL METHODS OF REPRODUCTION) A "process print" is a collective name for all photomechanically produced prints. In this book we are only indirectly concerned with commercial printing methods. There is so much confusion and controversy about the original print concept that some knowledge of process printing is a must. I have to emphasize that by necessity the following descriptions are oversimplifications. A thorough description of all commercial printing methods could be the subject of a large book in itself. There are, however, many manuals treating these subjects in depth for anyone interested in more information than I can give within the limitations of this book.

LINE CUT OR LINE BLOCK The line cut is the simplest and cheapest of all the photo-reproductive methods. It is used to reproduce only straight black and white drawings as it cannot register tonalities. If tones are needed in a line cut they can be achieved with the use of Ben Day screens (textures made out of dots). Most newspaper advertising uses this inexpensive method.

The basic principle of the line cut is similar to that of the woodcut, and the former can be used to reproduce the latter. I have seen this type of reproduction printed on good paper and sold as an original woodcut.

Line cuts are made on a photoengraver's zinc plate or on a similar metal alloy (Zomo, Micrometal, aluminum, magnesium) coated with an emulsion of albumin or gelatin mixed with potassium bichromate. This emulsion hardens on exposure to light. The light passing through the transparent parts of the negative (the dark areas on the positive image) hardens the emulsion. The emulsion areas (protected by the blacks of the negative) remain in their soluble state.

The plate is then rolled over the greasy ink and soaked in water. The unexposed, soft emulsion is washed out by the water. After the plate is dried it is dusted with powdered rosin, which adheres to the remaining inked emulsion areas. The plate is then heated to melt the rosin. This forms an acid-resisting coating. This procedure is similar to artists' use of the aquatint. The plate is then etched long enough to make the positive part of the image stand up in high relief. This is important because if the white or negative areas touch the printing paper, a blurred, fuzzy print might result.

HALFTONE CUT OR BLOCK The halftone cut is more sophisticated than the line cut and is capable of reproducing fine tonal variations. The basic principle is the fragmentation of tonal areas into tiny dots of various sizes. When printed, these create the optical illusion of continuous tones and textures. First, the subject to be reproduced is photographed through a glass screen. This screen consists of fine lines printed on glass at right angles, creating thousands of tiny openings through which the subject is photographed. The result is an image broken up into dots corresponding to the openings on the screen. There are great variations in screens from coarse (50 lines per inch) to the finest used by printmakers (220 lines per inch). The selection of the screen is dictated by the paper to be used for printing. For newsprint paper a coarse screen is used, but the fine screens must be printed on a hard, coated paper.

After the photonegative of the image is finished, it is printed on a sensitized copperplate. (For halftone, cut copper is much better than zinc because the fine details need a more-controlled etch.) From that point on, the procedure of wash-out and etch is similar to the one used on the line cut.

Halftone-cut prints can be readily recognized by the regular screen pattern. The coarse fifty-line screen can be seen with the naked eye, but finer screens should be examined with a magnifying glass.

Both the line cut and the halftone cut are mounted type-high on a wood block. This is necessary as these plates are usually printed in combination with type, and the presses are adjusted to that standard height.

HALFTONE COLOR REPRODUCTION This is a rather complex and expensive process. First a color separation is made by photographing the original to be reproduced through a series of color filters. A halftone plate has to be made for each color to be used. Generally four colors are used: the three basic colors—red, yellow, and blue—and black. Fine photoengraving houses specializing in art reproductions often use many more color plates. When all the plates are finished, they are over-

printed. The individual plates are made the same way as a regular black-and-white halftone cut, but usually the color plates have to be worked over by hand to establish the proper balance between them. The slightest inaccuracy in any of the color plates can ruin all the colors. It is also very important to print these plates in perfect register, because off-register creates fuzzy *moiré* patterns.

ROTOGRAVURE In the rotogravure process a thin copperplate is attached to a cylinder, functioning in a web-fed rotary press. To make the plate a reversed halftone screen is used with a grid of transparent lines and opaque black squares. On exposure to light, the emulsion on the plate hardens under the lines but leaves the squares soft. Then the same plate is exposed again through a diapositive (a photographic positive of the subject). This time the soft-emulsion squares harden in proportion to the range of grays or tonality of the negative. In etching this plate the softest squares are affected by the acid first, and the hardest ones the last. The result after the etch is a plate covered with squares of equal sizes but various depths. Because the deep squares hold more ink than the shallow ones, the tonalities in the reproduction are controlled in the same manner as in all intaglio printing methods. The rotogravure plate is inked by rotating it against another ink-carrying cylinder, and wiped by a steel blade that removes all excess ink from its surface with a scraping action. As the grid on a rotogravure plate is raised it appears as white lines on the print. It can easily be identified by this characteristic.

Although rotogravure is an intaglio printing process, it uses dry paper, light pressure, and thin ink. Therefore, it has hardly any embossment.

PHOTOLITHOGRAPHIC OFFSET A lithographic method applied to commercial mass production. Because the photo offset plate has to be mounted on a cylinder, instead of stone, specially treated thin zinc or aluminum plates are used. The image is photographed on the sensitized litho plate through a screen. The offset method is double printing. The image from the zinc plate is printed on another roller covered with a rubber blanket. From the rubber the image is printed on the paper. As the image is twice reversed, the final print corresponds to the original plate. As the litho offset ink is too thin to speed up the inking and facilitate transfer, the tonal areas lose some of their richness and tend to print gray. Litho offset can be used also for color printing. The color separation follows the same principle as with the halftone color plate. This method is often used to forge original lithographs. Printed on a rich paper, it can easily deceive the layman, so it is always advisable to examine prints with a magnifying glass.

RELIEF ETCHING See Etching.

RELIEF PRINTING Printing from a design surface standing on relief. Color is generally applied with rollers, and a printing can be made with either rubbing pressure, scraping pressure, straight pressure, or rolling pressure. The same principle applies to process printing also, except that it is accomplished mechanically.

ROLLERS OR BRAYERS They can be made of rubber, gelatin, or plastic of different sizes and densities. They are used to roll printing ink on plates, stones, and wood blocks.

REPOUSSAGE Technique of pressing or hammering back a low area on the plate created either by excessive etching or by scraping on its original level.

RETROUSSAGE Technique of pulling the ink out of the lines lightly with muslin, of an otherwise cleanly wiped plate, in order to make a richer print.

SERIGRAPHY OR SILK SCREEN "Serigraphy" is the name given to the silk screen by artists to get away from its commercial associations. Silk screen is a sophisticated stencil process, developed around the beginning of the ninetenth century and first used mostly for commercial advertising and display work.

 The process got its name from the fine-mesh silk that is tacked to a wooden frame and serves as a support for an intricately cut paper stencil. The printing was based on the simple principle that the open mesh of the silk lets the paint through, while the paper stencil glued to it blocks the paint out.

STEEL FACING Depositing a thin layer of steel by galvanic process on the surface of a copperplate to make it more resistant to wear. See dry point.

STIPPLE PRINT Stipple etching and engraving is creating a halftone effect by either etching or engraving tiny dots into the plate.

SUGAR LIFT See Lift-Ground Etching.

 SURFACE PRINT In this method the color printing ink is deposited on the surface of the metal plate or wood block and printed by rubbing, straight, or rolling pressure.

UNDERCUT The formulation of a cavity created by the side-biting tendency of acids. This is often the cause of a "Crevé," the crumbling of densely textured areas on the plate by overetching. Rembrandt often retouched these areas with dry point.

VELLUM The whole calf skin treated with lime and used for writing. "Vellum" is the misleading name of a paper resembling parchment.

WATERMARKS Identification marks of the manufacturer embossed into the paper.

The watermark is made by sewing an emblem made out of twisted wire onto the paper mold. Watermarks are important factors in determining the authenticity of old prints. Briquet's *Dictionary of Watermarks* (Geneva) is the best reference book on this subject.

WOODCUT (GRAVURE SUR BOIS, HOLZSCHNITT) The earliest type of relief print. In the East, eighth century; in the West, early fifteenth.

 The design is either painted directly onto the wood block or pasted on it. The cutter (either the artist himself or a skilled craftsman) cuts all the surface away except the design. When cutting is finished, the surface is rolled up with ink and printed with either straight pressure or rubbing.

WOOD ENGRAVING (GRAVURE SUR BOIS DEBOUT, HOLZSTICH) The wood engraving is a variation of the woodcut. For woodcut the wood is cut plankwise; for wood engraving it is cut cross-grain. This allows the cutter to move freely in any direction, and instead of large gouges he can use fine gravers.

MAJOR PRINTMAKING METHODS

WOODCUT.
Surface printing. Bold contrasts. Solid and textured areas.

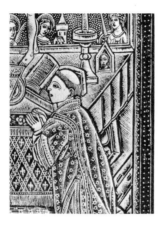

DOTTED PRINT.
Surface printing. Tones are created with punched textures.

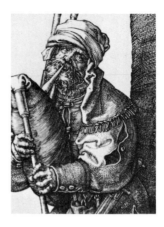

LINE ENGRAVING
on metal. Intaglio printing. Sharp, precise, swelling, and tapering lines.

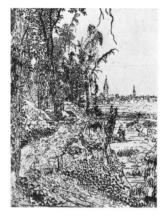

LINE ETCHING.
Intaglio printing. The variations in the lines and textures are controlled by the choices of metals, acids, and the length of the bite.

AQUATINT ETCHING. Intaglio printing. Granular tonal areas simulating the effect of washes.

SUGAR-LIFT or LIFT-GROUND ETCHING.
A method of etching direct and spontaneous brush strokes with aquatint.

WOOD ENGRAVING.
Surface printing. Fine, delicate lines and textures cut into cross-grained wood blocks with gravers.

SOFT-GROUND ETCHING. Intaglio printing. A method of etching textures into metal. It can be combined with other methods.

MAJOR PRINTMAKING METHODS

DRY POINT.
Intaglio printing.
Scratched lines on metal.
Fuzzy, warm, velvety
blacks. Hard to control
and wears out easily.

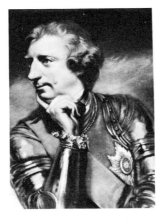

MEZZOTINT. Intaglio
printing. Rich blacks and
luminous passages
achieved with burnishing
and scraping a burr-
covered metal surface.

STIPPLE ENGRAVING
and **ETCHING.**
Intaglio printing. Mellow
tonal passages achieved
by either engraved or
etched tiny dots.

LITHOGRAPHY.
Planographic process.
Granular lines and tex-
tures. Also flat areas and
sharp edges depending
on the stone surface and
drawing material.

LINOLEUM CUT.
Surface printing. Similar
to woodcut except the
absence of wood grains
makes it more mechanical.

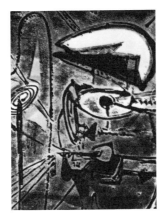

**CELLOCUT-
COLLAGRAPH.**
Variety of new methods
using plastics and glues
combined with other
materials to build a print-
ing surface. They can be
both surface- and intaglio-
printed.

METAL GRAPHIC.
Intaglio printing. Building
up a printing surface
with various metals.

SILK-SCREEN PRINT
or **SERIGRAPH.**
Stenciling method. Wide
range from big bold areas
to delicate textures. Used
primarily for color.

LINE ENGRAVING

INTRODUCTION

LINE ENGRAVING is the most direct and controlled graphic technique used on metal. Engraving is also one of the oldest techniques used by man to create an image.

Beginning with the cave man, and proceeding through the Egyptian, Sumerian, Greek, and Eastern civilizations down to the Renaissance, man has cut, chiseled, scraped, and engraved images into rock, bone, clay, and every conceivable material. Taking into consideration how long man has used engraving skill for decoration, it is amazing that only in the ninth century (Chinese woodcut) and in the fifteenth century (European woodcut and metal engraving) did man arrive at the idea of using it for printing. Because the

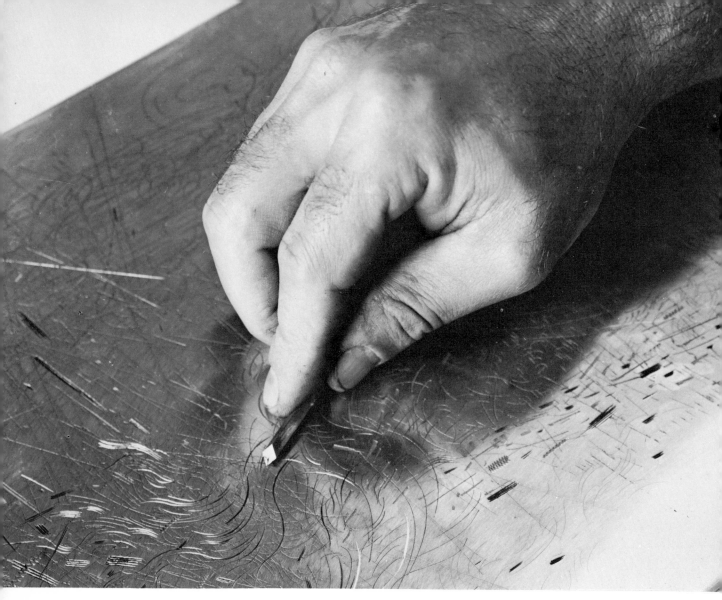

I,1 *Engraving with the burin*

reasons are complex, and because we are not here dealing with the history of art, I shall not discuss them.

In making an etching or a dry point, the physical factors of the creative process are similar to those used in drawing with a pen, pencil, or brush. In engraving, however, the artist is involved with a new experience. The hand does not function like the arm of a compass, moving freely in any direction, but pushes the graver or burin parallel with the body; change of direction is achieved by the manipulation of the plate with the other hand. Because this involves the constant twisting and turning of the plate, the artist has to look at his image and consider it from every angle. This aspect definitely proves to be

a great asset for artists working in an abstract idiom and trying to create a shifting, constantly moving dynamic expression of space. In etching, the needle penetrates only the ground; the depth of the lines is achieved by the corrosive action of the mordant. Even in dry point the penetration of the needle into the metal is superficial. In engraving, the artist is directly involved in the creation of a three-dimensional line, and physically experiences the relation between the penetration in depth and the resistance of the metal. The engraved line has an intensity and dynamic quality that no other line can equal. The physical effort involved in pushing the burin in the metal invests the line with the energy expended in creating it.

By this I do not mean to imply that physical energy is necessarily translated into vitality of expression. Such expression has to do more with conception than with any

I,2 *The correct position of the fingers on the burin*

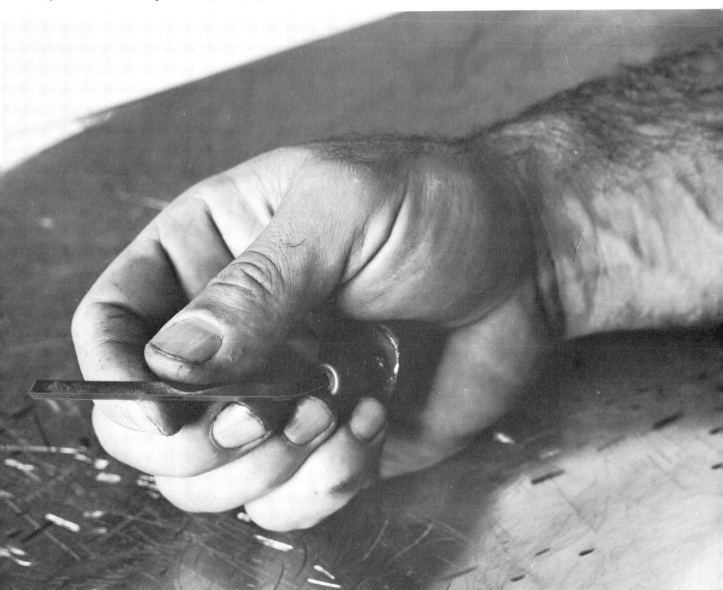

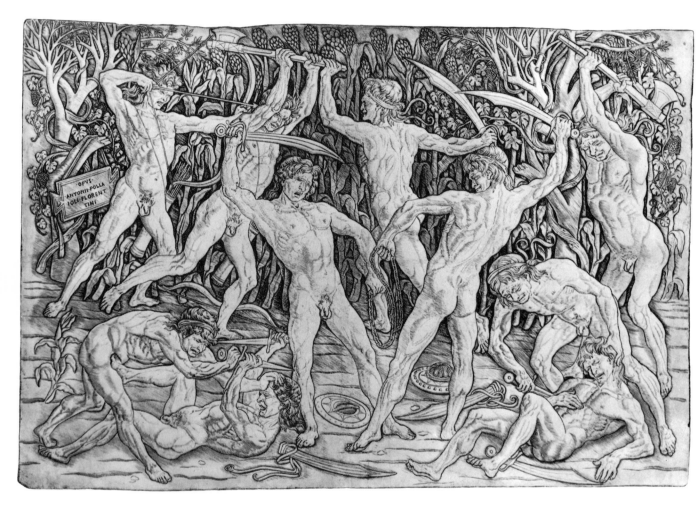

I,3 ANTONIO POLLAIUOLO (1429–1498), *Battle of the Naked Men*. Engraving.
Yale University Art Gallery

physical act. As a matter of fact, in engraving, contrary to drawing, there is no direct relation between the quality of line and the speed involved in creating it. A line engraved at a slow, steady pace can give the illusion of a swift pen stroke (Fig. I, 17, 25, 26, 29).

TOOLS AND MATERIALS FOR ENGRAVING

Burin
Scraper
Burnisher
Gouges
Assorted flat metal files
India stone

Arkansas stone
Three-in-One Oil
Engraver's charcoal
Snake slip
Metal plates: copper, zinc, aluminum, magnesium, Plexiglas

I,4 ANTONIO POLLAIUOLO, detail from *Battle of the Naked Men*

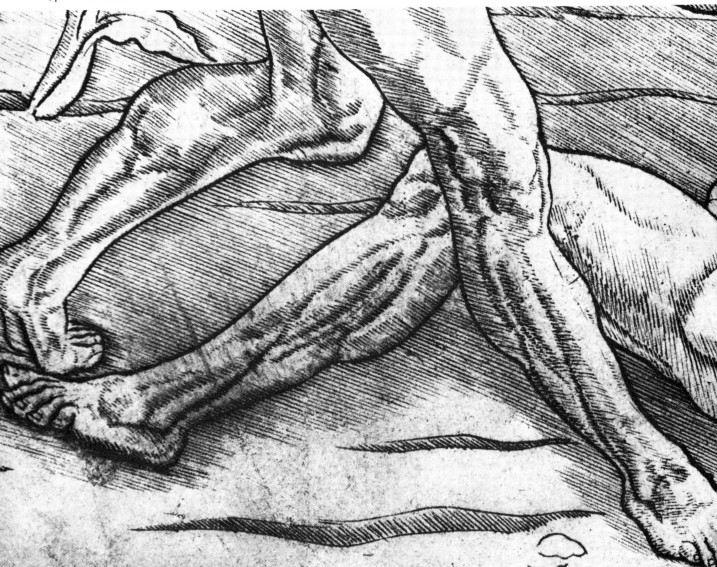

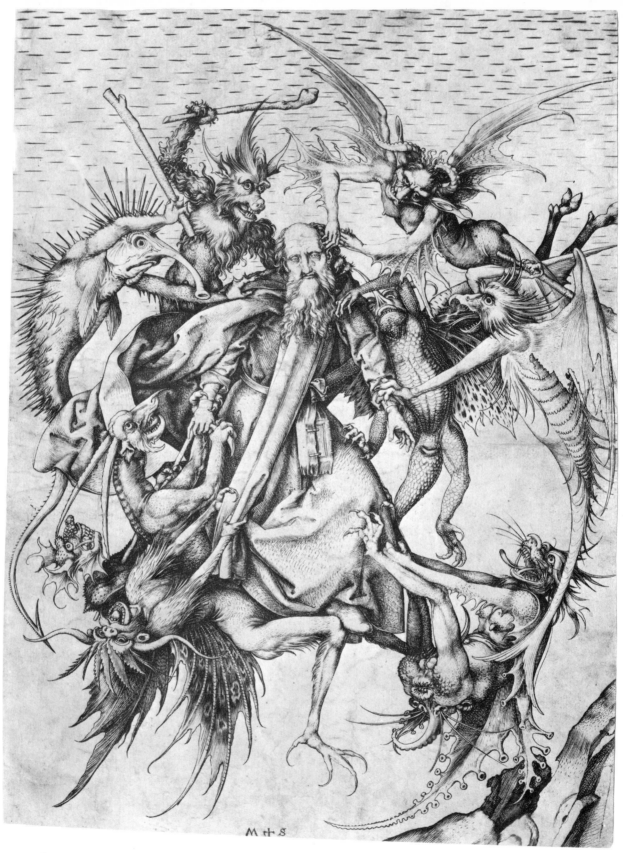

I,5 MARTIN SCHONGAUER (C. 1445–1491), *St. Anthony Tormented by Demons*. Engraving. The Metropolitan Museum of Art. Rogers Fund

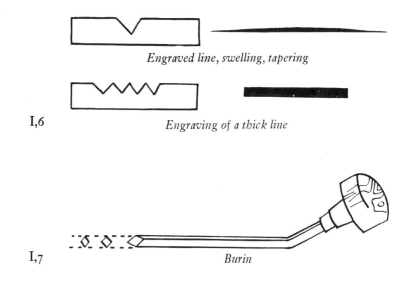

Engraved line, swelling, tapering

I,6 *Engraving of a thick line*

I,7 *Burin*

THE BURIN

The burin is a square or lozenge-shaped steel rod bent at the handle at approximately 30°
in order to let the pushing hand clear the plate (Fig. I, 7). As the meeting of the two
lower planes forms the cutting point, the engraved line is V-shaped. The point of the
burin always has to be kept perfectly sharp. Otherwise, it does not cut, but plows through
the metal. A dull burin will affect the quality and the character of the lines.

In rare instances the particular characteristics of the lines cut by a dull tool can be
exploited, as was done by Picasso in some of his engravings (Fig. I, 15). The coarse,
inflexible lines followed with unusually strong burr helped to invest some of his engrav-
ings with raw power and brutality.

The angle of the burin point varies according to personal preference of the engraver,
but approximately 35° seems to be a good standard angle. For very heavy, bold cutting,
it is advisable to have a burin sharpened so that there is more metal to support the cutting
point. Thus a blunter angle can be used.

A really well-sharpened burin will not slide over a fingernail when touched, nor will
it show any reflection of light.

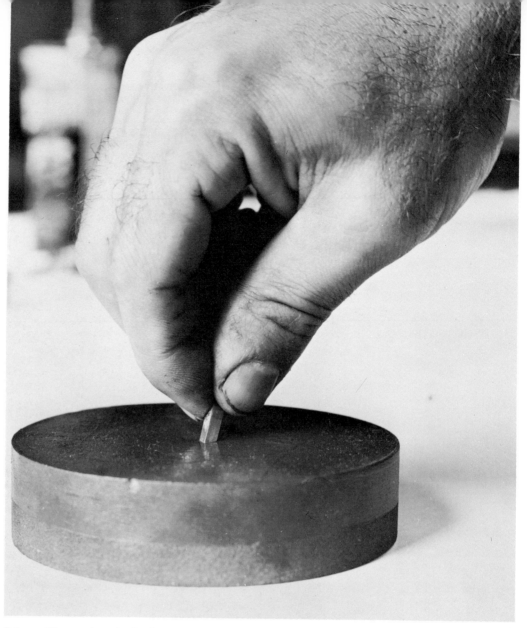

I,8 *Sharpening the burin*

Preparation of the Burin

Before a new burin can be used, it has to be properly prepared. A machine-finished tool can seldom be used as it comes from the factory. The first step is to true the belly of the burin (the two bottom planes forming the cutting point). This is done by putting the burin flat on the stone (using fine Norton India stone, Combination Round IB64). In this procedure always exert even pressure on the whole length of the tool (Fig. I, 9). Otherwise you may taper the point, and this can ruin the burin. The correct motion is to push and pull the whole length of the tool on the stone. Be careful not to rock the tool, because to do so rounds out the cutting edge.

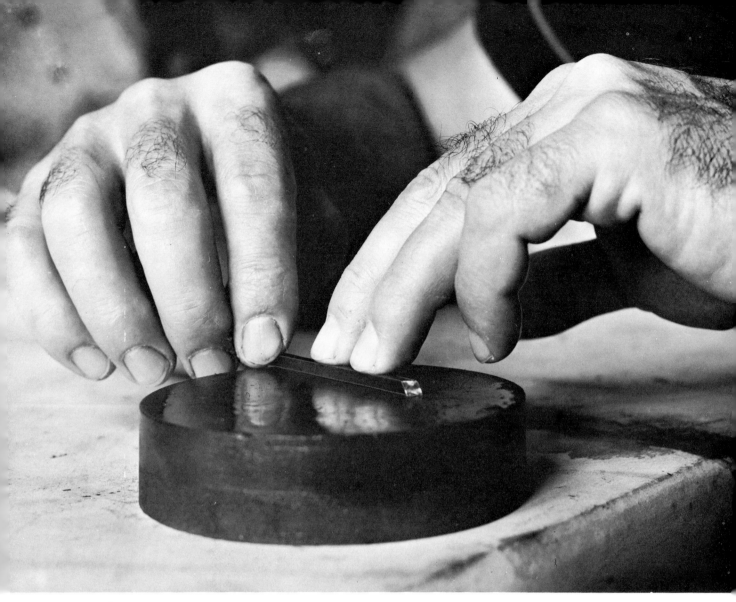

I,9 *Sharpening the belly of the burin*

Sharpening of the Burin

The burin comes with a point ground to the correct angle; and unless you want to change it by personal preference, it has only to be finished on the fine stone. This is done by holding the tool on the stone between your fingers close to the point and sharpening with a rotary motion (Fig. I, 8). A relaxed, even motion is advisable, as the exertion of too much power in any direction may make the surface lopsided.

Burin sizes range from No. 2 to No. 12. The number indicates the thickness of the shank, not the cutting point. The lozenge-shaped burins have finer points than the standard square profile. Burins below No. 6 are not rigid enough. No. 12 is

good for very heavy, bold cutting, but Nos. 7, 8, 9, and 10 are the best standard sizes.

I advise against the use of electric grinding stones for sharpening burins, as only the most experienced hands can avoid taking the temper out of the steel.

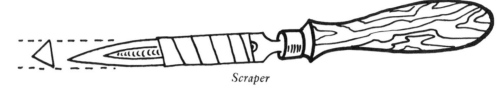

I,10 *Scraper*

THE SCRAPER

The scraper is made of triangular tempered steel with a tapered point and sides which are generally hollow-ground (Fig. I, 10). This tool is rough when it is bought, and must be sharpened and polished by hand.

I,11 *Cutting a burr with the scraper*

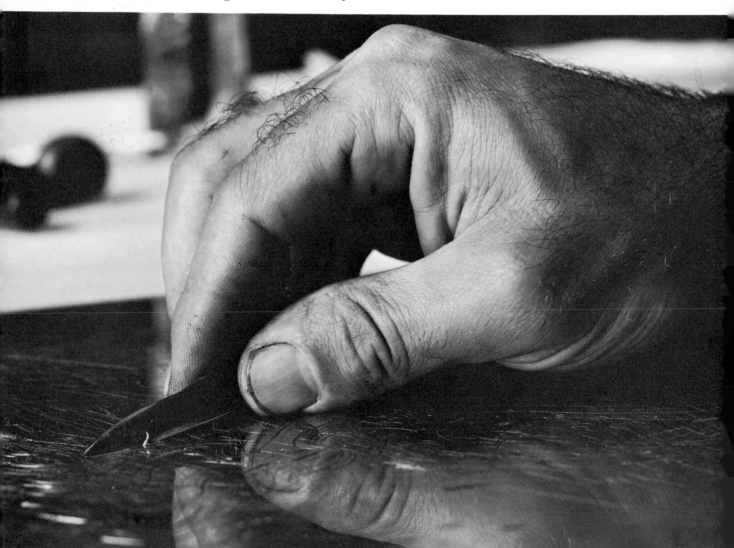

Sharpening is begun on the smooth side of a round combination India oil stone, continued on a soft Arkansas oil stone, and finished on 4/o emery paper.

The scraper edge must be kept in perfect mirror-like condition or it will injure the plate surface. When the scraper is being used, it should be examined frequently to ensure that the edges remain perfectly smooth. The scraper is generally used to clean metal burr raised by the engraver, thus lightening or eliminating dry-point lines or lightening aquatints and mezzotints. It should slide flat on the plate, following the direction of the lines, and it must be held very firmly because the slightest rocking and rolling would cut the plate (Fig. I, 11).

Metal is removed by shearing the plate with a tilted scraper blade (Fig. I, 36).

Like all sharp or pointed tools, the scraper point should be protected with a cork when not in use, and the blade should be oiled often to prevent rust.

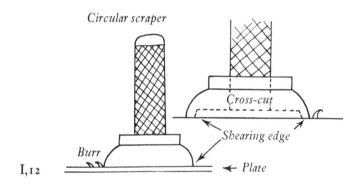

I recently received a new type of scraper from the artist Danny Pierce. After thorough testing I decided that it would be a very useful addition to the workshop (Fig. I, 12). This disc-shaped scraper has a cutting edge on its bottom circumference, and can be pushed in any direction. It is easy to manipulate on a flat surface without the danger of rocking, and is particularly valuable for cleaning engraved lines on an aquatinted surface. I am sure that any small machine shop can make this scraper out of stock materials.

THE BURNISHER

The burnisher is made of a highly polished, tapered elliptic steel rod with a slightly curved profile (Fig. I, 13). Agate burnishers made for gold-leaf work are also excellent,

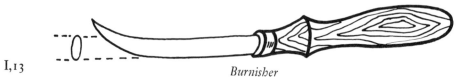

I,13 *Burnisher*

but they are very expensive and difficult to obtain in this country. The best ones are imported from Germany.

The burnisher is used to eliminate light scratches or to polish rough surfaces on the plate. It may also be used to lighten aquatints, mezzotints, and dry-point lines. Burnishing should always be done methodically with overlapping parallel strokes (Fig. I, 14). The metal to be burnished should first be covered with light machine oil to reduce friction.

I,14 *Burnishing*

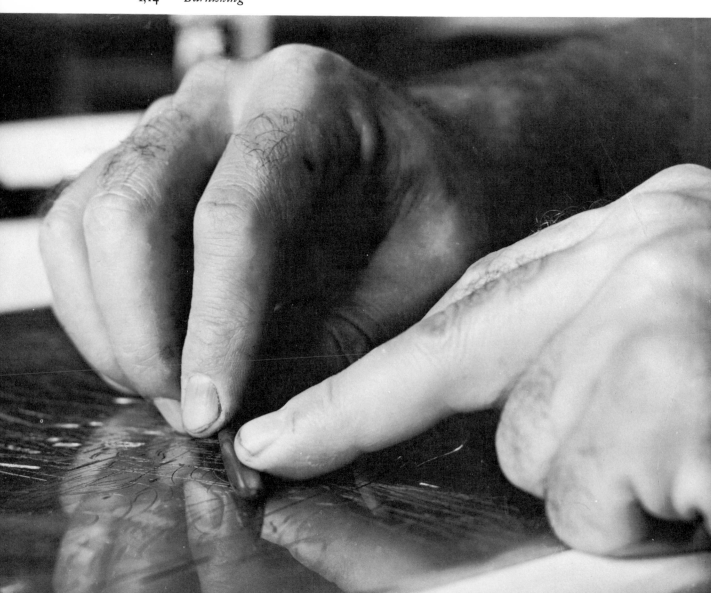

The burnisher must be kept in perfect condition; otherwise, instead of correcting, it may injure the plate. Because the greatest enemy of the burnisher is rust, the tool should be oiled often. If necessary, #0000 (4/0) emery paper can be used to clean the tool.

THE PLATE

For engraving, the best all-around metal is copper. In the past, soft iron and steel were also used, but for the size of the editions printed today there is no justification for using these less manageable metals. The copper we use today is generally 16- or 18-gauge cold rolled copper. In the past the engravers used hand-hammered copper that was superior to cold rolled copper because of its consistent structure. In rolled copper the crystallization of the metal is in the direction of the roll. Therefore, when you engrave, you can feel the difference in resistance as the line changes direction.

Whether the metal is freshly made or old also makes a great deal of difference. With time the molecular structure of the metal rearranges itself, acquiring a more even distribution. This structural change is clearly visible when you are relief etching a large area. As the acid bites down on the metal in new copper, you can clearly see ridges in the direction of the roll, while on old copper the bitten surface has an evenly distributed structure.

In recent years zinc plates also have become very widely used for engraving. I myself have used zinc plates extensively for engraving in the past ten or twelve years and have found them not only satisfactory but even preferable when bold free cutting is desired (Fig. I, 32).

In the past the opinion was held by some engravers that zinc was not suitable for engraving because of its softness. However, the engraver's zinc that we use today is really a zinc alloy, and is considerably harder than the pure zinc used in the past.

It isn't as pleasant to engrave on zinc as it is on copper. The slight unevenness existing in a fresh piece of copper is always present in zinc to a much greater degree; the zinc has a coarser and more uneven structure. Therefore you have to cope constantly with the changing resistance of the metal. For this reason I have always found it advisable to start my students engraving on copper and let them use zinc only after they have developed sufficient control to cope with the less manageable metal.

While engraving on copper, once the tool is engaged in the metal you do not have to put any downward pressure on it; but on zinc you have to hold the point of the tool down in the metal because when the burin is suddenly moved from a hard spot into a soft

spot it is difficult to control. It is interesting to note that although zinc is a softer metal than copper, it wears the burin point out much faster because of its coarseness.

There are several factors that may influence the artist in choosing either one of these metals. One is purely economical. During and after the war, with the cost of metals constantly rising, the price of copper was practically prohibitive to any young artist. It always was, and still is, just about double the price of zinc. The other factor—and this is my main reason for using zinc sometimes—is that for a certain type of free and very bold cutting zinc is actually better than copper. However, when I am working on a plate where I want extremely fine, controlled details, and an elegant rather than a violent line, I choose copper (Fig. I, 16).

Both copper and zinc plates come with a high polish that reflects light, and they are very hard to draw on. For this reason many artists prefer to alter the surface by dipping their plates in a weak solution of nitric acid (1 part of nitric acid, 12 parts of water) for a few seconds.

You can also use aluminum and magnesium for engraving, but I have found them extremely unpleasant—brittle and generally unsympathetic. Because they are more expensive than zinc, the only justification for their use would be that nothing else was available, or that you secured a quantity of these metals for nothing.

Engraving on Plexiglas has so little relation to metal engraving that I am going to discuss it in the chapter on plastics.

DRAWING ON THE PLATE

To draw directly on the metal plate, it is best to use a wax crayon or a china marking pencil. Ordinary soft pencils can be used if the plate has been dipped in acid previously, but this type of line smears very easily in the process of engraving.

I consider that the best method of fixing my drawing on the plate is by using a wax crayon while the plate still has a shiny surface. After I have finished my sketch, I dip the plate in the acid for a short time. The wax from the crayon acts as an acid resistant. The surface of the plate becomes dull by the effect of the acid except under the wax lines. Thus, even if the crayon lines are smeared or wiped off, the drawing remains visible.

The same procedure can be followed also with India ink, stop-out varnish or asphaltum varnish.

Some printmakers also use the method of going over the pencil-drawn lines with an etching needle, scratching the plate lightly to preserve the drawing as a light dry point, or even in some cases actually making an extremely light etching on the plate before they

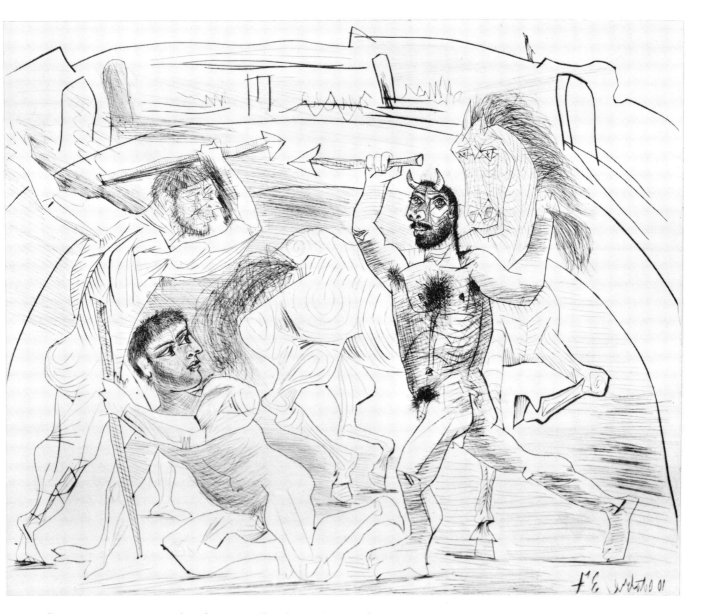

I,15 PABLO PICASSO, *Combat*, 1937. Etching and engraving.
The Museum of Modern Art Collection, New York

I,16 GABOR PETERDI, *La Grande Bataille*, 1939. Engraving.
The Brooklyn Museum Collection

I,17 GABOR PETERDI, detail from *La Grande Bataille*

begin their engraving. This method has the great disadvantage that unless you follow your drawing exactly, you will eventually have to scrape and burnish out the marks made by the needle on the plate.

The Reversal of the Image

Here I should like to say a word about a fact obvious to anyone who knows anything about printmaking, though it is one that always seems to surprise the beginner. The print is always the mirror image of the plate. Everyone has a tendency to draw asymmetrically

and distort to left or right, and the sudden appearance of the reversed image makes this asymmetry more obvious and is a shocking experience, particularly to artists working in a representational or naturalistic style. Even a slight distortion in architectural structure or a portrait can be quite disturbing.

This problem may easily be eliminated by transferring the original drawing in reverse on the plate so that the printed image will correspond to the original. The transfer can be easily done by using either white waxed carbon paper or even an ordinary carbon paper, and then dipping the plate in the acid as suggested previously with the wax crayon drawing.

If the artist intends to etch the design lightly into the plate before engraving, there are other transfer methods possible (see under "Etching").

CONCEPTION AND TECHNIQUE

To engrave without undue strain to the eyes, it is very important to work under proper lighting conditions. The ideal light is daylight in a studio with northern exposure. Cloudy days are particularly excellent because the mellow, even light tends to reduce glare on the metal.

The Proper Light for Engraving

If you have to work in front of a direct light, the best procedure is to stretch a tracing paper between yourself and the source of light. In other words, filter the light to the plate.

Beginners always seem to strain their eyes much more than an experienced engraver because they constantly try to focus their vision on the point of the tool. This is similar to the working habits of commercial engravers, who use magnifying lenses to follow the progress of their work. That is not necessary. After some experience the engraver can orient himself nearly as much by touch and sense of direction as by sight. Once I engage my tool in the metal, I know where it will go. This aspect of engraving develops naturally, with an increasing feeling of security gained by experience.

How to Use the Burin

In order to engrave with control, the beginner should observe the following rules:

1. The tools should be properly prepared and tested. Always have a small plate at hand on which to try the tools before you begin working.

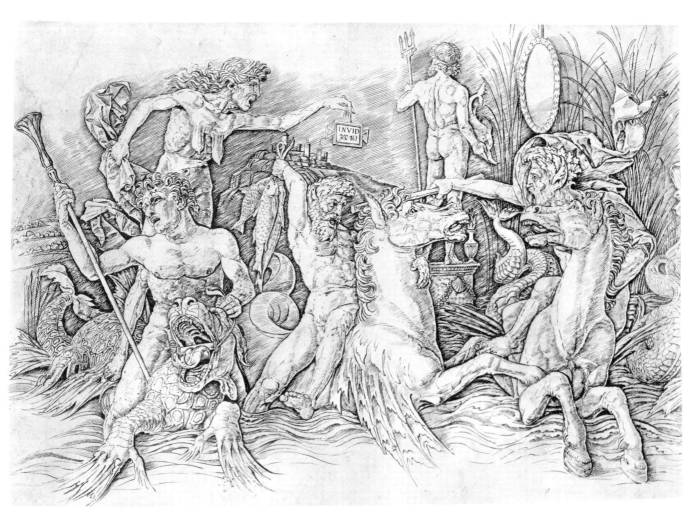

I,18 ANDREA MANTEGNA (1431–1506), *Battle of the Sea Gods*. Engraving.
Yale University Art Gallery

2. Position of the body in relation to the table is extremely important. You should sit high enough to lean comfortably over the plate and rest your cutting arm on the table. Too high a table puts strain on the shoulders. Too low a table strains the back. You have to face in the direction of the cutting motion; the right-handed man faces left, and vice versa.

The burin itself should be held in the following manner: the handle of the tool rests against the palm of your hand, and the little finger holds it securely in position. The two middle fingers should rest on the side of the burin—never under it, as that would force you to attack the plate at too steep an angle (Fig. I, 2). The point is stabilized between the thumb and the index finger. The tip of the thumb and the index finger actually slide on the plate while engraving (Fig. I, 1). This helps to stabilize the cutting. The point of the burin and the two fingertips form a tripod. If the burin is held correctly, you can rest it flat on the plate without any interference from your fingers. The pushing of the burin is done by following through with the shoulders and not by the arm alone. This gives greater power and more control over the speed of the cutting; also, in this way the relative position of the arm to the rest of the body remains more constant. Thus there is less likely to be strain either on the shoulder or on the wrist. Concentrate on not lifting your elbow (a very common bad habit), as this will strain your wrist. Remember that the pressure exerted should always be behind the burin, and that any position of the arm that puts sidewise pressure on the tool will eventually cause slips.

3. Keep your tool straight. Don't tilt it. Especially watch it on cutting curves. Beginners have a tendency to bank their tool in curves excessively, thus cutting lines that won't print properly.

4. Don't rock the tool. This will give a rugged, wobbly line. If the push is too hard, it is a sign that either you are trying to cut too deeply or your tool is dull. It is better to cut a heavy line in stages than to risk too much forcing. This can chip the burin point and cause really bad slips.

5. The working surface of the table should be polished enough to help the manipulation of the plate. A heavy glass plate, Plexiglas, or any plastic is an ideal surface to work on and easy to clean. In working on a very large and heavy plate, make turning easier by placing a folded paper or cardboard under the center of the plate to reduce friction.

6. Always keep a well-sharpened and polished scraper handy, as you will use it continually. The best practice is to clean the burrs of the lines as soon as they are cut. This is especially true with heavy, sharp burrs raised at the end of the line when you stop with the burin deep in the metal. Keep your hand away from these, for

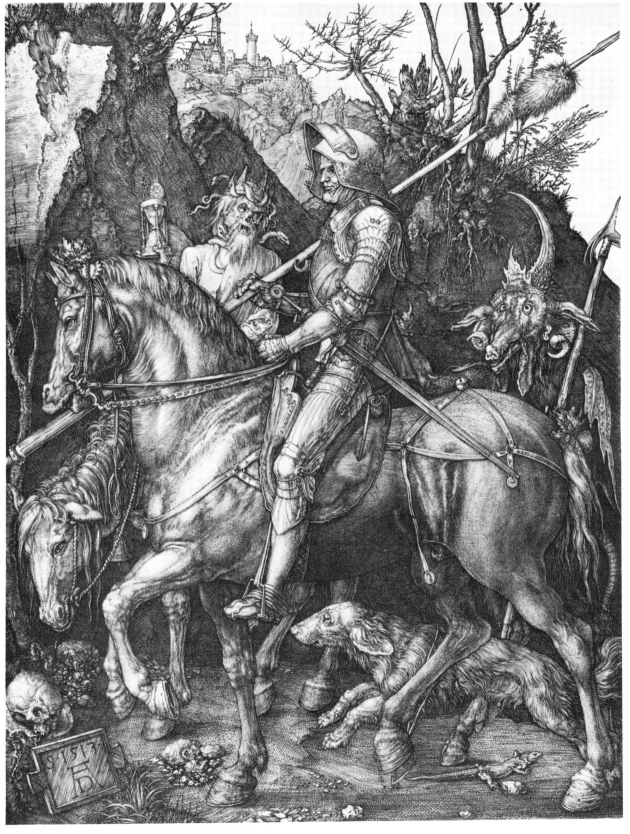

I,19 ALBRECHT DÜRER (1471–1528), *Knight, Death, and Devil.* Engraving.
The Brooklyn Museum Collection

they are as sharp as a razor and you can cut yourself badly. Shear these burrs off in the direction the line was engraved. Otherwise, you may push them back into the line (Fig. I, 11).

Engraved Textures

Besides cutting the lines, the burin can be used for a great variety of textures, from tiny dots (made by engaging the burin point in the metal and picking it up) to triangular cuts of different lengths (made by stabbing deep into the metal and stopping with the burin at the deepest point, then disengaging it by withdrawing), as well as long tapered cuts (made by starting light with the burin, going deep, and then coming up and finishing by tapering the cut out) (Fig. I, 17). You can also cut short curly textures by holding the burin at a sharp angle and pivoting the plate rapidly.

It is amazing what variety of color and texture can be achieved with the infinite combinations of these simple elements (Fig. I, 25, 28, 29, 30).

The early Italian engravers are generally divided into two major groups by art historians: those employing the fine manner and those using the broad manner.

The "fine manner" employs short strokes cut close together to describe shadows. This technique disregards the interplay of light between the parallel cuts. The school of Finiguerra and Master E. S. of 1466 are the best known practitioners of this style.

The "broad manner" is a style formed by parallel strokes engraved with sufficient spacing to allow the white of the paper to show through as light. Alternating short cuts within the long burin strokes for modeling establishes masses as against the earlier technique of simply building up contours. This school produced the two giants of Florentine engraving Antonio Pollaiuolo (1429–1498) and Andrea Mantegna (1431–1506) (Fig. I, 3, 4, 18).

The early German masters used texture sparingly, mostly dotting in combination with the lines, while Martin Schongauer and Lucas van Leyden worked toward a more complex technique of engraving (Fig. I, 5, 24). The culmination of this development was Dürer. His late plates reached an amazing technical virtuosity (Fig I, 19). This was not necessarily beneficial, because its overemphasis took away the directness and vigor of his earlier prints (Fig. I, 20, 21).

About the same time that Dürer was working in Germany, in Italy Marcantonio Raimondi, also an amazing technician but a much lesser artist, launched a very lucrative career of engraving reproductions mainly of Raphael's work, thus starting off a process

that eventually led the art of printmaking—within two hundred years of its invention in Europe—into a total degeneration. Printmaking eventually was regarded more as a reproductive medium than as an original creative process.

I think that generalizations are always dangerous, but somehow, with few exceptions, the whole history of engraving seems to prove that the most meaningful and expressive engravings were done with a simple and direct technique. The overuse of crosshatching and the abuse of textures obliterate the linear quality and destroy the marvelous vitality of the engraved line. One has only to compare a Mantegna print with a Marcantonio Raimondi to see my point. There are, naturally, exceptions. Even the overemphasis of technique in the late Dürer prints could not hide his genius (Fig. I, 19). The same is true of Lucas van Leyden and Duvet (Fig. I, 23). In contemporary printmaking Jacques Villon uses an extremely complex, methodical crosshatching technique to build up his cubist compositions in terms of flat planes.

As a study of outstanding contemporary engravings I recommend the prints of Stanley William Hayter. I doubt that anybody understood better the potentialities and limitations of this medium than he does. The lines engraved by Hayter project a vitality far beyond their descriptive intent (Fig. VI, 35).

On the Scale of Engraving

The scale of engraving is very misleading. One of the commonest mistakes committed by beginners is to oversize their plates. They think that a drawing can be engraved on a similar-size plate. This is very seldom true. If you take into consideration the scale and precision of the burin cuts (Fig. I, 5) as against the drawn line, by either pen or pencil, it is obvious that the dimension of the engraving has to be adjusted accordingly. Most of the drawings can be easily engraved on a plate three or four times smaller.

The inexperienced engraver usually has difficulty in judging from the plate how the engraved lines are going to look in print. The very fine lines are generally heavier than anticipated and the heavy lines are lighter. In other words, the beginner generally works in the middle register of values.

It is well to remember that no engraved line is too fine to print, but the really heavy black line can be obtained only by a series of parallel cuts blending together in print (Fig. VI, 35). In cutting a heavy line, never keep on cutting back into the same groove, because the result will be a line that will give trouble in printing because of its excessive depth. The heavy line consisting of a number of grooves will hold the ink well, won't wipe out easily, and won't blotch.

I,20 ALBRECHT DÜRER (1471–1528), *The Prodigal Son*. Engraving.
The Brooklyn Museum Collection

I,21
Detail from *The Prodigal Son*

The Color of Engraving

The fine scale and the intensity of the engraved line also tend to mislead in shading or texturing. The number of engraved dots or lines that would read as a tonal area if drawn with pen or pencil remain only a series of scattered dots and lines (Fig. I, 5). One often has to triple the number of cuts before they read as a tonal area. The engraved line does not blend easily. In cutting textures, the burin has to be carefully controlled because the slightest increase in pressure will register and create jumpy, uneven spots, thereby destroying the continuity of the surface. This inherent intensity of the engraved line is a very important asset when combined with another medium.

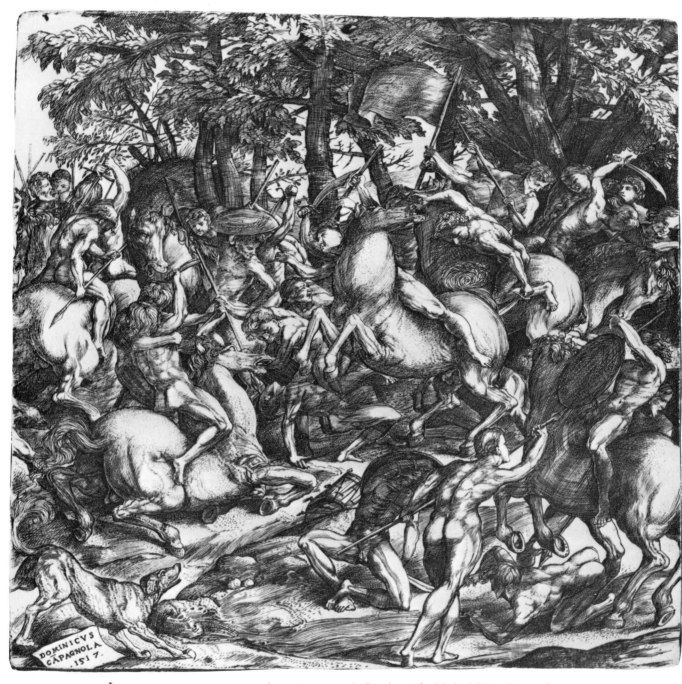

I,22 GIULIO CAMPAGNOLA (c. 1482–c. 1515), *Battle of the Naked Men*. Engraving.
Yale University Art Gallery

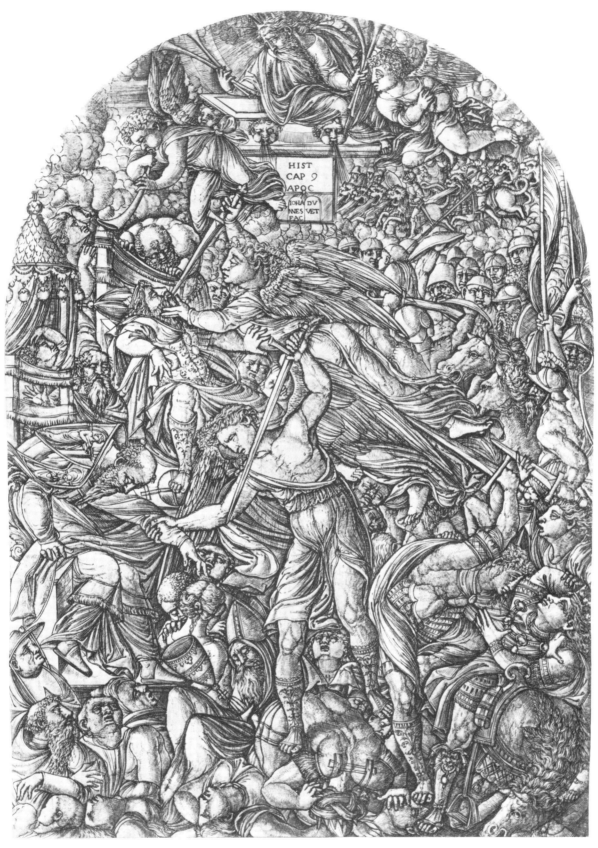

I,23 JEAN DUVET (c. 1485–1561), *The Angel Sounding the Sixth Trumpet*. Engraving from the Apocalypse. Yale University Art Gallery

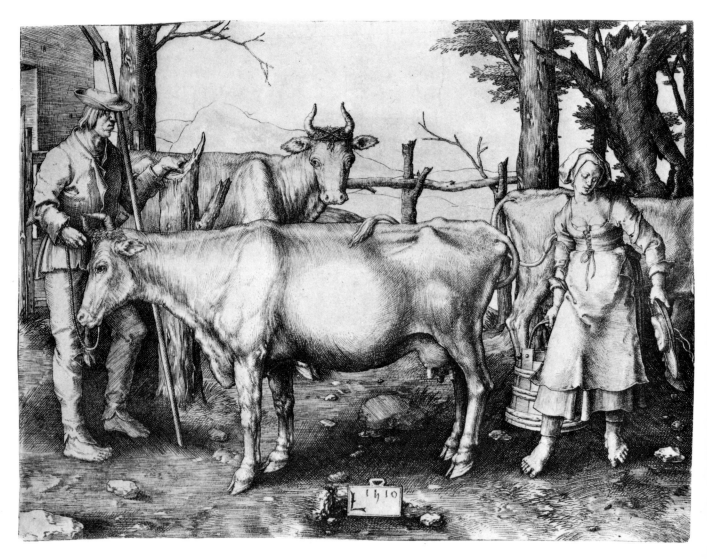

I,24 LUCAS VAN LEYDEN (1494–1533), *The Milkmaid*. Engraving.
The Metropolitan Museum of Art. Harris Brisbane Dick Fund

I,25 LEE CHESNEY, Engraving, 1952.
The Brooklyn Museum Collection

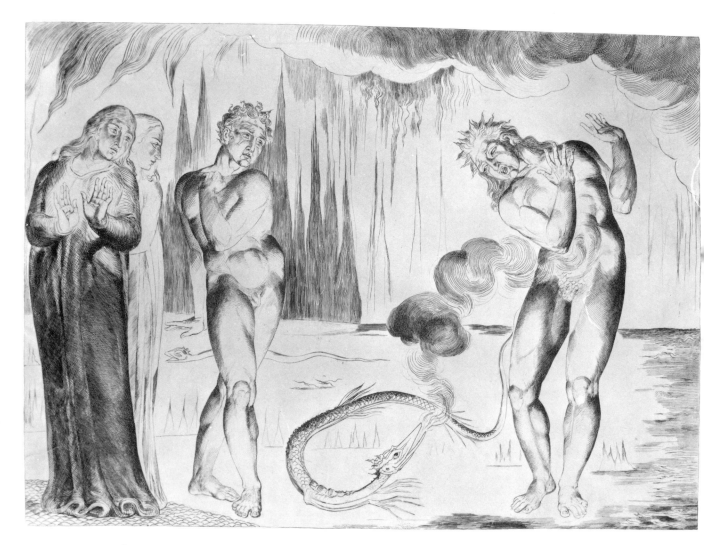

I,26 WILLIAM BLAKE, from Dante's *Inferno*, Canto XXV. Engraving.
The Metropolitan Museum of Art. Rogers Fund, 1917

I,27 FREDERICK G. BECKER, *Scaffolding*, 1952. Engraving on Dowmetal

I,28 MAURICIO LASANSKY, *Self-Portrait*, 1957. Engraving.
The Brooklyn Museum Collection

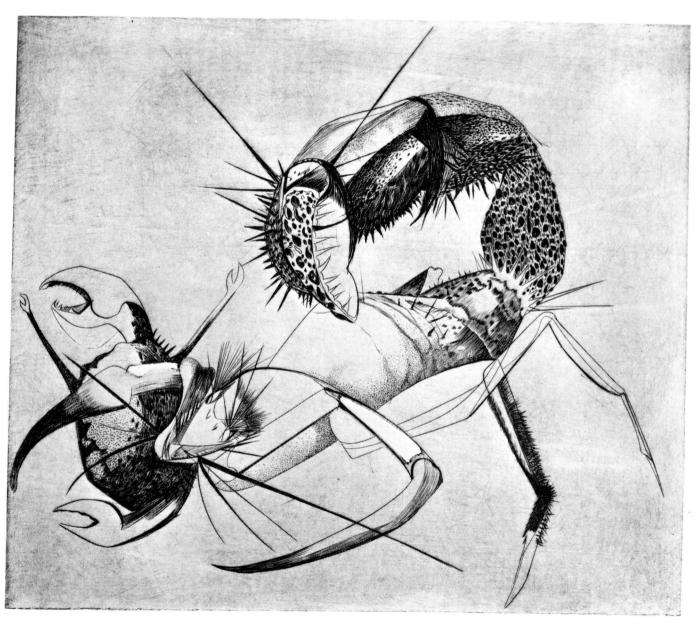

I,29 WALTER ROGALSKI, *Scorpion and Crab*, 1951. Engraving and embossment.
Author's collection

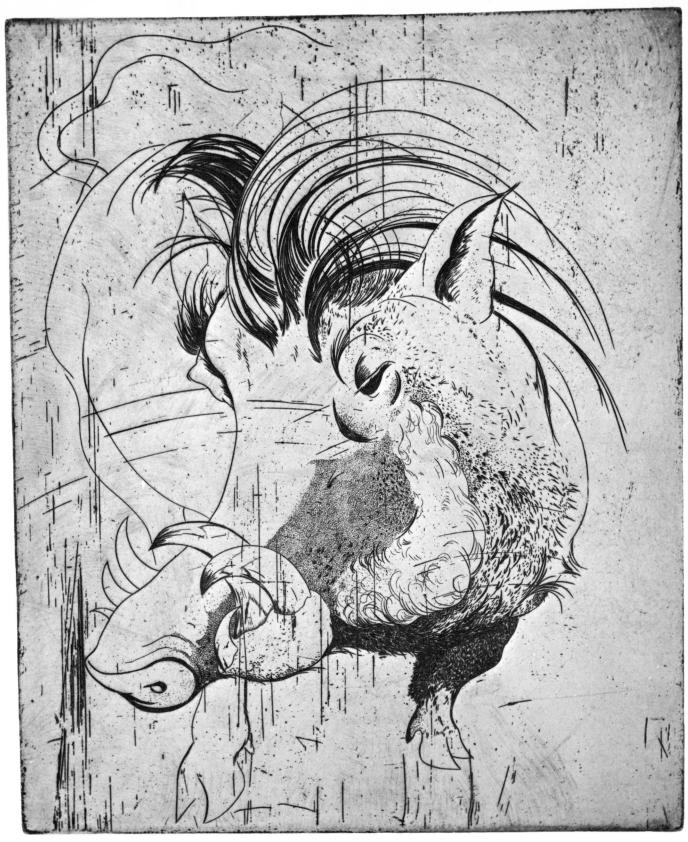

I,30 DANNY PIERCE, *Wild Boar*, 1950. Engraving.

I,31 H. G. ADAM, *Anse de la Torche*, 1957. Engraving.
The Brooklyn Museum Collection

I,32 GABOR PETERDI, *Landscape of Death*. Etching, engraving, and dry point, 1966

Engraving in Relation to Other Techniques

If a strong accent is needed in a densely worked etching, the engraved line will stand up (Fig. VI, 35). It will practically float on a surface that would drown another etched line of the same thickness. While this is an asset when a real contrast is needed, it can cause trouble when a harmonious blending of the different media is desirable. My past experience seems to indicate that the combination of engraving with other techniques—especially with aquatint or soft ground—works well within an abstract conception of space and form, but is too violently contrasting to be used on naturalistic, representational prints.

The ever-present ambiguity in lines crossing in space without attachment to a positive form characterizes engraved lines to a marked degree (Fig. VI, 35). The crossing burin lines can be bound to the same spatial plane by a dot of the crossing point—a device used a great deal by Hayter.

Besides the regular burin, the standard tool of the engraver, one can use multiple gravers, flat gravers, and gouges as auxiliary tools.

Multiple Gravers

The multiple gravers (lining tools) used mostly by commercial engravers can come in handy when a truly neutral tonal area is desirable to enrich an already densely etched passage (Fig. I, 33). The abuse of this tool, however, can be deadly because of its completely mechanical character. Multiple gravers come in the following sizes, with the size being determined by the number of lines to the inch:

0	200	7	85
1	175	10	65
2	150	19	45
3	133	22	35
5	100	18	25

Using Gouges

As for the gouges, their use is also limited, and you can very well get along without them; but I have found their use very important at times. The gouges and flat gravers cannot be used to cut a straight line like that cut by a burin. The metal would offer so much

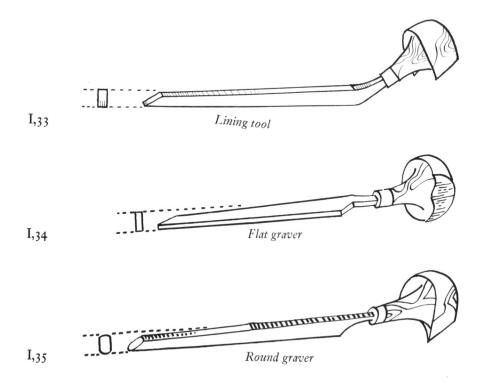

I,33 *Lining tool*

I,34 *Flat graver*

I,35 *Round graver*

resistance to these tools that it would require enormous physical strength to push them any distance in the metal. Even if we assume that they could be used to cut a line, it would be too shallow to print properly. The gouges and gravers are excellent for cutting scalloped, wide textural lines. This is done by holding the tools at a steep angle varying from 25° to 40°, and advancing with a wiggling motion of the wrist. The width of the line is determined by the width of the tool. The spacing of the zigzag twist of the line is controlled by the angle of the tool and the speed of the rocking in relation to the position. The steeper the angle and the faster the rocking, the denser the texture. These lines have a very strong burr that will withstand a goodly number of printings. If a rich black area is desirable, the burr can be left on. Scraping off the burr considerably reduces the density of such lines.

The flat gravers are numbered from 36 to 49, and I have found that to own a fine 36, a medium 43, and a heavy 49 is sufficient (Fig. I, 34).

The round gravers are numbered from 50 to 63, and there I have found the numbers 52, 57, 59, and 63 very useful (Fig. I, 35).

Sharpening of Gouges

These tools, like the burins, must always be kept sharp. Otherwise, they slip easily, and this can be disastrous over an aquatinted plate surface. The sharpening of gouges and flat gravers is done mostly on the cutting area with a push-and-pull motion. The sharpening of the curved belly side of a gouge on a flat stone is very tricky and not advisable. The safest way is to buy special sharpening stones with grooves cut into them corresponding to the tool profiles.

Embossed Areas

The gouges are also needed if you want to dig out the metal to create embossed areas on the paper, similar to the effect used on some of the early Japanese woodcuts (Fig. I, 26). To do this, first cut in the definition of the shape with a regular burin. The hollowing should be done in stages. To start, hold the gouge at a fairly shallow angle and scoop with a rocking motion. Then, as the hollowing nears the desired depth, the ridges created by the rocking of the gouges can be cleaned out with the flat gravers. To save much effort, if large areas have to be gouged out, you can etch the metal down and use the gouges only for the cleaning-out process. (See more about this in the section on "Relief Etching.")

I should like to advise the printmaker, the first time he intends to use the embossed white on a plate, to try it out on an old plate before it is applied on a work in progress. The embossed white disrupts the surface plane of the print much more violently than is generally anticipated, as the embossment is usually surrounded with the tone characteristic of the intaglio print. The optical illusion makes the embossment seem much whiter than the paper itself.

CORRECTIONS ON THE PLATE

Now I should like to say a few words about the correcting or eliminating of an engraved line. The beginner is always impressed, and sometimes practically paralyzed, by the seeming finality of anything that is cut into metal. It is true that to take out the line cut into metal is not so easy as erasing a pencil drawing on a paper. It requires a great deal of methodical work, but it can be done.

If it is a single line in a wide area, it is relatively easy, but if it is in a densely engraved area it means the scraping out of a whole section.

Cutting the burr *Shearing the metal*

I,36

Scraping

To eliminate an engraved line, first scrape methodically. Tilt the scraper on its edge and pull it toward you with a shearing motion (Fig. I, 36). Start with very light pressure, because the application of too much force will make the scraper cut into the plate and will result in a series of parallel ridges called "drifts" that will show up in printing. Scraping has to be done on a fairly wide area to give a tapered recession and not a hole, as the hole would give you an unevenly printed tone. After the scraping is finished and the line disappears, the plate surface has to be reworked to its original finish.

Repoussage

If the line is very deep and if the scraping created too much of a hollow, it is advisable to push the metal back to its original level. This can be done by using a caliper and determining the exact position of the hollow in relation to the back of the plate, then cutting out blotting paper the size and shape of the hollow. Glue this paper in the position marked by the caliper on the back of the plate. Run the plate through the press. In this way the paper glued to the back of the plate will force the metal up to its original level.

There are also ways to hammer the plate back, but this is much more difficult, and requires special skill.

Polishing

After the plate is leveled off, the next step is to polish the surface. First, work the scraped area over with an engraver's charcoal. The charcoaling is more effective if the plate is wet or has a slight film of oil on it. After the charcoaling is finished, use rotten stone or pumice powder and finally jewelers' rouge.

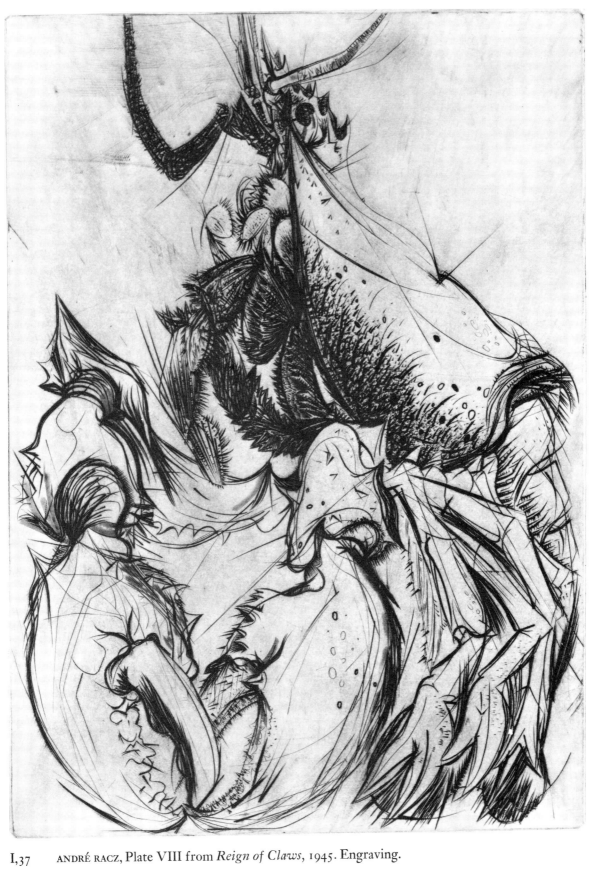

I,37 ANDRÉ RACZ, Plate VIII from *Reign of Claws*, 1945. Engraving.

Filling in Lines

For those who might be discouraged after reading my description of how much trouble they have to go through to correct an engraving, I should like to pass on the formula for filling in lines with a copper amalgam. To be honest, I always do it the hard way, but I pass this on for what it is worth. Copper amalgam can be obtained at dental laboratory supply houses. It is three parts of copper and seven parts of mercury. You must heat it in an iron spoon until the heat drives the mercury to the surface in small globules. Do not overheat it, as you may drive all the mercury out. After the heating, place the amalgam in the mortar and work it briskly with a pestle until it becomes completely smooth; then knead it in your hand into a soft-textured lump. Fill in the lines. In an etching the inside of the lines is rough enough to hold the amalgam; but in engraving, because the lines are V-shaped and smooth, it is necessary to rough up the lines to anchor the filling firmly.

It takes approximately a day for this to harden enough for printing. It is advisable not to overheat the plate corrected by this method.

THE WAX PROOFING

If you are working on an engraving without printing facilities, and if you would like to observe the progress of your plate, there are several methods that I should like to suggest.

The first, and simplest, is to rub either white talcum powder or black pigment into the lines; then place a tracing paper over the plate, thus cutting down the glare of the metal. The lines now show up very clearly.

There are ways, however, to make very coarse prints to get a vague idea of how the art work looks when it is reversed. One is called a "wax proof." Cover a sheer but strong paper with a thin layer of melted wax. Rub lampblack into the lines. Then place the paper with its waxed side down on the plate and work it over methodically with the burnisher. The wax will pick up some of the lampblack from the lines. This is a very coarse method and will not represent the real quality of your lines, but it is helpful in getting a general idea of the overall effect.

The other method is to cover a piece of fine linen with gesso. Fill the lines either with

dry black pigment or with a regulation but fairly loose printing ink. Place the linen over the plate before the gesso has a chance to dry completely. Pass a warm iron over it. The gesso will pick up a light impression of the plate. The same thing applies to this as to the wax proof. This is simply an auxiliary method, and not one that can be used for final printing.

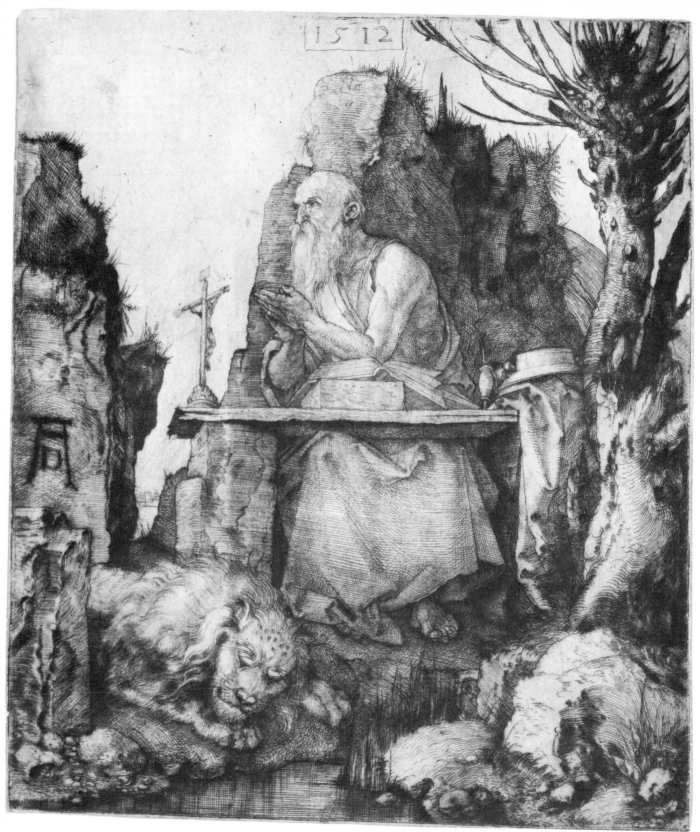

II,I ALBRECHT DÜRER (1471–1528), *St. Jerome by the Willow Tree*. Dry point.
The Metropolitan Museum Collection. Fletcher Fund

Two

DRY POINT

To MAKE A DRY POINT, scratch the design into the metal, and print. It sounds very simple —so simple, indeed, that it fools many. Those artists who resent the idea of becoming involved with the complexities of etching or with the special skills of line engraving naturally turn to a dry point, only to discover that it is one of the most difficult techniques to control.

The dry-point line is scratched into the metal with a sharp needle (Fig. II, 2). As the point is drawn in the metal, it raises a furrow as a plow does; this is the burr. The indentation in the metal is negligible. The rough burr itself is what will hold the printing ink.

The control of the thickness and color of the line is achieved by the coordination of pressure and the angle of the needle (Fig. II, 3). Actually, the angle has much more effect

on the width of the line than the pressure itself. Even the best controlled dry-point line sets slightly irregular burrs, and prints as a soft, modulated, velvety line. As long as the dry point is used for achieving color in large tonal areas, it is not too difficult to handle, because a strong burr can be scraped or burnished down (or reworked if it is too light); but linear treatment should be used only by an excellent draftsman. To go back into an already scratched line is very seldom successful, just as a pen line drawn over several times tends to be robbed of its freshness and vitality. To be right at the first stroke demands not only a great draftsman but a complete control of the technique.

Dry point had been tried by Dürer (Fig. II, 1), but Rembrandt was the first to produce really great prints with this medium. The rich mellow color of the dry point naturally appealed to the temperament of Rembrandt; especially in his late prints, he used dry point a great deal in combination with etching.

Dry point became very popular in the latter part of the nineteenth century. Whistler made a few really outstanding prints with this medium. In the twentieth century the German expressionists used dry point a great deal—like Max Beckmann (Fig. II, 6) and Emil Nolde; and in the Parisian school Jacques Villon (Fig. II, 7), Marc Chagall, Picasso, Joan Miró, and many others used the dry point with great success.

TOOLS AND MATERIALS

Copper, zinc, aluminum or magnesium plates
Steel-, diamond-, or sapphire-point needle
Burnisher
Scraper
Abrasives, and so on

THE PLATE

For dry point the copperplate is much better suited than zinc. One of the great problems of dry point is that the number of possible impressions is very limited owing to the flattening of the delicate burr under the printing pressure. Unless the printmaker is satisfied with a very limited edition—at the most, five or six prints—the plate has to be steel faced to harden up the burr. Steel facing deposits a fine layer of steel on the copperplate by galvanic action. The zinc plate cannot be steel faced. It would have to be copper faced first, and this is not a practical method.

If the steel facing is correctly done, the values of the plate should not be affected, but if something goes wrong (as I have seen happen with a Miró plate), the steel facing can be removed and done over again.

II,2 *Diamond point*

THE NEEDLE

The best needle for dry point is diamond (Fig. II, 2). The next is sapphire and the third is steel. The advantage of the diamond and sapphire points over the steel is that they cut with less effort and work with greater freedom in any direction. The only disadvantage is the price, but if someone uses dry point a great deal such a needle is worth the investment.

In purchasing a diamond or sapphire needle, be sure that the stone protrudes from the setting far enough to allow cutting at an acute angle. For steel point, any good hard-tempered steel can be used. (I have made good dry-point needles out of broken dentists' tools.)

Sharpening of the Needle

The correct sharpening is very important. A good needle should be ground without facets. Otherwise, it will be unmanageable and will drag if turned in the wrong direction. As I mentioned earlier, the angle of the tool to the plate will determine the thickness and quality of the lines.

Working with the Needle

If you draw with the needle vertically on the plate, the line will be fine and print well. Actually, this will be a fine double knife-edged line, as the point pulled vertically throws

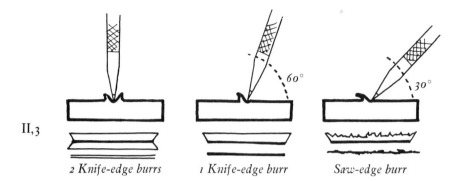

II,3

2 Knife-edge burrs *1 Knife-edge burr* *Saw-edge burr*

burrs on both sides. If the needle is tilted, the burr is raised in the opposite direction. As the tilting angle increases or decreases in relation to the plate (90° representing the vertical, and 30° the maximum tilt in relation to the plate level), so does the width of the line; and it reaches a point where it would produce a rough saw-edge burr too weak to stand up under the printing pressure (Fig. II, 3). The danger of weakening or destroying the burrs makes it inadvisable to pull trial prints while working on the plate.

In order better to follow the progress of the work, rub dry black pigment or chalk into the burrs.

In printing a dry point, be careful in the inking and wiping process and avoid any vigorous rubbing with either the inking dauber or the tarlatan. Excessive rubbing may weaken or even destroy some of the burrs.

ELECTRICAL ENGRAVERS

The electrical engraver is a small motor-driven sharp, pointed metal needle (carbide- or diamond-tipped) with an oscillating action. This small electric tool is manufactured primarily for the hobby market and can be bought in most large hardware stores. I became interested in them several years ago. The advertising claim that with this tool one can engrave on practically any material (glass, steel, plastics, etc.) fascinated me. They are not very expensive (approximately fifteen to eighteen dollars), so I felt it was worth the try. After looking over several brands, I decided on a Dremel model 290 because I liked its design best. One can hold it like a pen, and it has three speeds controlled by a switch. Experimentation convinced me that this tool can be very useful for printmakers working on metal.

The name of the tool is misleading. The electrical engraver doesn't engrave but punches tiny holes at very high speeds. If the tool is moved slowly, the effect is a continuous line, and only a magnifying glass reveals the dots. If, however, one moves it fast, it produces a distinctly dotted line. The interval between the dots is determined by the speed. The width and depth of the line are determined more by the speed of the motor than by pressure. Much pressure is not advised, as it can put too much burden on the tiny motor and burn it out.

In printing it is not so much the depth of the marks but rather the burr that holds the ink, as with the conventional dry-point line. Corrections and alterations are easily made by removal of the burr with scrapers and burnishers.

In printing, however, a plate made with the electrical engraver has a very distinct advantage over a plate drawn with a conventional needle. Although the traditional dry point is very fragile and has to be steelfaced for more than three or four prints, the plate made with an electrical engraver stands up very well. In printing tests I pulled twenty-five proofs of a zinc plate without noticing any significant deterioration. It is interesting to note that the electrical engraver produces a tougher burr on zinc than on copper.

In addition, I found that the electrical engraver is of great value for retouching aquatinted areas, darkening underbitten etchings and roughing up the inside of wide and shallow lines that otherwise wouldn't hold ink.

PRINTING AND DRY POINT

The printing pressure should be always considerably lower than the one used for etching and engraving. With dry point the ink is deposited mainly in the surface burr. Therefore great pressure is not necessary. While an engraving is printed with about 250 to 300 pounds of pressure, approximately 100 pounds is sufficient for dry point.

A dry point always should be printed with soft, fluffy felts, and possibly on a heavy but soft paper—but more about this in the chapter on printing.

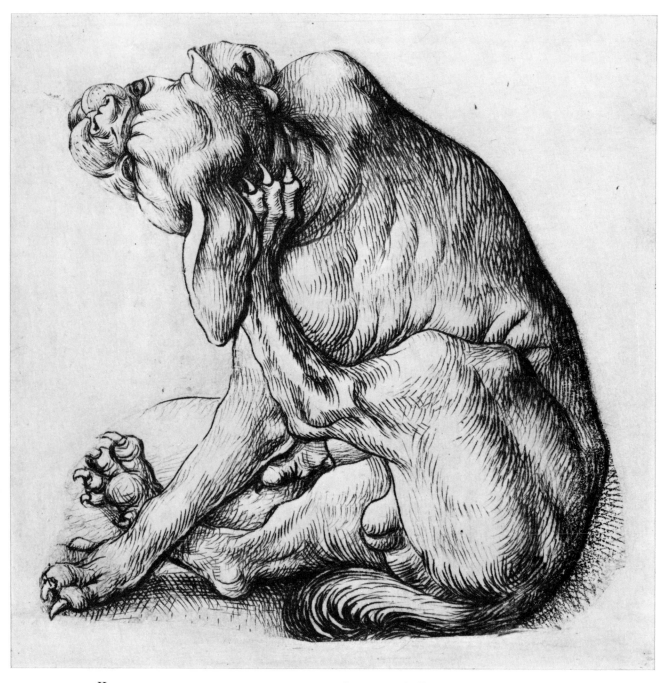

II,4 MASTER OF THE AMSTERDAM CABINET (1467–1507), *Dog*. Dry point.
Rijksmuseum, Amsterdam

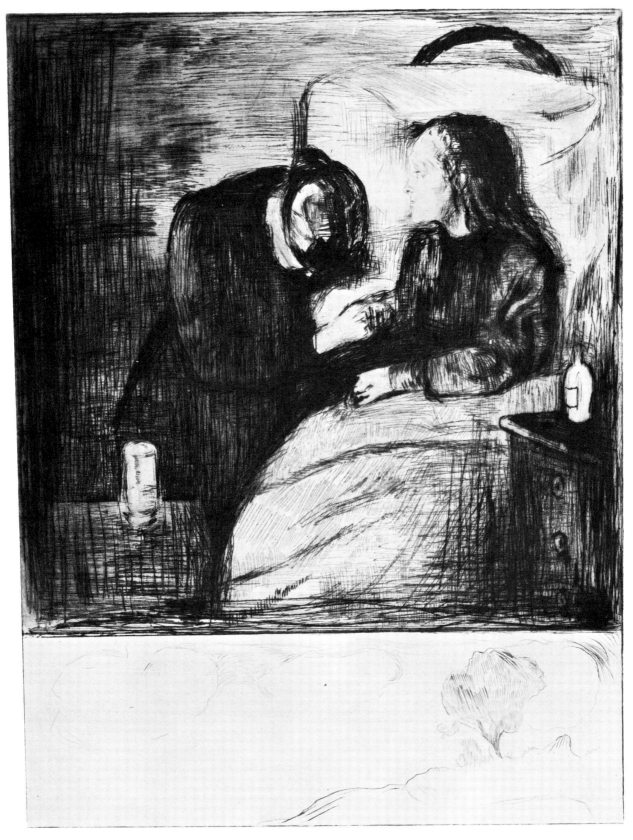

II,5 EDVARD MUNCH, *The Sick Girl*, 1894. Dry point.
The Museum of Modern Art, New York

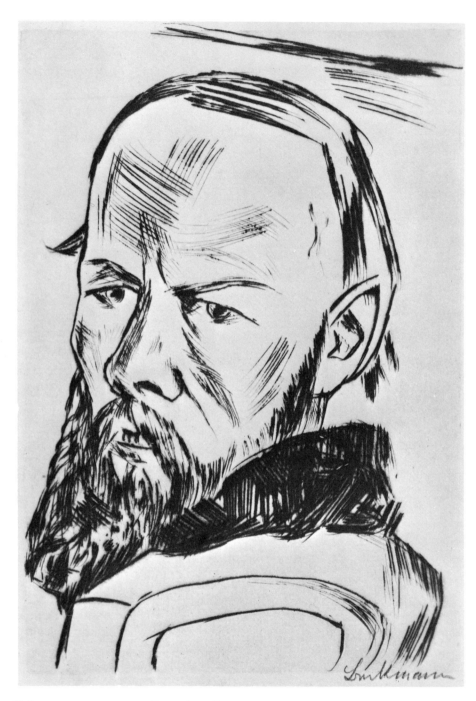

II,6 MAX BECKMANN, *Portrait of Dostoevsky*, 1921. Dry point.
The Museum of Modern Art, New York

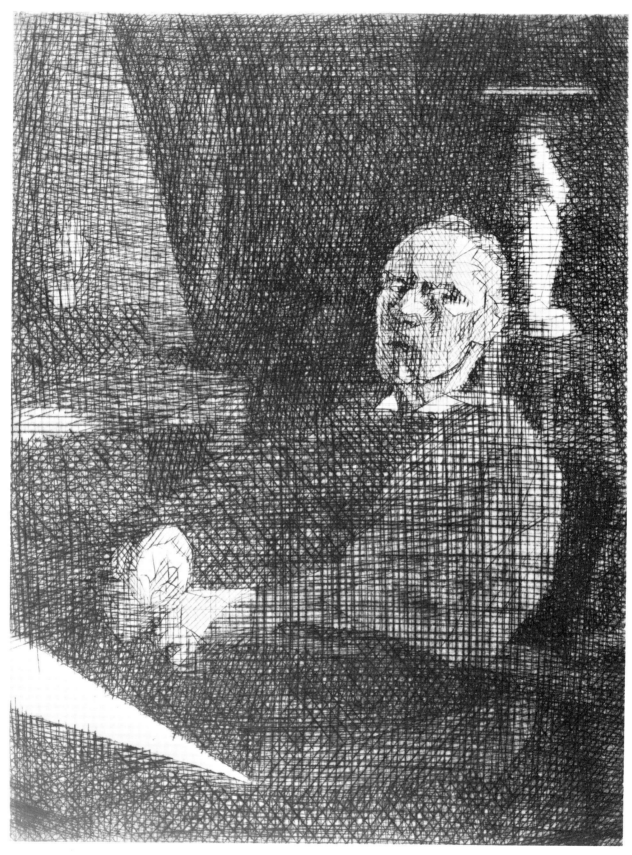

II,7 JACQUES VILLON, *Self-Portrait*, 1935. Dry point.
The Museum of Modern Art, New York

II,8 HANS HARTUNG, *Composition*. Dry point and etching.
The Brooklyn Museum Collection

II,9 LOVIS CORINTH (1858–1925). From portfolio *Am Waltchensee*. Dry point.
The Brooklyn Museum Collection

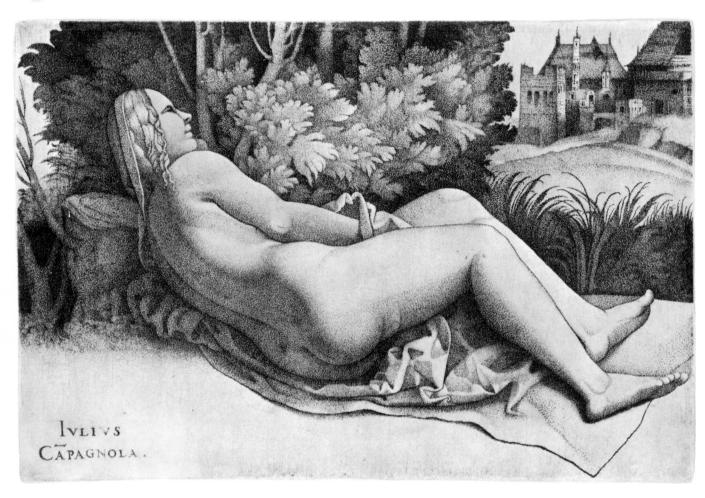

III,1 GIULIO CAMPAGNOLA (c. 1482–c. 1515), *Venus Reclining*. Stipple engraving.
The Cleveland Museum of Art. Gift of The Print Club of Cleveland

STIPPLE ENGRAVING AND ETCHING

STIPPLE ENGRAVING AND ETCHING was a method invented by the French in the eighteenth century and used extensively in England through the nineteenth century for reproduction of paintings. Today this technique is obsolete; and, to my knowledge, no one ever did anything interesting with it from a creative standpoint, except maybe Campagnola, who pioneered this method (Fig. III, 1).

TOOLS

Wheel, drum, and chalk roll roulette (Fig. V, 6, 7, 8)
Stippling burin with curved shank (Fig. III, 2)
Conventional burin
Single and multiple point etching needle

III,2 *Stippling tool*

The procedure was generally begun by etching the main structure of the design on the plate with very fine dots. Then came the slow development of shading by the use of the multiple needles and the assorted roulettes for the fine gradations. The plate was generally finished with the engraving of tiny dots. For this a curved burin was developed in order to make this particular stippling process less tiring to the wrist. With this technique it was possible to achieve effects comparable to fine half-tone reproductions. These stipple engravings seem to prove only that some human beings have practically unlimited patience.

III,3 Illustration from *Encyclopédie de Recueil* (1767) showing the tools and system of Crayon Manner, a technique closely related to stipple engraving. Burndy Library, Norwalk, Connecticut

IV,1 German, XVth century, *The Mass of St. Gregory*. Criblé.
The Metropolitan Museum of Art

Four

CRIBLÉ (DOTTED PRINT)

THE CRIBLÉ is one of the earliest techniques for creating a design on metal for printing purposes. Many art historians are convinced that the dotted print preceded the printed engraving. This is, however, of minor importance for our consideration. Today the criblé is just about extinct in its pure form. I have seen only a few examples by contemporary printmakers, usually mixed with other media of etching and engraving for textural effects.

Plate: copper, zinc, soft iron
Tools: assorted steel punches

Originally the dotted print was a surface printing medium. The holes (dots) driven

into the metal with punches were conceived as negative areas. The large white areas were in many cases chiseled out or cut away. In some of the dotted prints made in the sixteenth century one can notice the mixture of dots and burin cuts. The burin was used mainly in the manner of stippling, to blend with the rest of the print (Fig. IV, 1). As the dots were driven into the metal with sharp punches, a very strong burr rose around the indentation. If this burr was left on, and the plate printed in intaglio, it functioned like a dry point.

In contemporary printmaking, criblé is used mostly in this manner.

IV,2 Master of the Clubs (15th Century), *Calvary*. Dotted print.
National Gallery of Art. Rosenwald Collection

V,1 RICHARD EARLOM (c. 1742–1822), *A Concert of Birds*, after Mario di Fiori. Mezzotint.
The Brooklyn Museum Collection

Five

MEZZOTINT

MEZZOTINT was invented in the seventeenth century in Germany. The basic idea was to rough up the surface of the metal until it printed a rich, velvety black. Then the artist would work back toward the lighter values with scrapers and burnishers. For this reason, mezzotint is also called "manière noire," or black manner.

Mezzotint flourished throughout the eighteenth and nineteenth centuries and was widely used to reproduce paintings and to make portraits (Fig. V, 1). Today mezzotint is practically a dead art. As a means of reproduction it has lost its meaning, and the imitative character of the medium has made it unsympathetic to most of the contemporary printmakers. The limited number of artists who still use mezzotint belong to the traditional extreme academic school. A notable exception is Jacques Villon, who made a few mezzotints in a very personal manner.

V,2 YOZO HAMAGUCHI, *Coupe de Raisins*. Mezzotint.
The Cleveland Museum of Art. Gift of The Print Club of Cleveland

The idea of working back from dark to light is used today by many printmakers, but mostly with aquatint and soft ground.

TOOLS

Rockers, No. 50–No. 90 (the number of teeth to the inch) (Fig. V, 3)
Roulettes (American-German): drum, chalk roll (Fig. V, 6, 7, 8)
Assorted scrapers and burnishers (Fig. V, 4, 5)
Plate: 16- to 18-gauge copper

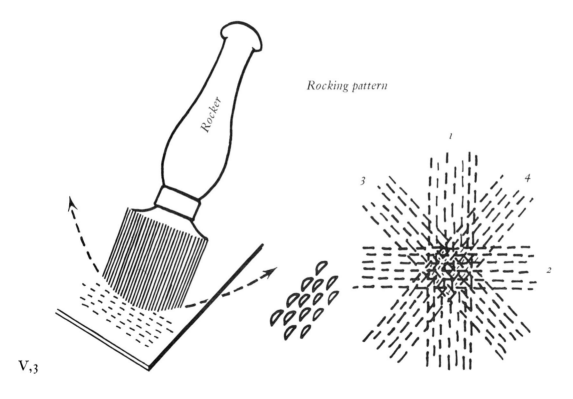

V,3

Grounding a Mezzotint Plate

To prepare a mezzotint plate, the first step is to rough up the whole plate surface with the rocker as evenly as possible. The number of the rocker selected for this purpose has to do with the quality of color and texture the printmaker prefers. Generally speaking,

a plate well worked over with the rough rocker will give richer color and tougher burr than will that with the fine rocker. It is vital that the rocking process should be done very methodically in order to avoid going over the same area in the same direction, as this will produce ugly "digs" in the plate comparable to the "crevé" in etching. The safest thing is to mark the plate into rows with wax crayon; then rock one row after another in one direction. Next, mark the plate off again at another angle and follow this same procedure until the desired density of texture is reached (Fig. V, 3). The standard rocking number is eight; this includes right-angle and diagonal crossings of the rocker.

The rocking has a great deal to do with personal skill and judgment developed only by practice.

After the surface is finished, the design can be transferred with paper coated with soft litho crayon. In tracing, avoid too much pressure, as this might spoil the plate surface.

Scraping the Mezzotint

Once the composition is fixed on the plate, you can begin the scraping. You can use the standard scraper employed for etching, but for meticulous, tight details, the smaller pointed, curved, or flat sword-shaped scraper makes the job easier. It is very important to keep the scrapers in perfectly sharpened and polished condition. The scraping should begin with the broad middle values and proceed in stages toward the light polished areas. The scraping should be even, never heavy-handed. Otherwise, you will dig ridges in the plate and will have to rework the whole area with the rocker. (It is advisable for someone who is doing a mezzotint for the first time to make a small test plate and experiment with the rocking and scraping before attempting a larger plate.)

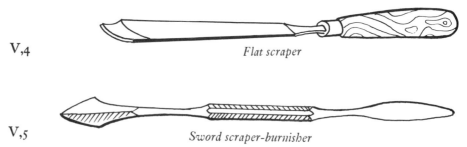

V,4 *Flat scraper*

V,5 *Sword scraper-burnisher*

Burnishing the Plate

The lighter spots on the plate are finished with the burnisher. It goes without saying that the burnisher also should be kept in perfectly polished condition. Otherwise, it may produce streaky areas on the plate. The burnishing is done with a light film of oil on the

metal to reduce friction. For the printmaker doing extensive mezzotint work, it pays to have a few fine agate burnishers. A fine gray can be achieved without scraping by burnishing the burrs. This should be done in stages, beginning lightly and applying more pressure as the burrs start to close in. Correct burnishing is a matter of touch developed only with experience.

After the scraping and burnishing are finished, the final details can be added or touched up with the assorted roulettes, from the single line to the drum (Fig. V, 6, 7, 8). Here and there a burin can be used to strengthen some details in the manner of stipple engraving.

V,6 *Drum roulette*

V,7 *American roulette*

V,8 *Single row roulette*

The Roulette Print

Here I should like to mention that the roulettes can be used themselves to develop a print in terms of tonal areas; but, unlike the mezzotint, this is done by working from light toward the dark areas, and the scraping is a corrective measure. Toward the end of the nineteenth century quite a few artists made so-called roulette prints, and Jacques Villon used the roulette in combination with line etching.

Printing the Mezzotint

The printing of mezzotint plates differs slightly from the printing of etchings or of engravings. First of all, the etching ink has to be looser and oilier, because the layer of burr on the mezzotint acts as a blotting paper, absorbing a great deal of oil. One should also use more of light linseed oil than of heavy plate oil in the printing ink to make hand-wiping easier. The ink should be distributed either with the soft rubber or with an old

gelatin brayer. To work the ink into the grooves, use a piece of soft rag, not the dauber, just as you would do with dry point. To wipe the plate, avoid a stiff, starchy tarlatan; use instead tightly packed fine cotton, silk, or nylon cloth. Finish with a clean hand wipe; a rag wipe would drag the ink out of the dense texture and produce muddy tones, as on the aquatint.

As for the selection of printing paper, it should be soft and thick. The Japanese Kochi, German Copperplate, and some of the Fabriano papers are excellent. The printing pressure should not be excessive—considerably below the pressure needed to print an engraving or a deeply etched plate.

V,9 Mario Avanti, *Les Coquillages d'Amagansett*. Mezzotint. Yale University
Art Gallery. J. Paul Oppenheim Memorial Collection

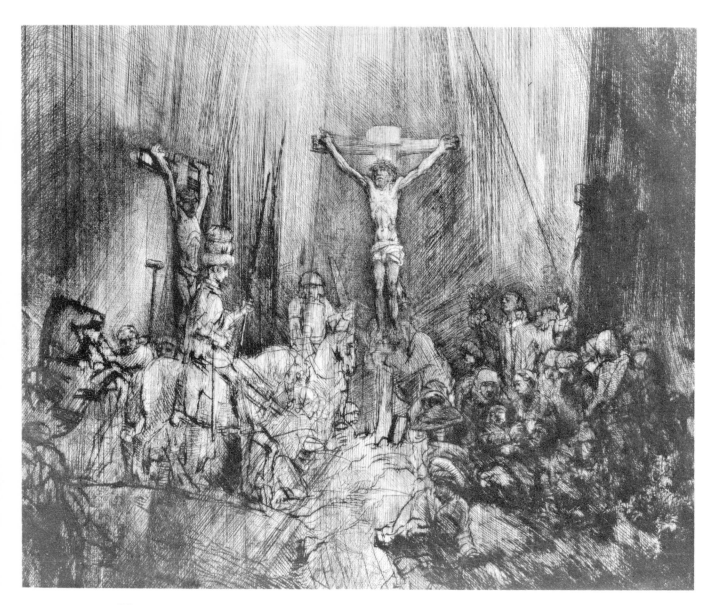

VI,1 REMBRANDT VAN RIJN (1606–1669), *Three Crosses*, state 4 detail. Etching and dry point. The Metropolitan Museum of Art

Six

ETCHING

INTRODUCTION

To MAKE AN ETCHING (for print purposes) is to bite lines and textures into metal with a variety of mordants. The biting action is a precipitated corrosion. The metal plate is covered with an acid-resisting coating (ground). The design is scraped or pressed into the ground, exposing the metal in those areas. The plate is then submerged in the acid solution until the desired depth or width in the bitten areas is reached.

The basic principle of etching is very simple, but the possible variations within the technique are so great that etching can be as complex as you wish to make it.

The materials used for etching in themselves offer us a great range of possible variations.

VI,2 GABOR PETERDI, copperplate (1953). Relief etching, line etching, and engraving

It makes a big difference whether one uses copper, zinc, or aluminum to work on. It makes an even greater difference whether one uses nitric, hydrochloric, ferric chloride, or perchlorate of iron for the etching process. Then we can begin to contemplate the possible variations in the strength of the mordants, the time element for biting, and the atmospheric conditions that affect both. To these one has to add the number of grounds available, the ways and means to work into these grounds, and then finally the infinite variations possible in printing an etching.

I enumerate all these factors more to impress the possibilities offered by etching than to emphasize the difficulty of control. As a matter of fact, I doubt that anyone could work with so many elements under the fairly primitive conditions in a workshop, and claim total control over them. In addition, it seems that printmakers who make a fetish of trying to work within the predictability of the medium produce the dullest kind of images. One of the most exciting aspects of etching is the metamorphosis of an image from idea to print. By this I do not mean to imply that an artist should work completely in the dark and base his entire conception on chance or accident. After one is familiar with the possibilities and the limitations of a particular technique, and has had enough experience with the materials he uses, an instinctive control develops. The technique itself becomes an integral part of the creative process. In etching, just as in painting, no matter how much experience one has, the possible variations in color relations are so infinite that one can always discover exciting new possibilities.

I emphasize this point in my introduction to etching because every artist in the beginning thinks more in terms of transferring a drawing to the plate than in terms of the print. The beginner always thinks that he is creating the etching while working on the plate, and forgets that the action of the acid is just as much one of his working instruments as is the etching needle. This is an aspect that actually cannot be taught; only through experience can an artist reach the point where he draws a line and simultaneously visualizes it as a totally different one, transformed by the action of the acid. In other words, one might draw two equally fine lines on the ground and yet know that one of these lines will remain fine with a controlled light bite but that the other one is going to be transforméd into a heavy rugged line by the violent action of a strong mordant.

In this chapter on etching, I am going to deal first with those tools and materials that are used primarily with all the etching techniques; then I shall go into the particular characteristics of the different techniques in detail.

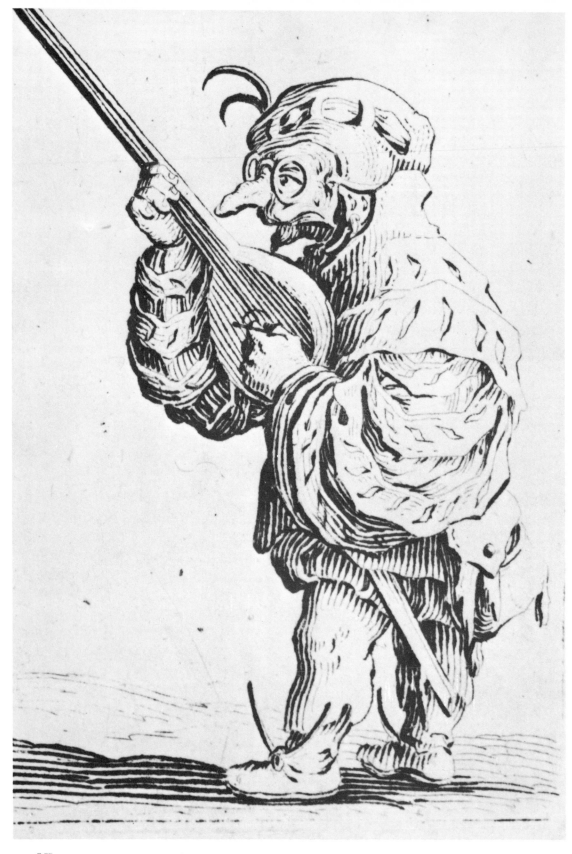

VI,3 JACQUES CALLOT (1592–1635), detail from *Two Masked Figures*. Etching.
The Metropolitan Museum of Art

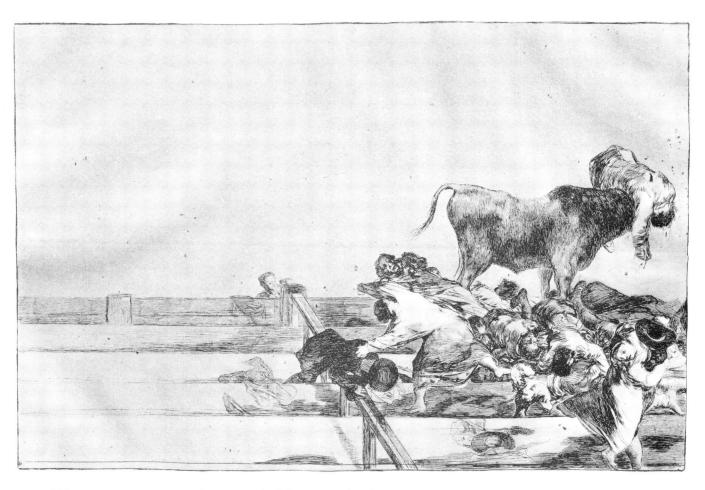

VI,4 FRANCISCO GOYA (1746–1828), *Disaster in the Arena at Madrid*. Etching and aquatint.
The Metropolitan Museum of Art. Rogers Fund

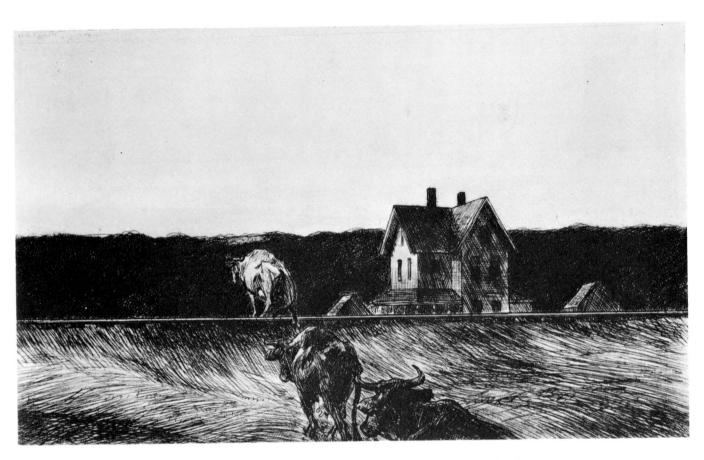

VI,5 EDWARD HOPPER (1882–1966), *American Landscape*, 1921. Etching.
The Museum of Modern Art, New York. Gift of Abby A. Rockefeller

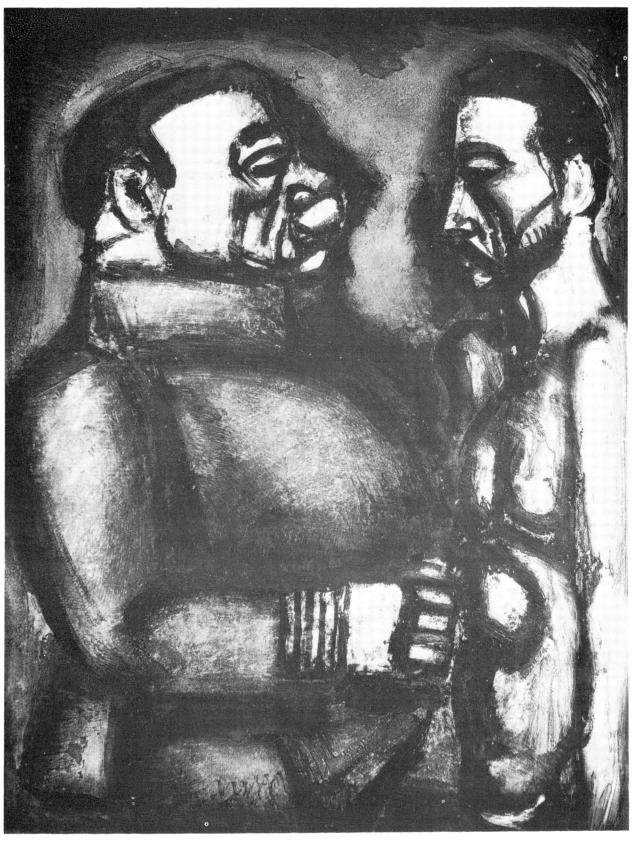

VI,6 GEORGES ROUAULT, *Face to Face*. Plate 40 from *Miserere*. Aquatint, dry point, and roulette. The Museum of Modern Art, New York. Gift of the artist

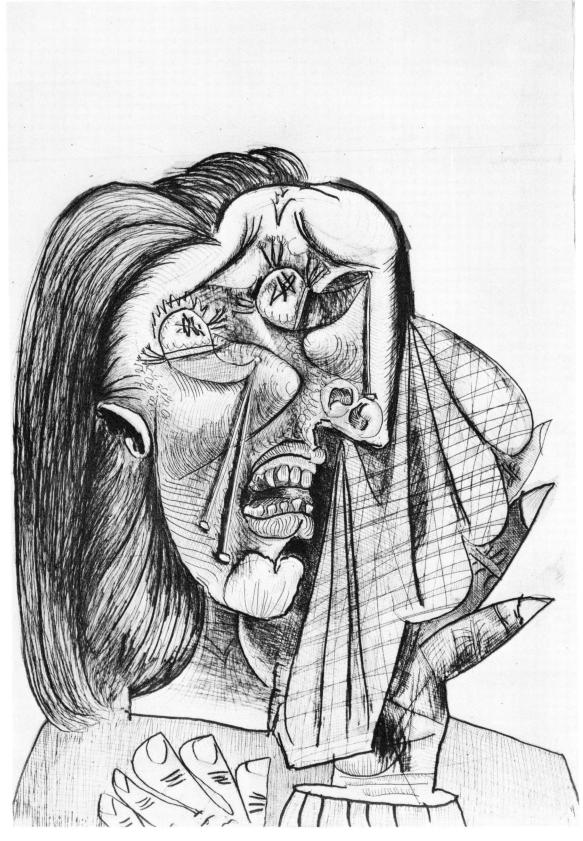

VI,7 PABLO PICASSO, *Weeping Woman*, 1937. Etching and aquatint.
Lent by the artist to the Museum of Modern Art, New York

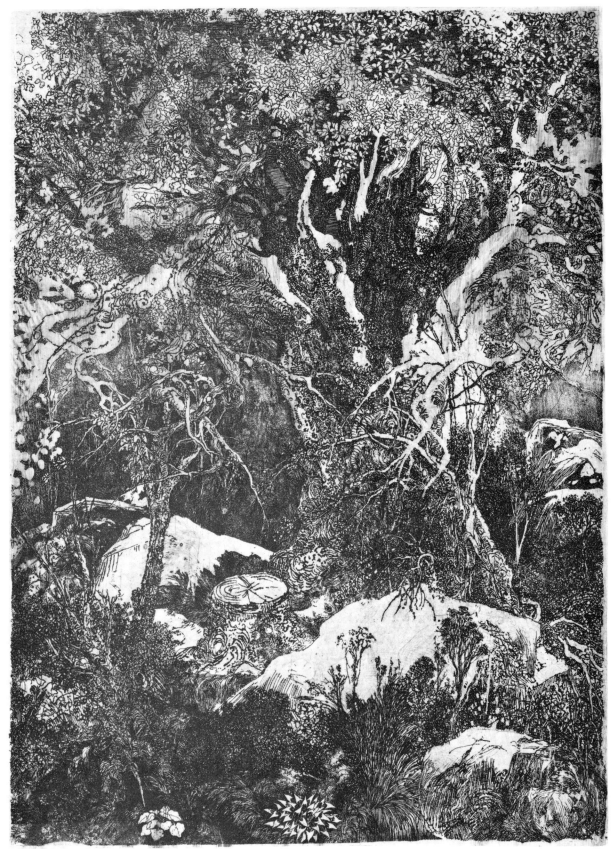

VI,8 RUDOLPHE BRESDIN (1822–1885), *The Forest of Fontainebleau*. Etching.
Courtesy of The Art Institute of Chicago. W. S. Brewster Collection

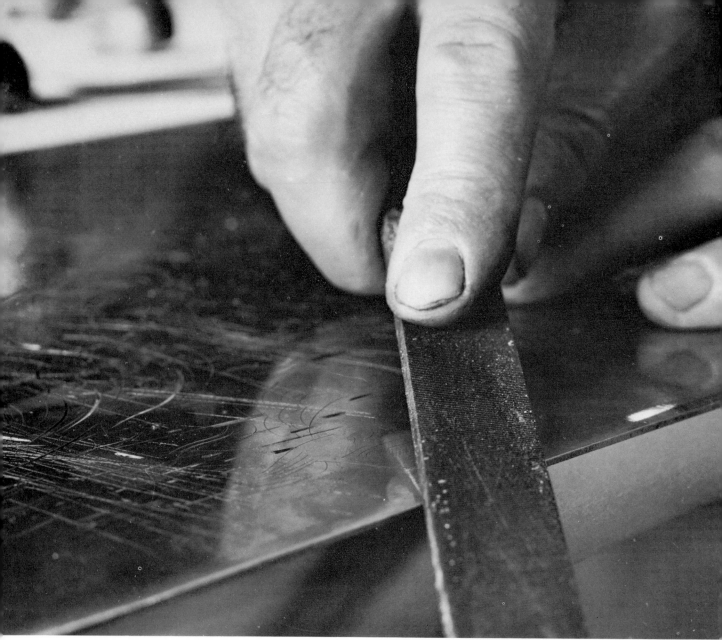

VI,9 *Beveling the plate*

TOOLS AND MATERIALS

Plates: copper, zinc, aluminum, magnesium—16 or 18 gauge
Etching needles
Scraper
Burnisher
Heating box or hot plate

Acid trays: hard rubber, enameled, Pyrex, home-made wooden, or stainless steel

Acids to make mordants: nitric acid C.P., hydrochloric acid C.P. (Optional: perchlorate of iron, ferric chloride, acetic acid)

Potassium chlorate

Wide-mouth amber jars with plastic caps

Materials to make ground: beeswax—white or yellow, Egyptian asphaltum or Gilsonite, rosin—lump form (colophony), axle grease, tallow

Brushes or rollers to apply ground

Cleaning agents: ammonia, whiting, salt, vinegar

Abrasives: pumice powder, jewelers' rouge, engraver's charcoal, snake slip, rotton stone

Solvents: benzine, kerosene, turpentine, alcohol

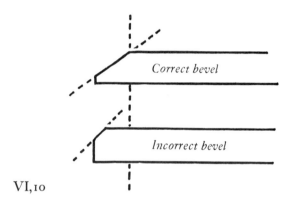

Correct bevel

Incorrect bevel

VI,10

BEVELING THE PLATE

The edges of the plate should always be filed to a flat bevel and the corners should be rounded. The first beveling may be superficial simply to get rid of the excessively sharp edges as a precautionary measure against cutting your fingers and also because a beveled edge can be better protected against excessive pitting by the acid.

Cutting the Plate

I should like to say a few words about the cutting of a plate; it is a great saving to buy the plates in large sheets from a supplier of commercial photoengravers and cut to the

desired proportion yourself. The standard size of a full sheet of zinc or copper is 24″ by 36″, but one can buy a half-sheet 18″ by 24″, 15″ by 18″, or 18″ by 20″ without being charged for the cutting. For any odd size below these, however, you will be charged a fee. The most efficient way of cutting is with either a bench saw equipped with an 8″ or 10″ metal cutting blade or a band saw. A jigsaw may also be used. These machines are not always available in every workshop. Therefore it is a good thing to know how to cut a plate by hand.

For hand cutting you can use either regular burins or so-called "draw tools" used by commercial engravers to cut white lines on halftone plates. Unless you are an experienced engraver, it is better to use the draw tool.

Draw tool

VI,11

To Cut with a Draw Tool

A draw tool is used with a steel ruler clamped down in position securely on the plate. The draw tool has a hooked blade, and you cut with it by engaging the cutting edge and pulling it toward you (Fig. VI, 11). The best manner is to score the plate lightly at first, and to keep on going over the same groove until the line penetrates about half the thickness of the plate. Then the plate can be broken. To break, clamp the plate to the edge of the table so that the scored line runs parallel with the table edge. This will prevent excessive buckling of the plate. Then pull up. Keep on repeating this up-and-down motion until the plate breaks.

The other method, that of cutting with a burin, is similar, except that the scoring is engraved. Plates cut by hand as described above need a little more working over with the file, as the breaking produces excessively ragged edges.

A note of caution: If you use a power tool to cut the plates, it is obvious that you should be very careful of your fingers and that you should never wear a tie, or loose shirt sleeves, or any article of clothing that can possibly get caught or snagged in a power tool. Most of all, you should wear goggles, because the flying metal particles are extremely dangerous to the eyes.

Filing the Plate

The proper beveling of the plates is important for many reasons (Fig. VI, 10). Sharp edges or corners can cut the paper or the felts. Beveled plates will produce cleaner and better-looking prints. A coarse file can be used to begin the beveling process and the fine file to continue the job. In filing, don't file up and down; push the file sideways so that it will function in a shearing fashion. If the bevels of the plate are not carefully protected through the progressive stages in the making of the plate, they will become ragged and notched and will have to be rebeveled. It is well to check the bevels before any print is made, and especially before one starts to print the final edition. For the final printing, the bevel can be scraped and burnished to a mirror-like finish.

Beveling with Portable Belt Sanders

The portable electric belt sander is one of the most useful tools in the workshop. Without it, beveling a large plate might take hours; with it, the job can be finished in minutes. It can also save long hours of scraping if you have to work over a large surface.

In selecting a sander keep in mind that you need a relatively light tool. I found the 21″ x 3″ sold by Sears, Roebuck an ideal size and weight. Comparable sanders are available in many other brands.

The sanding belt usually comes in three grades—fine, medium, and coarse. For beveling, I start with the medium and finish with the fine. When the plate is ready for printing, final finish is given with a scraper and burnisher.

In using the belt sander the following rules should be observed:

1. Be sure the belt is put on correctly. Inside, the direction in which it should rotate is indicated. This is very important; otherwise the belt might break and mar the plate surface.
2. Clamp the plate securely to a table. The belt rotates at very high speed, and the friction can turn a plate into a flying missile.
3. The beveling action should start outside the plate and finish outside. Keep your angle constant, and don't apply too much pressure. The weight of the tool is sufficient.

After discussing the belt sander it might be appropriate to give a short description of two other sanding machines available to the printmaker.

Oscillating Sanders

The oscillating sander works with a vibrating action. For heavy work it doesn't have the belt sander's efficiency, but for fine finish it is easier to control. For this sander a great variety of sandpapers are available. It is an ideal tool for lightening aquatints and soft ground textures, and for working on softer materials, like wood or plastics.

Orbital Sanders

The orbital sander works with a rotary action. This is the most generally used sander, as it is available as an inexpensive attachment to electrical drills. The action of this sander is very efficient but very difficult to control. Unless one uses it with great care, the orbital action tends to cut ridges all over the surface. The most useful aspect of this tool is the buffing attachment. Treated with buffing compounds, it is excellent for polishing metal surfaces.

CLEANING THE PLATE

Before one can put a hard ground or an aquatint ground on the plate, it has to be thoroughly cleaned. It is especially important to be sure that no greasy spots remain on the plate surface. Grease on an aquatint plate will cause uneven tones in the print, and on a hard ground plate it may cause the ground to lift in the acid and thus ruin everything. Vinegar or ordinary kitchen ammonia (not the new kind mixed with soap) should be used to remove grease. Ammonia is stronger and therefore better. A tablespoon of whiting is put on the plate and enough ammonia or vinegar is added to form a thin paste which is then rubbed over the surface of the plate with a clean cloth. After the paste is thoroughly rubbed over the entire plate, the plate is carefully rinsed. If the water runs off in an unbroken film, the plate is free of grease. If the water pulls away in beads, it means that the plate is still greasy and that the application of paste must be repeated.

Whiting powder must be removed in the rinsing, especially if an aquatint is to be used, as it may cause streaky tones. It is better to dry the plate by heating it than by rubbing or wiping, as one very seldom has a wiping material clean enough to be completely safe. The plate must cool off before ground or aquatint is applied.

If these cleaning materials are not available, dipping in acetic acid will also do the job.

If this is not available, a mild solution of nitric acid (12 parts water to 1 part nitric acid) can be used; but this will remove the high polish of the plate surface as well. After using the acid, the plate has to be thoroughly rinsed and dried in the same manner as described above.

Once the grease has been removed, the plate should be handled by its edges to avoid smudging it with fingerprints.

THE ETCHING NEEDLE

Any pointed instrument can be used as an etching needle, including ordinary nails. It is best to have an assortment, from fine to broad points. Broken dental instruments resharpened make excellent needles. (In sharpening, remember that the round point will move freely in any direction, while a point ground with facets will cut well only in certain

VI,12 *Working on a plate with hand rest*

directions.) A phonograph needle set in a holder makes an excellent fine point. A scraper can be used for very bold strokes.

Etching needles should always be slightly dulled on a fine stone, since too sharp points hook into the metal and do not permit free movement.

Experiments have been tried with various tools besides the etching needle. I used an electric drill with various rotary files with an interesting result. The vibration of the drill and the rotation of the point give a dotted line that provides an interesting variation of the conventional etched or engraved line. The effect of the drill can be controlled by changing points, varying the angle, and pushing the drill either with or against the rotation of the bits. In connection with this, I should like to observe that, strangely enough, using this mechanical instrument produces a completely unmechanical characteristic in the line. The power is involved only in the rotation of the point, but the whole instrument functions simply as an extremely heavy and clumsy etching needle. The physical struggle involved in keeping this tool under control gives a unique characteristic to the drawing (Fig. VI, 13, 14).

Razor blades, pie trimmers, steel combs, and any other instrument rigid or sharp enough to cut into the ground may be used to achieve a specific result. They are objectionable only when exploited for their own sake as decorative gimmicks.

WORKING WITH FLEXIBLE SHAFT ELECTRIC DRILLS AND ENGRAVERS

In the previous section I described how I started to work with electric drills on hard ground. Eventually I realized that working directly with a drill did not give me enough control. I found the solution by purchasing a flexible shaft and a drill press stand. With this equipment not only my controls increased but also the range of bits I could use.

First I drew only on hard ground and etched the lines. Later I became interested in working directly into the metal. I found, however, that the rpm of the electric drills aren't sufficient really to dig into the metal. I started to look around for a jeweler's electrical engraver and polisher. I know that these have the necessary rpm. Finally I found one ideal for my purpose. This is a small electric motor manufactured by the Foredom Electric Company, Bethel, Connecticut. The Series EE can receive two flexible shafts (a great time-saver), and with a rheostat it has a speed range of 0–14000 rpm on direct drive. As this tool can accept a wide variety of bits, rotary files, grinders, and polishers, it is a very valuable addition to the workshop.

ETCHING GROUNDS

Any acid-resistant coating that one can use to make an etching is commonly called a "ground." A great variety of grounds has been developed, so that one has ample opportunity to choose the right kind for any requirement.

First I am going to describe the grounds I generally use, and their application. Then I am going to give some formulas that have come down to us through the centuries from the time of Rembrandt. As you will see, there isn't too much difference, basically, between the grounds Rembrandt used and those we use today. Practically all the grounds contain beeswax, asphaltum, and some sort of varnish. The relative proportion of these ingredients depends a great deal on the personal working habits of the artist who uses them. Therefore the reader should take these formulas as a basis from which, eventually, he can find the ground that suits his own personal way of working best.

The asphaltum itself is a strong acid-resistant, suspended in a solvent used as a varnish. Alone, however, it is too brittle to allow close work with the etching needle. The wax is also an acid-resistant, but it is too soft to be used in itself as a ground. The rosin is the hardest of the three, and when it is dissolved in alcohol it is used as a stop-out varnish. The three mixed together in the right proportion give a coating that is extremely tough— neither too hard nor too soft—and one that retains the finest details drawn in an etching.

LIQUID HARD GROUND

Ingredients:

2 parts asphaltum (Gilsonite)
2 parts beeswax (white or yellow)
1 part rosin
All measured by weight. The solvent is benzine.

I experimented with various solvents and found benzine to be the best because, although volatile, it allows you to brush the ground out leisurely on a large plate. Commercial liquid grounds dry too fast.

IMPORTANT WARNING: Don't confuse benzine with benzene. Benzene has harmful ingredients that the body stores up. Excessive exposure to benzene might cause leukemia and other serious illnesses. Benzine is fairly safe so long as normal precautions are ob-

served. Keep it away from open flame. Avoid excessive inhalation of fumes by using it always in a well-ventilated place.

To make ground you need the following equipment:

1. One large pot big enough to be only half full when all ingredients are in it. This prevents overboiling. Always have a lid handy, just in case.
2. A long-handled wooden ladle for stirring the ground.
3. A pair of thick working gloves. Asbestos is best. Always have gloves on when making ground. Hot ground might splatter.

PROCEDURE: First put pulverized rosin in a pot and melt it. When the rosin is liquid add wax broken into small lumps. After this is thoroughly mixed with the rosin, add the asphaltum powder. Stir the mixture constantly to achieve thorough blending and to avoid scorching the ground.

After all the ingredients are melted into a smooth, lump-free mass, take the pot off the heater. Let the mixture cool approximately ten minutes, then start adding benzine. The benzine should be added in small quantities and stirred constantly. By the time you have added sufficient solvent to keep the ground liquid, it will have expanded approximately four times in volume.

When you feel that the ground is sufficiently diluted, make some tests on a plate. If the ground solidifies immediately on the plate, you should add more benzine. When you are satisfied that the consistency of the ground is correct, test the working qualities.

Brush some on the plate, heat it up, and let it cool. If the ground is tacky, it needs more rosin. If it is too brittle, it needs more wax. When the ground is completely satisfactory, strain it through cheesecloth into wide-mouth jars for storage.

HARD GROUND, SOLID FORM

The formula is the same as for the liquid hard ground, but the ingredients are mixed at low heat and without benzine. Asphaltum is added to the wax and the rosin is mixed in last. The mixture must be stirred constantly, as it will scorch very easily. It is best to use a double boiler for this purpose. When the ingredients have melted, the ground is strained through several layers of cheesecloth into a pan of cold water. As the ground cools, it can be rolled into balls which may then be wrapped individually in pieces of silk or fine linen to keep them clean and easy to handle.

I should like to clear up here a confusion that seems to exist because some of the early papers on etching refer to our hard ground as soft ground. Many of the sixteenth and

seventeenth century printmakers used a much harder, enamel-like ground that was ideal for their etching, which was still completely dominated by the conception of line engraving. For instance, Jacques Callot used a ground made of *huile de grasse* (linseed oil) and mastic melted together, into which he worked with a specially constructed *échoppe*-like needle to simulate the swelled character of the engraved line (Fig. VI, 3). Because our soft ground was not invented until the second half of the eighteenth century, the printmakers before that period referred to the wax-based flexible grounds as "soft" ground.

APPLICATION OF LIQUID HARD GROUND

The ground is best applied with a 2″ or 3″ soft-bristled painter's brush, and should be put on in a thin, even coat. It is difficult to control the etching needle on a ground which is thick and unevenly applied. As the ground is brushed on, it may appear streaked or uneven; but as it dries it tends to level off and become even, especially when it is heated. Since the benzine evaporates from the ground fairly fast, prolonging brushing will only aggravate streaking.

After the plate is covered with the ground, it is put on the hot plate to hasten evaporation. When it is heated, the ground will assume a shiny liquid appearance and irregularities will even out by themselves. Sometimes small solid particles seem to appear in the ground. These are impurities that one cannot totally eliminate, no matter how many times the ground is strained. (It is important to keep ground in a tightly sealed jar when the ground is not in use.) These irregularities in the ground are not dangerous unless there are so many of them that they would interfere with the control of fine details.

The hot plate should be warm but not too hot, because excessive heat makes the benzine evaporate too fast and causes the rapidly shrinking ground to pull away from the edge of the plate. The plate is left on the heat for about a minute. Then it is removed to cool; it should be hard enough to work on without smearing or lifting. If the ground is still tacky after the plate is cooled, it needs additional heating. Never leave a grounded plate on the heat too long lest it scorch.

APPLICATION OF SOLID HARD GROUND

With a ball of ground it is necessary, of course, to use a roller to achieve an even distribution over the surface of the plate. The roller must be firm but flexible and it should be made of heat-resistant materials. The best roller for this purpose is made out of leather.

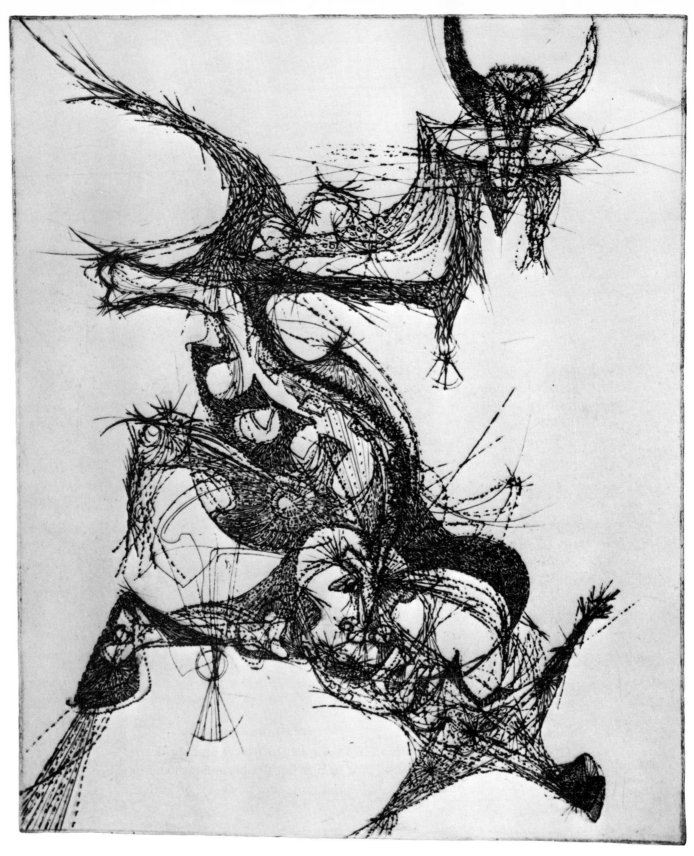

VI,13 GABOR PETERDI, *The Black Horn*, 1952. Etching and engraving

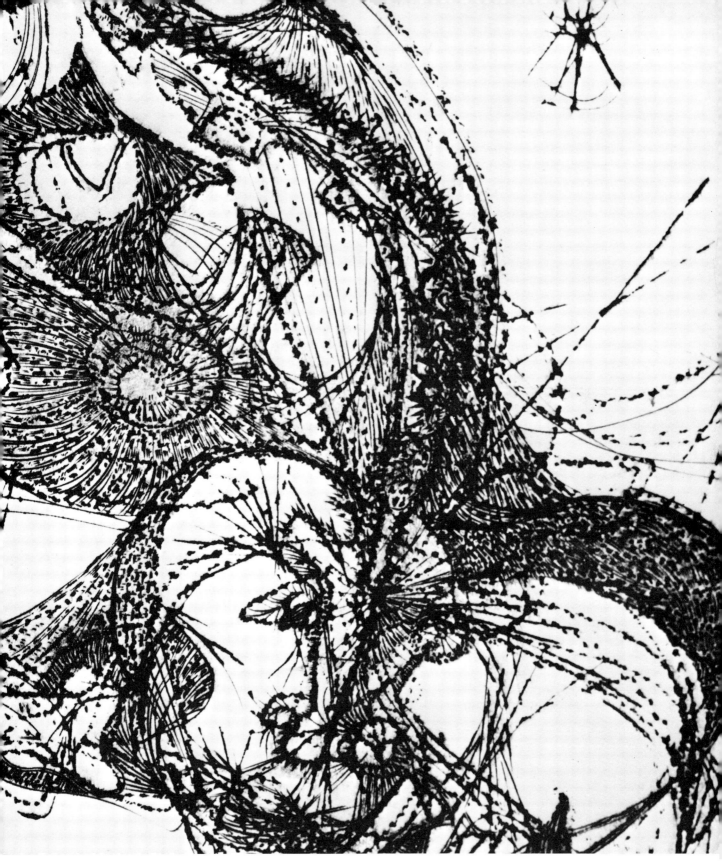

VI,14 GABOR PETERDI, detail from *The Black Horn*

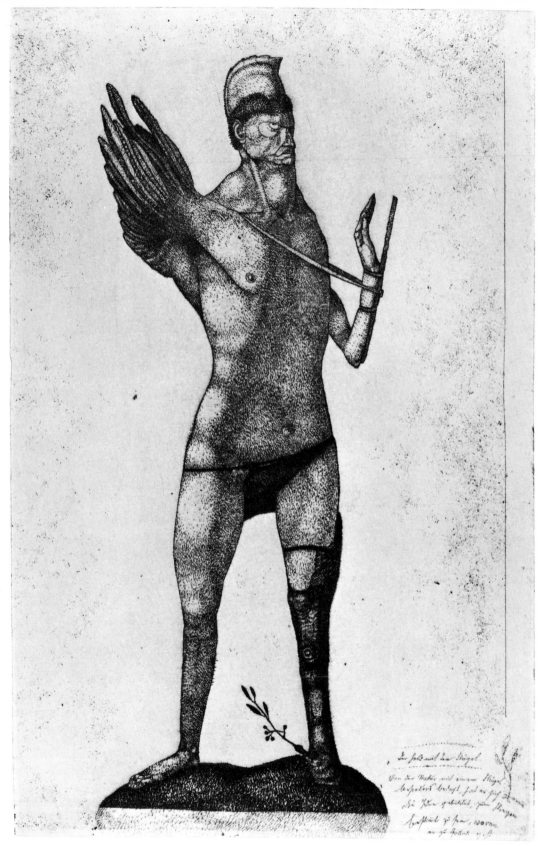

VI,15 PAUL KLEE, *The Hero with the Wing*, 1905. Etching.
The Museum of Modern Art, New York

The core is wood, covered with two layers of felt, and then a leather sleeve which is shrunk over the other materials. This roller must be made professionally by a saddle maker so that it will be certain to show no stitch marks. Industry recently developed rollers made of heat-resistant synthetic rubber, and a number of printmakers use this type of roller successfully. The old-timers also used a dauber made out of leather filled with horsehair, but it is practically impossible to lay an even ground on a large plate with this method.

The work begins with the melting of some of the hard ground on the plate, followed by the rolling out. To apply the hard ground successfully with the roller keep the temperature of the plate even and low. If the plate gets too hot, the ground liquefies. If the plate gets too cold, the ground comes off the roller in globs. The moment the ground begins to smoke, the plate must be removed from the heat.

It is more difficult to roll ground on a zinc plate than on a copper one because the zinc is not so good as a conductor of heat, and tends to fluctuate between the extremes, being either too hot or too cold.

Anyone who has tried applying ground both ways has discovered that rolling is clumsy and slow as compared with brushing on liquid ground.

In finishing, I should like to remind the reader once more that the plate has to be thoroughly clean and free of grease before hard ground in any form is applied.

Ground Formulas of the Seventeenth and Eighteenth Centuries

Abraham Bosse's grounds, from his book published in 1645 in Paris:

1.	Virgin wax	1 ¼ oz.
	Mastic	1 oz.
	Asphaltum	½ oz.
2.	Virgin wax	1 oz.
	Asphaltum, or Greek pitch	1 oz.
	Black pitch	½ oz.
	Burgundy pitch	¼ oz.
3.	Virgin wax	2 oz.
	Asphaltum	2 oz.
	Black pitch	½ oz.
	Burgundy pitch	½ oz.

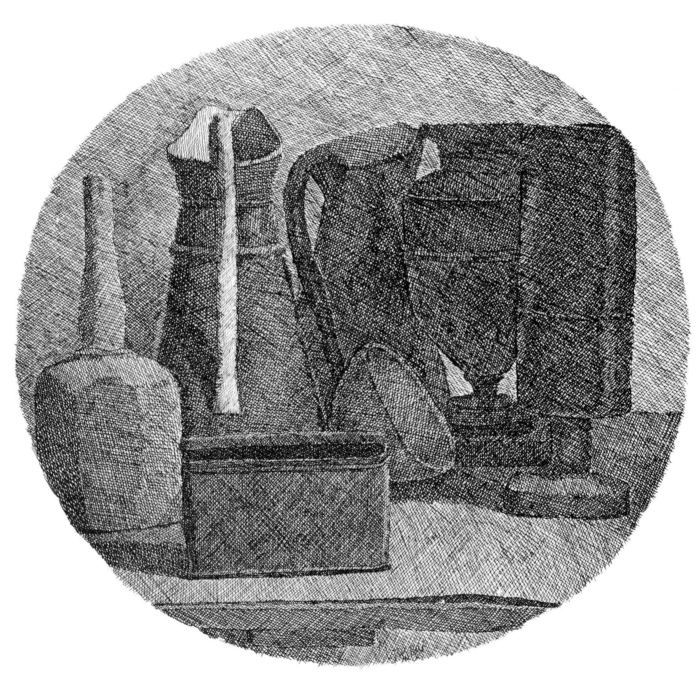

VI,16 GIORGIO MORANDI, *Oval Still Life*, 1945. Etching.
The Museum of Modern Art, New York

Rimbrant's ground (Bosse's spelling):

Virgin wax	1 oz.
Mastic	½ oz.
Asphaltum or amber	½ oz.

White ground from *Ars Pictoria* by Alex Browne, 1675:

Wax	1 oz.
Rosin	2 oz.
Venice cerus	1 oz.

First two melted, grounded cerus added.

Jacques Callot's hard ground:

Equal parts of *huile de grasse* (linseed oil) and mastic heated and melted together.

Eighteenth century

Hard Ground:

Greek pitch or Burgundy pitch	5 oz.
Ordinary rosin	5 oz.

Soft Ground:

Virgin wax	2 oz.
Burgundy pitch	½ oz.
Common pitch	½ oz.
Asphaltum	2 oz.

Eighteenth century Hammerton's transparent ground:

White wax	5 parts by weight
Gum mastic	3 parts by weight

White or transparent ground was used by printmakers to make the etched lines look dark in contrast. The idea was to approximate the effect of the printed line on paper.

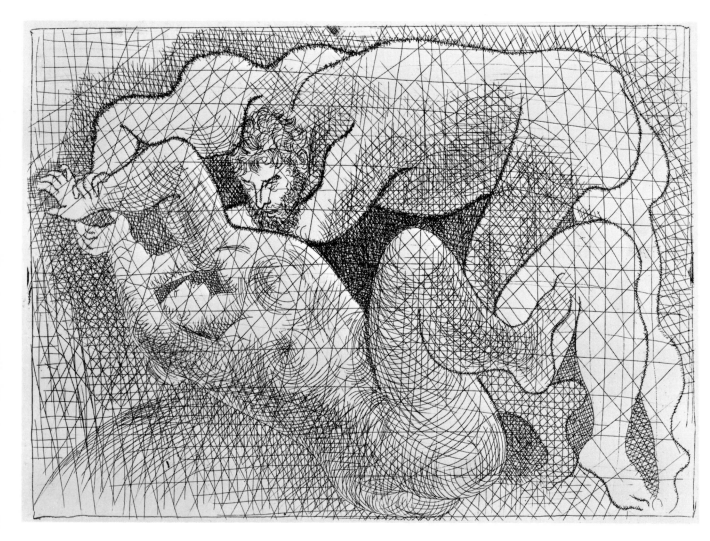

VI,17 PABLO PICASSO, *The Rape*, 1931. Etching.
The Museum of Modern Art, New York

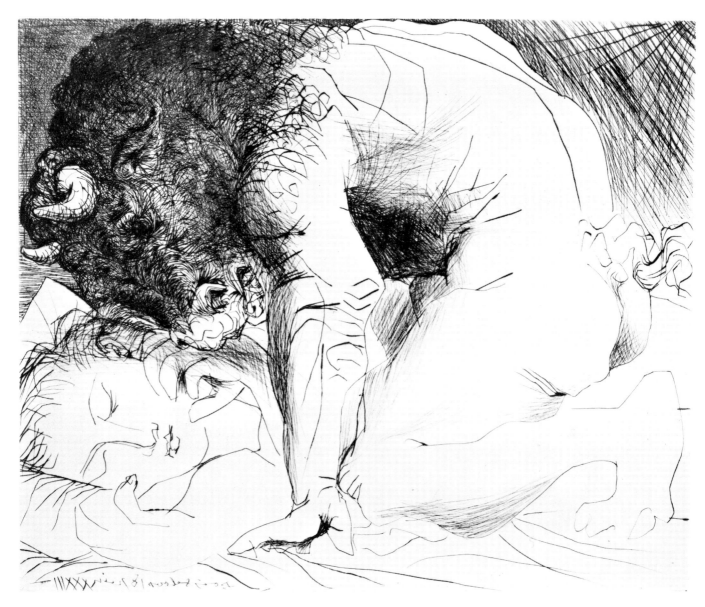

VI,18 PABLO PICASSO, *Minotaur and Reclining Woman*, 1933. Etching and dry point. The Museum of Modern Art, New York

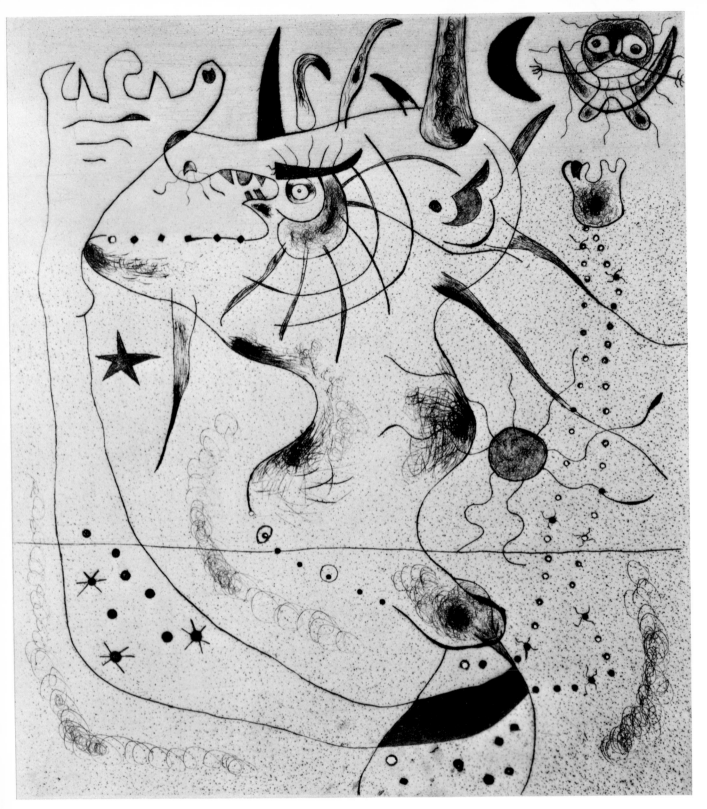

VI,19 JOAN MIRÓ, *Composition*, 1937. Etching and dry point.
The Museum of Modern Art, New York

VI,20 HENRI MATISSE, *Charles Baudelaire*, 1932. Etching.
The Museum of Modern Art, New York

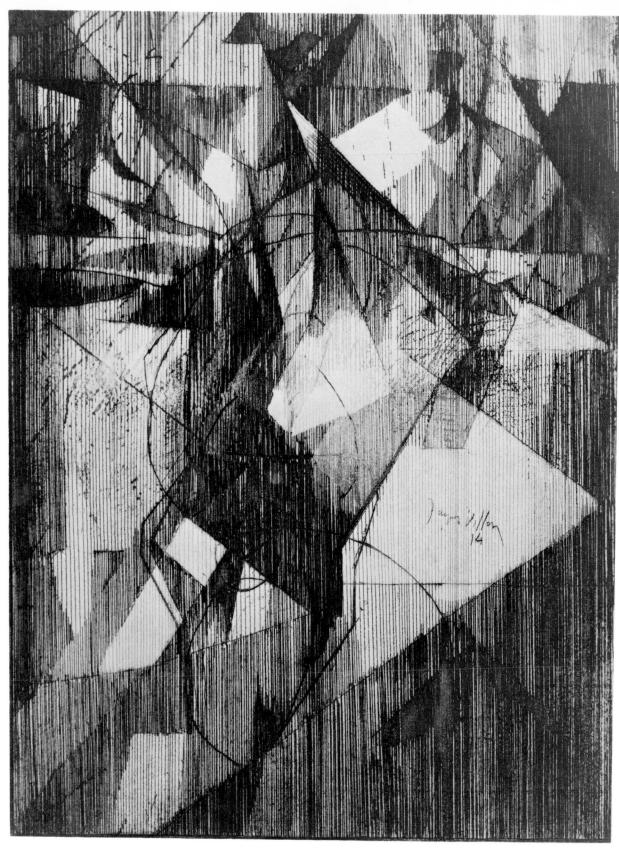

VI,21 JACQUES VILLON, *Equilibrist*, 1914. Etching.
The Museum of Modern Art, New York

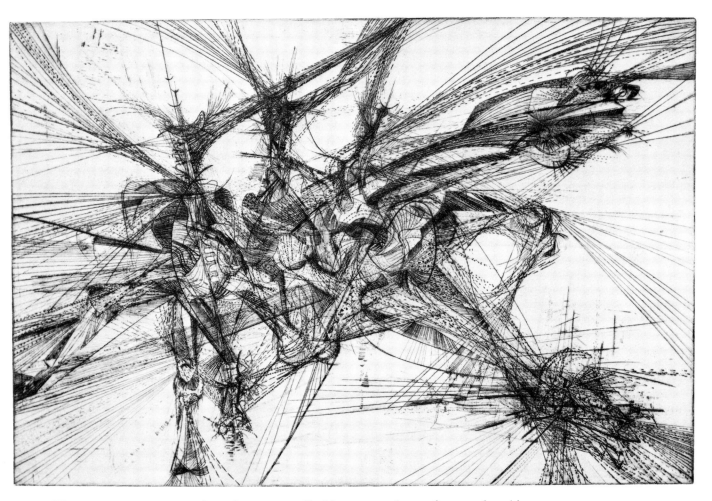

VI,22 GABOR PETERDI, *Apocalypse*, 1952. Etching, engraving, soft-ground etching.
The Brooklyn Museum Collection

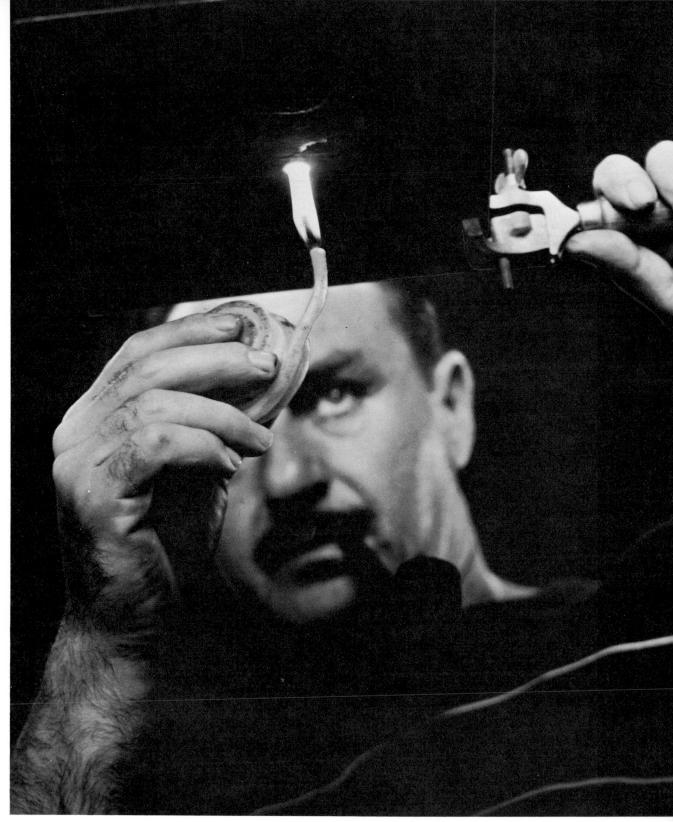

VI,23 *The author smokes a hard ground*

VI,24 *Hand vise*

SMOKING A HARD GROUND

To get a black enamel-like hard ground, in order to make the fine needlework more visible by contrast, the ground has to be smoked. The smoking is generally done with tapers (Fig. VI, 23), but if they are not available ordinary candles will also do.

After the hard ground is applied as described, the plate has to be put in the hand vise for easy manipulation (Fig. VI, 24). The plate is then held by the vise in one hand with the ground side facing downwards. The lit taper is held in the other hand under the plate. The flame has to be kept in constant motion in order to distribute the smoke evenly over the whole surface and also to avoid overheating any part of the plate that might scorch the ground. In addition, one has to be careful not to come too close to the ground with the wick of the taper, as it may mark up the ground.

After a minute or so (depending upon the size of the plate), the ground starts to shine, softened by the heat of the taper. The smoke penetrates into the ground and forms a hard, shiny surface. The plate is then cooled off, ready for work.

A properly smoked ground does not smudge, as the carbon becomes an integral part of the ground. If the ground is covered with a great deal of soot on the surface, it needs reheating.

Smoked ground cannot be used for re-etching because it would completely hide the work done previously on the plate.

TRANSFERRING A DRAWING ON HARD GROUND

The best method of transferring a pencil drawing on hard ground is to draw with a soft pencil ("B" or "1-B"). The drawing is then placed face down on the plate and run

through the press under medium pressure (if the pressure is set with three felts, remove one). The pencil lines will offset into the ground and show up very clearly. You must be cautious with this procedure to have a completely hardened ground and not to use a soft, fuzzy paper. Otherwise, it may stick to the plate.

If for some reason this method is not feasible, you can rub white chalk on the back of the drawing, and it can then be traced on the plate. The white chalk offsets on the ground. Carbon paper or white waxed paper can also be used to trace, and these are less likely to smear or accidentally rub off than the chalk.

Here again I want to remind the reader that in an etching the printed image is reversed. Therefore, the original drawing should be traced reversed in order to get the composition back to its original direction in the print.

I should also like to interject here my own personal observation in relation to working with the tracing on the plate. I feel that as much as possible the tracing should be used only as a guide; the actual details of the drawing should be solved in the process of work to leave room for invention. To follow closely a meticulously worked-out tracing tends to become mechanical, as all the vitality and the excitement of creation went into the original drawing.

WORKING ON THE HARD GROUND

The function of the etching needle is to expose the plate to the mordants in controlled areas. The drawing is fixed on the plate when the acid etches it into the metal. It is important to exert sufficient pressure on the needle to remove all the ground from the plate. Sometimes, if the pressure is too light, you can leave a practically invisible film of ground, but it will be sufficient to stop or to retard the action of the acid. This can be disastrous on an extremely complex linear work where an uneven bite or the necessity to go over the lines completely destroys its quality. This does not mean that you have to dig into the plate, as to do so would reduce the freedom of action and might make the drawing awkward. Furthermore, if changes are necessary on the drawing, an excessively deep scratch on the plate will take considerable time to correct.

Hard ground is sufficiently tough to resist light pressure and rubbing. Your hands may be rested on it when you are drawing, but care should be taken not to scratch the surface with your fingernails. A piece of paper under the hand provides protection for the ground.

A print can be started by making a light sketch on the plate and etching it. After the plate is printed, another ground is applied and further work is added. This process can be

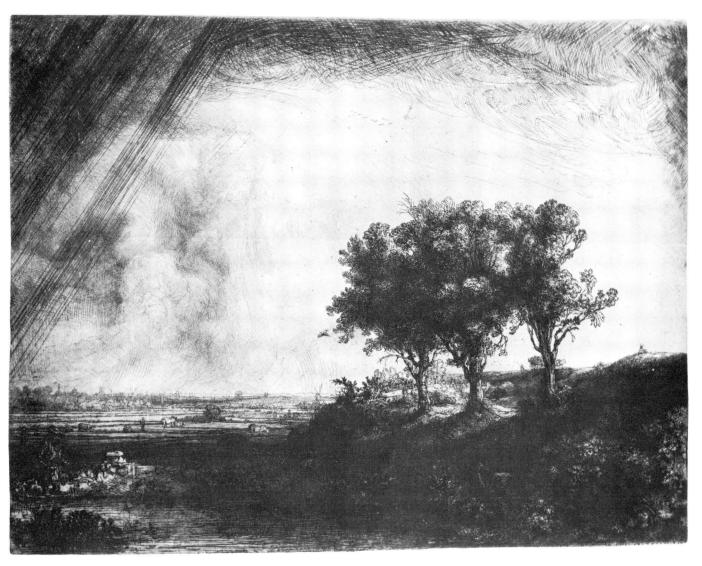

VI,25 REMBRANDT VAN RIJN (1606–1669), *The Three Trees*. Etching.
Yale University Art Gallery

repeated as many times as necessary to finish the etching. The lines previously bitten will show clearly through the ground. The richness in Rembrandt and Piranesi etchings is the result of many successive stages in the development of their plates (Fig. VI, 25, 26). In dark areas the overlapping web of lines, functioning as a glaze does in painting, gives depth and luminosity to the darkest passages. This cannot be achieved by trying to create maximum density in one bite.

Building Up the Etching in Stages

This method of developing an etching in stages is the wisest procedure for a beginner who cannot visualize at once the result obtainable on a metal plate. Through successive trial prints one has the opportunity to visualize the work on the plate in terms of the print and not as the transfer of a drawing. It always takes some time to discover that, no matter how closely a drawing is copied on the plate, the action of the acid or the burin and the three-dimensional quality of the lines completely change its character.

If an etching is conceived in a purely linear calligraphic style, it is better if the plate can be completed without the necessity of the re-etching, because underbitten lines which are reopened for further etching have a tendency to lose their freshness. Here I should like to interject that, as a general rule, in a line etching, if there is any doubt whether the lines are bitten deep enough, it is better to leave the plate in a little longer than take it out too soon. Unless one uses an unusually strong mordant, it takes considerable time for the lines to show a marked widening—but more about this when I discuss the action of the acids.

Re-etching Underbitten Lines

One way to avoid the necessity of going back into the lines with the etching needle in the case of underetching is to fill the lines with poster paint or any water-soluble paste. The poster paint hardens in the line, and the thin coat of ground is then brushed over the entire surface of the plate. After the ground has hardened, the poster paint is washed out of the lines by gentle soaking and rubbing in warm water, and the plate is ready for the etching. If this method seems unsatisfactory, as a last resort you must use a fine needle to reopen the lines. In doing so, keep the needle perpendicular to the plate, since a slanted needle will widen the lines. The needle should be guided by the grooves of the original lines, and not subjected to excessive pressure, or it will have a tendency to slide out.

It is very easy to foul bite a plate when working on previously etched areas. When the ground is brushed on the plate, an extra check should be made to see that it gets into all lines and crevices.

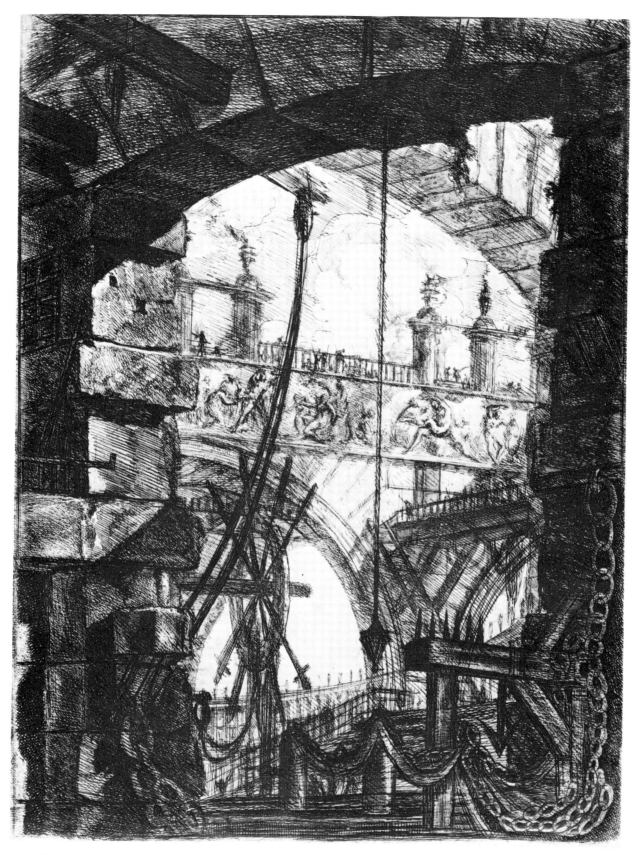

VI,26 GIAMBATTISTA PIRANESI (1720–1778), *Gli Carceri*. Etching.
Yale University Art Gallery

How to Put on Ground for Re-etching

A plate that has been etched should never be put on a very hot plate to expedite the evaporation of the ground, because excessive heat causes the ground to pull away from the lines, and this, in turn, will widen these lines when the plate is re-etched. The safest procedure is to air-dry the ground. This takes somewhat longer but may spare a great deal of difficulty.

Special Effects with Ground

Here I wish to point out that sometimes an effect that can be disastrous under some conditions can be used very successfully under proper controls. Many times I have used such procedures to widen etched lines where I felt that this kind of rugged effect was needed (Fig. VI, 22). I found ways to control it by cleaning the lines well in some areas and leaving a deposit of ink in others.

Where any oily, greasy substance is left in the lines, the shrinking of the ground will occur in a marked degree. This can be controlled further by applying stop-out varnishes where necessary, plus the timing of the etching period.

The width of the etching-needle stroke is limited. If a wide black line is desired, it should be drawn with multiple parallel strokes. This will make several grooves to hold the ink, and the grooves will be close enough together to print as a single line. If the ground is scraped from an area of any great width, that area will print as a dirty gray rather than black because a wide shallow line won't hold the ink and it will be wiped out. The only way to correct a too wide line is to roughen the inside of the groove with a sharp point or a burin. Sometimes a scraper rocked through the area will roughen it sufficiently to print a rich black. While a wide shallow line won't hold the ink properly, a line etched too deeply will contain too much ink and smear when the plate is wiped, or squeeze out under the printing pressure and produce a blotch or a run on the print.

STOP-OUT VARNISH

The most commonly used varnish for stopping-out is rosin dissolved in alcohol. This solution is a transparent light yellow liquid that dries quickly and is tough enough to resist acid. The consistency of the varnish varies according to individual working methods. Too thick a varnish is difficult to brush on freely, and varnish that is too thin will have a

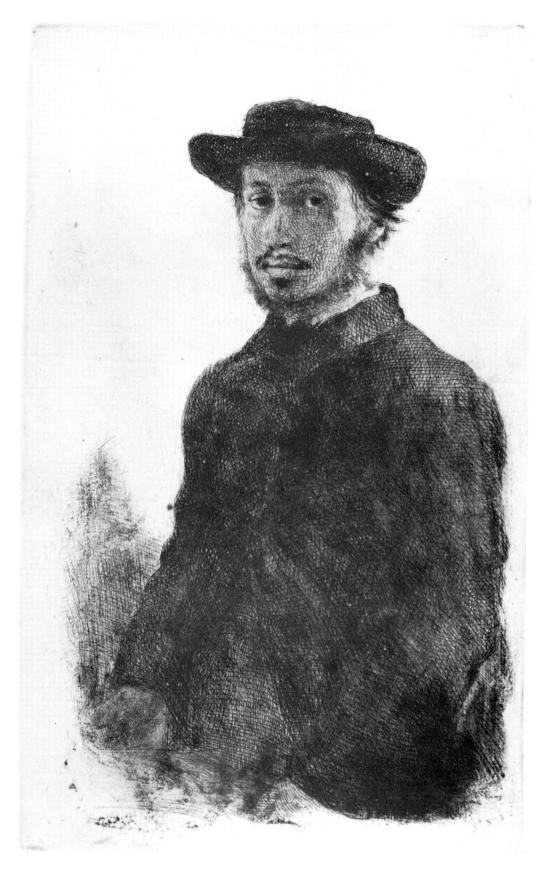

VI,27 EDGAR DEGAS (1834–1914), *Self-Portrait*. Etching.
National Gallery of Art. Rosenwald Collection

VI,28 ROBERT BIRMELIN, *Monkey*, 1956. Etching and dry point

tendency to run and spread on the plate. A mixture of 1 part rosin to 3 parts alcohol should prove satisfactory.

Stop-out varnish is used to protect the back and edges of the plate while it is in the acid. Because photoengravers' zinc plates are usually manufactured with a protective coating on one side, with these one does not have to worry about the back of the plate.

The varnish can be used to stop-out any part of the needle work not to be etched. It can also be used to cover up scratches or faults in the ground. It is wise to stop-out any spot that might be doubtful. A variety of controlled values can be produced on a plate by stopping-out various areas and etching in several stages (Fig. VI, 34).

The transparency of the stop-out varnish is very important when comparative tonal values in the etchings are to be observed visually. This is particularly important in etching an aquatint. The transparency of the stop-out varnish also makes it difficult to see on a dark ground. An experienced etcher develops an eye to see the varnish, but beginners tend to miss spots. If the plate is held at eye level with the light opposite, the varnish will appear shiny against the dullness of the ground.

Stopping-out varnish must be applied very methodically. Careless work can ruin the plate or cost many hours of correction.

Stopping-out varnish can be slightly tinted with methyl violet dye, and this, of course, makes it easier to observe.

Another stopping-out formula:

Shellac	4 oz.
Methylated spirit	8 oz.
Methyl violet dye	few drops

ASPHALTUM VARNISH

Egyptian asphaltum, or Gilsonite, dissolved in turpentine produces a black, opaque varnish. Benzine may be used in place of turpentine to produce faster drying. Asphaltum varnish is very tough and is generally used to coat the back of plates and to black out areas in the relief etching.

Asphaltum dries slowly and chips easily if used as a ground. If it is used directly on the metal, the plate must be absolutely free of grease and dirt. Otherwise, the varnish will lift. A small quantity of beeswax, approximately 1 part to 8 of asphaltum, makes the varnish more flexible and less likely to chip. However, liquid hard ground can be used for the same purposes, and is much more reliable.

SOFT GROUND

Soft ground is made by mixing 2 parts liquid hard ground with 1 part tallow, axle grease, or Vaseline. These proportions can be varied to suit individual preferences. For softer qualities, more grease is added, and for firmer ground more hard ground is used. Since soft ground already contains grease, the plate does not have to be so meticulously cleaned as for hard ground or aquatint.

Soft ground is applied with a brush in the same manner as liquid hard ground. The plate should not be coated too heavily or it will not be sufficiently sensitive to pressure and it will tend to squash. The same brush should not be used for both hard and soft ground, because dipping the brush from one to another would cause a change in their consistency and inevitably produce problems.

Offset Drawing on Soft Ground

In using the soft ground in the conventional manner, the artist covers the plate with a paper. The position of the plate has to be marked on the paper. On drawing on this paper with a hard pencil or any instrument, the soft ground offsets on the paper by the pressure of the drawing instrument, and exposes the plate. The lines obtained are soft and granular, somewhat like a crayon line on a lithograph (Fig. VI, 37). The character of the line is determined by the thickness and texture of the paper and by the drawing tool. The amount of pressure exerted will also cause variations in the lines. The width of the lines produced will equal approximately the width of the drawing point plus twice the thickness of the paper.

The following steps should be taken in preparing to work on soft ground. The plate must be handled carefully to avoid leaving any contact marks. The position of the plate should be registered on the working surface and the paper hinged to it with a tab so that it can be folded back and forth and the plate examined. The paper should not be touched with the hands or fingers once it is in position, or it will offset the ground.

After the drawing is finished, the plate is examined carefully, and any mistakes or accidental smudges may then be stopped-out. The paper should be left taped to the table so that the work may be reregistered if further drawing is needed after the first etching stage.

Textures on Soft Ground

The above-described method is the way soft ground was originally used. Today, however, it is exploited in many other ways. The contemporary artist is interested in the sen-

VI,29 JAMES ENSOR (1860–1951), *The Entrance of Christ into Brussels*, 1898. Etching.
The Museum of Modern Art, New York. Aldrich Rockefeller Fund

sitivity of soft ground, which will register anything from the delicate texture of a thumb-print to the coarse texture of a burlap. Hayter and the Studio Seventeen made the most extensive exploration of these possibilities (Fig. VI, 35).

The soft-ground textures were explored from two different points of view: one that was similar to the motivation producing the cubist collages; the other, simply to create neutral textures for tonal areas more or less functioning like an aquatint. These had the advantage of great durability in printing, but I do not consider them, under any condition, interchangeable.

The variety of textures usable for soft ground is practically infinite. By successive bites one can build up rich tonal areas that are dense but remain luminous at the same time. The soft-ground texture, however, has to be used with great discipline, and I doubt that any technique has been more abused than this one.

Anyone can learn in a short lesson the effectiveness of a piece of lace or any other decorative material pressed into soft ground. Immediately after the introduction of this method, a number of people discovered that nothing is quite so kind to a poor drawing as the veil of a rich texture.

When soft-ground textures are properly used, they can add a great deal to the print-maker's graphic vocabulary. Most of the prints by Hayter are excellent examples of how textures should be used—always functioning within the plastic content of the print, never as a surface decoration.

The procedure for imprinting texture into soft ground is as follows:

First, the selection of the materials to be used for the impression.

Second, the reduction of pressure from the press by the removal of at least one felt. It is necessary to have some waxed paper or other coated paper ready to cover the plate after the texture has been placed on it. Otherwise, the ground will squeeze through the texture on the printing felts.

Stopping-Out the Soft Ground

Third, the control of the design achieved by the texture is done by stopping-out; this gives a greater flexibility than trying to mask or cut the textures themselves to shapes. The stopping-out also provides the opportunity for using light areas or lines against a dark, heavy-textured area. It is possible to overlap different textures either by running the plate through the press successively or by successive stages of etching (Fig. VI, 35). This choice must be dictated by the particular necessity of the plate. Negative images of textures can be transferred and etched by running the plate through the press with a fairly heavy coating of soft ground. The protective paper that has the negative impression of the

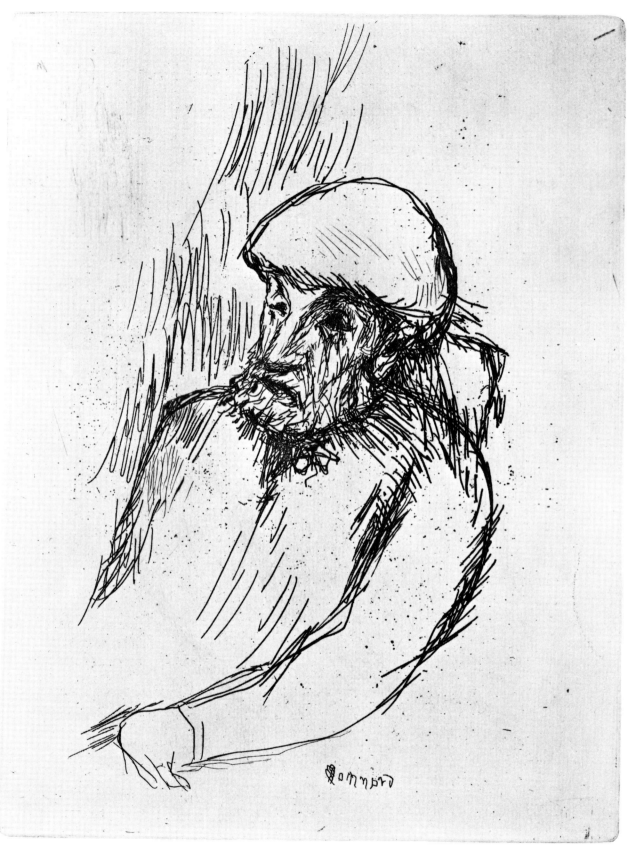

VI,30 PIERRE BONNARD, *Renoir*, 1914. Etching and dry point.
The Museum of Modern Art, New York

texture is placed face down on a clean plate and then run through the press. The resulting transfer is then etched.

When soft-ground textures are used, the stopping-out must be especially thorough, because when the plate is run through the press it is almost impossible to avoid offsetting the ground in areas that are not to be etched. Unless these sections are adequately covered, the plate will have a great many foul bites.

If line etching or engraving and soft-ground textures are to be combined, the linear work should be done first, since it is difficult to control the needle on a rough surface. In addition, lines on the plate will help to control the stopping-out process by providing natural boundaries, as it were. This does not mean that lines cannot be added to a plate already textured. It means only that the difficulties of linear work are increased by the adding of texture. If lines are to be put on the plate underneath the ground to serve as guides, they should be drawn with India ink, although even a pencil line will show through a ground not too thickly applied.

AQUATINT

Aquatint is a porous ground consisting of rosin powder dusted on the plate and fused with heat. It is used to etch tonal areas on the plate controlled by the texture of the rosin and the time allowed for etching.

The acid bites tiny crevices into the metal through the pores of the ground. The crevices hold the ink and print as a tone. Density, width, and depth of these crevices determine the tones and textures.

The aquatint method was invented in the eighteenth century; and, although a great number of pure aquatint plates were done, its main function was to be used with line etching just as a wash is with pen drawing. Theoretically, there is no limit to the number of tonal values one can etch with aquatint.

From my experience and deductions made by studying a number of aquatint plates going back to Goya, I am convinced that aquatint has to be used with simplicity and directness in order to be effective. Nothing can produce a more colorless, dull plate than over-fussy aquatinting. Anyone comparing some of the aquatint plates made in the late nineteenth century by the English or French landscape school with those of Goya can see my point immediately. In technical mastery alone, Goya was a primitive compared to these virtuosos—some of the books written on printmaking around the turn of the century speak of Goya's technique with great disdain—yet the forcefulness and richness of color achieved by Goya make these printmakers look sick in comparison. Goya seldom

VI,31 PETER MILTON, *Julia Passing*. Etching, second state, 1968.
Courtesy of the artist

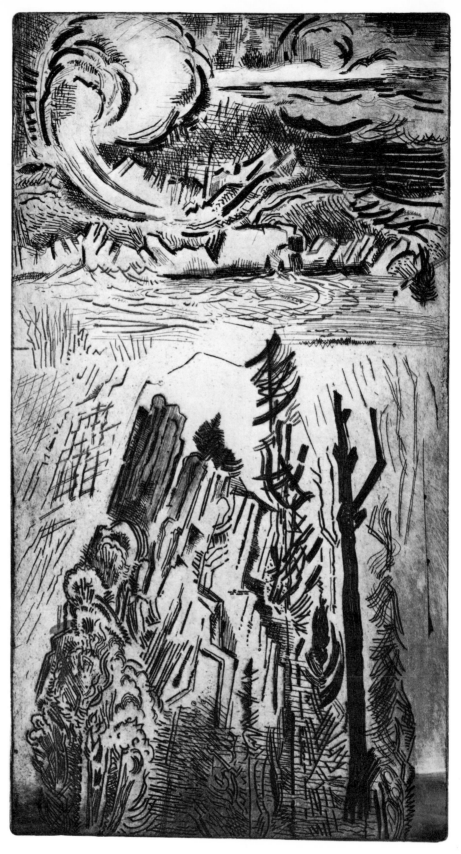

VI,32 KARL SCHRAG, *Lonely Heights*, 1955. Color etching.
Courtesy of the artist

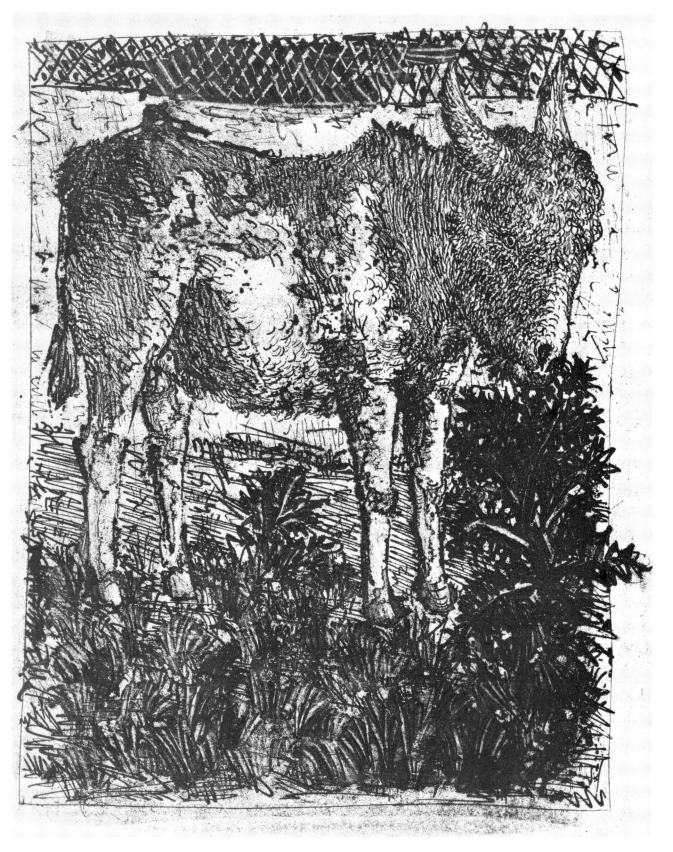

VI,33 PABLO PICASSO, *Ass from Buffon's "Histoire Naturelle,"* 1936. Aquatint.
The Museum of Modern Art, New York. Gift of Abby A. Rockefeller

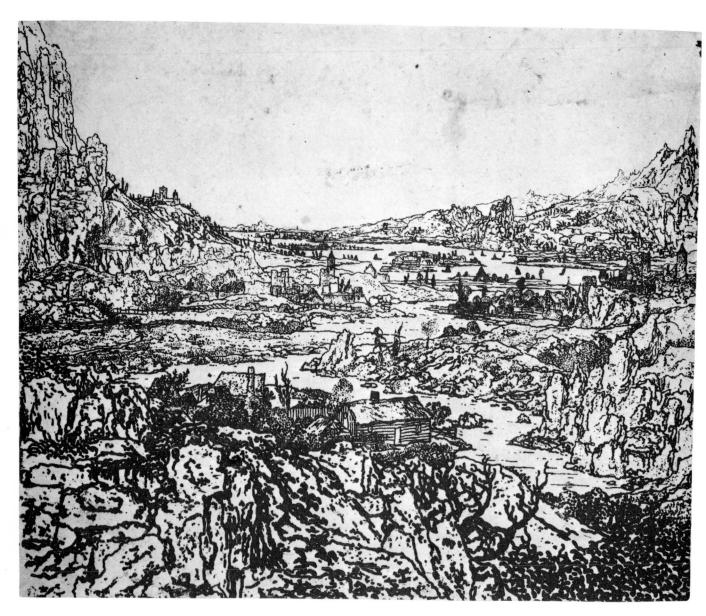

VI,34 HERCULES SEGHERS (1589?–1638?), *The Rocky River Landscape*. Etching. Rijksmuseum, Amsterdam

VI,35 STANLEY WILLIAM HAYTER, *Tarantella*, 1943. Engraving and soft-ground etching.
The Museum of Modern Art, New York

VI,36 GABOR PETERDI, *Despair I*, 1938. Soft- and hard-ground etching and engraving.
The Museum of Modern Art, New York

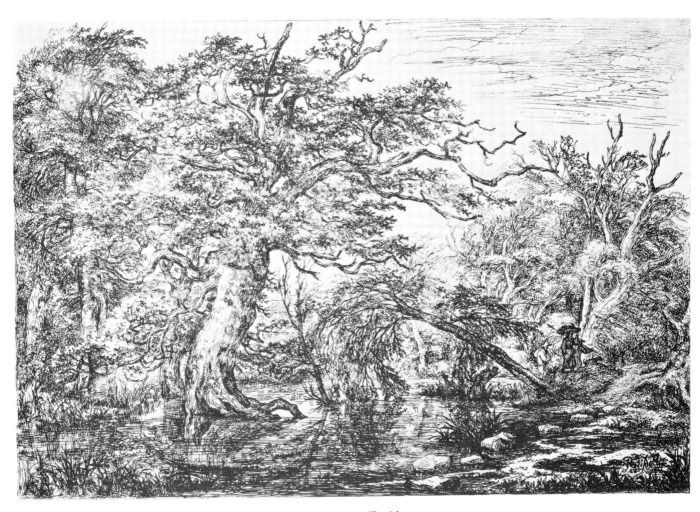

VI,37 JACOB RUYSDAEL (1628–1682), *The Traveller*. Etching.
The Metropolitan Museum of Art. Harris Brisbane Dick Fund

used more than three basic tone values in his aquatints and often less that that. Yet he achieved the illusion of infinite variety by the masterful combination of the tone with the line (Fig. VI, 40). He let the aquatint retain its flat character and only sparingly used scraping or burnishing to soften some of the edges.

Materials and Equipment

Rosin

Dust boxes or dust bags

Assorted brushes

Stop-out varnish

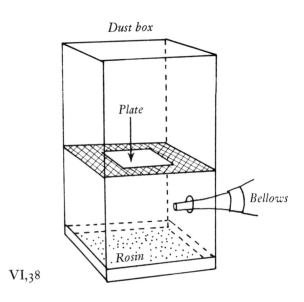

Dust box

Plate

Bellows

Rosin

VI,38

Dust Boxes

The dust box was the most commonly used method to aquatint a plate. There was great variety in the construction of these boxes, which ranged from very crude contraptions to elaborate fan systems.

The size of the box to be constructed is determined by the size of the plates generally used, as the plate has to be placed in the box itself. The box is completely enclosed with a sliding tray above the dust tray to hold the plate. This tray is generally constructed of steel mesh. After the rosin is placed in the box, the box is picked up and shaken well by hand to activate the rosin dust. Then the plate is inserted in the box for the necessary time to allow sufficient density of rosin dust to settle over its surface (Fig. VI, 38). The time

element has to be determined through personal experimentation—but more about this later.

The second method uses a box similar to the first, except that this one has an opening above the dust tray for a bellows. The dust is activated with the bellows, instead of by shaking.

A third box is also constructed with the bottom tray for the rosin dust and the top tray for the plate, but it is built on a revolving axis which is connected with a fan placed inside the box. The fan activates the rosin dust.

In experimenting with the time element, the printmaker will find that if the plate is placed in the box immediately after the rosin dust is activated, the ground will be coarse, as the heavier particles are still in the air. If, however, one waits a little while, the heavier particles settle down first and leave only the fine dust suspended.

As I mentioned before, the time element has to be determind by personal experiment, as accurate time predictions are impossible.

Dusting Bags

Dusting bags are used today most often to aquatint a plate. There are several reasons for this procedure. One of the most obvious is the size of the plates. Many of the contemporary printmakers use such enormous plates that the manipulation of a box big enough to accommodate them would be distinctly impractical.

A second reason is that although the laying of an aquatint ground with dust bags is most tedious, it offers much greater flexibility and control because one can vary the density and texture in any particular area of the plate at will (Fig. VI, 39).

VARIETY OF DUST BAGS

The common practice is to prepare a number of dust bags, using a variety of materials from fine to coarse. One should have at least three: one fine one made of silk or fine cotton, a second of medium grain, and a third of a very coarse material. Cheesecloth folded two or three times, or burlap, provides a suitable material for the third bag. The preparation of the bags is very simple. The rosin is crushed and the powder placed in the material. The material is folded into bag form, then tied securely with string.

These bags must be kept in a dust-free, clean box, and I remind you again that the plate to be used must be meticulously clean, because the slightest trace of grime or grease can cause disaster in this delicate technique.

Aquatint is one of the most fragile of etching media. If it is to be used in conjunction with other methods on one plate, it should be done last if possible. Then it will not be

exposed to accidents or injuries from a slip of the burin or scraper. And here I wish to mention that copperplates are better for aquatinting than zinc, because copper bites more evenly and consistently. Furthermore, in using Dutch mordant on copper, the visual control is not hampered by the air bubbles always present on a zinc plate etched in nitric acid—but more about this when discussing etching.

Determining Correct Amount of Aquatint

Aquatint should be prepared in a draft-free area. The ground is deposited by shaking the rosin bags over the plate. This is best done by holding the bag firmly in one hand and

VI,39 *Laying aquatint ground with dust bag on a relief-etched plate*

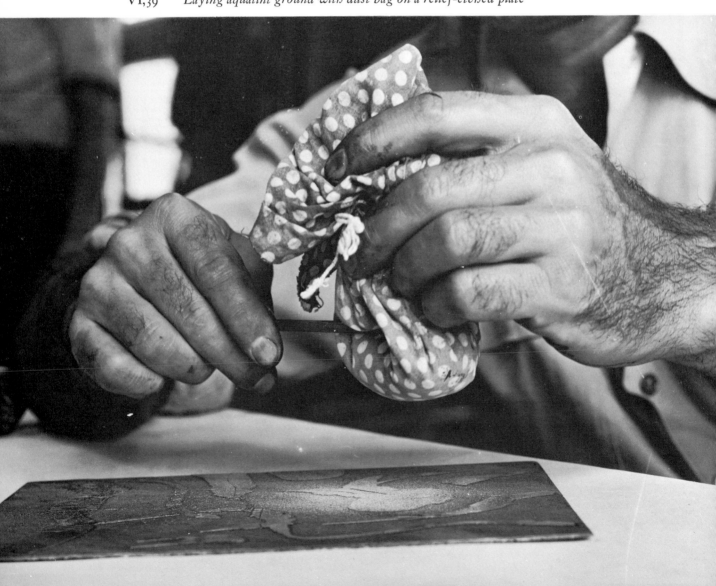

VI,40 FRANCISCO GOYA (1776–1828), *Ensayos from Los Caprichos*. Etching.
Courtesy of The Brooklyn Museum

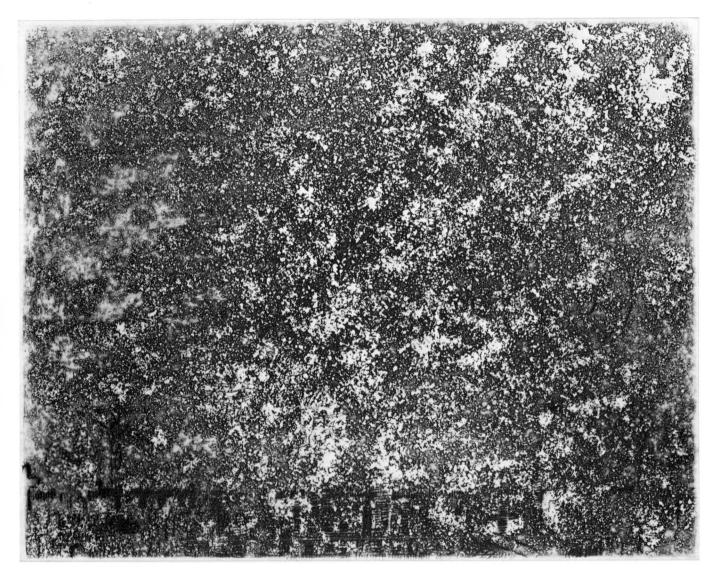

VI,41 JAMES ENSOR, *Stars at the Cemetery*, 1888. Line etching and aquatint.
The Museum of Modern Art, New York

VI,42 JOHN PAUL JONES, *Suspension*. Aquatint and engraving.
The Brooklyn Museum Collection

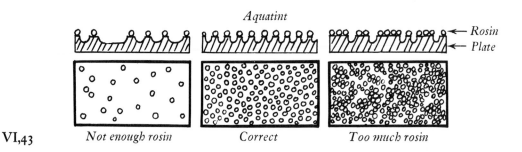

Aquatint

← *Rosin*
← *Plate*

VI,43 *Not enough rosin* *Correct* *Too much rosin*

tapping it briskly with the index finger or by flicking the bag sharply with a wrist action. The bag should be kept in constant motion in order to achieve a uniform coating, if desired. Different grains of rosin can be combined on one plate.

If the plate is observed at eye level, the exact amount of rosin on the plate can be better determined in that position than by looking down on it. A too thin coating of rosin will produce a rough grain on the plate; if the amount of dust is increased the grain will become proportionately finer. A 50 to 60 per cent coverage will produce the best result. An excessive amount of rosin deposited on the plate tends to coagulate and produce large white areas in the tone (Fig. VI, 41). Of course, if the whole area is fused the purpose of aquatinting is entirely defeated. If it appears that several overlapping tones are to be etched, it is best to start with a coarse texture and make progressively finer ones.

If the rosin is disturbed on the plate before it is fused, the plate should be cleaned and the whole process repeated. Aquatint cannot be patched successfully.

Fusing the Aquatint

Dusting should be done near a heating unit so that the hazards of transportation are eliminated. Any swift movement or sudden breeze can disturb the rosin before it is fused. After the plate is placed on the heating unit, it is best to observe it at eye level, as with the dusting. As the plate warms up, the rosin becomes transparent. When the whole plate surface does not show any white particles, then the fusing is finished. Unless one has a hot plate that is uniformly heated on its whole surface, the plate will have to be kept in motion in order to avoid scorching one section of the aquatint before the rest is fused. The timing of the fusing is extremely important; because, just as overheating can ruin the ground by scorching, underheating will produce a loose ground that might flake off in the process of biting.

Although rosin powder is the material most commonly used to make aquatints, there are other materials and methods that can be used to create tonal effects on the plate. For

instance, powdered asphaltum (the same as that which we used in hard ground) can be used for very fine aquatint instead of rosin.

Spirit Ground

There is also a method used a great deal in the last century but practically extinct today called a "spirit" ground. With this technique either rosin or dammar crystals are suspended in alcohol and floated on the surface of the plate. This is hard to control, but I have seen some extremely delicate things etched with it.

RECIPE FOR SPIRIT GROUND

Dissolve 5 ounces of rosin in a pint of alcohol, letting the residue settle in the bottle. Then take this solution and mix it with another pint of alcohol.

If you mix 1 part of the initial solution with 3 parts of alcohol, it will give a fine grain.

If you mix 1 part to 2 parts of alcohol, it will be coarse.

To use, pour this solution over the plate and let the alcohol evaporate.

Flour-of-Sulphur Method

Flour of sulphur was used in the nineteenth century to etch delicate tints on copperplate. This was done by a variety of methods. I give you here two of the most commonly used:

1. Paint the area to be etched with olive oil; then sprinkle it with flour of sulphur. Let it stand several hours. If the tint is not heavy enough, repeat the process.
2. Mix the flour of sulphur with oil until it is thick enough to be laid on with a brush. The corrosive action can be precipitated by placing the plate in hot water. A few minutes' submersion will produce a fairly solid tone. Many of the old masters used this method to etch binding tonality on their crosshatched areas.

Enamel Spray for Tonal Etching

Recently the painting industry has made available several lacquers and enamels in spray cans. Many of these are sufficiently acid-resistant to use for moderately long bites. The use of these spray cans allows a control over tonal areas difficult to achieve with dust.

In recent years these sprays became so popular that in many workshops they nearly replaced conventional aquatint. Having used it extensively myself, and through my experience with students, I learned much about the advantages and limitations of this method.

First of all, one shouldn't consider spraying as a complete substitute for aquatint.

VI,44 PABLO PICASSO, *Head*, 1946–1948, from Gongora's *Vingt Poèmes*. Aquatint. The Museum of Modern Art, New York

VI,45 MARC CHAGALL, *Self-Portrait with Grimace*, 1924. Line etching and aquatint. The Museum of Modern Art, New York

Spraying is excellent for creating uniform tonal areas or for controlled blending from light to dark. It is also very good for etching really saturated blacks. The texture of spray differs from aquatint. The dots are more uniformly round. Therefore, if one wants a ragged, uneven texture it is better to use a coarse rosin dust. This doesn't mean that the spray always produces dots of uniform sizes. This depends on the distance you spray from and on the spraying technique used. The spray can has a tendency to spit and splatter at the beginning and at the moment when pressure is stopped. Therefore, if you want a uniform texture, start spraying outside the plate, and stop outside.

Before spray is applied, the plate has to be completely grease-free; otherwise it will lift in the acid. I have found plastic-base lacquers the best, preferably high gloss.

The plastic sprays are most valuable when used for lift-ground etching. They eliminate the need to heat the plate, which, therefore, can be used safely after the lift ground is washed out.

WARNING: If sprays are used a lot, a spray booth with exhaust should be installed. Excessive inhalation of spray fumes is a serious health hazard.

To remove plastic sprays use lacquer thinner.

Salt Method

Another technique employed to simulate the effect of aquatint is hard ground sprinkled with salt. The plate is coated with a thin layer of hard ground. While the ground is still tacky, it is sprinkled with salt. The plate is warmed to make sure that the salt sinks completely into the ground. Then the plate is cooled. When the ground is hard, the plate is placed in a tray of lukewarm water. The salt will dissolve and expose the plate. Then the plate can be stopped-out and it is ready for etching.

This is in reality a modified lift-ground technique, of which I shall say more later.

Sand Ground

This method consists of running a plate coated with hard ground through the press with a sandpaper face down on the plate.

This can be repeated as many times as is necessary to produce sufficient density in the texture. (Each time the plate is run through, the sandpaper is slightly shifted in position.) This process is a crude one, but it does have the advantage of being able to withstand an unlimited number of printings.

STOPPING-OUT THE AQUATINT

After the fusing of the aquatint, the plate cools and is ready for stopping-out. This is a process that requires consideration and care, especially if the aquatint is applied on a plate that already has considerable work on it. A bad stopping-out job can completely ruin a plate, as the scraping will affect the already etched area.

The aesthetic considerations governing the stopping-out are too obvious to be explained, but there are technical considerations. The brush should not be overloaded, because the varnish tends to run on the slick rosin surface. The brushing should be begun in the middle of an area and extended outward.

The aquatint must be handled very carefully because it scrapes off easily, because grease from the hands may be transferred, and because a smudge may cause a spotty tone. The use of a wooden hand rest or a clean piece of paper under the hand provides adequate protection.

If a white linear effect and a gray background are desired, lithographing crayon or wax crayon will produce a wide-textured line. For a solid white line an extra thick solution of stop-out varnish or asphaltum varnish can be used. Stopped-out aquatint will produce sharply defined tonal areas. Since the boundary lines between stopped-out and tonal areas will show up clearly no matter how much one tries to control the passages by graduated etching, it is best to exploit it (Fig. VI, 45).

If soft blending is desired, it can be achieved after the tone is etched by using a scraper, burnisher, or an engraver's charcoal block. Because aquatint is so easily removed, it is not wise to experiment with unfamiliar tools on a plate in progress. It is better to have available a small plate for trial work.

HANDLING ACIDS

First of all, I should like to emphasize that acids, especially in the undiluted form, are dangerous. Therefore they should be kept in a safe place and in proper containers. Pure acid should be kept in cabinets on shelves inaccessible to children. The acids should be in heavy glass containers equipped with wax-sealed plastic caps. These containers should never be handled with wet or slippery hands. Above all, never hurry when you handle acids.

Safety Measures

When mixing solutions, there is one rule which should never be violated: Acid is always poured into water; water is never poured into acid. Never lean over acid while pouring it, because it tends to spatter.

The eyes are the only part of the body that can be injured permanently by acid. However, should large areas of your skin come in contact with pure acid, wash them well with water; apply baking soda immediately, and then seek medical attention. It will reassure the reader to learn that in years of experience with workshops and schools, I have never seen any serious accidents; however, this is one time when it is better to be a little scared than sorry.

Acid bottles must always have their contents clearly marked, both for convenience and for safety.

Plates can be handled in diluted acid without rubber gloves provided the hands are washed immediately in water. Most harm is done by those who are in a hurry or by those who splash plates into the acid solution because they are afraid of it. Printmaking is one occupation in which hurrying does not pay. Efficiency is the result of a deliberate rhythm in working.

Jars of acid solution should always be placed behind a tray to indicate what strength of acid is in it and to facilitate putting the solution back into the proper bottle. This is particularly important in the workshop where a number of people handle everything and where mix-ups can occur very easily.

At this point I also wish to add that in the workshop it is important that only the monitor, or a few selected members, should ever handle the acids, those concerned always consulting others if any change is to be made in the acid baths. Otherwise, a great many disastrous mix-ups can occur.

If zinc and copper baths are placed on the same table, they should be far enough apart to avoid the dripping of one mordant into the other when plates are removed. The mixture generally causes an electrolysis, and may ruin plates submerged in the mordant. I have seen grounds blistered, blasted full of holes, and ruined by this action.

Acids should not be left in a tray overnight or at any time when they are not in use, because evaporation of water will change the strength of the solution.

Hard rubber trays deteriorate rapidly if acid is allowed to remain in them for extended periods.

As far as possible, when a great deal of acid is exposed the studio should be well ventilated in order to avoid inhalation of the fumes.

VI,46 RICHARD ZIEMANN, Edge of the Clearing, 1968–69. Etching and engraving

THE ACID TRAY

Good acid trays are made out of hard rubber and are obtainable in photographic supply stores. Their disadvantage is that they are quite expensive. These trays last for many years if they are properly cared for. They are not brittle, although a violent blow may break them. After considerable time, especially if they have been exposed to strong acid solutions a great deal, the rubber slowly starts to disintegrate into powder. A periodic coating of the inside with asphaltum varnish will lengthen the life of the tray considerably.

Pyrex trays can be used for small plates. They have to be handled carefully because of their brittleness, but they are very cheap.

The sturdiest trays of all are those of stainless steel (resistant to most of the acids we generally use), but they are so expensive that unless one can pick up a bargain their price is prohibitive.

Recently, large plastic trays made to order have become available. One can have practically any size within reason. These trays don't deteriorate like rubber and are equipped with a plastic spigot. They aren't cheap, but they are worth the price considering how long they last and the convenience they offer. I ordered mine from Harold M. Pitman Company, but I am sure they are obtainable through other companies selling engravers' supplies.

Enameled metal trays are also excellent, but they are heavy and the slightest blow may chip them. Once the enamel is gone, unless the spot is immediately covered with an acid-resistant, the metal is bitten through by the acid. Therefore, although hard rubber trays and plastic trays are more expensive initially, I have found them more economical in the long run.

How to Make Acid Trays

I constructed a tray out of wood and used it for years without any trouble. Wood is cheap, and you can build it in the proportions best suited to your working problems. The procedure is simple, requires few tools, and very little experience in carpentry.

For the walls of the tray I used 1″ by 4″ pine, but if you have any harder wood available it would be better to use it. The bottom of the tray is made out of hard, tempered Masonite.

First, nail the sides together (the size of my tray is 26″ x 40″, in order to accommodate

VI,47 GABOR PETERDI, *The Nervous Lobster*, 1947. Etching with gouged whites

easily a full 24″ by 36″ metal plate). If you have the tools, make a mitered or rabbet joint, but this is not absolutely necessary. The bottom can be glued and nailed to the sides, or if you have an electric saw available you can cut grooves in the sides so that the bottom of the tray can slide in, giving a tighter joint.

After the tray is finished, pour asphaltum varnish inside and manipulate it so as to make sure that every crack in the wood is filled, especially along the seams. After the first coat of asphaltum dries, put linen tape along the seams inside and outside, and cover the tray again with another coat of asphaltum varnish. Naturally the outside, too, has to be covered. Because my tray is very large and the Masonite bottom flexible, I nailed several cross braces on the bottom to make it more sturdy. For a very fancy job, in order to facilitate the emptying and rinsing of the tray, a spigot can be installed near the bottom.

ETCHING ZINC PLATES

The acid solution used by most of the printmakers today to etch zinc plates is one part of nitric acid, c.p., to nine parts of water, but one learns by experience how to vary these proportions to gain specific effects. The solution might range from one part of acid and six parts of water for a rugged, uneven bite, to one part nitric and twelve parts of water for use on aquatints.

The stronger the acid, the less control we have over it. I have had considerable trouble with students who think that by doubling the acid strength they simply reduce the time element by half, with the same final effect. This is not true. The effect of acid is cumulative and the faster it bites, the more momentum it gains in the heating process which follows the extremely fast corrosion. Therefore, beyond a certain point all control is lost and an unchecked disintegration takes place.

Acid solutions constantly vary in their strength through use. They will weaken in proportion to the amount of metal suspended in the solution. Therefore, at times, the mordant has to be strengthened. When the solution becomes too dirty, a fresh supply must be made. The acid strength will also be affected considerably by atmospheric and temperature changes. Acid will bite much faster on a hot, humid day than on a cold day. Therefore it is obvious that in a workshop where these elements are not controllable, one cannot depend on timing alone. One can only rely on visual and tactile testing.

The idea of a test plate (recommended by most of the books written on etching) can serve only to formulate a basic conception of what acid might do under a certain con-

dition; unless the conditions under which the test plate was made can be identically duplicated it is of little use, and to rely on it would be courting disaster.

Be particularly careful if you change from one brand of zinc plate to another. As they are alloys, they can vary considerably. After changing from Zomo to Micrometal I discovered that I had to use a much milder acid solution on the latter, 12–1, instead of 9–1. I also found that Micrometal develops more sediments than Zomo. The first time you use a new alloy, make a small test plate before you undertake a large, ambitious project.

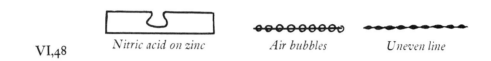

VI,48 *Nitric acid on zinc* *Air bubbles* *Uneven line*

Detection of Foul Bite and Opening of Lines

A zinc plate in a nitric bath liberates hydrogen gas over the etching area (Fig. VI, 48). This gas appears in the form of tiny air bubbles after the plate has been submerged for a few seconds in the acid bath. These make the detection of foul bite easy; at the same time, the lack of bubbles would indicate just as clearly that an area was not being exposed sufficiently to the acid. If a line remains shiny and no bubbles appear, the plate must be removed from the acid and the lines reopened with the needle. Remember that the thinnest, nearly invisible coat of ground is enough to retard or even completely stop the acid action.

Sometimes it is possible to break down this thin coat of ground by pouring a small quantity of pure acid into the bath immediately over the area. The extremely fast action of the acid lasts a few seconds, just enough to penetrate through the weak ground; then it is dispersed in the large volume of weaker solution. This procedure is not without risk. Too much pure acid might considerably widen the lines and can cause foul bites if the ground isn't perfect.

Sometimes I use this technique for irregular rugged lines. The accelerated action practically erodes the bitten area. But again I must caution you: this can easily get out of control, and only the experienced etcher should use it.

In a workshop where many people use the same acid bath this procedure should not be allowed. Just imagine what would happen to the acid proportion if everybody in the workshop "spiked" the mordant!

The Effect of Air Bubbles

If the bubbles are allowed to remain undisturbed for too long, they will cause the uneven bite typically associated with zinc (Fig. VI, 22). On a line, the bubbles form a string (like beads); the acid action is slower under them than between them, and the line bitten into the plate will be uneven unless the bubbles are broken or brushed aside. If the bubbles are kept disturbed constantly, this effect can be considerably reduced. The brushing of bubbles generally is done with a feather, and is therefore called "tickling" a plate. However, anything can be used—a pipe cleaner, an old brush—so long as it is not sharp enough to injure the ground.

The ruggedness of the zinc etch is a characteristic that should be exploited rather than overcome (Fig. VI, 14). If this effect is undesirable, then the logical choice would be to use copper instead of zinc. Naturally, there are conditions which make a combination of effects and the compromise of techniques desirable or necessary (not to mention the economic factor, zinc being half the price of copper).

For a precise soft-ground texture or an aquatint, the nitric acid has to be fought constantly. Therefore, I repeat: if possible, use copper for these techniques.

Undercutting

When etching a plate it is essential to remember that acid bites sideways as well as in depth. This is called "undercutting."

The lines must be tested periodically with an etching needle because often the undercutting is hidden by the ground and the line may be much wider than it appears. If the line is deep enough to hold the needle securely in the groove, it is deep enough to print. In cases of doubt it is best to leave the plate in the acid a little longer.

The Crevé

On a linear etching it is better to run the risk of slightly thickened lines than to have them too shallow. In closely needled or fine-textured areas, especially close watch must be kept to make certain that the detail is not undercut and lost. When corners formed by the crossing of two lines begin to round off, it is a sign of deterioration. If the plate is not taken out of the acid immediately, eventually the whole area might collapse, creating what is generally called a "crevé" (Fig. VI, 49).

This shallow, rough area then will have to be completely reworked. In some cases

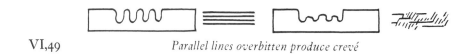

VI,49 *Parallel lines overbitten produce crevé*

it has to be scraped down completely, the plate pushed back to its original level, and the etching process repeated.

ETCHING COPPERPLATES

Most books on etching state that zinc plates wear out more quickly in printing than the copper. This is true to a limited extent, but not enough to have any influence on the size of editions generally printed today. I must also add that in the past printmakers used pure zinc plates much softer than the zinc alloys we use today. With zinc alloy, editions of over two hundred were printed without any noticeable deterioration of the plate.

For a fine, controlled etching, copper is the most suitable metal. Copper can be etched with nitric acid and Dutch mordant. The use of nitric acid is advisable only where large areas of the copper are to be etched out, as in relief etching. To use nitric on a fine linear art work would make the use of copper senseless, as the action of nitric on copper is similar to its action on zinc; thus the printmaker would have to cope with the same difficulties (air bubbles, uneven, ragged bites, and so on). Dutch mordant, however, works slowly, evenly, without air bubbles, and precipitates negligible amounts of sediment (Fig. VI, 50).

VI,50 *Dutch mordant* *Fine even line*

Dutch Mordant

Dutch mordant is a mixture of saturated water with potassium chlorate and hydrochloric acid. Saturation means dissolving the potassium chlorate crystals in water until the water will not absorb any more salts. Any excess salt that might recrystallize in the bottom of the jar has no effect on the efficiency of the mordant.

The proportion most commonly used is 9 parts of saturated water to 1 part of hydrochloric acid.

We can also formulate this by saying: 2 parts of potassium chlorate, 88 parts of water, 10 parts of hydrochloric acid.

Ferric Chloride

In the past some printmakers have used ferric chloride or perchloride of iron. It was an aqueous saturated solution with 2 parts of water. This was generally used where an extremely gentle, controlled biting action was needed (fine textures, aquatints). The disadvantage of this solution is the deposit of iron oxide in the lines that stops the action of the acid. Therefore the plate either has to be etched face down in the acid (in order to make the deposits fall out of the lines) or the plate has to be cleaned at intervals.

For the cleaning, use either a weak solution of hydrochloric acid or acetic acid.

Visual Control

As I mentioned before, Dutch mordant releases no gas bubbles. This eliminates the problem of an uneven bite (Fig. VI, 29) and also makes it easier to watch the progression of the etching process. Dutch mordant also has much less tendency to undercut the lines than nitric acid. For these reasons Dutch mordant is unquestionably the ideal solution where a controlled etching process is desired.

Because of the absence of gases, it is more difficult with this medium to detect immediately where the biting starts. Therefore one has to be doubly cautious in laying the ground and stopping-out to avoid foul bites.

If one observes the plate carefully in the acid, he will notice that as the corrosion starts the lines will become dark, whereas the unbitten areas will remain shiny. As the lines reach a certain depth, if the plate is held at an angle against the light, they will appear darker than the ground by the cast shadows.

If there is a large area covered with texture or close detail, it should be watched carefully because it will etch much faster than an isolated line (Fig. VI, 51). The metal has a tendency to heat during the etching process, and the heat in turn speeds the action of the acid. Therefore an area where a large metal surface is exposed to the acid has to be tested constantly. This condition exists to a greater extent on copper than on zinc.

When Dutch mordant is first used, it has very little color, then slowly turns green. The longer the solution is used, the darker it will get. The color alone makes it easy to distinguish Dutch mordant from the zinc solutions. Zinc will turn blue when used on copper.

Dutch mordant can be strengthened by the addition of hydrochloric acid without adding potassium chlorate to the solution.

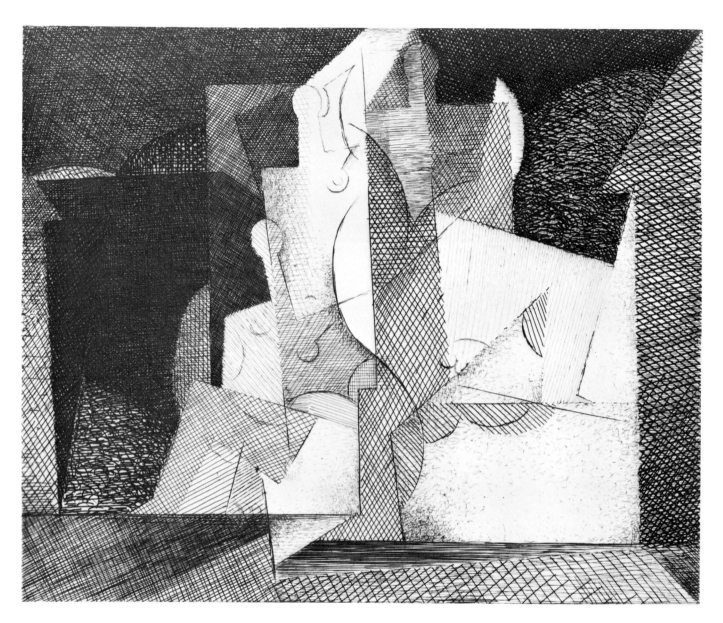

VI,51 LOUIS MARCOUSSIS, plate from *Planche de Salut*, 1931. Etching.
The Museum of Modern Art, New York

When the mordant becomes too dark for the fine details to be observed easily, it should be discarded and a new batch mixed.

ETCHING THE AQUATINT

The most difficult etching technique to control is the aquatint. As etching conditions are never the same, test plates are not much help. You can make a small test plate to get a vague notion about the time pattern in relation to tonal values, but you should rely only on testing, and hope for the best.

The increase of tones in relation to length of time in acid generally follows a geometric progression: 1:2, 4:8, 16:32, and so on.

VI,52 *Observation of plate in acid*

Visual Control

The plate in the acid should be observed closely at an angle with the source of light opposite the observer (Fig. VI, 52). As the acid bites tiny crevices into the plate, the shadows in these will show up as a tone. After some experience it is possible to estimate the contrast between the tone and the unbitten areas of the plate in relation to what it will give in printing.

In the first stages of the bite, the contrasts between the light and medium grays are clearly visible, but as we progress toward the darker values the visual contrast lessens. From then on, we have to rely on time estimate plus tactile testing with the needle. It is

a mistake to think that the longer the plate is in the acid, the darker it will get. There is a point when the plate reaches its maximum darkness, after which the underbiting action of the acid will begin to destroy the granular texture and the plate will start to lighten.

An overbitten aquatint generally gives a mottled dirty gray area comparable to the crevé of the regular line etching.

The above-mentioned problems make it clear that to bite an aquatint on zinc is a process even harder to control than one on copper, because the bubbles make visual control difficult and because nitric is generally less controllable than Dutch mordant. In addition, it should be obvious why we use a transparent stop-out varnish for aquatint. An opaque varnish like asphaltum would make visual observation between the bitten and stopped-out areas impossible.

Spit Bite

There are conditions, like the etching of very small areas or fine details, when the application of acid by brush is preferable to the submersion of the plate. The border of the area to be etched can be defined by applying saliva with a brush; this will keep the acid from spreading. This procedure is generally called a "spit bite."

Drawing with Acid on Aquatint

It is also possible to create a free calligraphic design on aquatint by painting directly with acid on the ground. For this type of work one should use an unusually strong acid solution—at least 4 to 1, instead of the 9 to 1 ordinarily used. There is no danger of overbiting because the quantity of acid applied this way is so limited that it neutralizes itself rapidly on the metal. With this method it is impossible to control tonalities.

At times a graduated tone over a large area may be desired. This can be achieved by etching the whole area to the darkest value desired, then working out the modulations by scraping and burnishing.

Creeping Bite

Another method is a graduated etching generally called a "creeping bite." The acid tray is placed in a tilted position (Fig. VI, 53). The plate is placed in the acid with the

VI,53 *Creeping bite*

section to be the darkest covered first with acid. Then the plate is slowly worked deeper into the acid, which should be kept in constant wavy motion so that the hard lines between the graduations may be avoided.

LIFT-GROUND ETCHING (OR SUGAR BITE)

Lift ground is in a sense no more than working with aquatint—but in the reverse of the ordinary procedure. In aquatint the negative areas are stopped-out, while in lift ground we can etch the positive image of a brush stroke or a pen line into the plate (Fig. VI, 54).

The main value of lift ground is that it enables the artist to fix an image conceived in free calligraphic character. When one has to paint the stop-out varnish around a line, as it is done in aquatint, it is nearly impossible to do so without a complete loss of the immediacy and vitality of that line. In hard-ground etching the lines are even, threaded like a wire and limited by the rigidity of the etching tools; wide strokes can be achieved only by multiple grooves. In many respects the effect of a lift-ground etching is quite similar to that of a lithograph, except that the range of possibilities is wider and the quality of the print richer.

I have practically never used lift ground in itself on a plate, but I have found it very stimulating sometimes to be able to fix an idea in its freshness on the plate and then develop it further with line etching and engraving (Fig. VI, 56).

The lift ground is a water-soluble substance which protects the aquatint from the

ground or stop-out varnish, and which then by dissolving in water exposes the metal to the acid in a controlled area.

Lift-Ground Formulas

Maxime Lalanne in his book *A Treatise on Etching* mentions that one can draw with ordinary ink on a metal plate, then cover it with a ground. Once the plate is submerged in acid, the ground lifts over the drawn area; thus the drawing is etched. Much more reliable formulas have been developed for this procedure. An excellent result can be obtained with 50 per cent tempera or poster paint and 50 per cent gum arabic. Another excellent formula generally used in Studio Seventeen is 50 per cent saturated sugar dissolved in 50 per cent India ink. I have had good results even with ordinary poster paint.

There are two basic procedures that one can follow in making a lift ground. The first is by putting an aquatint over the plate and then starting to draw with the lift ground.

The second is to make the lift ground first and the aquatint only after the lift ground is washed off the plate.

Before I go further into the merits of the respective procedures, I should like to go through the basic procedure step by step in order to give the reader a full understanding of the problems involved.

How to Use the Lift Ground

The first step is preparing the plate—either by laying the aquatint in the manner described in the section on this subject or by just cleaning it thoroughly in order to make sure the plate is free of grease and will offer adhesion to the lift ground. Some printmakers like to rinse the plate down with a light sugar solution in order to give better adhesive qualities to it—or the plate can be submerged in acid for a few seconds to give a slight grain to the surface, thus giving a firmer basis for the lift ground.

After the drawing is finished, the lift ground has to dry. You can hasten the drying process with a slight warming of the plate. Never use excessive heating because it can affect the aquatint and also blister the lift ground. When the drawing is dry, the plate is covered with a very thin coat of an acid-resistant. For this liquid hard ground, stop-out varnish or asphaltum varnish may be used. One of the most important things to remember is that in order to succeed, it is imperative to use the lift ground thick and the acid-resistant ground very thin. This ground should be put on the plate with a wide soft brush as rapidly as possible in order not to subject the lift ground to excessive friction that might loosen it.

VI,54 JAMES WHISTLER (1834–1903), *Nocturne, Danse Russe*. Etching.
The Metropolitan Museum of Art. Harris Brisbane Dick Fund

After the plate is covered with the acid-resistant, it has to dry thoroughly. Once it is dry, the plate can be submerged in a pan of lukewarm water. If the process was correctly done, the lift ground will swell up slightly, becoming porous and thus allowing the water to work in, eventually lifting completely. In order to speed this process, one can rub the lift ground gently while it is in water with a brush or cotton. Once the surface is broken, the rest comes off without any trouble.

If aquatint is under the lift ground, avoid excessive rubbing because you may injure it. In preparing an aquatint for lift ground, I found that there are two important rules:

1. The aquatint should be an extremely fine and dense one (Fig. VI, 44).
2. It has to be fused thoroughly to the plate. Otherwise, it will come off, because it is exposed to a great deal of wear and tear.

Lift Ground Without Aquatint

If the lift ground was applied directly on the plate, then the aquatint is put on after the lift ground is washed off. I personally have found this method less reliable than the other, because a great deal of aquatint goes on the acid-resistant; then, when the plate is heated in order to fuse the aquatint, the ground can be weakened to a point where excessive foul bite may result. I know that theoretically this does not make sense, the rosin itself being an acid-resistant, but in practice it has happened to me several times. Thus, although I am unable to give a scientific reason for it, through painful experience I know it exists. In addition, if the drawing has some extremely fine, close detail, the spreading of the ground in the heated state may close it in.

This problem is eliminated, however, if instead of the conventional rosin Aquatint one substitutes plastic sprays. With the plastic spray no heating is necessary, only be sure that the exposed metal is completely clean. If you have any doubts, wash the plate with ammonia, rinse it well, dry it, then apply the spray.

Why Aquatint Is Necessary with Lift Ground

Anticipating the question in some of my readers' minds, the aquatint is necessary on the lift ground to create a toothy surface under the wide brush strokes in order to hold the ink. The lift ground etched without the aquatint would produce mainly very uneven grays, unless the whole drawing was done exclusively in fine pen line.

The etching procedure follows the same rules as those described in etching an aquatint. It is possible also—if the acid-resistant used is really hard, like stop-out, for instance

—to put a soft ground over a lifted area and, instead of aquatint, press a texture into it. Then etch it in the same way as you would a soft ground.

Some printmakers, instead of washing the lift ground off in water, let this happen in the acid bath. I think this is a bad practice because the whole drawing does not lift immediately, thus causing an uneven bite; then the loose lift ground soils the acid to the extent that it has to be discarded.

RELIEF ETCHING

When large areas of the plate are etched out, leaving the design standing high, to be surface printed, it is generally called "relief etching."

The effect of the relief-etched plate is comparable to some extent to the criblés made in the fifteenth century. Hercules Seghers, the first truly experimental printmaker, used relief etching at times but in a sense different from that in which we use it today. The first printmaker who used relief etching extensively was William Blake, the great English poet and printmaker of the nineteenth century. He even devised a very ingenious way of transferring handwritten illustrated poems on metal for relief printing. The transferring method was lost, but after considerable experimentation Hayter found a method that must be quite similar to the one used by Blake. In Studio Seventeen, the English poet Ruthven Todd etched several of his poems illustrated by Miró with this process.

Transfer Method for Relief Etching

The writing is done on a strong paper coated with a mixture of gum arabic and soap, with asphaltum and rosin diluted in benzine. The paper is placed on a well heated clean plate, and passed through the press. After this the paper is soaked, and then peeled off, leaving the acid-resistant on the metal. Imperfections can be retouched with a fine brush.

One of the most delicate parts of this procedure is to find the right consistency and thickness of asphaltum varnish. If the varnish is too thin, it does not transfer well enough. If it is too thick, it will have a tendency to blotch when heated. This can be controlled only after considerable trial and error.

Varnishes for Relief Etching

I experimented with using the liquid hard ground (formula, page 89) and found it superior to straight asphaltum varnish because of its greater adhesion; it has less of a tendency to flake off in a precipitated biting process.

VI,55 GABOR PETERDI, *Arctic Birds*, 1965.
Mixed media color, relief etching, engraving, movable plates

VI,56 GABOR PETERDI, *Swamp III*, 1954. Lift-ground aquatint, engraving, gouged whites, two colors

VI,57 MICHAEL MAZUR, *Confrontation Across Two Shadows*, 1968. Etching, cut-out plate. Courtesy of Association of American Artists, Inc.

Asphaltum varnish is the most generally used acid-resistant for relief etching, but I have found that unless the plate is meticulously clean before it is applied, and unless the varnish is thoroughly dried, it will give trouble because of a tendency to blister as the metal heats up in the acid. A small proportion—about 25 per cent—of beeswax added to the asphaltum makes it more reliable. However, as I mentioned before, the liquid hard ground, which is basically nothing but asphaltum and beeswax plus rosin, is really the most workable and dependable.

One of the great problems in relief etching, unless one wants to etch a plate for eight to ten hours, is that one has to use an unusually strong nitric solution that varies between 2-to-1 to 4-to-1 for copper and 4-to-1 to 6-to-1 for zinc. If the relief has to be fairly high (about half the thickness of a 16-gauge plate), one has to take into consideration that by the time this depth is reached the thickness of the fine line is going to be reduced because of the side action of the acid. Therefore, on making a fine drawing with pen, one has to increase the thickness of the lines as much as one-third.

Here I should like to mention that this technique gives a unique opportunity to make original plates that can be printed on commercial presses. Actually a relief etching is nothing but a handmade original line cut that can be mounted type high for printing in the same manner as a plate made by a photoengraver. I experimented with this and found that by using soft-ground textures or coarse aquatints, even tonal effects can be successfully incorporated. Unfortunately, large commercial publishers don't encourage this idea much because of union restrictions.

Here are some useful acid formulas:

SOFT STEEL

nitric acid	10 OZ.
hydrochloric acid	1 OZ.
alcohol (methylated) (70%)	5 OZ.
water	35 OZ.

ALUMINUM

sulphuric acid	1 OZ.
potassium dichlorate	1 OZ.
water	10 OZ.
hydrochloric acid	1½ OZ.
liquid soap	2 drops

VI,58 GABOR PETERDI, *Dark Visit*, 1948. Relief etching on zinc plate.
The Brooklyn Museum Collection

VI,59 William Blake. From the *Songs of Innocence*. Relief etching.
The Metropolitan Museum of Art. Rogers Fund

STAINLESS STEEL

iron trichlorate (crystals) 4 OZ.

grain alcohol (70%) 1 OZ.

Keep at 80°F. Should be kept in glass stoppered jar.

Cover biting, as alcohol evaporates.

Water can be used with ferric crystals, but acts slower.

THE ROUTER

At the present there is a great deal of preoccupation with the sculptured aspect of the intaglio print. To get the desired depth often the relief has to be so deep that it takes hours of etching to achieve it. Besides the time involved, this can present many problems. If one removes large quantities of metal with strong acid, the plate heats up. Often the plate becomes so hot that the protective ground blisters. The resulting foul bites might ruin the artwork. I have seen plates heat up to a point where even the baked backing started to flake off. Often this problem can be resolved with the use of a router.

The router is a portable small electric motor activating rotary cutting bits at very high rpm. The router can be used two ways. If the design consists of sharply defined bold shapes, you can cut it out directly. If the design is intricate and you want soft, irregular edges, then first etch it out to approximately one third the desired depth, then finish it with a router. Very bold linear designs can be also drawn with this tool.

Routers are available in many sizes and shapes. I recommend the following while selecting one:

1. Buy a light but well-built tool. Get enough power. Mine is 1¼ hp., Stanley.
2. The cutting bit should be easy to see when the tool is in operation. This is critical, as without good visibility you cannot do precise work.
3. It should have a built-in light to illuminate the cutting area.
4. To work on metal you need carbide-tipped, specially hardened bits.
5. *Important safety precaution:* Never operate a router without safety goggles. Metal shavings propelled at high speed can injure your eyes.
6. Some routers have an attachment for collecting waste. This is a practical feature, as metal shavings can fly all over.

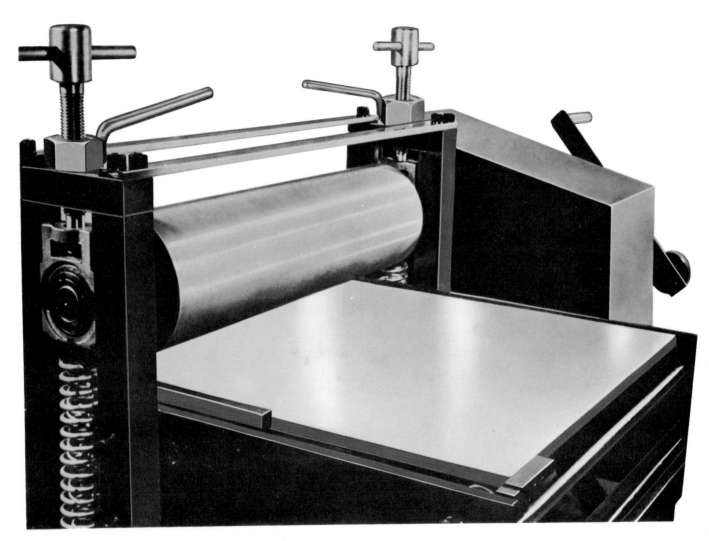

VII,1 *Charles Brand etching press*

PRINTING EQUIPMENT AND TOOLS

THE ETCHING PRESS

GREAT EMPHASIS should be placed on the importance of careful and methodical printing. It is a waste of effort to make a good plate and print it carelessly to produce a bad print. After all, we must remember that the print itself is the end product. Strangely enough, in my experience as a teacher, I have found that the majority of students sustain interest and excitement only in making the plate but consider printing itself merely as a necessary evil. The beginner considers printing as unpleasant manual labor—a mere technical procedure—that can be done by anyone. I hope that by the time I finish this chapter it will be clear that printing is much more than that, that it can reflect personal conception and in-

dividual touch as a plate does, and that the printing sometimes can be a decisive factor in the successful realization of an idea.

The first and most important piece of equipment in the graphic workshop is the etching press. The press is a very simple machine, but if the structure or proportion of the basic parts is wrong it is worthless.

The press consists of a solid steel plate (the bed) driven between two rollers. A screw mechanism on both sides of the top roller adjusts the pressure. Presses are either directly driven by a star wheel on the top roller axle or geared to facilitate the turning. Gears are necessary only if the press bed is over twenty inches wide. (Fig. VII, 1).

The printing is done by placing the inked plate on the bed of the press face up. Dampened paper is placed carefully on the plate. The paper is covered with several layers of pure wool printing felts and the bed is driven through the rollers. The felts, being squeezed between the metal rollers and the plate, are pushed into the crevices of the plate, forcing the paper into contact with the ink and thus transferring the image.

Practically all of the small presses on the market have undersized rollers. My experience has shown that, regardless of the width of the bed, the press should have a roller with a diameter of no less than 4½″ to 5″ but preferably 6″ or 7″.

The bed should be solid steel ¾″ to 1″ in thicknes.

The bottom roller, or drum, should be from 12″ to 16″ in diameter and should be made of 1″ steel with bushings inside.

If the press uses discs instead of a bottom roller, the axis of the discs should be around 1½″ thick steel and the heavy discs should not be placed farther apart than 4″ to 5″.

Selection of the Etching Press

In selecting or constructing a press for personal use, you should keep in mind that in all probability it will last a lifetime. Therefore it is foolish to compromise on something which might not be satisfactory.

The dimensions of the press chosen are very important. A large press prints better than a small press and will provide a larger printing area. When estimating the width of the rollers, it is best not to plan on printing from end to end (although it is possible to do so on a good press). It is wise to allow a 2″ margin on either end of the roller beyond the maximum width planned for the print. This will allow ample margin for the paper.

The press must be level when it is set up.

Since this book was first published about eleven years ago, the situation concerning etching presses has improved considerably. Before, you either had the luck to find a good old press or had to settle for a rather inadequate new one. Today there are several presses manufactured both in the United States and abroad not only equal to the old presses but in many features superior to them. My new press, manufactured by Charles Brand in New York, is the best I have printed on. It is solid and precisely manufactured, with self-aligning ball bearings. It is motorized, and equipped with micro-dial pressure gauges, features that have drastically changed my printing methods. Later in this book I will discuss the problems of pressure setting, a rather tedious and delicate procedure. Pressure gauges eliminate this. In my color prints I often use many superimposed plates, so I have to print heavy embossments of various depths. With this type of printing, the pressure has to be readjusted often. Without gauges this would represent a constant problem and a great deal of wasted time. Another custom-built feature on my press which I find often useful is a calibrated sliding steel parallel ruler installed on the press bed. This I use for lining up, or registering color prints.

Besides Brand, Rembrandt and Sturgis have good presses. The Dickerson press is quite cheap, and adequate if you don't work with a heavy embossment, which would strain this press.

There is an excellent import from Europe, the Neckar press. It is well designed and solid. The large ones are motorized and their price, because of shipping costs, are about par with those of the American products. The Neckar is made in Germany and distributed by Claude Boulanger, Paris.

Motorizing the Press

At present I own a motorized Brand press, but the following information may be helpful to any artist who wishes to motorize an old press.

Etching presses are normally hand operated. It does not take too much physical strength to pull a print on a small press. On a larger press, however (twenty inches or wider), unless the press is properly geared, it takes considerable physical exertion to print a large plate. With the old star wheel presses, ungeared, directly driven, often the men had to help the women in the workshop because they lacked sufficient strength or weight to pull a print through.

I worked my 24″ Kelton press for twelve years by hand, printing enormous plates— some 24″ by 36″—in large editions, but I have to admit that it took all my 190 pounds to

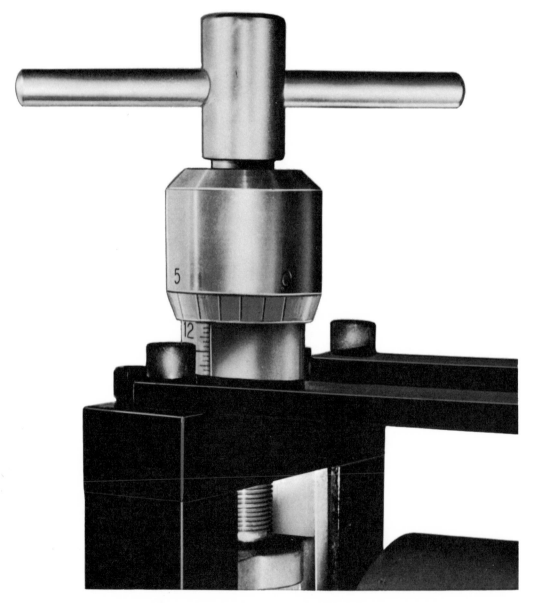

VII,2 *Charles Brand micro-dial indicator gauges*

do it, and after a day of finishing thirty or forty prints my back wasn't exactly in good shape.

Furthermore, printing large plates alone poses certain problems in handling the felts, not to mention the fact that regardless of how strong the printmaker is it is physically impossible to run through an enormous plate with a completely steady, unbroken motion. In a plate where large areas are white and a completely even tone is desirable, the uneven rolling generally causes very unpleasant streaks. Therefore I decided to look into the possibility of motorizing my press. I consulted a machinist and found out that it was fairly simple and not prohibitively expensive, especially as my press was already geared. Only the large flywheel had to be replaced by a large gear connected to the motor.

I give here the specifications of the gearing and the motor. My press bed is 24″ wide and 48″ long. The top roller is 7½″ in diameter and its axis is 1½″. There is a 15½″ gear on the main axis engaged to a 6″ gear that has its own axis, with a 13½″ gear on the other end. This larger gear in order is engaged to a 3¾″ gear on the driving axis.

The flywheel on the end of the driving axis is 22¾″ in diameter and is connected with a bicycle chain to the reduction gear box that is bolted to the floor. The reduction gear box is connected to a one-horsepower General Electric motor with reversible cycle, in order to operate the press bed back and forth. The specifications of the reduction gear are: Hp 109, ratio 1367, size 26 lbs., rpm 1800. Its manufacturer is Eberhard, Denver, Colorado.

The result is excellent. The quality of my printing improved on the large plates because of the steady rolling. I can keep my felts tight so that there is no damage from wrinkling, and I can print easily 50 per cent more without excessive strain.

Setting the Pressure

Adjusting the pressure on the press is a delicate operation. Even the best press will not print well with incorrectly adjusted pressure.

In setting up a press the relation of the bottom roller to the bed is first checked. The bottom roller adjustment is independent from that of the top roller. The under roller is adjusted by packing thin metal strips under the axle bushings. When the press is not under printing pressure, it should not rest on the drum. The distance should be just sufficient for

a strip of newsprint to be pulled between the drum and the bed. The evenness of this space may be checked by rolling ink in the drum and by driving the bed through the rollers with a piece of paper between the drum and the bed. The resulting print will indicate unevenness in the pressure.

TESTING

On the top rollers one should start with very light pressure, inserting the felts and turning the setting screws until a slight resistance is felt. A plate (preferably one which has a great variety of engraving from edge to edge) is then covered with blotting paper and the felts and run through the press. The indentation of the edges of the plate and the embossment of the lines should be examined, and if the pressure is correct every detail from the finest to the boldest will be clearly embossed on the blotting paper.

If the imprint is good all around the plate but weak in the center, it may indicate that the roller is worn or that it gives under pressure. In the first case, it will be well to refinish the roller in a machine shop, but if this is not feasible packing may be used on the felts or under the plate to compensate for the weak place in the roller.

PACKING A PLATE

Packing generally consists of a few strips of newsprint. Pressure is so sensitive that one strip of newsprint may make the difference between a good or a bad print. Weakness in the center of a print may also mean that the distance between the bed and the bottom roller is too great.

The object is to find the minimum pressure that will print everything correctly. Too much pressure can be as bad as insufficient pressure, because it will distort the values on the plate, not to mention injuring more delicate surfaces like aquatint or dry point. Too much pressure may also tear the paper, causing it to stick in the grooves, or cut it at the edges, blotch heavy lines, muddy the tones, and produce an unpleasant shiny surface on the print.

If the pressure is judged by the blotter test to be correct, final adjustments are made in the actual printing. Since setting the pressure is a lengthy, delicate operation, once the right pressure is established it is better to try to make adjustments to particular printing problems by using a variety of felts or by packing.

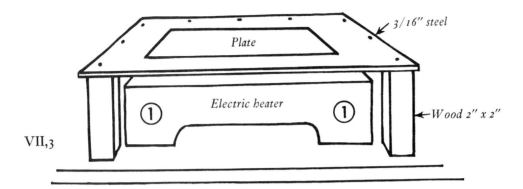

3/16" steel

Plate

Electric heater

① ①

Wood 2" x 2"

VII,3

THE HOT PLATE

A hot plate is needed to put on grounds, to fuse aquatints, to facilitate the inking and wiping of the plate. Heat makes the printing ink loose so that it works into the lines more easily and comes off the surface with less effort.

For the heating unit, a two-burner electric stove is excellent; gas heat may be used also.

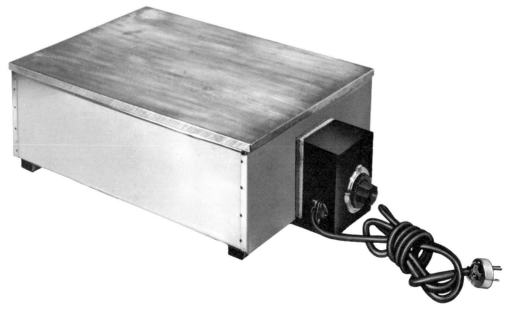

VII,4 *Charles Brand electric thermostat-controlled hot plate*

The hot plate itself is a metal table which straddles the heating unit. The bed of the table should be made from a sheet of iron one-fourth to three-eighths of an inch thick. The legs of the table should be long enough so that the bed will clear the heating unit by at least one half inch. A blacksmith can make a hot plate quite cheaply, or any metalworking shop can make it. With an electric drill one can make one's own. Wooden legs are perfectly acceptable. If screws are used on the top, they must be countersunk or they may damage the plate. The hot plate should be large enough to accommodate the largest plate that is to be printed (Fig. VII, 3).

With luck you might have an opportunity to pick up at secondhand a large electric hot plate of the kind generally used at hamburger stands. These plates are excellent for our purpose, but very costly if purchased new.

In recent years the popularity of printmaking has put enough pressure on manufacturers to produce good, efficient hot plates. At the present, several makes of thermostatically controlled heaters are available. The thermostat is very crucial because it makes it possible to maintain constant temperature, the essential condition for good aquatint and ground laying.

WIPING MATERIALS

The best material with which to wipe the excess ink from the plate is tarlatan, usually obtainable from millinery supply houses or the dry-goods section of a department store. If tarlatan is unavailable, starched cheesecloth may be used.

To wipe the plate properly, a loosely woven material should be used—sheer enough to pick up the ink but not too soft. Unstarched cheesecloth overwipes the plate.

Tarlatan is prepared for wiping by rubbing a yard of material until it loses its stiffness, then folding and compressing it into a tight bundle. The wiping surface of this bundle should be comparatively flat and free of any wrinkles or faults (Fig. VII, 5).

Tightly woven linen or silk is usable only to finish an extra-clean wiping. These materials, however, have to be wrapped around a compressed hard cotton or cheesecloth ball; otherwise they overwipe the plate. Cotton or linen is used to wipe the bevels of the plate clean.

Some printmakers use soft papers like paper towels or Kleenex to finish the wiping. I am against this, however, because the result is generally a hard, insensitive tone much inferior in quality to hand wiping.

THE INKING ROLLER AND DAUBER

Rollers are the best implements for distributing ink over the surface of the plate. Any paint roller will work if it is covered with a soft material that takes ink well. A Kemtone 3″ roller is excellent.

If the material is worn down or becomes hard, the covering may be removed and replaced with a piece of old felt.

The dauber is used to work the ink into the lines. It also can be made from strips of old

VII,5 *Rag wiping with tarlatan*

felt. A strip of felt 5″ or 6″ wide is rolled tightly and tied securely with a string or piece of adhesive. The end of the roll is then trimmed clean with a razor blade. It has to be trimmed further from time to time as it becomes hard with old age.

FELTS

The felts used for intaglio printing should be soft, closely woven or pressed, and of pure wool. It is better to use a greater number of thin felts than a few heavy ones. The best combination seems to be three medium-thick felts, about one-eighth of an inch, all of the same quality and thickness.

VII,6 *Handling of felts and paper*

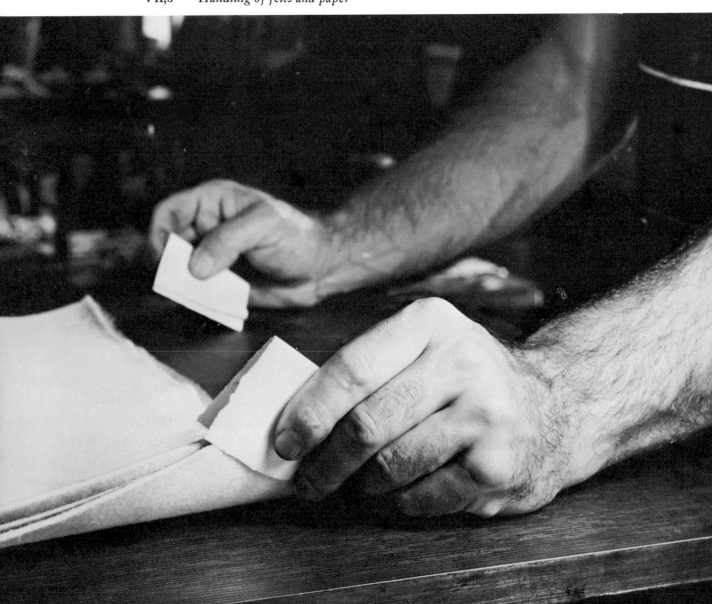

Some printmakers use a fine wool over the paper and a heavier, coarser felt over that, but if a greater number of felts are used they can be rotated as the bottom one gets damp from the paper.

Woven wool is better than pressed because it retains its elasticity longer, wears better, and regains its flatness after washing. It is quite expensive as compared with pressed wool, which can be had very reasonably at remnant houses. Coarse wool should never be used over the paper because it produces uneven and mottled tones in printing.

It is advisable to buy at least two sets of felts in order to have a set for use while the others are being washed. When a large edition is printed, the felts have to be changed quite often because they become damp. Some printmakers like to print with newsprint between the paper and the felt to absorb some of the dampness. Some printmakers even use blotting paper for this purpose, but I find this a bad habit because the blotting paper is stiffer than a fine felt and therefore reduces the tonal richness of the plate.

How to Wash Felts

Paper or metal clips can be used to handle felts to avoid soiling them with dirty hands (Fig. VII, 6). Felts must be washed even if they appear to be clean if they have absorbed too much sizing from the printing paper and have become very stiff. A large washtub or a bathtub can be used for washing felts. The water should be hot but not boiling. If the felts are very dirty, a little ammonia may be added to the water. The felts should soak for a few hours and then be washed thoroughly and squeezed (but not wrung). They should be rinsed well. A felt must never be wrung or twisted; instead, the water should be squeezed out either with a hand rubber roller or with the palm of the hand. Nor should they be hung out to dry, since they may lose their shape that way. It is best to lay them flat on several layers of newsprint that should be changed when it becomes too wet.

The felt must be placed evenly and flat under the roller, since a carelessly placed felt may wrinkle and the wrinkle may cut under the pressure of printing. Dampness may also cause wrinkling.

To keep felts straight while printing, weights can be attached to the edge toward which the roller will be moving in the printing, or elastic tape can be attached to the felts at one end and to the press frame at the other end.

The size of the felts should have some relationship to the size of the plates printed. Small plates printed over a large felt will eventually cause a pocket to wear in the felt.

Felts should always be taken out of the press when not in use.

PAPERS

The best papers for intaglio printing are handmade pure rag papers. They are made of long fibers with very little sizing. Today the cost of such paper is almost prohibitive, and very few printmakers can afford to use it. Papers made in the eighteenth and nineteenth centuries are excellent, but difficult to find and limited in size.

For a basic supply, we must depend on machine-made pure rag papers. With the discontinuation of Ruysdael, there is practically no good domestic paper available for printing. Of the foreign papers, Arches, Rives, German Copperplate, Weimar, and Fabriano are all good. Umbria, Tovil, and Kelmscott are fine handmade papers, but expensive. In recent years, in response to demand, Nelson and Whitehead has sold a specially manufactured domestic rag paper. This is a heavy white paper that comes in extra-large sheets. My experience with it is most favorable.

Selection of Papers

Koshi and mulberry papers are usable for some prints, but they will not stand too much soaking. In some instances, the Japanese rice papers have to be sized before they can be used for intaglio prints. Damp blotters are sufficient to wet them.

Whatman cold pressed water-color is good, but the sizing must be soaked out first. Hot pressed water-color papers have too hard a finish to print on satisfactorily.

In selecting paper, one should remember that the character of the print is influenced by the weight, texture, and color of the paper used.

A heavy, soft paper will produce rich prints especially on tonal areas. A light paper is good for delicate plates, especially if a clean wipe is desired. Deeply etched or heavily cut plates should be printed on heavy soft paper, because they absorb better, have less tendency to blotch, and hold the embossment. A thin paper takes a richer print if it is backed with a soft paper. For a list of some popular printing papers, see p. 373.

Tinting the Paper

If the paper is too white, it can be tinted by dipping it in lukewarm water which has absorbed the tint from a few pinches of tea or tobacco. Quantity should be determined by experimentation.

Pulp papers print well but they are not permanent; they discolor and disintegrate with time.

Dampening of Paper

The paper for intaglio printing should be dampened thoroughly to soften the fibers, but if there is too much water in the paper the roller pressure will force the excess water to the surface and produce a spotty or blotched print. A properly dampened paper will not show any water on the surface. If shiny spots are detected, they should be brushed down well or blotted. I have found that the best procedure is to prepare paper the day before printing. If the paper to be printed is soaked and stacked alternately with dry sheets between two heavy pieces of glass, by the next day the dry papers will have absorbed the excess water and the whole lot will be uniformly damp. Sometimes an oilcloth or piece of plastic wrapped around the outside of the paper stack will help to achieve uniform dampness, especially if the weather is dry and warm. It is easy to construct a box with a tight-fitting lid lined with linoleum that will keep the papers damp longer, especially around the edges, than the glass plates will.

The paper must be checked before printing to see that the edges have not dried out, since this will cause uneven stress when the paper is run through the press and may produce creases. In this case, just rewet the edges before printing.

The papers should not be kept under glass for more than a few days because they may become moldy.

PRINTING INKS

It is difficult to buy in the United States commercially prepared etching ink that is satisfactory. Generally it does not contain the correct oil and it is overground. Commercial ink costs considerably more than the homemade, and the grinding and preparation of ink is so simple that no printmaker should hesitate to make his own.

The basic equipment necessary consists of a glass muller with a grinding surface 2½″ to 3″ in diameter, a heavy glass plate or marble slab, and two wide printers' knives made of stiff tempered steel. To roughen the surface of the glass or marble, carborundum powder and water can be used.

The best printing ink, according to my experience, is made from a combination of Frankfort and vine black ground in heavy plate oil. The proportion is: 2 parts of Frankfort black to 1 part of vine black. If Frankfort black is not available, it can be replaced by ivory black or lampblack. The vine black is interchangeable with lake black. In this mixture, the Frankfort, ivory, or lampblack is the lighter pigment with greater oil absorption

properties. The vine and lake black add body and color to the pigment. When the amount of vine black is reduced, the ink becomes gray. Too much vine or lake black will produce a sticky ink, hard to wipe.

If a very intense black is desired, a small quantity of Thalo Blue may be added to the mixture. Some printmakers like to add Venetian red or burnt sienna to make a warm black.

It is well to remember that the ink color will become warmer in time, when the oil film envelops the pigment molecules. After the dry pigments are thoroughly mixed on the glass slab with knives, the pigments are ground in heavy plate oil (burned linseed oil). This is sometimes hard to obtain and must not be confused with printers' varnish, which is sticky and would make the ink difficult to wipe. If you live in an area where burned plate oil is unavailable, you can make it yourself. This is a simple process, but because of the fumes it is best to make it outdoors.

To this I would like to add that although I still like to grind my own printing inks, particularly the black, today there are fairly good commercial inks available. The Graphic Chemical and Ink Company of Chicago manufactures a line that both I and my students used with good results. There are also several French inks on the market; they are good but rather expensive. According to my experience most commercial inks, particularly the colors, tend to be sticky and hard to wipe. With these the adding of Easy-Wipe compound is advisable.

Making of Heavy Plate Oil

Fill a large metal drum or a pot about half full with old (but not rancid) raw linseed oil. From one-half to two-thirds of the bulk will be lost in the boiling process. The pot should not be too full because it might boil over and ignite; the lid should be available to smother any accidental fire. The oil is boiled until it becomes thick and very sticky. It is then ignited, the pot is removed from the fire, and the boiling oil stirred for a few minutes. The flames should subside as soon as the stirring is stopped, but if they do not the fire can be smothered with the lid. To determine whether the oil is of proper consistency, remove a little on a stick or knife and test its ability to pull out into strings. A good plate oil should pull out into strings a foot long. If the oil does not meet these requirements, put it back on the fire and boil and test it until it does. The oil can never be too thick; the best printing ink can be made by grinding it in oil so thick that it will not flow.

The heavy oil is added to the pigment in small quantities and worked in well with an ink spatula. This mixture should appear very dry and lumpy, because the oil will not show

until it is ground in. Each time the heavy oil is mixed in the dry pigment, a small quantity of light linseed oil can be added to it to make it easier to wipe.

Grinding the Ink

The printing ink never should be made too oily, because ink will keep much better if not too much oil is used. In a workshop where ink is used up rapidly, one can use a little more oil because it makes grinding easier and faster. The ink must be ground very methodically until it loses its granular texture and appears smooth and silky when spread out with the spatula. If the ink is insufficiently ground, spotty tones will result and some of the small, very fine lines won't print correctly.

The ink should be stored in tightly sealed jars. If the ink is to be kept for a long time, cover it with wax paper or even pour water over it to retard the formation of skin. When removing ink from the jar, smooth the surface of the ink down again; otherwise, skin will form on the exterior of gouges or digs, allowing the skin to become mixed in with the ink, a very annoying condition in printing.

INKING THE PLATES

Once everything is ready for printing, the plate is placed on the stove. Ink is rolled on the plate. The dauber is used to force the ink into the impressions with a rotary motion. This has to be done very thoroughly. If the ink is not properly worked into the plate, the resultant print will have uninked lines no matter how much ink is put on the surface of the plate (Fig. VII, 7).

At the first inking the spots missed will show up as shiny areas if the plate is examined carefully against light. On deeply etched or engraved plates it is possible to use a spatula to work the ink into the grooves. A generous helping of ink is used and the excess scraped off before wiping; one has to be extremely careful in doing this, as the slightest nick of the spatula edge might scratch the plate. This method never should be used on dry point or aquatint.

WIPING THE PLATES

Three tarlatan pads are used to wipe the plate. The first pad is saturated with ink. This is done more to ensure good inking than to wipe the plate. The second pad is a little cleaner,

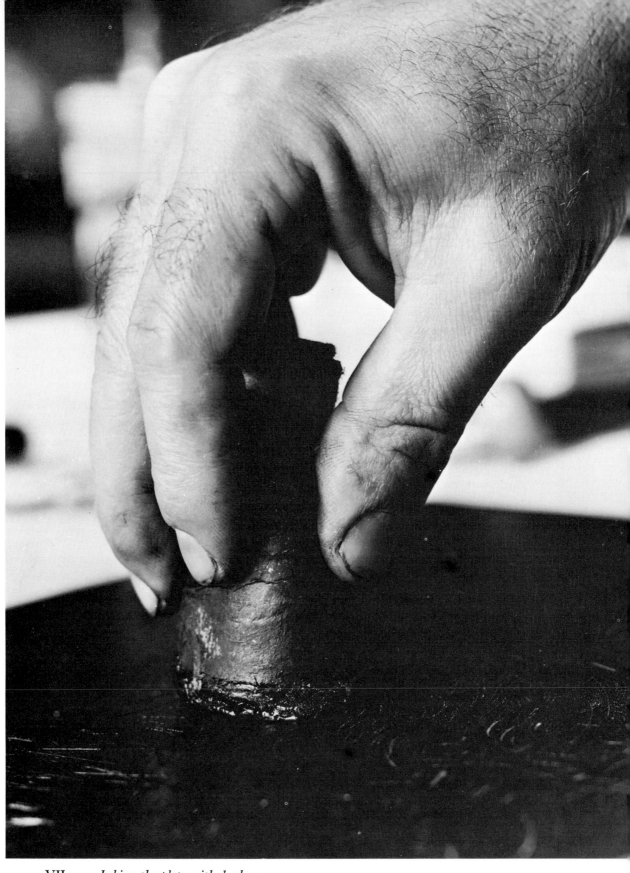

VII,7 *Inking the plate with dauber*

and this is used to wipe most of the ink from the plate. The third pad is used for the final clean wipe.

Rag Wipe

The pads are manipulated with a slow rotary motion from the center out. Then the plate is turned around and the pad is worked from the edges to the center. Most beginners have a tendency to overwipe the center and leave too much ink around the edges. Wiping should be done with very light pressure, because heavy pressure with an inky tarlatan would put ink back on the plate instead of removing it, and with a clean tarlatan would result in overwiping.

Before the final rag wipe, the plate is rubbed over lightly with a new tarlatan pad simply to break this in for future use. Completely new pads are not used for a final wiping, as the material is so stiff that it would leave a streaky tone. Regardless of how much tone is on the plate, the wiping should be uniform.

It is important to understand that wiping is never done to achieve an effect on the plate. Correct wiping should exploit to the maximum everything already on the plate—no more. Too much manipulation in wiping cannot be consistently controlled and will result in an uneven edition. The beauty of printmaking is to work within the limits of the medium. Decision on the final wiping depends a great deal on the style and technique used on the plate.

It is best to experiment with the printing when making trial proofs so that by the time the plate is finished, the best way of printing a final edition is determined.

Rag wiping always has a tendency to leave more of a halo around the lines than hand wiping would. Therefore, when a warm print is desired, it is best to give the plate a rag wipe. Line etchings and dry points are often printed by this method. Hand wiping should be used for line engravings to accentuate the crisp precision of the lines. Too great a halo left around the engraved line can defeat the basic purpose of the medium. On aquatint plates it is also advisable to use hand wiping to bring out luminous transparent tones. Too much surface ink makes aquatints look muddy.

How to Hand Wipe the Plate

Hand wiping is begun after the bulk of the ink has been removed with the tarlatan. The wiping is done with the lower meaty part of the palm; the motion must be light, the hand hardly touching the plate (Fig. VII, 8). You should begin the motion with your hand off the plate, and then swing across with the palm making only the slightest contact with

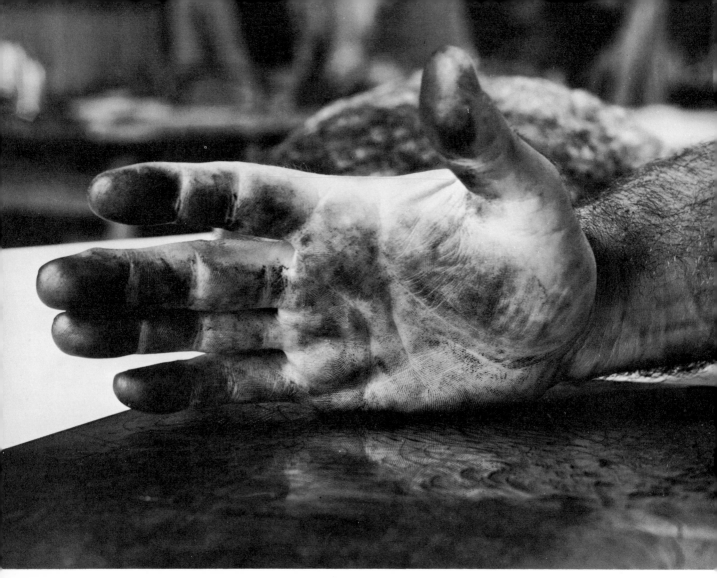

VII,8 *Hand wiping the plate*

the surface. If the motion is stopped on the plate, a mark will be left that will show in the print. The palm must be dry. Some printmakers like to rub a little whiting on their hands, but too much whiting produces an extremely light surface tone; if this is not desired, use it sparingly. I prefer to dry my hand with a cheesecloth.

Retroussage

In some instances when a light surface tone is to be combined with rich lines, it is desirable to use two wiping procedures. First, the plate is hand wiped. Then the lines are rubbed over lightly with a slightly inked tarlatan to pull some of the ink out of the lines. This method is called "retroussage."

Control of Tones

Some plates present special wiping problems, especially those with wide and shallow lines. A very stiff ink and a light hand wiping offer the only solution to this problem. Small light areas within deeply etched areas are difficult to wipe clean. After the plate is wiped in the usual way, these areas must again be wiped from the center of the light toward the texture (Fig. VII, 8). In deciding what type of wiping to use, one must consider whether the plate will be printed hot or cold. If a rich tone is desired in the print, as I have already mentioned, it should be printed warm. If the plate is large, however, the press is geared to a slow ratio, one end of the plate will be cold by the time it goes through the roller. This produces an uneven tone. In this case, compensation is made by leaving extra rich tones on the plate and printing it cold.

The variations of printing situations are endless, and the procedure for any two plates will never be the same. This is the reason why printing cannot be considered a purely technical procedure but, in a sense, just as much of a creative act as the making of the plate.

No matter how well a plate is printed, somehow I can always feel the difference between a proof pulled by the artist himself and a commercial printer's.

PRINTING

It is a good practice to check the following things before beginning to print:
1. The press should be ready, the felts inserted in printing position, and the bed of the press clear. In preparation for printing a large edition, it is well to mark the plate position in relation to the paper in order to keep a uniform margin.
2. The printing paper should be sufficiently damp.
3. The hot plate should be warm.
4. The printing ink should be prepared. Light linseed oil may be added if it is too stiff. Ink of a standard consistency will drip slowly from the end of a spatula. The consistency will vary somewhat, according to the particular character of the plate to be printed. An increase of oil in the ink will produce richer, warmer prints (a "halo" around the lines) and darker surface tones. The basic rule is to use a stiff ink if a clean wipe is desired and to increase oil for a rich surface tone. Naturally, there is a limit to both conditions. If ink is too dry, the plate will be very hard to ink and it will produce a spotty print. If the ink is too oily, it will smear instead of wiping properly and

it will print muddy tones and will have a tendency to blotch in the densely worked areas or deep lines. The subtle application of these principles can be learned only through experience.

Temperature also makes a great difference in the tonal qualities of the print. A warm plate will always print darker and richer than a cold plate. Oily ink on a warm plate will produce the darkest print, while stiff ink on a cold plate will yield the lightest print.

Too much ink should not be prepared on the slab because the leftover ink is generally wasted. If a sizable amount is left and if it is to be used the following day, it can be wrapped in wax paper.

It is also important to check before the ink is prepared to see that the glass plate is completely free of grime and dust, because any solid particles mixed into the printing ink may injure the plate surface.

The plate must be clean. Cleaning of the plate is a good habit even if the plate does not show any visible dirt. Special care must be taken to remove any metal dust from filing or scraping that may have remained in the lines. Metal particles mixed into the ink will play havoc with the plate. The price of a few minutes' cleaning may save hours of burnishing.

Double Run

If exceptionally dense tones and strong embossment are desired, a double run may be indicated, but unless the plate had deep cuts and ridges to grip the paper on the first run, a second run will result in a double image. Such prints have a blurred or out-of-focus appearance. Sometimes the direction in which a plate is printed makes a difference. This is true of plates having unusually deep engraved lines. If the rolling pressure runs parallel with these lines, the ink tends to be squeezed out and ugly blotches may spoil the print. The same lines might print perfectly if the plate is turned and printed in the other direction.

Again, the pressure also varies with different plates. An engraving generally needs more pressure than an etching, and, as I mentioned before, the pressure needed for engraving may ruin a dry point.

How to Dry Prints

The drying conditions for the finished prints should be prepared. If the prints are needed in a hurry, the best method is to stretch them with taped edges to a stiff board. They must be taped firmly all the way around, because one loose spot will create a crease on the print and that would necessitate rewetting the print and restretching it. The stretch method

should be used only when there is a great hurry and only with trial prints, as stretching has a tendency to pull out plate marks and flatten embossments.

On a regular edition, the use of blotting paper is much preferred. First, the prints are put between blotters without any weight on top of them. At the end of the day, when printing is finished, the prints are changed to a new set of dry blotters. By that time the excess water has been absorbed in the first set of blotters.

Humidity has a tendency to make the blotter buckle, and if a great number of prints are left in the damp blotters for a long time they may not dry flat.

If one has a sufficient quantity of blotters and wishes to speed up the drying process, changing to the third set after two days is advisable. By that time the ink is dry enough to place weight on top of the lot without running the risk of flattening out the lines. Care must be taken in handling blotters with wet prints between them, since any juggling may offset ink from the blotter to the print.

After three or four days a print is sufficiently dry to be handled, but thorough drying actually takes several weeks.

STORING THE PLATE

When the printing is finished, and if you are not going to use the plate the next day, it should be cleaned thoroughly. The ink has to be removed from the lines with either kerosene or turpentine. Work the plate over well with an old bristle brush or a not too stiff toothbrush. If ink is left to dry in the lines, depending on the quantity, it might give either a poor print the next time or it won't print at all. If that happens, you have to wash the plate with caustic soda and water. Completely dried ink can be loosened by pure caustic soda.

To preserve a metal plate for a long time, it has to be protected from corrosion by a coat of Vaseline, axle grease, or a thin layer of varnish. Zinc plates are particularly vulnerable to corrosion and are affected by impurities in the air. Be particularly careful not to leave any thumbprints, because sweat contains acid, and if given enough time it will etch into the plate, producing an excellent print.

PLASTER PRINT

It is possible to make a very good proof of an intaglio plate by plaster casting. Fine plaster of Paris will pick up the most delicate details and can be particularly attractive if the plate has deeply etched or engraved sections.

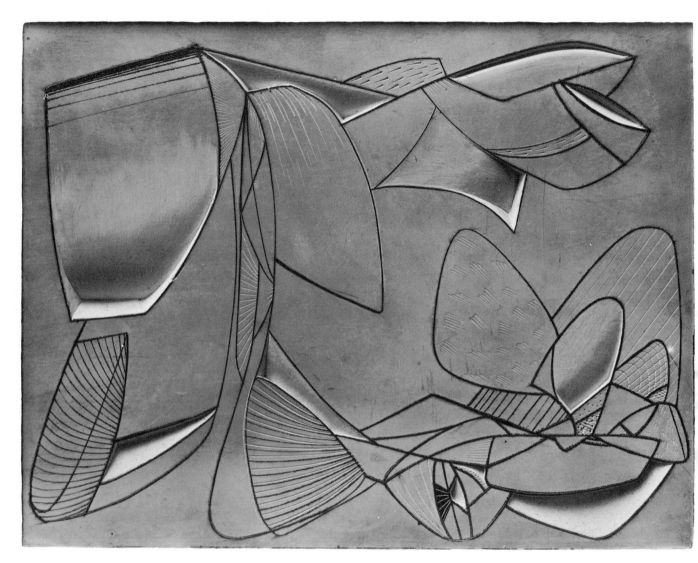

VII,9 JOHN FERREN, *Carved Plaster Print*, 1937

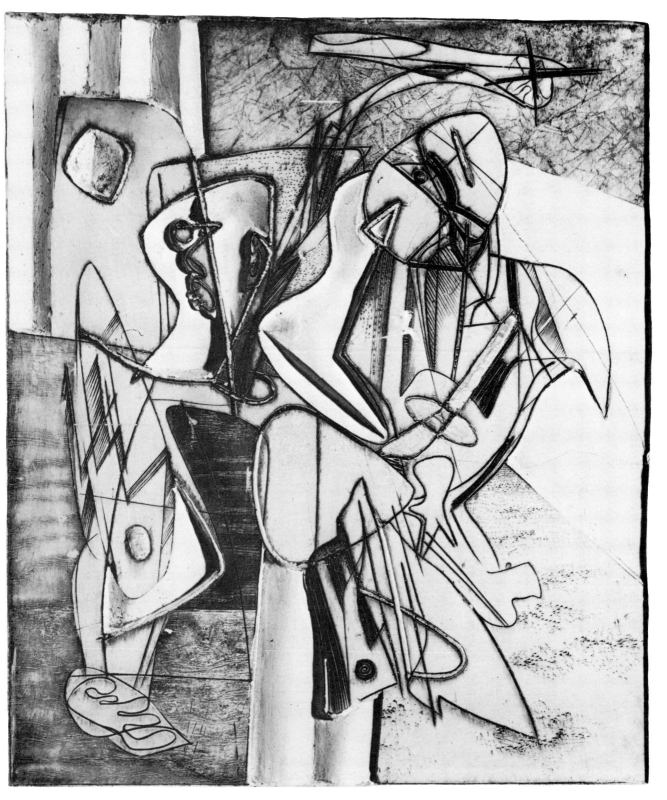

VII,10 STANLEY WILLIAM HAYTER, *Carved Plaster Print*, 1941.
Author's collection

If the plate is unusually strong in relief, even an uninked plaster proof can be exciting by virtue of the intricate interplay of shadow and light.

Most plaster casts are made with the plate inked approximately as it would be for a conventional print on paper, with a few allowances made for the particular properties of the plaster.

The plaster-casting method was developed by Studio Seventeen in the early thirties in Paris (Fig. VII, 10). I am not sure who originated the idea (many people worked at it during the same period), but at that time John Ferren made the most extensive experimentation with it and produced a whole series of plaster casts that he exhibited at the Pierre Matisse Galleries with great success. Ferren engraved plates especially for the casting, with the idea of further developing the plaster proof with carving and color (Fig. VII, 9).

In the beginning he experimented with tinting the plaster itself, sometimes using a variety of colors in successive layers. These strata of colors were to appear as the plaster was carved in depth. Because this method, however, proved to be hard to control, it was discarded for straight painting.

There were also a few experiments made during this period to combine the plaster cast with the mosaic idea by incorporating colored stones and glasses into the cast by placing them on the plate.

Plaster casts are made for two different reasons: (1) they can be used to test a plate if one is working in an area where there are no etching presses available, or (2) they may be considered as works of art on their own merit.

I personally consider that the mural quality of the cast can be used very handsomely in the modern architectural setting where an integration of the structure and the art work is desirable. Strangely enough, so far as I know, this possibility was not exploited until very recently.

To make a plaster cast is very simple, and few tools and equipment are needed.

Tools and Equipment

Plaster of Paris	1″ by 2″ or 1″ by 3″ stripping to make
Spatulas	a frame
Saw, hammer, nails	Some wire mesh or metal rods to stiffen
A good-sized pan to mix plaster	plaster cast and the usual equipment
	for inking and wiping a plate

The first step in making the preparations for casting is to construct from the stripping a frame, allowing from 2½″ to 3½″ margin around the plate. The nails that will hold

VII,11 OMAR RAYO, *Water, Please*, 1964. Embossed intaglio on paper.
Courtesy of the artist

the plaster in the stripping should be driven in the frame beforehand. It is a good idea to cover the nails with a light coat of shellac or plastic spray in order to prevent their rusting in the plaster. The frame is placed on the large glass plate.

The next step is to ink the plate. The inking is done in the same fashion as for a conventional print, except that one should use a great deal looser oil or ink to allow for the plaster's great absorption quality. Also, in wiping you should leave a little heavier surface tone on the plate than you normally do. A wipe that would give a heavy gray almost muddy print on paper is just about right for plaster.

Good oily film on the plate surface also makes the separation of the plate from the plaster easier.

After the plate is inked, it is placed in the frame under the glass plate with the ink face up, carefully centered. It is advisable to place some weights on the frame in order to make sure that it lies flat on the glass and won't move when the plaster is poured.

The next step is to cut the wire mesh or the metal rods to proper size so that after the first layer of plaster is poured, they can be pushed into it in order to give it greater strength.

Next prepare the plaster. It is important that the first batch be of sufficient quantity to cover the whole area within the frame with a ½″- to ¾″-thick layer. The consistency of the plaster should be thin enough to run fairly freely, in order to facilitate the spreading, but it should not be overwatery because it might not take the ink well; also, it will then have a tendency to seep out of the frame easily (Fig. VII, 12).

It is important to mix the plaster thoroughly to make sure that there are no lumps in it and that the air bubbles are worked out as well as possible. In pouring the plaster, it is best to start with one corner and then drive the plaster from that point all over the surface. This way one can get rid of the remaining air bubbles.

After the plaster has been distributed evenly with a spatula, one can wait a short time until it starts to thicken; then the metal supports can be placed in it.

After this is done, a second batch of plaster can be mixed—about the same quantity— and poured over the supports. After the plaster has set and cooled, the cast can be picked up carefully and turned over. If any plaster has seeped under the plate (this can happen if the plate is not completely flat), it should be carefully cleaned away with a sharp blade. Then, by placing either a fine blade or the corner of a spatula under the edge of the plate, it should be gently pried up. Normally, the plate will separate from the cast without much trouble. The plate never should be forced, however—especially if it has a deeply etched or engraved surface, as this might cause chips in some of the detail. In this case, it is a good idea to warm the plate slightly with an electric iron and then try gently, prying at different points, until it is loose.

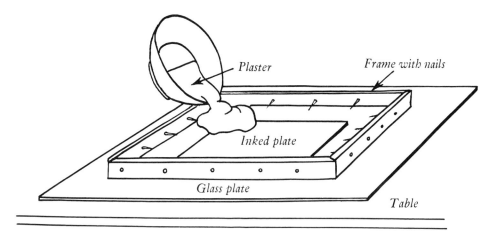

Plaster

Frame with nails

Inked plate

Glass plate

Table

VII,12

Once a plate is lifted, the stripping can be cleaned of some of the plaster that may have seeped under it, and the cast is left to dry thoroughly before any painting is done.

If, however, one intends to carve into the plaster, this is better done while the plaster is somewhat damp, as it is then less likely to chip.

For painting I have found tempera and casein colors the most suitable, although even water colors sometimes give handsome luminous colors on plaster.

If water-soluble paint has been used, the cast should be protected from dust and dirt because washing would affect the colors. Many artists cover the cast with a glass plate, but personally I am against this, as the glass has a tendency to hide the character of the plaster and makes it look like just another print. I have found that the perfect solution is to spray it with a good solid coat of Krylon, thus making it washable.

Further experimentation seems to indicate that large plaster prints are very hard to control. The most frequent problem I have had is that in certain areas, water has accumulated near the surface and rejected the printing ink. Neither extensive tests with various plasters nor various mixing methods would produce reliable controls. I even tried reheating the plate, but without success. With smaller plates, not larger than 12″ by 16″, this problem rarely arises.

PRINTING ON TEXTILE

Surface printing on textile has been done through the ages, and museums all over the world have in their collections handsome examples of Coptic textiles, medieval church

banners, and so on, printed from wood blocks. This type of printing was especially popular in the early periods when all papers were handmade and it was difficult or impossible to obtain large sheets.

It is not uncommon today to see draperies, table mats, lamp shades, and other house furnishings decorated by hobbyists with prints made with linoleum blocks.

Intaglio printing on textile, however, is much more rare and a more difficult procedure. There is nothing new about this, either. Hercules Seghers in his attempt to create print paintings experimented a great deal with printing on various textiles with uneven success, and I have seen some very handsome prints made of engravings done in Italy in the seventeenth century.

You can print on any material that is woven finely enough not to break up the details of the print, and that is made out of fibers with oil-absorption properties. This latter requirement eliminates most of the synthetic materials, like Nylon, for instance. I am sure most printmakers have had the opportunity to find out accidentally how well a plate is printed on a fine wool felt. It is not uncommon in art schools to see students run through a plate forgetting to place a paper on it—a rather costly experiment in view of the price of felts.

I have experimented a great deal with printing on various materials, mainly for fun and with the idea of being able to give my friends unusual Christmas presents.

When we first experimented in Studio Seventeen with printing on textiles, we began by using a damp backing on the material, with the assumption that this would give better impression, especially with fine cotton and silk. Though we got excellent impressions, we had a great deal of trouble with creasing, and the material generally absorbed a great deal of sizing from the backing paper, becoming quite stiff when dry. After some experimentation I found that the damp backing is not necessary, and by using a much oilier ink and a richer wipe I found that I could pull very good prints completely dry. The consistency of the ink should be oily enough to run off freely from the spatula when picked up. In addition, it is a good idea to mix a small amount of cobalt dryer in the ink, thus making it dry faster.

It is especially important, if you use a very sheer material, first, to be sure that the material is flat (if necessary, press it out), and, second, that it is backed with dry blank newsprint because otherwise the ink may go right through the material and print into the felt.

It is also advisable, especially if one prints a large plate, to have someone assist you. An assistant is a great help in handling the materials, for it is almost impossible for the man who inks and wipes the plate to keep his hands clean enough. Furthermore, the assistant can pull the felts tight while the plate is being rolled through, in order to reduce the chance of creasing.

In printing on textiles I have found that while it is no problem to obtain a good black impression by using etching inks, the color is much more of a problem. Ordinary oil paints surface rolled just as you would print them on paper will give only weak mottled tones. For surface painting it is best to use the special block-printing colors made for textiles. About the most handsome combination is the use of dye colors. The dyes either have to be stenciled on the textile or hand painted after the intaglio print is thoroughly dry.

In closing, I also wish to mention that natural leathers take prints beautifully. As a matter of fact, a fine leather is so sensitive that, contrary to the condition existing with textiles, the plate has to be wiped even cleaner if possible than it would be for a conventional print, because the leather picks up tones so well. Leather also takes and keeps embossment beautifully. If a specially strong effect is desired, the leather should be dampened. Leathers with hard finishes are not suitable for printing.

Eight

COLOR PRINTING

INTRODUCTION

THE GREATEST technical development in contemporary graphic art is in the realm of color printing. It seems that in the past twenty-five years printmakers throughout the world have concentrated all their inventiveness on finding new and better ways to print in color. The driving forces behind this development are many-sided, both aesthetic and economic.

As a great number, if not the majority, of the printmakers are also painters, it is understandable that they should instinctively explore the possibilities of color printing.

In the last decades the function of the print has changed a great deal. In the past, prints

were collected mainly by bibliophiles to be kept in drawers and in handsomely bound portfolios to be handled and admired occasionally. With the exception of the Japanese print, a truly popular art, and the early Christian woodcuts teaching the gospel to the illiterate, the print was universally considered to be a precious thing. When in the nineteenth century Parisian artists discovered the Japanese print, a revolution began that is still going on today. The lithographic posters of Toulouse-Lautrec and Bonnard opened up the tightly closed drawers and liberated the print.

Color printing with wood blocks and lithography has some history, but the intaglio color printing developed truly only in our time. Of all the great etchers of the past, only Hercules Seghers and William Blake did any experimentation that directly ties in with the development of contemporary research in intaglio color printing. Seghers was unquestionably a great forerunner of modern printmaking, although in many respects his singular obsession with trying to create a printed painting was different from the basic conception most of us have today toward the color print. While we try to exploit all the possibilities of color printing, we do not want to do this at the price of destroying the print itself. As a matter of fact, most of the prominent printmakers and museum curators who do not want to see printmaking lose its pureness and directness hope that this frantic experimentation with color won't change the print into a printed painting.

Today we have an ever-increasing popular interest in color prints. The public wants large color prints to fulfill the function of paintings. The small black-and-white print has very little interest for them. There are aesthetic reasons following parallel to the developments in the postcubist period of painting—the reaction against cubism's primary preoccupation with form and the reborn interest in the impressionists' preoccupation with color.

The development of color printing was unavoidable, and it is also natural that the excitement of new possibilities proved to be too great a temptation for many to resist. I think that already there are strong signs that this period is over; serious artists now use color with restraint and dignity. I do not see anything wrong in using any number of colors in a print if the color is an integrated part of a graphic expression, as it was in the Japanese woodcut. Color is only objectionable if it is used as pure surface decoration, but bad artists made bad prints even without color.

In recent years there have been some rather spectacular developments in color printing. What has happened relates closely to the major trends of art, and even the art market. Some of the most dominant trends, like hard-edge abstraction, optical art, and field painting, depend primarily on the manipulation of color. Pop art relies on it either for psychological impact or decorative effect. Because few galleries or their artists could resist the temptation of the fantastically lucrative print market, suddenly a new concept invaded

the print world. Most of the artists involved in it are not interested in printmaking as an original creative medium but rather as a convenient method of reproducing painterly ideas. Because the work of these artists depends a great deal on photo processes and skilled craftsmen, it is natural that they would turn toward those media where this service is available—primarily to silk screen and then lithography.

In the following chapters I shall try to cover all of the major phases of contemporary color printing techniques, from the intaglio color print to experimental mixed media.

INTAGLIO COLOR PRINTING

The intaglio color print is made with two or more intaglio plates successively over-printed on the same paper (Fig. VIII, 3). Each plate represents one color and its possible graduations. In principle, it is possible to take four plates—the three basic colors, yellow, red, and blue, plus black—and make a print that will have the full range of the color wheel from white to black. In that case, the color-separation principle would be the same as in a full-color photoengraved color reproduction.

In planning an intaglio color plate, it is important to keep in mind the basic characteristics of this medium. The primary assets of intaglio printing are the luminous mellow quality of the color and the variations—from full intensity to the most subtle tonal values. In order to get the full range of possibilities from an intaglio color plate, one should use practically every technique known to work on metal—line etching and engraving for intensity and linear character, soft-ground textures for full rich values, and aquatint for tonal variations, scraping and burnishing for fine modulations, gouging or cutting out areas to produce either brilliant whites or the pure color of the alternate plates.

I think it is advisable, as much as possible, to develop all the plates simultaneously, although this involves a great deal of trial proofing. This, however, helps to avoid one of the most common mistakes of inexperienced printmakers—that of making the first, or key, plate too complete or self-sufficient. In a good color print the color is not used as a fill-in for already established form, space, and movement; it is used in total integration to establish these qualities only when they are printed together.

Planning the Plate

The planning for an intaglio color plate is a very personal problem, and a great deal depends on the personality and temperament of the artist. To make a good color plate, however, is a complex technical procedure where some degree of planning is unavoidable.

For instance, no matter how well you wipe a color plate, even the unbitten surface area is going to retain some tone. Therefore, the only way you can have a really pure color coming through is to drop out that area from all the plates except the one you want to print. In other words, let's assume that you use a yellow, blue, and red combination. If you want pure yellow, you have to drop the corresponding area from the blue and red plates. Dropping out can be done just as any embossment is done; either etch out the shape and finish it by cleaning with gouges, or in some cases you can completely cut it out with either a jigsaw or a cutting drill.

Some printmakers like to work out the major dispositions of their color areas on a sketch and work from this, improvising the color separation and developing the details as they go along. In this case, the key plate is begun first.

After the first state is etched, a wet proof is offset on the second plate. The second plate is submerged for a short time in a weak solution of acid—just long enough to oxidize the surface. After the plate is cleaned, the image from the first plate appears with a shiny, highly polished metal surface protected by the printing ink offset from the first proof. This will give enough orientation to begin the second plate.

It is obvious that this method is not suited to an extremely close register.

If a more controlled procedure is desirable, then a color sketch done in exact size should be worked out in color separations. For this, one can use colored inks on acetate, as this would give an approximate idea of the disposition of overlapping color areas. This method is unquestionably the safest, although I am very much opposed to over-planning; I feel that even if the basic color structure is planned, the actual development of the plates themselves can be improvised.

I am opposed to the widespread belief that spontaneous expression in art is necessarily the result of a spontaneous physical action. True spontaneity is the result of freedom, and freedom is possible only through knowledge. This is the real idea of Tao that is being abused and misquoted so much today. Strength is a result of conviction that no grandiose gesture or physical violence can simulate. Furthermore, I wonder whether spontaneity (in the sense in which this word is understood today) is a necessary ingredient of all great art. I can think of many masters—Cimabue, Uccello, Mantegna, Vermeer, Poussin, Ingres, and so on—whose work could not be called spontaneous by the widest stretch of imagination.

In intaglio color printing the printing itself is the really difficult task and has much to do with its limitations. Therefore I think a detailed discussion of this problem will make the planning procedures self-evident.

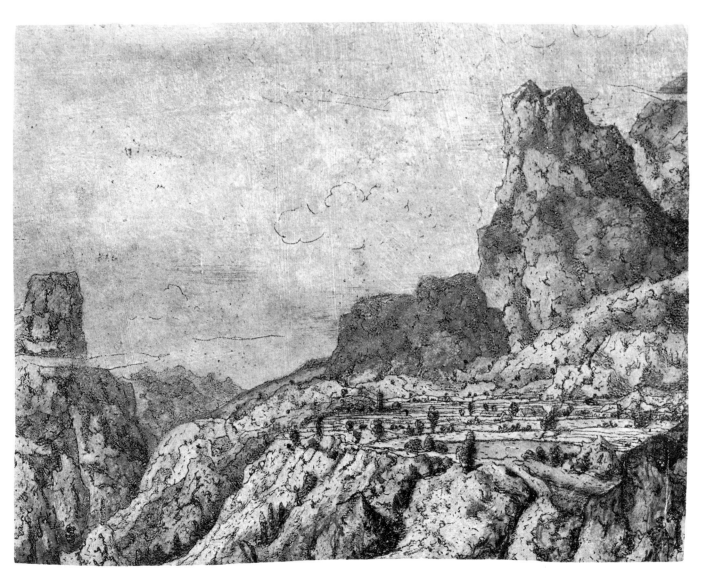

VIII,2 HERCULES SEGHERS (c. 1590–1645), *Rocky Landscape with a Plateau*. Etching.
The Metropolitan Museum of Art. Harris Brisbane Dick Fund.

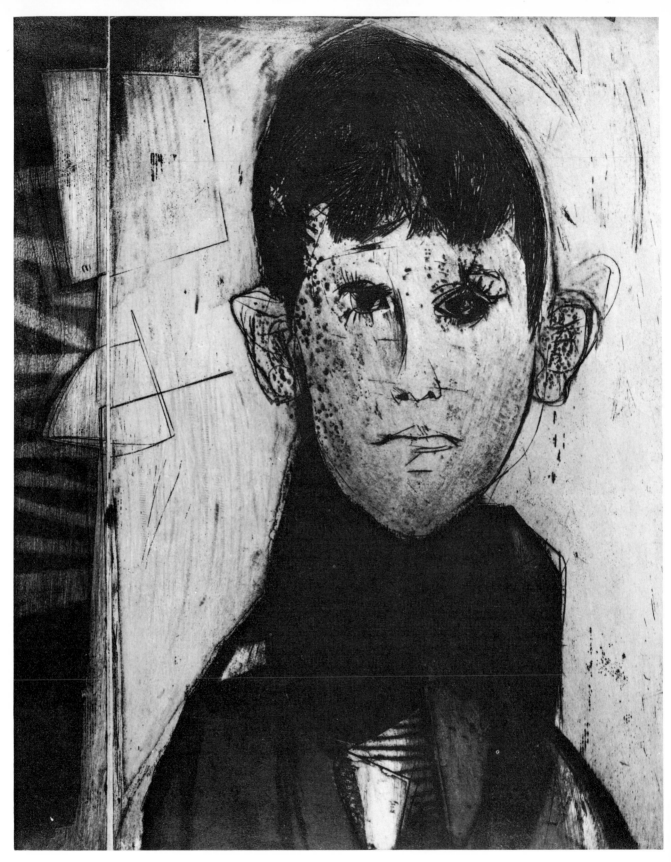

VIII,3 MAURICIO LASANSKY, *My Boy*. Color etching and engraving.
Collection of the artist

Printing of Intaglio Color

Intaglio printing has to be made on damp paper. The paper stretches when wet and shrinks when it dries. This is the source of great difficulty in achieving perfect registry in a multiple-impression intaglio color print.

Let us assume that we are working on a print consisting of overprinting three intaglio plates.

The printing of the first plate is simple. The problem begins with the second one. First of all, it has to be decided whether it is possible to print the second plate immediately after the first one. After the first plate is pulled the paper is still wet (unless the plate was too hot and dried it), but so is the etching ink. If the first plate consists only of shallow textures or of aquatint tones, the wet-on-wet color printing is possible. If the first plate has deeply etched or engraved sections, the second printing would crush the fine linear details of the first. As this is the most common condition, one may generalize and say that, with a few exceptions, the right procedure is to dry the first print thoroughly and rewet it for the second printing. It is obvious that the same condition prevails for the third or fourth or for any number of printings.

The rewetting of the print in itself is not difficult except that you have to try to get the print back to the same degree of dampness as it had originally. Otherwise, its dimensions would change, making a good register impossible. There are several methods used to register intaglio color prints, and the choice is made according to the particular problem that has to be solved.

Improvised Registering

With very small plates a simple method can be used. The print is placed face up on the press bed. Then the plate is easily put in register, as you can visually control it. Then by placing one hand under the print and the other on the plate, the print is carefully turned over on the bed. This operation has to be done carefully, for it is very easy to let the paper slip slightly and thus put a plate out of register. This is an improvised method good enough for trial proofing, but it would certainly be too awkward for handling a large edition. With this method you can immediately judge whether the print has expanded back to its original size. If not, it is not damp enough; if the print is too large, it may need further drying.

One thing should be kept in mind. If the plate is very warm, the printing operation has to be fast and efficient; otherwise the paper may become too dry before it is run through the press.

Registering with Mat

The most often used and most reliable method for registering an intaglio print is by making a tin or cardboard mat for the plate. First, all the paper to be used in the edition has to be cut to the same size. Then take a sheet of 20- or 22-gauge tin and cut it to the same size that your printing paper will be when wet. (For this purpose dampen one paper and check your size this way.) When you cut the metal mat, leave a thin strip on each side of three corners. Folded over, these are going to act as stops once the paper is placed in printing position. The opening in the mat should be cut exactly to the size of your plate. Too much play will affect a delicate register (Fig. VIII, 4).

If you have room enough on the press and if the paper is big enough, make the mat wide enough so that the printing felt won't have to cover the stops. In this way you can avoid the constant flattening of the stops by the printing pressure.

At this point I should like to emphasize again the necessity of careful, precise preparation. A rushed, sloppy job will result only in great loss of time and material. You have to bear in mind that if you make a mistake in color printing, if it is your second or third color, you lose all previous effort invested in it.

Once everything is prepared correctly, the printing itself is simple. The mat is placed on the press bed; the ink plate is placed in the mat. The paper is registered on the mat, slipping the three corners in the stops. The paper should be handled carefully, especially avoiding excessive contact with the plate surface, as this might smear some of the colors. Be sure the paper lines up perfectly with the edges of the mat. The plate is then rolled through as usual.

Registering with Pinholes

If the print is not too large, one can use the mat system without stops and do the registering by punching three pinholes—one in each corner of the mat. The whole lot of the printing paper has to be punched through with corresponding pinholes.

After the inked plate is in printing position on the press bed, the paper is picked up with two heavy needles through the already punched holes. (For easier handling it is a good idea to wedge the needles in a wooden handle.) The needles are then inserted in the corresponding holes on the mat and the paper is released. The third hole serves

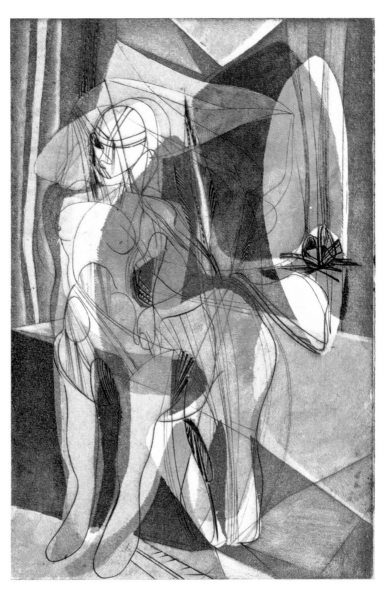

VIII,1 STANLEY WILLIAM HAYTER, *Centauresse*, 1944.
Etching, engraving, stenciled color.
Author's collection

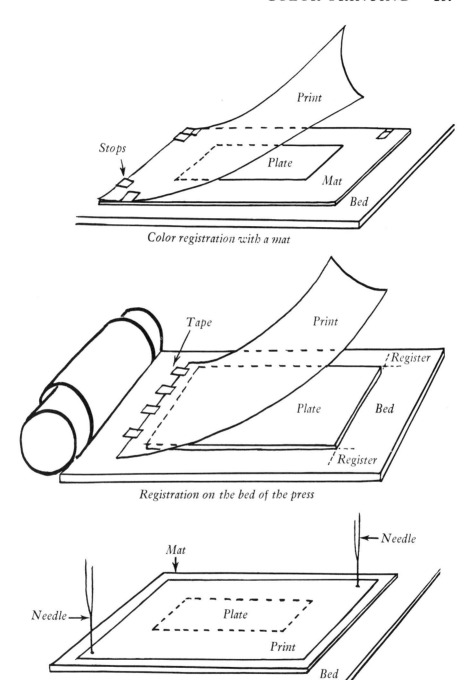

Color registration with a mat

Registration on the bed of the press

Registration with two needles

VIII,4

as a double check to ensure good register. The holes should be placed close enough to the edge to be trimmed after the prints are dry (Fig. VIII, 4).

Both of these previously described registering methods may also be made with cardboard mats, although this is not as accurate and does not stand up as well for a large edition. On the cardboard mat one has to glue the stops, using a strong stencil paper for this purpose. The cardboard has to be strong and hard and, if possible, slightly thinner but never thicker than the plate.

The Lasansky Method

Another excellent printing method was developed by Mauricio Lasansky. The following is his description especially written for this book:

"Twenty-three years ago the Museo Nacional de Bellas Artes in Buenos Aires bought a print of mine which I had done in two colors from the same plate by running the print twice through the press to superimpose one color upon another.

"The idea for this technique came to me as I realized that the tension created by the superimposition of warm and cold colors in perfect register could provide a three-dimensional quality unattained by the traditional method of making color prints with different plates.

"However, as I was working with large plates, the considerable expansion and contraction of the paper made the problem of register rather difficult. The diagonal-point method which gave good register for small plates, where the paper was small and changed little in size, was useless here.

"Since then, the method I have worked out for obtaining perfect register of superimposed colors with large plates is as follows: First I soak the paper overnight; then, to control the humidity, I place it for two days in a damp box made of two sheets of metal with heavy weights on top. Then, I take the first print in the regular manner with the plate on the press bed followed by the paper and felts. I print with a cold plate so as not to change the size of the paper. Also, to avoid this paper problem the print should be kept in the damp box under pressure until the next color is printed. I have found that it takes from three to five hours, depending on the amount of glue in the paper, for it to begin to contract.

"For the second printing, place the print face up on the felts and use the marks of the plate edge on the length and width of the paper as a guide in placing the newly inked plate over the first print. Then add two felts on top plus a cardboard. This helps to prevent the plate from curling. The principle behind placing the plate over the paper is that there is no chance that the roller should move the paper and ruin the register.

If the plate should move, the paper underneath would move correspondingly. However, if the paper were over the plate, it is conceivable that the strain of the roller on the paper could move it, or stretch it slightly, thus ruining the register. In general I like to run a plate through the press twice. For the second time through I turn the plate and print over. This is easy to do since the paper has adhered to the inked plate, and it helps to correct any tendency of the plate to curl. This extra run is not always necessary.

"This system of obtaining register works with equal precision when different plates are being used. I have used as many as nine different plates to make a single print with perfect register each time."

Registering on Press Bed

If the second printing can be done immediately after the first, there is a very simple registering procedure. Have both plates inked and ready for printing. Place the first plate on the press bed and mark its position with a pencil. Place the paper over the plate and secure one end of it to the press bed with masking tape. After the plate has been run through the press, the hinged print can be folded back and the second plate can be placed in the position marked with pencil. Then the print is folded back on the plate and run through the press. With this method it is imperative that the plate should be exactly the same size and that the paper should be attached to the press bed securely. Also, it is important to remember that the first plate should be cold. Otherwise, it will dry the print too much and the second printing will be a very poor one (Fig. VIII, 4).

I think it is self-evident by now how much one has to take into consideration the particular problems of a printing process in planning the plate. For instance, with the overprinting of several intaglio plates, it would be foolish to attempt a hairline register. Even in commercial printing, working with mechanical means more precise than ours and not facing the problems we have with the paper, most of the color separations are made with a sixteenth of an inch overlap.

Selection of Paper

For an intaglio color print the selection of the right kind of paper is very important. If the paper is subjected to a number of printings, it has to be strong. It has to be thick and rich in order to take the quantity of color involved in the multiple overprinting. It has to be stiff enough to be placed properly on the mat without smearing the color on the plate. Nothing is more exasperating than to try to handle a soft, limp paper that collapses or tears in your hand by its own weight.

Colors for Intaglio Printing

The next problem to consider in intaglio color printing is the colored ink itself. As I described in the chapter on printing equipment, the etching ink is a special mixture with a lot of body in order to retain its three-dimensional quality; it has to be ground in heavy plate oil in order to avoid bleeding and, at the same time, it has to be easy to wipe. By combining the right kind of black pigments, this can be easily accomplished.

The color is a different problem. One cannot mix alien materials into a colored pigment without changing it. Therefore the printmaker is at the mercy of the particular characteristics of each pigment. Alizarin red, for instance, is an extremely sticky pigment that has a tendency to smear hopelessly in hand wiping. This is generally true of all the lake colors. The earth colors are easy to wipe and the cadmiums are fair.

Grinding of Colors

It is not necessary to grind colored pigments as much as the black printing ink. I generally mix my colors with an equal amount of light linseed and heavy plate oil on a glass plate and work it over well with a printer's spatula. The quantity of oil to be used is considerably greater than it would be with black etching ink. The colored pigments should be oily enough to form a puddle in the glass and run off the knife when picked up. It is important that the oil should be consistent all through the pigment. If the color is too granular, light mauling is advisable. Some of the dark colors can be mixed by using the regular etching ink as a base. This makes them easier to wipe.

The most delicate colors are the yellows, as they have a tendency to turn greenish in contact with the metal, especially on zinc.

For color inking the plate has to be thoroughly warm. Some of the sticky colors simply cannot be wiped on a cold plate. As I mentioned before, I have found it nearly impossible to hand wipe colored plates. A clean regular rag wipe seems to give the best result. It is self-evident that clean tarlatan and wiping rags should be used for each color.

As I already mentioned earlier, with sticky colors add Easy-wipe compound instead of oil. Also, I have found that for a clean wipe with sticky colors, soft paper towels are more efficient than hand wipe. Wrap the paper towel tightly around a wood block and wipe with a light circular motion. A paper towel without hard backing pulls the ink out of the lines.

The Sequence of Colors

When overprinting intaglio color plates, the sequence of colors is very important. The customary order is to start with the light colors and proceed toward the dark. Black is generally the last color printed. I have experimented with light-on-dark intaglio printing, but it very seldom produces a completely satisfactory result. It is very difficult to print a totally opaque light color except in heavily engraved or etched areas.

I experimented also with woodcut and lithoprinting inks but found them generally much too sticky for my purpose. In addition, very few of the commercial printing inks are really stable colors. I have seen practically total discoloration on woodcuts exposed to light.

The regular tube oil colors used for painting are ground much too fine and have not enough body for intaglio printing. In some instances they can be used by adding dry pigments to them, but this is generally a very expensive way of printing.

OFFSET PRINTING WITH STENCIL

Stenciling is one of the simplest ways to use a number of colors combined with an intaglio plate.

This method has great advantages and great limitations. The main advantage is that it eliminates all the problems encountered in intaglio color printing. As all the stencil colors are on the surface of the plate, there is only one printing, and therefore no registering problem. On the other hand, stencil is good only if you can solve your problem with flat, sharply defined color areas. The modulation of tonal values, the subtle transitions of intaglio color are nonexistent with this technique. This is a comparable situation one has to face many times in the choice of techniques and materials. One does not really replace the other. The choice should always be determined on the basis of which will best serve your expression. I don't believe in compromise simply to eliminate a complex procedure. It is possible sometimes to find a personal solution for the application of a method to eliminate its otherwise disturbing characteristics.

Any technical manipulation is justified as long as it serves an expressive purpose. I am only against the compromise on content. My reason for talking about this in relation to stencil color printing is that in recent years I have seen a great deal of misuse of this method. A number of printmakers working with modeled forms use stencil color as a

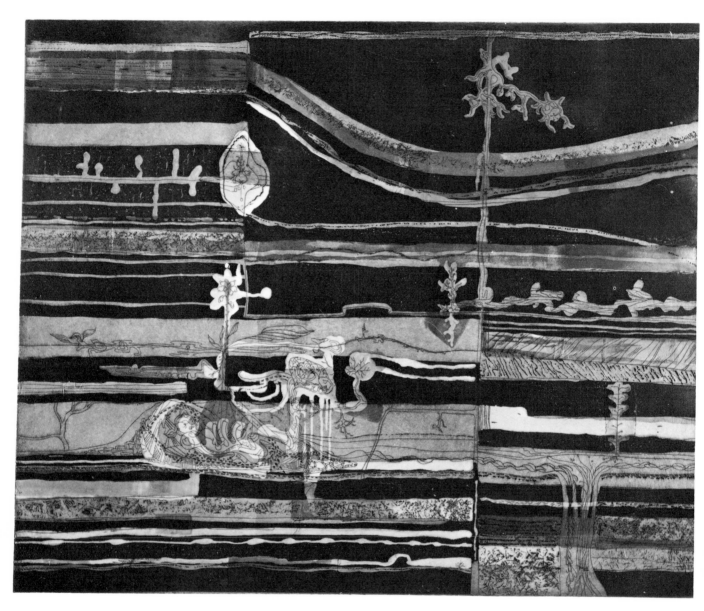

VIII,6 GABOR PETERDI, *Germination No. I*, 1952.
Aquatint, line etching, soft-ground etching, engraving, and eight stenciled surface colors.
The Museum of Modern Art Collection, New York

decorative element. The flat color planes are completely contradictory to the basic conception of their style. These artsits should use the intaglio color process where the modulation of colors can be organically integrated with their forms. I have seen stencils used also on naturalistically conceived landscapes, the arbitrarily used color planes floating on the surface, completely contradicting the image conceived in depth.

As much as is possible in generalization, one can say of stencil color that it lends itself more to abstract work than to naturalistic representation. It is not accidental that this method was pioneered and explored by Hayter and Studio Seventeen, since practically all the artists involved belonged to the young *avant-garde* of the Parisian school.

In my earlier plates, when I began to use the stencil colors, I was disturbed by a too obvious combination of the two media. I realized later that my mistake was in making my intaglio plates too light, letting the mechanical character of the stencil dominate. I found the stencil color the most satisfactory on plates having great tonal or textural variations (Fig. VIII, 6). As the stencil color closes and overlaps the varied, rich intaglio areas, it takes on modulations and becomes integrated with the plate.

Stencil Papers

To cut the stencils, a special paper can be purchased; but I use ordinary strong papers, often with good result. The important qualities of a good stencil paper are strength, hardness, and thickness. A too heavy paper interferes with the rolling of the color into narrow openings. Stencil cutting is limited and does not lend itself to very fine detail or to intricate interlocking design. Some of these effects can be achieved with great pains, but there are other methods better suited for these, like silk screen, for instance.

For cutting the stencil, razor blades or tapered mat-cutting knives are excellent.

Registering Stencils

The registering of stencils on the plate is quite simple. Cut a mat for the plate from a cardboard not thicker than the plate itself. For a 16-gauge plate, an ordinary mat board is just about right. Place the plate in the mat. Take tracing paper and draw the area to be cut out; also, mark the position of the corner. After the drawing is traced on the stencil paper, cut it out together with small triangular openings where the corner of the plate is marked. This will help you to place the stencil in the correct position on the mat. After you are sure that the stencil is placed correctly, it is hinged to the mat board with masking tape (Fig. VIII, 7). The cutout areas on the stencil should be slightly larger than the dimension of the planned color area. The thickness of the stencil paper

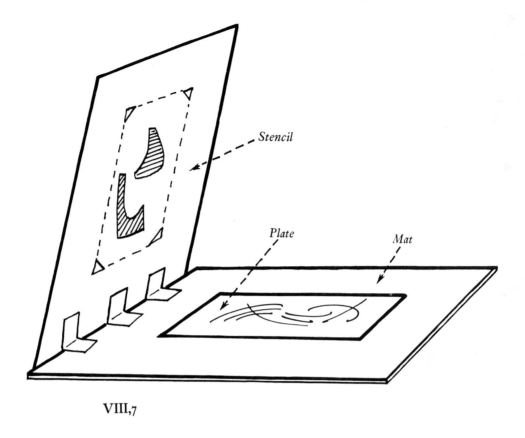

Stencil

Plate

Mat

VIII,7

does not let the roller print up to the edge. The margin allowed depends on the thickness of the paper and the flexibility of the roller. The safest way is to cut out a trial opening and try it out. This eliminates guesswork.

For well-contoured printing it is important to have various sizes of perfect gelatin brayers (Fig. VIII, 8, 9). The brayer for stenciling never should be used for woodcut printing and should not be laid against a hard surface for any length of time. Gelatin is very sensitive, and any abuse will ruin it in no time. If possible, when not in use, the gelatin rollers should be hung in a dust-free area.

I have experimented with a new type of rubber composition roller that may prove hardier. They are manufactured by the Apex Printers Roller Co. in St. Louis. The old-fashioned hard rubber rollers are useless for stenciling.

A well-designed roller handle should provide protective legs to serve as rests between printings (Fig. VIII, 8, 9).

VIII,8 *Large gelatin roller*

VIII,9 *Gelatin roller*

Rolling the Colors

The rolling itself should be done with great care. Never touch a very hot plate with the gelatin roller because to do so will distort it. The color should be rolled out in a thin even film on the glass plate. Thick tacky color gives an ugly, blotchy print. Don't put too much pressure on the roller. The weight alone of a good, sensitive brayer is almost sufficient. Rolling over and over the same area generally produces a messy, smeary color, as the roller tends to pick up some ink from the intaglio areas and deposit it on other parts of the plate. The roller should be big enough to cover the widest part of your stencil openings. Double runs with the roller are streaky most of the time.

Several colors can be applied with one stencil if the color areas are far enough apart to allow free manipulation of the roller. For different colors touching or overlapping, you have to use separate stencils. More than two stencils on one plate are hard to control,

because the second and third ones will have a tendency to pick up or smear the colors already deposited with the first.

On one of my plates, "The Sign of the Lobster," I used three stencils; but I had to clean them often, and worked with perfect, very soft gelatin brayers so that I was able to roll my colors with a minimum amount of pressure.

In this chapter I also wish to discuss a way of printing that is basically nothing more than a slightly different combination of the two basic printing methods: surface and intaglio.

Intaglio Color Through Stencil

With this method I simply reversed the customarily used color values and printed a light intaglio line with a darker color rolled on the surface. On one of my plates, "Voices in the Dark," I used a number of colors in intaglio, and surface rolled it with an off-black. In order to control my color areas, I inked and wiped the intaglio colors through stencils. This is a very tedious method and can be used only if the colors are restricted to fairly simple areas. A slight blending of the colors where they meet in the lines is unavoidable. The plate has to be wiped as clean as possible. Otherwise, the surface tone will tend to mix into the surface color and make it muddy. While this printing method can produce a quite startling effect, it has one very annoying aspect that makes the printing of a large edition a very tiresome affair. After each printing the plate has to be washed thoroughly clean because the remains of the dark surface color make it impossible to keep the light intaglio colors clean and pure.

The surface rolling has to be done with great care, especially if the intaglio plate has fine linear or textural details. A heavy layer of surface color has a tendency to close these lines, and in some cases completely to obliterate them. Generally speaking, if you plan a plate especially for this printing method, I would advise purposely etching or engraving the lines slightly wider, keeping this particular problem in mind.

STENCIL PRINTING DIRECTLY ON PAPER

The stencil color offset printed from the plate has a luminous, transparent quality, but it also has certain limitations. As I mentioned earlier, some of the light colors—especially the yellows—have a tendency to be affected by the direct contact with metal. In addi-

tion, the surface tone of the intaglio color will mix into the rolled areas. On top of that, the stencil imposes limitations on the number of colors used.

Sometimes these problems can be solved by printing colors with stencil directly on the paper and then overprinting it with the intaglio plate. With this method one can use a practically unlimited number of brilliant colors (Fig. VIII, 12).

The registering principle follows so closely the one used with stenciling on the plate that I do not feel I have to go into that in detail. The only special problem to be taken into consideration is the stenciling made on dry paper, and this will have to be dampened for the intaglio printing. Therefore, the slight increase of dimensions has to be remembered when the stencil is cut. To facilitate the registering of an intricate plate, I have found that the printing of several proofs from the key plate on a strong paper is a great help. By using the proofs themselves as stencils, you are saved the trouble of making time-consuming and less accurate tracings.

Remember to use the stencil right side up. This warning might seem childish, but I have seen a great number of prints spoiled by momentary absent-mindedness.

For direct stenciling, the printing paper should be strong, fairly heavy, and not too rough textured. A rough hard paper will show its texture under the rolled color. On figuring your register with this method it is advisable to allow a generous overlap if possible—at least an eighth of an inch. Any area where you want pure brilliant color to come through should be gouged out of the plate and wiped clean with a rag.

You can overprint colors on the paper with colors stenciled on the plate. This will produce luminous color areas with great depth, similar to the glazed areas in painting.

To stencil fine lines, the roller is often not flexible enough. These can be best controlled with a stiff, short-haired bristle brush.

With one of my large color plates, "Still Life No. 1" (1955) (Fig. VIII, 12), I accidentally made the discovery of a printing method that can be extremely useful. On this plate I tried to achieve a very soft, luminous color. I experimented with a wide range of stenciled colors, but I was not satisfied with the sharp definition of my overlapping color areas. I was on the verge of giving this up and making another intaglio plate when I made one more proof with stenciled colors on the paper, drying it for approximately twenty-four hours. I printed the plate well warmed. When I examined the print, I found the flat hard color areas miraculously transformed into luminous soft colors—exactly what I wanted.

After analyzing the print, I realized what had happened. The color on the paper had not completely dried, and when I ran it through the press the warm plate under the pressure picked up some of the color from the paper surface, making it porous, like an

aquatint. I printed my whole edition following the same pattern and I found the method completely reliable. The effect was consistent throughout the whole edition.

COMBINATION OF SILK-SCREEN AND INTAGLIO PRINTING

Another method of combining surface color with an intaglio plate is to use silk-screen printing instead of stencils. To my knowledge, this method also was first used in the Studio Seventeen, as it was a logical extension of the experiments with stencil. Hayter made several plates combined with screen color, including the "'Cinq Personnages," in which he used three screens.

The advantage of silk screen over the stencil is that it offers much more freedom and variety. The stencil can be used only for larger areas or heavy lines, while with silk screen one can print fine lines, textures, brush strokes. Therefore the color can become a much more active participant in the graphic conception of the plate. There are some problems, however, that one has to consider seriously in planning the screen for a plate.

First, there is the balance between the two media. I have seen prints destroyed by the overuse of crude or too complex surface color. The very same characteristic that makes most of the silk-screen prints commercial-looking makes it hard to blend one with an intaglio plate unless it is used with great discrimination. What's the point of going through a great effort to engrave or etch intricate linear or textural relations only to destroy them with heavy and vulgar colors?

The other problems are purely technical. The oil colors used in silk-screen printing must be liquid enough to go through the fine screen mesh. As the quantity of color deposited on the plate is much harder to control than with stenciling, one runs the risk of depositing a too heavy layer of oily color to blotch the intaglio lines; especially, the fine engraved lines can lose their particular beauty with too much oil seepage. As the quantity of ink is controlled by the screen and by the thickness of the stencils, for our purpose it is best to stick to fine screens and the thinnest possible stencil. As a matter of fact, I find it more sympathetic to use stop-outs on the screen if possible, instead of stencils.

If a great number of colors are to be used, it is wiser to print directly on the paper and overprint it with the intaglio plate. Even with this, one has to be cautious not to overload the paper with heavy pigment to an extent where it would lose all its absorbing quality. In this instance, the registering principle is similar to the one described in relation to stenciling on paper.

Because some of my readers may not be familiar with the silk-screen printing tech-

VIII,11 GABOR PETERDI, *Sea & Land & Moon*, 1967.
Combined media color. Etching, relief etching, engraving, five movable plates

VIII,12 GABOR PETERDI, *Still Life No. I*, 1955. Etching, engraving, twelve stenciled colors.
Yale University Art Gallery Collection

nique, I am going to give here a short description of the basic technique and some in-
formation about the materials and equipment involved. As the silk screen today is a very
popular and highly sophisticated method, I would like to make it clear that I am con-
cerned only with screen printing related to the mixed media color-printing process. For
anyone interested in the more complex photomechanical processes, there are specialized
books available.

THE TECHNIQUE OF SILK-SCREEN PRINTING

Silk screen is a stenciling method. The fine-meshed silk, gauze, or wire screen is stretched
on a wooden frame. The design is blocked out on the screen either by the applica-
tion of paper stencils or by the tusche-and-glue method. The printing is done by
squeezing liquid colors through the screen with the help of a rubber blade set in a handle
called a "squeegee."

Materials and Equipment

Assorted length 2″ by 2″ oven-dried
 pine; spruce, hemlock, or boxwood
 may also be used.
Silk mesh No. 10 XX or No. 12 XX
Nylon Nos. 10 XX, 12 XX, 14 XX,
 16 XX
Wire mesh No. 180 to No. 200
Plywood to support frame
Solvents: turpentine, kerosene, ben-
 zine, alcohol, etc.

Squeegee
Shellac
Tusche
Glycerin
Stencil papers
Mat knife, tacks and hammer, or stap-
 ler
Upholsterer's pliers, or the tool used
 by painters to stretch canvass, broad
 printer's knife, etc.

The Frame

The first step in preparing a screening outfit is the construction of the frame out of the
2″ by 2″ pine. The frame should be solid, as it takes quite a beating. For the corners,
miter joints, butt joints, or endlap joints can be used; if necessary, the corners can be
reinforced on the top with metal corner plates.

 As a matter of fact, I think that unless one has the proper tools it is worth while to buy a
silk-screen outfit commercially made; they are not too expensive and are stronger and

VIII,13
JOHN VON WICHT, *Icarus*. Stencil print.
Courtesy of the Grippi Gallery

VIII,5 GABOR PETERDI, *Studio*, 1958. Etching, engraving, intaglio with stenciled colors

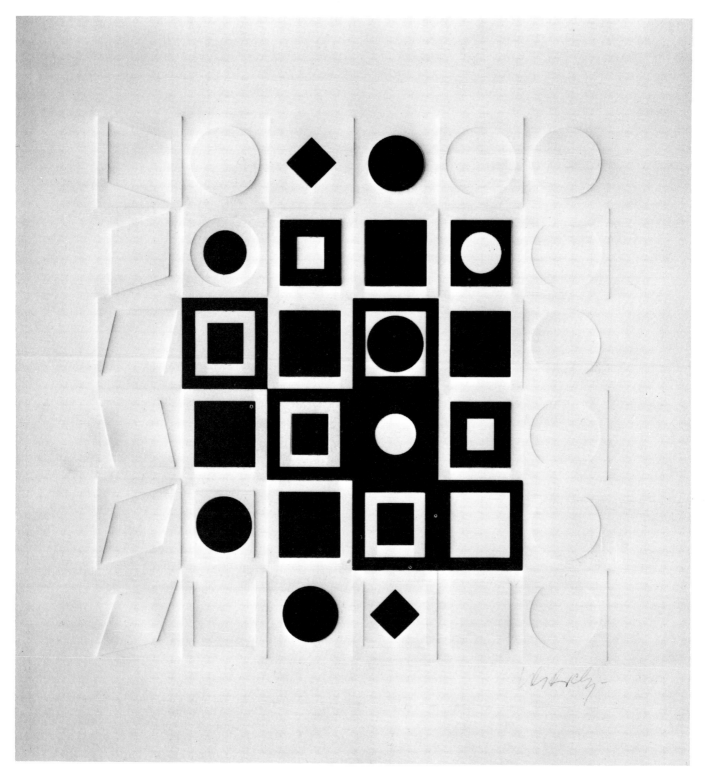

VIII,14 VICTOR VASARELY. Embossed serigraph.
The Cleveland Museum of Art. Gift of The Print Club of Cleveland

more precisely made than one constructed by the artist with inadequate tools. Screens are available in a great variety of sizes, and come with squeegees fitted to the frame—an important thing. Even if one decides to make the frame at home, it is advisable to buy the squeegees in the desired width and then construct the frame.

The Squeegee

The squeegee is a very delicate part of the equipment, as the rubber blade has to be fitted tightly in the handle and it has to be completely true—a task requiring professional skill. Synthetic rubbers are generally better for the blade than natural rubber, as they better resist the solvents used in screen printing. The squeegee should be approximately one inch shorter than the frame, but it should be long enough to cover the full width of the design with one stroke (Fig. VIII, 15, 17).

For screening directly on the plate, one has to have a separate screen for each color, as they are printed simultaneously.

The Screen

As I mentioned before, for our purpose only fine screens are suitable. Silk is the finest and strongest of the natural fibers. For screens it is classified according to weave, mesh num-

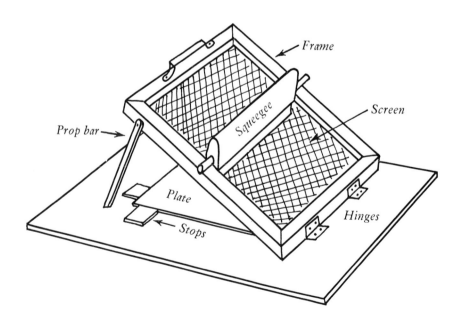

VIII,15

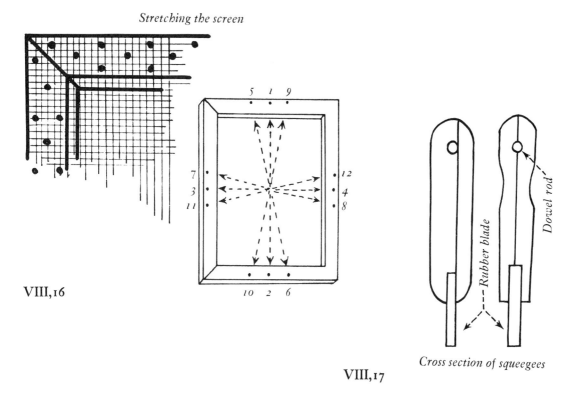

Stretching the screen

VIII,16

VIII,17

Cross section of squeegees

Rubber blade

Dowel rod

ber, and strength. There are three weave classifications: gauze weave, leno weave, and plain weave. The first two are strong; the plain weave wears out easily.

The most commonly used synthetic fibers for silk-screen printing are Nylon and Vinyon. Nylon is the stronger of the two. It deteriorates less with age than natural fibers.

Wire cloth for screen is made out of copper, brass, Monel metal, and stainless steel. Wire is excellent for very long runs and for printing with heavy layers of colors. For our purpose silk or Nylon is better.

Stretching the Screen

The correct stretching of the screens is very important. The silk should be stretched so that the length of the bolt will follow the length of the frame. On attaching the screen, make sure the threads are running parallel with the sides of the frame. Start to tack in the center, and work your way around. Three staggered rows of tacks or staples will hold the screen securely. Stapling should be done diagonally to the weave (Fig. VIII, 16).

Washing the Screen

After the screen is stretched, it should be washed with soap and lukewarm water to remove sizing and dirt. When it is dry, check it for any loose or uneven point. Ripples on the screen make the attachment of stencils and the control of printing difficult.

When the screen is finished, it can be hinged to the base board. This support has to be strong and flat; a warped, uneven surface can create a great deal of trouble in printing. Therefore it is best to use 1″ plywood, strengthened with a few cross braces on the bottom.

The registering of the colors is accomplished by nailing stops on the supporting board; this may be made of thin plywood or cardboard; mats also can be used for plates, as in ordinary stencil printing.

The woodwork, including the base board, should be covered with a coat of shellac or plastic varnish to protect it from humidity. Unvarnished wood will warp in time (Fig. VIII, 15).

To develop a design on the screen, there are two basic methods. The first is to cut out a stencil and attach it to the screen; the second is to block out the design with glue or other suitable substance. A variation of this latter procedure is the tusche-and-glue method, similar to the lift-ground principle in etching.

Film Stencils

For the knife-cut stencils one can use commercially produced "screen process printing plates" or conventional stencil papers prepared for this purpose.

For fine, accurate work the screen process plates are the best. The process plate is a transparent backing paper or plastic, to which a film is attached. The areas to be printed are cut out of the film and peeled off, leaving the rest on the backing paper. After the completed design is attached to the screen, the backing paper is removed. This procedure allows control over intricate details far beyond that permitted by the ordinary stencil.

The process plate comes in different colors: amber, blue, ruby; and they are semitransparent to make registering easier. The thickness of the film is graded: medium, heavy, and extra thick. For our purpose the medium thickness is the best.

Process films should not be stored too long; they can cause trouble. Generally the use of film over a year old is not recommended. Films should be protected from humidity and from excess heat or cold.

For cutting one should have extremely sharp, pointed knives. The best knives are made of surgical steel. Extreme care should be exercised not to cut through the backing paper, for this can ruin the whole stencil.

Attaching the Film to the Screen

There are two ways to attach the film to the screen. The first is to soften the film with a special solvent; the second, by the application of heat.

Before the stencil is applied to the screen it is advisable to clean the screen cloth; the smallest particles of dirt may interfere with the proper adhesion of the film. To wash screen, use gentle soap and water; then finish with adhering liquid or lacquer thinner.

To apply the film, the base level should be built up slightly by placing a cardboard under the screen. The finished stencil film is placed on the cardboard in position; the screen is then lowered on it. Be sure that the entire screen surface is in contact with the stencil. Place weights on the screen frame to ensure continuous contact.

In using commercial plates it is best to use the adhering liquid recommended by the manufacturer. The liquid should be applied methodically to the screen, section by section. The best procedure is to wet the screen with one cloth and dry immediately with another. If too much adhering liquid seeps through the screen, it can ruin the edges of the stencil. After the film is dry, the backing sheet can be peeled off. Make sure, however, that the entire stencil has properly adhered to the screen; otherwise the film will come off with the backing paper and the procedure will have to be repeated again.

When application of the stencil is finished, the edge of the screen is blocked out with tape, lacquer, varnish, or coated paper.

Removing the Film

After the printing has been completed, the stencil can be removed from the screen in the following manner: Place a cardboard under the screen as you did when attaching the stencil. Place newspaper on top of it. Lower screen on to newspaper and then saturate the screen with cleaning solvent recommended by manufacturer. Lacquer thinner or acetone generally works well. Keep the screen saturated for a few minutes; then raise it and pull the newspaper off. By this time the stencil should have become stuck to the paper and should come away with it.

Handmade Stencils

For the handmade printing plates one can use paper, shellacked paper, stencil paper, celluloid; the transparency of celluloid is a great help when the stencil is cut over a prepared drawing.

Ordinary paper or stencil paper can be attached to the screen by tape, glue, or the color used in printing. Shellacked paper adheres upon application of heat. Place paper under

screen on built-up base. Lower screen. Place a thin material on it and press it with a warm iron. Don't use excessive heat; you may burn the screen cloth. Stencils covered with lacquer can be attached with solvents in a manner similar to that used with the commercial film plates. The celluloid stencil can be secured to the screen by special solvents, celluloid cements, or it can be coated with shellac and handled in the same way as the paper.

To paint on the screen to block out the design, you can use a water-soluble medium which resists oil, lacquer, and enamel. These media are generally thinned with warm water and removed by water.

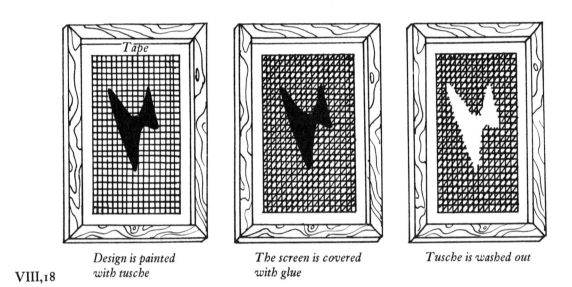

VIII,18 *Design is painted with tusche* *The screen is covered with glue* *Tusche is washed out*

Tusche-and-Glue Method

There is a procedure called the "tusche-and-glue" method. This is basically the same principle as the lift-ground etching. The design is painted on the screen with tusche, and the screen is then covered with glue. Sometimes shellac or lacquer is used in combination with the tusche.

After the screen is stopped-out with glue, shellac, or lacquer, the tusche is washed out with either kerosene or turpentine. With this method the function of the screen is similar to that of the aquatint in lift-ground etching (Fig. VIII, 18).

Tusche is made from stearic acid, lampblack, shellac, and soap. It is water-soluble before drying. Dry tusche is soluble in kerosene, turpentine, benzine, naphtha, and special solvents provided by manufacturers.

Tusche can be bought in liquid form for brushing or in solid form like lithographic crayon. The use of tusche crayons can produce screen prints deceptively resembling lithographic prints. These crayons come in three grades: hard, medium, and soft.

It is important to apply the tusche thickly enough on the screen, or the blocking-out medium won't let it lift. It is also a good idea, if one uses glue, to add some glycerin for flexibility (approximately 1 tablespoonful to 4 ounces of liquid glue mixture).

Be sure the blocking-out medium is thoroughly dry before the tusche is washed out. Use a soft cloth saturated with the solvent for the washing out. Lay a sufficient amount of newspaper under the screen to absorb the excess solvent.

Colors for Silk Screen

There are special colors developed for silk-screen printing. For our purpose, however, I have found regular Artiste oil colors preferable. The colors naturally have to be extended to make them liquid enough to go through the screen properly. To liquefy oil colors use special silk-screen color extender, with linseed oil. Oil alone would make the color too light in body, with a tendency to seep and run. The extender also has a tendency to make the colors much more translucent—a very important quality for us. Heavy, opaque colors destroy the effect of the intaglio plate.

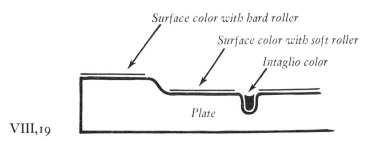

Surface color with hard roller

Surface color with soft roller

Intaglio color

Plate

VIII,19

INTAGLIO AND SURFACE COLOR WITH RELIEF ETCHING

In the previous pages I discussed the combination of intaglio and surface printing and silk screen. Another possibility that offers further variations is to etch a plate so that its main color structure is defined by the plate surface etched to different levels. The linear or textural elements moving from one level to another bind the whole together. Owing to the particular illusion created by the relief etched areas, the lines seem to live in a strangely ambiguous space (Fig. VIII, 21).

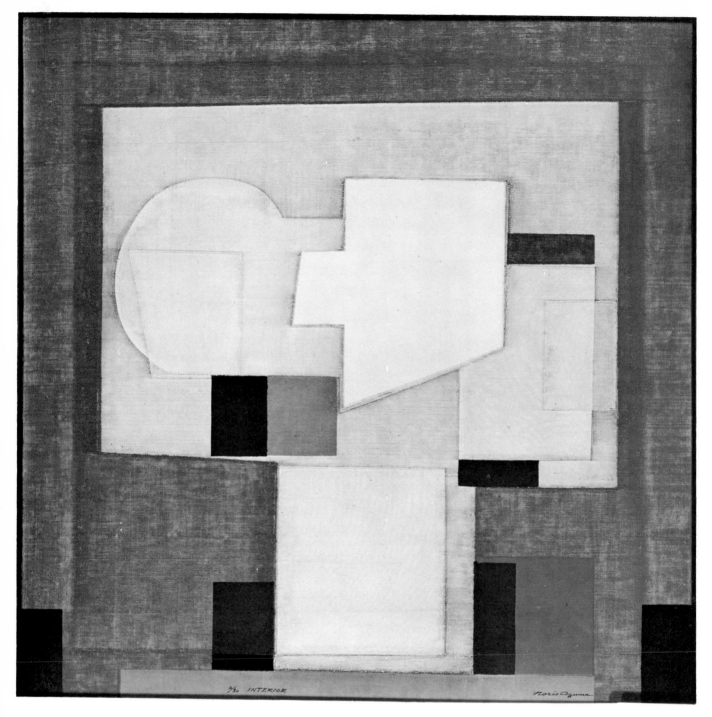

VIII,20 NORIO AZUMA, *Interior*. Silk screen on canvas.
Courtesy of Associated American Artists, Inc.

VIII,2 1 GABOR PETERDI, Angry Gulf, 1970. Dry point with electric graver. Photo by Joseph
Szaszfai

Remember that what is low on the plate will be high on the print. The sequence of printing begins with intaglio inking and wiping of the plate. Then comes the first surface color, rolled on with a soft gelatin roller that penetrates the lower levels of the plate. The highest areas then are wiped clean, if necessary, and the color is rolled on with a hard rubber roller (Fig. VIII, 19). This technique does not have the flexibility of the stencil or silk-screen method and its use is restricted to a specific pictorial conception. Any print conceived in naturalistic terms is eliminated automatically by the ever-present ambiguity of space I mentioned before. It is really best suited to ideas dealing with the interrelation of positive and negative areas, as the optical illusion created by the embossment tends to put a strange emphasis on the space surrounding positive forms.

The color separation created by the relation of the plate levels and the flexibility of the rollers automatically puts a limitation on the number of colors to be used. It is possible, however, to combine this with stenciling the colors, thereby not only augmenting the number of colors but introducing further formal elements if they are necessary.

For information on additional techniques in color printing—multilevel viscosity, chine collé, lye wipe, and monoprint—see Chapter 13.

COMBINATION OF WAX INTAGLIO OVERPRINTED WITH OIL COLORS

This is a rather complex printing process very seldom used and difficult to control. The wax crayon is printed first from a plate etched in relief to separate the color areas. The plate should be bitten with a good rough aquatint to hold a sufficiently heavy layer of crayon color. Otherwise, the result will be weak, spotty tints. The plate has to be warm when printed in order to keep the wax crayon soft enough to offset on the paper.

For the crayon printing it is best to use dry paper, as water generally prevents the proper adhesion of the colors.

I have seen some printmakers applying the wax crayon on a plate that had no etched definition for the color. This makes a controlled-edition printing impossible. Therefore, it has to be considered as a monoprint.

After the crayon is printed, the paper has to be dampened for the intaglio printing. As the paper is going to stretch when dampened, this has to be taken into consideration when the first plate is planned. The registering follows the same process one would use with any multiple intaglio color printing. The special problem of this process is to get proper adhesion of the intaglio plate on the wax crayon surface. This can be solved in two ways—either by dusting the wet paper with talcum powder or by covering the colors

with a light coat of dammar varnish. The powder is used by most of the printmakers working with this process. The function of the talcum powder is to create a toothy dry surface to hold the intaglio lines. One has to shake or blow off any excess powder before the second printing is done. Otherwise, you may produce poor prints by creating spotty tones or missed lines. Practically every print I have seen done with this method carries on the second plate a light surface color rolled on to serve as a unifying element. In addition, this surface tone, generally a light transparent, luminous color, acts as a glaze over the crayon colors, giving them a rich mellow quality.

I experimented with brushing a thin layer of dammar varnish over the crayon colors instead of using talcum powder over the wet paper. This method produced some prints with more brilliance and luminosity than the others, but it also proved to be rather hard to control. The biggest problem is to judge the proper amount of varnish to be used and the timing for the printing. One has to wait just the proper length of time to let the varnish sink in, softening both the crayon and the paper to a sufficient degree. If the waiting period is either too short or too long, the result is a poor print.

Of all the different crayons with which I have experimented, the Sketcho crayons give the most satisfying result.

When successful, this printing method produces an encaustic-like rich color. The control is so difficult that I have found it completely impractical for large plates and for large editions. This might be a good technique to exploit in the direction of monoprinting.

INTAGLIO COLOR PRINTING COMBINED WITH OTHER SURFACE MEDIA

Linocut
Woodcut
Rubber mold

In recent years there has been a great deal of experimentation with a combination of a variety of surface printing techniques with the intaglio-printed metal plate. There are two basic approaches, and the choice would depend on the particular effect desired.

The first and the simplest is to print the woodcut or linoleum cut on the paper and then overprint it with the intaglio plate (Fig. VIII, 22). If this method is used, the same registration problem exists as we faced with the color stenciled directly on paper. The surface printing is generally done on dry paper that has to be wetted for the intaglio printing. Therefore, the paper will go through a change of dimension which will have to be

taken into consideration. Another thing that has to be worked out carefully is the selection of the paper itself. The problem is that the special papers generally used for wood or linoleum cuts are too weak for intaglio printing, while the etching paper is generally too hard to get a good surface print with rubbing. With the linoleum cut this is less of a problem, because it is possible to work on linoleum of about the same thickness as the metal plate so that it can be printed on the etching press. With the pressure of the etching press, it is possible to use ordinary etching paper. If the linoleum is slightly thicker than the plate, one should cut a very good bevel and place a thin cardboard in front of the edge where the roller will climb on, thus making this easier by the graduation. Nothing is more dangerous to the press than to subject it to a sudden shock. Even a slightly thick linoleum is enough to break the roller axis if it is not handled carefully. Besides this, the pressure can be slightly reduced by the elimination of one felt.

Linoleum cut printed on the press will produce an extremely strong embossment that will flatten out after the paper is wetted and run through the press with the intaglio plate. With the woodcut this method cannot be used unless one has a special proofing press made to accommodate type-high wooden blocks. It is also possible to use very thin Masonite that can be printed on the press in the same manner as the linoleum cut. About this, I shall have more to say later, when I discuss woodcutting.

The technical problem of combining these different media is rather simple. It is much more difficult to integrate them from a stylistic point of view. While these media offer great possibilities, much greater freedom than one has with the stencil, for instance, each technique has such strong characteristics that it simply refuses to integrate, and the combination "reads" like two art works accidentally overprinted. These combinations again belong to the category of many of the recent experimentations lending themselves much better to abstract conception than to naturalistic representation. All this, however, falls so much into the category of personal problems that it has to be solved on that basis. It wouldn't make much sense to discuss it in terms of generalities.

In the realm of the printing problem, besides the papers one has to consider also the colors to be used. I have found that the printing inks generally used for wood or linoleum cuts are not sympathetic in combination with the intaglio print. The water-base colors cannot be wetted and the ordinary printer's ink is too loaded with varnish and produces a rather unpleasant shine on the print. I have found that regular oil colors give the best result.

The other method is to offset the wood or linoleum cut on the plate instead of printing it directly on the paper. While this is a somewhat more delicate operation than the direct printing, it produces an effect that at least I find much easier to integrate with the intaglio plate. Somehow with the offsetting process the colors gain a luminosity and the edges lose

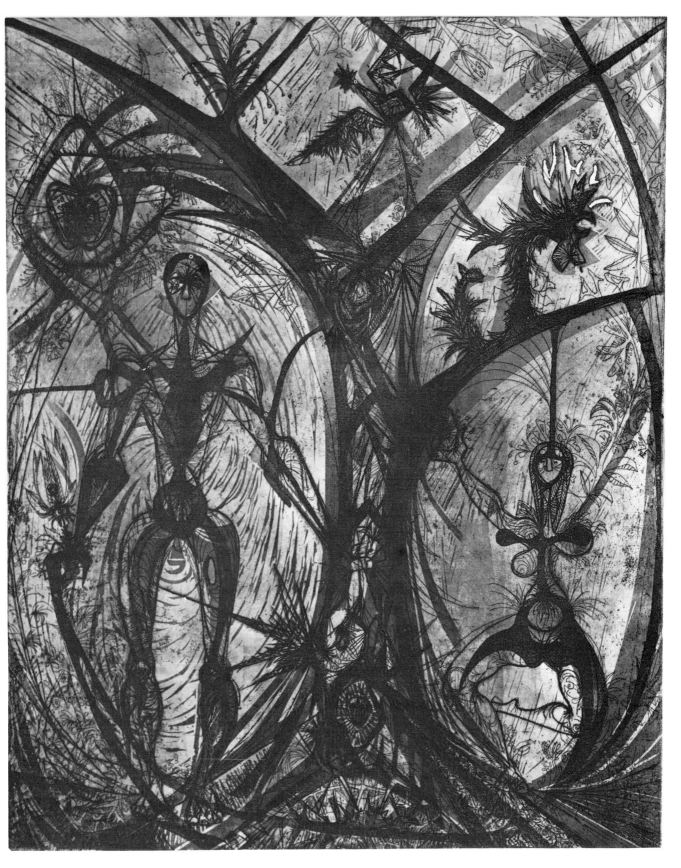

VIII,22 GABOR PETERDI, *Miracle in the Forest*, 1949.
Five-color linoleum cut overprinted with intaglio plate, etching, engraving, aquatint

the cruel hardness so characteristic of most of the surface prints. The offsetting again can be done in several ways.

Offsetting Linoleum on Metal

One method is to print directly on the metal plate. The other is to pick up the image from one surface and deposit it on the other with a gelatin roller. The direct printing can be used only with materials that have some degree of flexibility—linoleum, for instance. I used this technique on my plate "The Massacre of the Innocents" (Fig. VIII, 23). On a white background I wanted to have yellow and red flamelike shapes printed with a totally different feeling from that which the intaglio plate itself would give. First I tried to print the linoleum directly on the paper, but I felt the sharp definition of the shapes destroyed the illusion I was seeking. After experimenting with different ways of printing, I tried to press the inked linoleum cuts directly against the metal. The result was exactly the effect I was seeking—luminous light color with a slight burr around the edges which, instead of competing against my etched and engraved lines, made them more explosive by contrast.

Wood, being too rigid, cannot be used that way.

Offset Printing on Metal with Rollers

The other method works basically on the same principle as the commercial offset printing. The roller picks up the image of an area and deposits it on another; in our case instead of on the paper it is deposited on the plate. Every printmaker who has ever experimented with rolling surface colors on a metal plate with a gelatin brayer must have accidentally stumbled onto this offset printing principle. As a matter of fact, this is something that often causes a great deal of trouble when one tries to roll an even tone on a large surface with a small roller. As the roller passes over etched or engraved areas, it picks up the design. Once it passes its complete revolution, it deposits it in another section—a rather annoying thing if you desire nice even color tone. The same thing under control can be exploited. It is very important, however, that the roller to be used should be at least as wide as the plate, and the circumference should at least equal the length. Otherwise, the same problem will prevail. If we have the right kind of roller, the procedure is fairly simple.

The wood or linoleum block is inked. The gelatin roller is passed over it, picking up the image. This is then deposited by rolling on the metal plate. The most important factor in the success of this maneuver has to do with the personal touch that will come with practice only. The rolling has to be done with just the right amount of pressure and a steady

VIII,23 GABOR PETERDI, *The Massacre of the Innocents*, 1952.
Etching, engraving, and two linoleum-cut colors offset on metal plate

hand, because the slightest unsteadiness will produce slides and a blurred image. Actually, the most difficult part is to put the roller in the right position in relation to the intaglio plate. Otherwise, the image will be deposited in the wrong position. Again, it is obvious that this method cannot be used for very close register.

Surface Printing on Metal with Rubber Cast

In relation to these methods I should like to discuss some experiments I made by combining the intaglio print with rubber casts. Accidentally I stumbled on a synthetic rubber product that can be cured at very low heat. I felt right away that the possibilities of this material were worth investigating (Fig. VIII, 28). I was especially interested in the possibilities of surface printing on a metal plate with an image taken from another intaglio print. I felt that in some instances this could be used when the alien character of the wood or linocut would create too much conflict.

How to Make a Rubber Cast

This synthetic rubber (manufactured under the trade name Cordo, in Norwalk, Connecticut) comes in the form of a liquid paste. Poured on the metal plate, it can be spread easily with a spatula. After the rubber is spread in sufficient thickness (I generally use about a quarter of an inch), the plate is heated. In about ten or fifteen minutes, depending on the amount of heat, the rubber becomes solid. The first indication of this is a slight dulling of color and the loss of shine. It can be tested also by touch. When the whole surface has evenly hardened, the plate should be taken off the heat and submerged in a tray of cold water. When the whole mass has cooled, it can be easily peeled off the plate. The result is a rubber blanket that has picked up the finest details of the intaglio plate.

This can then be printed with any of the methods described previously in relation to wood or linoleum cuts. If necessary, further work can be done on the rubber with engraving and linocutting tools.

METAL GRAPHIC

This is a method of working on a plate that was originated by Rolf Nesch, the German printmaker. In all the methods I have discussed up to now, the design of the art work was created by making indentations in the plate either directly with punches or gravers, or by

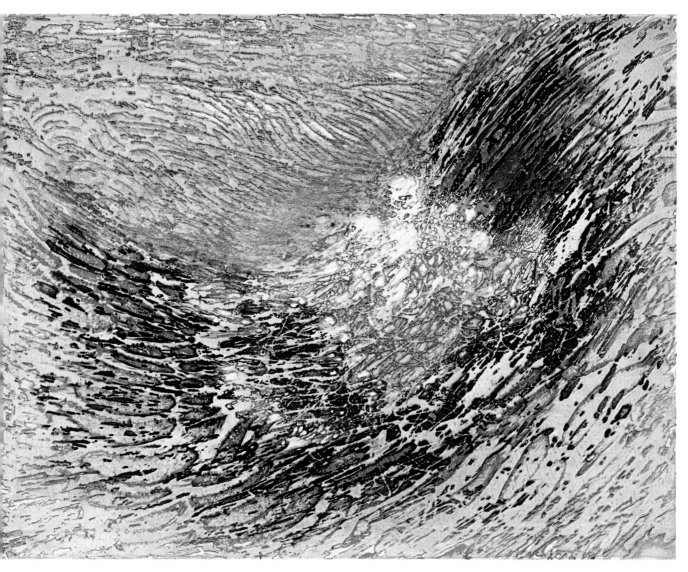

VIII,10 KRISHNA REDDY, *Wave*. Intaglio and relief color.
 Colors of varying viscosity, applied with rollers of varying density.
 Author's collection

biting them out with various mordants. The method of Nesch is simply the reverse of this process. He builds up the art work like a montage, by cutting out different shapes of metals and wires and soldering them on the surface of the plate. Instead of the etching needle and the graver, his tools are shears, wire cutters, and a soldering iron. These plates have a very strong relief, and the resulting embossment is exploited a great deal by Nesch (Fig. VIII, 24).

As a matter of fact, quite often there are whole sections in his prints in which the plate isn't inked at all and where the design appears only in the interplay of shadow and light. This method, because of its awkwardness, imposes a brutal simplicity on his style, strong and expressive. These plates can be printed in black and white or in color in much the same manner as any deeply bitten relief etching would be. Besides metal Nesch often mounts other materials on the plate, and with surface-rolled colors prints directly from them. The effect of this is comparable to that of the soft-ground technique except that the relief is generally much deeper, and the printing less controlled. Most of Nesch's prints are unique, and his editions seldom go over ten. Even in these small editions great variety exists between proofs.

To print the type of exceptionally deep relief found in Nesch's prints, the press has to be specially prepared. The safest way is to use heavy springs under the screws that regulate the pressures on the top roller. This absorbs the shock, which is sometimes sufficient to break the roller shaft. To produce deep embossments, and as an additional safety measure, unusually thick, fluffy blankets should be used.

Rolf Nesch was a pioneer of the sculptural metal collage print. Today artists all over the world are making prints using all types of materials, tools, and printing methods, but their basic idea of building surface relates to Nesch. One of the most interesting artists working in this idiom in the United States is Michel Ponce de León. He worked with me many years ago in the Brooklyn Museum and later went to Norway to work with Nesch. He is involved in all kinds of experimentation including kinetic (moving) prints. As the working process and thinking of Ponce de León represent a strong contemporary position, I decided to include a description of his method written by himself:

> My plates are multidimensional constructions. Some units are welded to the main plate, others are interchangeables that adjust freely like a jig-saw puzzle. My plate for "Entrapment" consists of sixty-two separate shapes. Some units are reused in new combinations and different relationships. Since my work is not based on drawing but on composition, instead of sketches, I start with a miniature, 3-D, cardboard construction. By working small I manage to eliminate all the unessentials and arrive at a bigger scale concept in my final work. I use copper, zinc, aluminum, brass, steel, etc., for each metal responds uniquely to hammers, saws, needles, acids, papers and inks. For hammering surfaces copper is best.

However, in order to retain convexities under the printing pressure, the reverse concavities have to be filled in with aluminum solder.

Some other shapes and objects to be made printable have to be remodeled in clay or wax or carved out of wood before being cast in metal. I do all my casting (except for things done in metal that requires a melting point of over one thousand degrees). I always rework the surface of my molds with vibrators, acids, sanders, etc., to enable them to retain the ink. Since most metal impressions are usually from one to two inches thick, other shapes to be printed have to be built up and adjusted to the right height by means of plastic materials or other metals. The next step consists of beveling every shape to a 45-degree angle in order to make good contact with the paper and pick up every particle of ink in the printing. Some of my finished constructions weigh as much as sixty pounds.

I make my own inks and use a variety of oils and other media to attain transparencies and densities. The inking is done unit by unit in as many colors as necessary since each shape is attached on different levels or fitted freely. For wiping I use my fingers or the palm of my hand, tarlatan is out of the question for this type of surface.

My paper, one of the most important factors in my work, is made specially for me by Douglas Howell. This hand-made paper, one inch thick, is prepared out of pure linen in long fibers to be able to stretch to the limit of its flexibility. Cooperation between us is an absolute necessity in some cases when unique experiments are attempted. The dampening of this type of paper is done with sponges. A 24″ x 24″ x 1″ absorbs two quarts of water mixed with a tablespoonful of plaster of Paris and a teaspoonful of pure gelatin. This solution hardens the paper when dry and retains its sculptural form.

To print from my bas-relief constructions I had to design a new type of hydraulic press embodying the principles of die-casting and operated by hydraulic pumps that exert an overall 10,000 pounds pressure. This press, to me, is what an instrument is to a musician, for with it I am able to extract every nuance of ink and embossment from my dimensional plates. There are a number of advantages to this press. A plate of any height can be printed. Free pieces can be stamped without danger of shifting. Reprintings over specific areas can be pin-pointed without destroying previous embossments. Plate and paper may be left under compression for any length of time for a deeper and more permanent relief. The adjustment of the counter-molds (blankets for the average print) is done with wet pulp, a form of papier-mâché, to equalize the multiple levels of the matrix; over this mass of pulp I place damp blotters and blankets. After printing and with the paper still attached to the mold I go over the back of it with a burnisher and force the paper into the extreme depressions not reached by the press.

In pursuit of an obsession with continuity, my plates, after fulfilling their duty as printing surfaces, are metamorphosed into three-dimensional sculptures with a brand new destiny. Some pieces are infused with other dimensions by means of lights, sounds and movements.

Still in another effort to explore and extend the possibilities of graphics in our technological age, I have developed a new kind of kinetic print form. The one in the photo consists of three parts. The outer box is printed from five plates in nine colors. The center is composed of three pieces containing a stylized eye and a photomontage arrangement of events that alternate by means of a shutter device that operates electrically.

VIII,24 ROLF NESCH, *Wind*. Metal graphic.
Collection of Mr. and Mrs. Art Brown. Photo courtesy of Meltzer Gallery

INTAGLIO COLOR PRINTING A PLATE CUT INTO SECTIONS

I was working on a small landscape composition with a strong horizontal structure. Somehow, all the while I was working on it, I visualized it in two colors dividing the plate horizontally. My first idea was to use one intaglio color and stencil the second on the surface. When I finished the plate and printed it in this manner, I was dissatisfied with the flatness of the stenciled color. I wanted something with great luminosity and depth. It did not take me long to realize that only intaglio color could give me what I wanted. I also realized that no matter how carefully I might do my inking, the meeting of the two colors would give me a slightly smudged line.

Suddenly it occurred to me that I might be able to eliminate this problem by cutting the plate apart, inking the two sections separately, and then putting them together on the press bed and printing it. My plate was ideal for this method because it gave me a natural division on the horizon line. The only thing about which I was not sure was whether the two sections would hold together on the press bed, as the slightest separation would have given me a white between the two colors, destroying completely the illusion I was seeking.

I used a jigsaw with a fine blade to cut my plate in order not to lose too much metal. I also set my saw at a slight angle, because I felt that in this way, once the roller climbed the plate, the pressure would hold the sections together. The experiment worked perfectly, and I printed the whole edition in this way without losing a print. At the time that I made the print, I had never seen anyone else using this method; but a few months afterward I discovered in an exhibition a print done in a similar manner.

I should also like to discuss in this chapter "The Vision of Fear"—probably the most complex plate I ever made (Fig. VIII, 28).

When I began to work my image was clear, but I had not the faintest idea of the technical complications I was facing in order to materialize the image. The story of this plate is again a good illustration of how content and form—the "what" and the "how"—are inseparable in a work of art.

My basic idea was to create an oppressive, enervating image haunted by the fearful symbols of destruction. I tried to express a composite feeling of flying with deadly birds and of watching them from below.

In 1945, while my outfit was moving through Bavaria, German planes strafed us. My print began there; by 1953 it included many experiences intensified by the blinding flash of atomic explosions.

I began to build my space by combining sharp burin slashes with the staccato rhythm of the electric drill. My plan was to create an ambiguous space feeling, moving back and

VIII,26 MICHEL PONCE DE LEÓN, *Entrapment*. Collage intaglio.
Courtesy of the artist

forth and at times totally disrupted with superimposed color areas. My intaglio plate proceeded well; the complication began with the introduction of color.

My first attempt was to superimpose stenciled color sections on the intaglio plate. It didn't work. The color was floating on the surface, destroying the ambiguity by over-emphasis of the picture plan. After some experimentation it became clear to me that to achieve the desired effect I would have to use intaglio color.

To ink sections of the plate in different colors was out of the question. This would be impossible to control through an edition; furthermore, it would not have given me the abrupt change I was seeking.

The only solution was to make separate small plates developed as variations on the large theme. I had to solve the technical problem of registering these small plates with the large one. This plate—23″ by 36″—was a problem to print in itself. I knew that multiple printing with this plate would be difficult. Furthermore, the overprinted gray tone would muddy the color of my small plates. Suddenly I had the solution. Why not make the small plates on thin copper, place them on top of the large plate, and print them together? Only one question had to be answered. Would the superimposed plates remain in position under the printing pressure? This I found out quickly by making a test plate. It worked perfectly.

For my small color plates I used 20-gauge copper. I cut them into irregular shapes, echoing some of the forms appearing on the large plate. Within the plates I etched and engraved fragments of the large one in smaller scale.

The selection of colors was dictated by the content of the plate. I made four plates: light red, dark red, purple and, for the fourth, a red intaglio surface rolled with black. Though my first trial proof with the color plates was close to the effect I was seeking, something was missing. The color plates had to be better integrated with the large one, and there had to be another color dimension.

For my extra color I made a rubber cast with Cordo (S-255A) of an intaglio plate etched for this purpose. The cast was surface rolled with red, then offset on the plate behind one of the superimposed color plates. On the small color plates I superimposed black lines by offset method. The plate was ready.

The process I started using with the previously described two plates was the beginning of a method I now often use in my color printing. In recent years I have become increasingly fascinated by the opportunities offered by movable superimposed plates. Once a plate is cut, and its surface integrity destroyed, the rest follows as a logical extension. A plate consisting of many movable parts, including many contrasting materials, is full of ambiguities and potentials of metamorphosis. I am very much concerned with contrasting the physical reality of the print with its visual illusion.

With this idea, being involved with the printing potentials of new materials and techniques was practically inevitable. Thus, often these plates turned into a synthesis of practically everything that one can do with an intaglio print. This has produced many revelations even about the printing potentials of certain materials. Few people would believe that sometimes a piece of paper can stand more printing than a metal plate.

It was inevitable that with these plates I had to change my printing methods also. The multilevel embossment, carrying fine details, requires a printing setup totally different from a conventional intaglio plate. The adjustment of pressure, and the number of felts used, became critical. To print these correctly I have had to work out a different combination for each print.

THE CELLOCUT

This method was named by, and is associated with, one artist, the originator of the technique, Boris Margo. He was unquestionably one of the first to exploit creatively the possibilities that plastics can offer to the artist. Today a number of printmakers use acetate, Plexiglas, and Lucite, but mostly as just another material to work with. Boris Margo went much further with his experimentation. He built his images out of plastic (Fig. VIII, 27). I like to quote Margo himself: "My cellocut technique for printmaking is based on the use of a varnish made of plastic dissolved in acetone. Poured on to a rigid support, it can be textured, raised into relief, worked with tools and, more, used in combination with other graphic techniques."

In other words, the cellocut can be used in itself as a print or it can be applied on a metal plate for intaglio printing, or even combined with a woodcut for relief printing. Margo generally uses a thin enough support so that the cellocut can be run through an etching press and printed either surface or intaglio, or both.

Working with Lucite

I experimented with Lucite made by Du Pont. Either Lucite #44 or #45 can be used, but #45 is preferable for printing because it is harder. Lucite comes in crystal form and dissolves in toluene or xylene—highly volatile solvents. These should be used only in a well-ventilated room, and extreme caution should be exercised because they are highly inflammable.

In mixing the Lucite, add solvent slowly and test until the desired consistency is reached; the mixture should be thick enough to hold in relief. A thin mixture would run

VIII,27 BORIS MARGO, *The Wall*, 1964. Cellocut, embossment on paper.
Courtesy of the artist

and eventually flatten out completely. The support can be anything from Masonite, wood block, or Plexiglas to a strong paper. The choice depends on how it will be printed. If the plastic is printed alone, the support should be rigid; but if it is to be applied on top of a plate and printed simultaneously or combined with a woodcut, the support should be as thin as possible. Once the Lucite has hardened, it can be cut and engraved like any other plastic.

Engraving on Plexiglas

A number of printmakers use Plexiglas today. Some engrave it for intaglio printing; some cut it more or less like a wood block for surface printing. Recently the American printmaker Arthur Deshaies made several interesting intaglio prints on plastics (Fig. VIII, 35). Most of the plastics engrave quite well, although to someone like myself, accustomed to the feeling of metal, it seems rather "cheesy"—not offering the same resistance and control. The engraved lines on plastic seem to combine the characteristics we generally associate with two really contrasting techniques, the dry point and the engraving.

In other words, the cuts are swelled and tapering; they also have the directional control of the engraved line, but the edges are softer and fuzzier, more like a dry point.

Tonal areas can be achieved by scratching and sandpapering. The control of this is much more limited than the comparable aquatint would be on metal. In printing plastics, one has to be very careful because the surface mars very easily and scratches cannot be eliminated with as much facility as on metal. I have found also that in surface tonalities the plastic offers a much narrower range than metal.

As for surface printing, unles it is used in the context of a color print where the transparency is helpful in the register, I do not find that it has any special advantages.

The character of the print is quite similar to what one gets on Masonite or any fairly hard, closely grained wood, and it is not inexpensive. I feel that the use of a material should have either an aesthetic or an economic justification. I mention this because in recent years a number of artists have gone to a great deal of trouble just to find some kind of material that no one else has used. This is a poor substitute for originality and has succeeded only in driving a number of museum curators to despair, trying to figure out a proper classification for them.

COLLAGRAPHY

Collagraphy is based on the same principle as metal graphic. It is an additive method; the printing surface is built up. It is essentially an intaglio, but it can be combined with surface

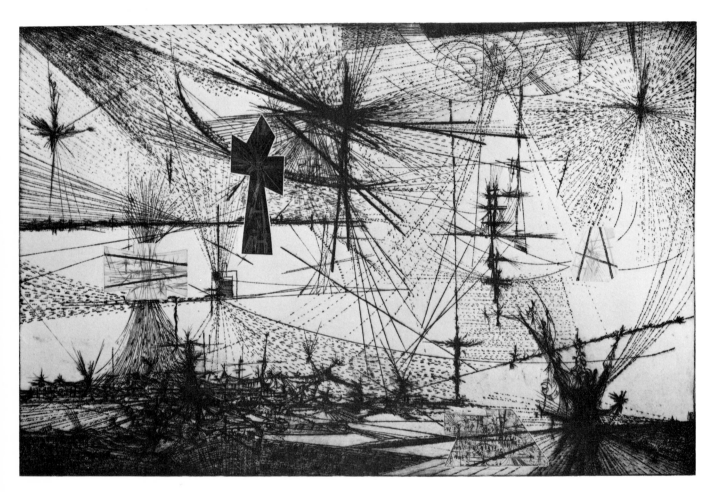

VIII,28 GABOR PETERDI, *The Vision of Fear*, 1953.
Etching, engraving, four-color intaglio, and surface color printed from rubber cast.
Collection of Washington University, St. Louis

printing. In recent years, collagraphy has become quite popular, partially because the materials used for making it are cheap and easily obtainable.

Essentially, collagraphy is a sophisticated version of a printing method used by children as an introduction to printmaking. This consists of gluing various materials and textures to a support (Masonite, cardboard) and thus creating a printing surface. Today, with synthetic rosins, plastics, and countless new materials available, the possibilities are limitless. In recent years I used this method in combination with metal plates, as I am interested in the printing quality of contrasting materials.

The Support

Any kind of thin and strong material can be used. Most popular is ⅛″ tempered Masonite. It is cheap and strong, doesn't warp, and besides, it can be carved. One can also use various types of cardboard (mat board, Upsom or Collins board); these have to be sealed well on both sides with shellac or Krylon or any other good varnish. I prefer synthetic rosins.

Besides wood and cardboard, plastics and thin metal sheets can be used.

Adhesives

To build up a tough, durable printing surface, one needs a good, strong adhesive. One of the most commonly used is polyvinyl acetate (TVA, Elmer's glue); however, one can use other glues, and plastics like Lucite. I prefer to all these an adhesive compound used by painters to put up sealing tape. This is a paste sold in gallon cans. It is inexpensive and has the advantage that besides gluing, it can be used to build up any kind of surface. Although it sets fairly fast, it allows enough time for manipulation. Once it is dry, one can sand it or even incise into it. I use Perf-a-Tape compound manufactured by the U.S. Gypsom Company, Chicago.

Surface Materials

The materials available for building up a printing surface are literally unlimited. For tonal areas (like aquatint) one can use sawdust, sand, carborundum, sandpaper, ground walnut shells, etc. For specific texture (like soft ground) one can set tarlatan, laces, crushed paper, etc., into the adhesive.

Sealers

After the building of the printing surface is finished it has to be sealed. The sealer has to be a liquid that one can either spray or brush on the surface. It has to be tough and

resistant to friction and to the solvents one uses to clean the plate. Heat resistance is also a desirable quality. The most commonly used sealers are white lacquer and polyester rosins. Spraying is preferable to brushing because it gives better penetration, it is faster, and it saves lots of brushes.

Printing

The collagraph is basically an intaglio process, but like most intaglio plates it can be combined with surface printing. Because of the great variety of materials making up the surface of the collagraph, it is more difficult to wipe than the metal plate; therefore, consistency in printing it is difficult to maintain. The textures are often sharp and have a tendency to tear the wiping materials. Considering all this, one should avoid a too sticky printing ink; therefore, it is better to use Easy-Wipe compound than oils to loosen the ink. It is also important to use a good, strong, heavy printing paper that can take lots of beating and a heavy embossment. As for the printing pressure, it is about the same as with any other intaglio print; one can't generalize. Each plate is a different problem. The only generality that might stand is that most collagraphs should be printed with a rather thick layer of soft felts.

PRINTMAKING AND THE "NEW LOOK"

In this last section on color printing I will attempt to review some of the most striking characteristics of contemporary printmaking. When I started to work on this revised edition of Printmaking, I reread the book looking for omissions of important new techniques. In summing up, it seems to me that few revolutionary new ideas have surfaced in the past decade. Instead, trends that started many years ago have become more sophisticated and have changed in emphasis. In printmaking, just as all the other arts, there are attempts to push the techniques beyond its limits. These attempts usually succeed only in forcing philosophical confrontation with the basic concept and definition of the printed image. When is a print not a print any more?

The Large Print

Prints started to grow forty years ago and they never stopped. In fact, the evolution of print closely paralleled painting. As the dimensions of paintings exploded to thirty to forty feet, the six-foot print became fairly common. The three-dimensional-shaped canvas

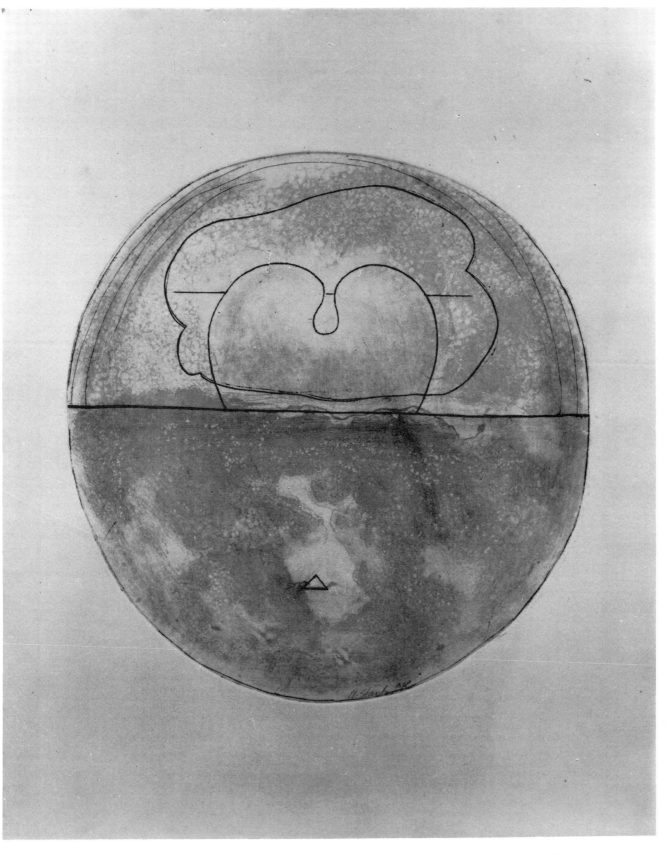

VIII,29 ANDREW STASIK, *Round Landscape, Summer*. Lithograph overprinted with etching, color. Courtesy of the artist

finds its equivalent in shaped, sculptural prints. All this inevitably affected both the concept and the technology of printmaking. As the print became increasingly "mural" it had to orient itself toward the monumental and decorative at the expense of qualities and characteristics generally associated with the graphic expression.

It goes without saying that to produce a six-foot print the artist needs space and equipment to accommodate it. From this point of view, intaglio printing demands the most complex and expensive adjustments. When I decided to make some rather large intaglios (30′ x 40′) I had to get a larger press, a new hot plate, acid trays, blankets, wet box, rollers, specially made paper, etc. I had to change my workshop and my working methods. Because few artists are in a position to do all this, most large prints are produced in commercial workshops and in a technique in which this service is available. That is one of the main reasons why most very large prints are silk screens or lithographs. The exceptions are woodcut and stencil prints because they can be made with very simple equipment.

The Sculptural Print

The sculptural print falls into two distinct categories—the embossed print and the shaped print. The white, uninked embossed print is a natural outgrowth of the very nature of the intaglio print. As early as the thirties it was used often by artists connected with Studio Seventeen but usually as a contrast to the inked areas of the plate. Today all over the world artists are producing paper bas-reliefs. The technical problems involved with embossment depend on the nature and complexity of the image to be embossed. The artist has to prepare a negative die. He can pick the technique and material best suited to his imagery. He can use metals, plastic, woods; he can etch it, cut it, or mold it. The printing problem depends on the depth of the embossment. Most embossments can be printed on etching presses, but for some exceptionally deep embossments a hydraulic press is needed.

The shaped print is a three-dimensional object. It is either made by cutting and folding the printed paper, or built by assembling pre-cut printed surfaces. Many of these are metal and plastic objects with some printing on them (usually silk screen). For most of these objects one has to stretch far the concept of print to accept them. After all, any object or structure carrying some printed matter could be called a print.

I feel that in this category the kinetic (moving) print should also be mentioned. We do not yet see many of these, but the present emphasis on light and movement surely will intrigue more graphic artists in the future. The attempts I have seen so far are rather crude experiments to reconcile antagonistic elements. The arbitrary decision to put a print on a moving part is not enough. A visually manifested, deep compulsion has to justify its existence. Of course I don't exclude the possibility that someone, someday will produce something exciting with this idea. When that happens, it won't really matter whether it is

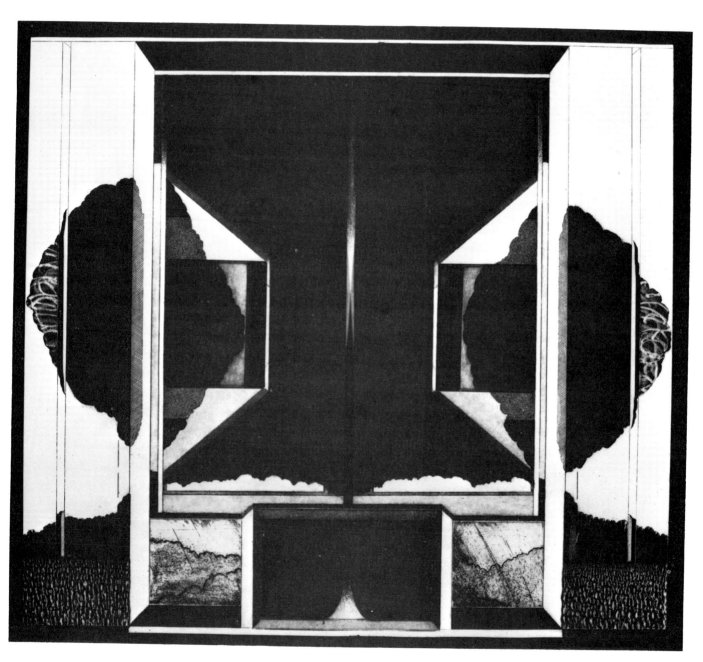

VIII,30 RONALD T. KRAVER, untitled. Folded three-dimensional intaglio in color.
Courtesy of the artist

a print or not. I am only a little tired of seeing art turned into the novelty business. The shaped-print idea already has produced some good prints and many new possibilities. Unquestionably the rigid division between the various media is breaking down and we are heading toward a synthesis of the arts.

Photography and the Print

In recent years photography has been playing an ever widening role in the development of printmaking. Photography participates in two important ways in the evolution of contemporary graphic arts—first, by its incorporation into the print as an integral part of our visual language, and second, as a means of reproduction. The use of the photographic image either alone or in conjunction with other media opens up limitless possibilities. Photography can be incorporated into the intaglio process in two ways: the image can be transferred and etched into a photosensitized plate; this can then be reworked or combined with other techniques. Or like a collage, halftone process plates can be combined with other plates and materials. The possibilities of combined photography and intaglio are so rich and varied that they could easily make the subject of an entire book.

Although I view the use of the photographic image in printmaking with great expectations, I am much less elated by the increased use of photography to make "original prints" out of paintings and drawings. I consider this profit-motivated practice detrimental to printmaking and to art in general. I am afraid that in the long run it may destroy the creative vitality of printmaking and erode the public's trust in the print.

Recently Peter Milton has been using a photographic method to transfer and etch his drawing into the copperplate. He uses this method now instead of lift ground because it gives greater control over the very fine details, and it is easier to manipulate. As I consider this information of great value for the printmaker I give you Mr. Milton's own description of this method:

> I do my drawings on Mylar (acetate could be used) with sugar ink. This has good opacity and it can be easily removed when changes are needed.
> The photo sensitive ground is Kodak's KPR 3. Dilute it 50–50 with KOR thinner. I flow coat the plate, letting it dry in upright position, then flow coat it again, and let it dry in the opposite upright position. The ground can also be put on using a 78 rpm turntable, using it full strength, but I had too much trouble with beading at the edge of the plate. I put the ground on at night, using a bug-lite bulb for a safe light. The ground has to be totally dry before exposing. Baking it in an oven for 10 minutes at 250° F. before exposing will ensure that there is no residual solvent in the ground.

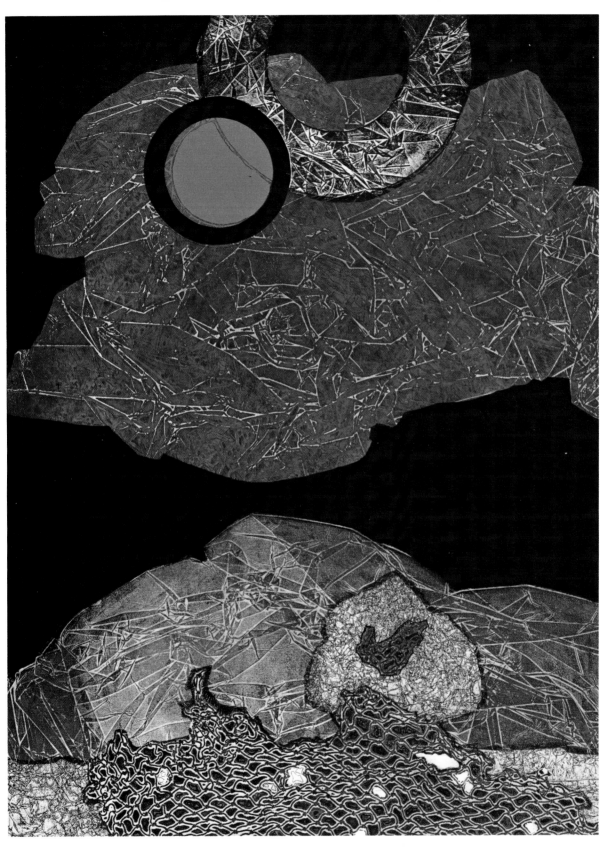

VIII,25 GABOR PETERDI, *Red & Blue Eclipse*, 1967.
Combined media color. Two intaglio plates plus two cut-out plates

VIII,31 JUAN GOMEZ-QUIROZ, folded five-color intaglio in Plexiglas, 1968.
Courtesy of the artist

VIII,32 J. L. STEG, mixed media intaglio with photoengraving.
Courtesy of Associated American Artists, Inc.

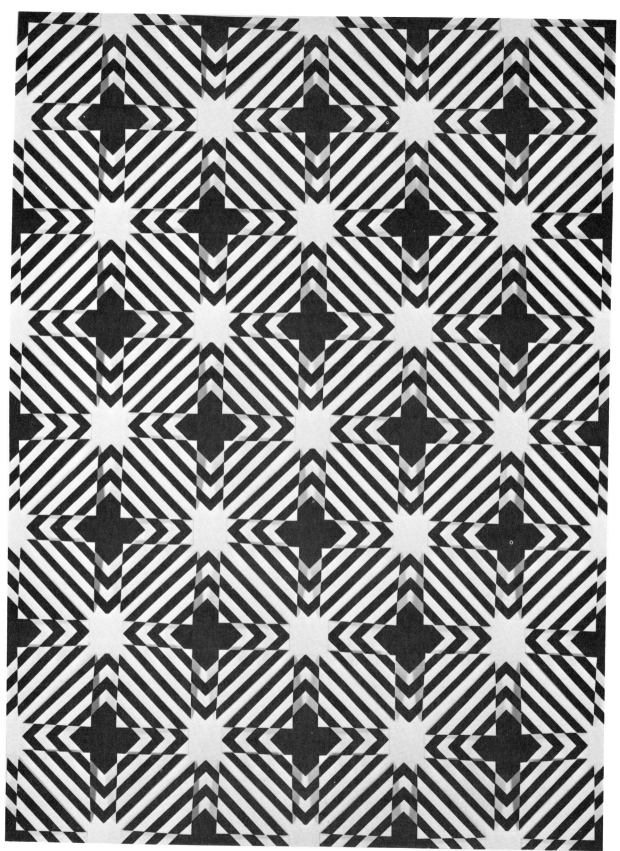

VIII,33 ANNE YOUKELES, *Square Dance*. Folded silk screen.
Courtesy of Associated American Artists, Inc.

The exposure can be done with any ultra-violet source: an arc-lamp, sunlamp, even a fluorescent tube. I use a sunlamp. The drawing is contact printed under a piece of plate glass.

The plate is developed in KOR developer for 3 minutes, then rinsed in running water. The plate can then be dyed in a solution of KPR Dye if maximum visibility is desirable.

The plate can be baked again for the toughest ground at 250° F. for 10 minutes, though this is not necessary. After this the plate can be etched. I use Ferric Chloride at 95° with the plate being agitated upside down in the bath. I do this by making tape handles on the back, holding the plate in the acid bath suspended by the tape. The ground is removed by a commercial stripper.

If more detailed information is desired write to: Eastman Kodak Co., Department 454, Rochester, N. Y. 14650 and ask for Pamphlet P-79, "An Introduction to Photofabrication."

VIII,34 GABOR PETERDI, *Bloody Sky*, 1951. Two-color intaglio

VIII,35 ARTHUR DESHAIES, *Engraving on Lucite*.
The Brooklyn Museum Collection

VIII,36 GABOR PETERDI, *Arctic Bird I*, 1964.
Combined media color. Cardboard and zinc plates.
Relief, soft-ground, hard-ground etching, engraving, intaglio, and surface printing

IX,1　TOSHUSAI SHARAKU, *Azaiki Rijkuse*. Color woodcut.
Courtesy of The Brooklyn Museum

Nine

WOODCUT AND
WOOD ENGRAVING

INTRODUCTION

THE EARLIEST PRINTS made by man were printed from wood blocks. In China the Paul Pelliot Expedition discovered prints made in the ninth century. The first European woodcuts were produced much later—at the beginning of the fifteenth century.

Before I go any further in this discussion, I wish to clarify the existing confusion on the distinction between woodcutting and wood engraving. It is customary to call any cutting done on the end grain block a wood engraving, and any cutting made on the wood sawn plankwise a woodcut. This type of distinction seems to disregard completely the character of the art work and the technique used to achieve that character. This is one of those

situations in which it is difficult sometimes to make a clear distinction, and I think many of the early German and Japanese woodcuts are really mixtures of both techniques (Fig. IX, 1, 2).

The Japanese cutters—and the same is true of most of the early European print-makers—used only wood with sufficient density and close grain to allow the finest detailed work.

In view of these reasons, I feel that the correct definition should indicate the technique and conception instead of the wood block used. I would call a wood engraving any print wherein the majority of the work was dong by engravers; therefore, such a print has a predominantly linear conception, while any work done with knives and gouges, and conceived in broad, openly cut areas, I should call a woodcut.

The early European woodcut was conceived mainly as a linear definition, often filled in by hand coloring later. These woodcuts had a great deal of strength, achieved by simple and direct means. Crosshatching and textures were used sparingly. As the technique of cutting became more and more sophisticated, parallel with the evolution of the "master" conception in European art, it was progressively relegated to the reproduction of pen drawings. In most cases, the master who made the drawings had very little to do with the cutting itself. A great deal of the crosshatching (completely alien to the character of the woodcut) used in these prints is the best proof of this. Whenever a master cut his own block, this element was reduced to a minimum or totally disappeared.

The Japanese woodcut also belongs to the reproduction category, although their master drawing was developed with a great understanding and respect for the character of the medium.

The system of employing skilled craftsmen for the cutting was used chiefly for reasons of economy and physical necessity. The production of Dürer, Holbein, and all the other masters of this period was so enormous that even if their life span had been ten times longer they could not have cut all their blocks.

As for the Japanese masters, Hokusai, for instance, produced over thirty thousand prints in his long life, many of them intricate color blocks.

The contemporary printmaker cuts his own block. That practice in itself introduced a totally different attitude toward the medium. We regard the cutting itself as an important aspect of the creative process (Fig. IX, 4, 5, 6). This is especially important when we take into consideration that no two pieces of wood are exactly alike. Therefore, the organic character of the material offers infinite variety in cutting to the sensitive craftsman.

The basic distinction between working on metal and on wood is that on an intaglio print the drawing is built up by addition, while the wood engraving reveals the drawing by cutting away the superfluous wood. Wood also has a tendency to impose itself on the

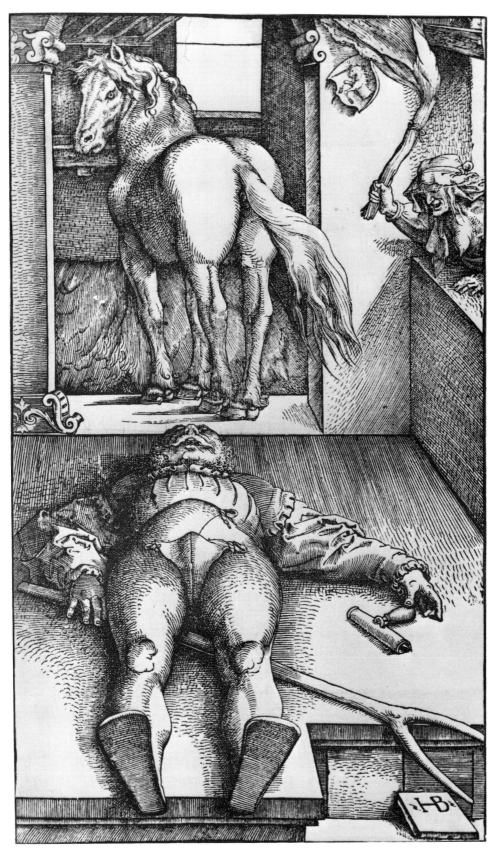

IX,2 HANS BALDUNG GRIEN (1484–1545), *The Groom Bewitched*. Woodcut.
Yale University Art Gallery

artist to a much greater degree than the metal, although there are marked differences between the metals (age, manner of manufacture, and so on). Still, they are much more consistent and predictable.

Each time the printmaker begins to work on a wood block, he has to adjust himself to new conditions. Working on the end grain of the wood offers more control because the graver or the gouge can travel freely in any direction (Fig. IX, 3). This is not true with the board cut plankwise, where the cutting is much easier traveling with the grain than against it. This makes the selection of the wood very important.

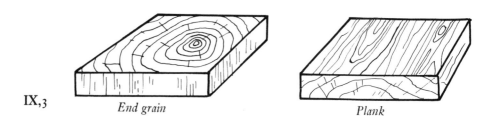

IX,3 *End grain* *Plank*

THE WOOD

In selecting the wood the following qualities should be considered:

The wood should not be too hard or too soft; a hard wood like oak is too difficult to cut, and the soft, spongy wood does not yield any fine detail work and would break down in the printing process. A fine, evenly distributed grain structure always yields more control than the broad, unevenly distributed grain; a knot or chip has to be considered a great disadvantage unless the effect of it can be incorporated in the composition. The wood also should be well seasoned and dry. A wet block—one filled with resin—is difficult to cut and may curl up and eventually split in printing. A soft, open-grained wood can be hardened to a great extent by saturating it with boiled linseed oil.

In order to protect the wood from humidity, cover all sides with oil. This treatment also makes the first printings easier, as it eliminates the oil absorption.

How to Straighten a Warped Block

A warped plank can be straightened, but it has to be done carefully and gradually, especially if the warping is excessive. The best procedure is slightly to dampen or to steam the wood, then place it under pressure. Large screw presses are excellent for this, but the pressure should be applied gradually. If a press is not available, then either place weights

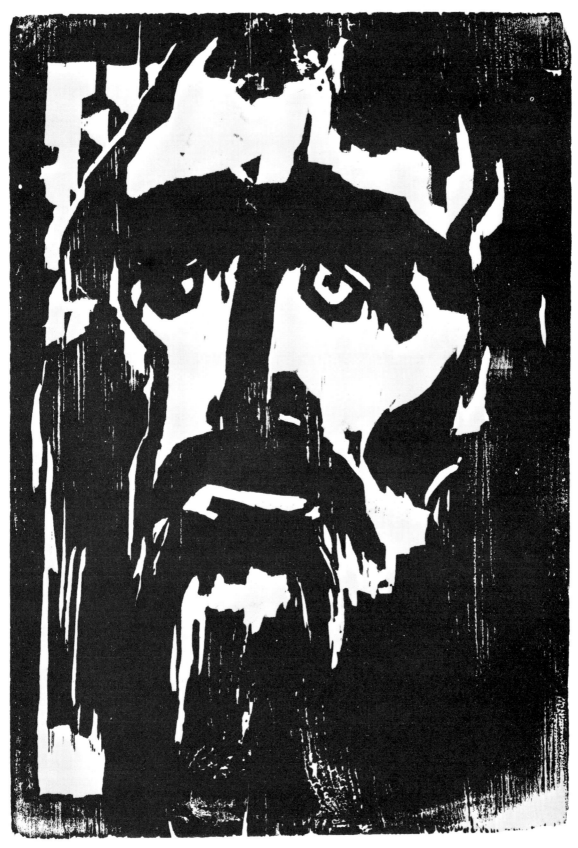

IX,4 EMIL NOLDE, *Prophet*, 1912. Woodcut.
The Museum of Modern Art, New York

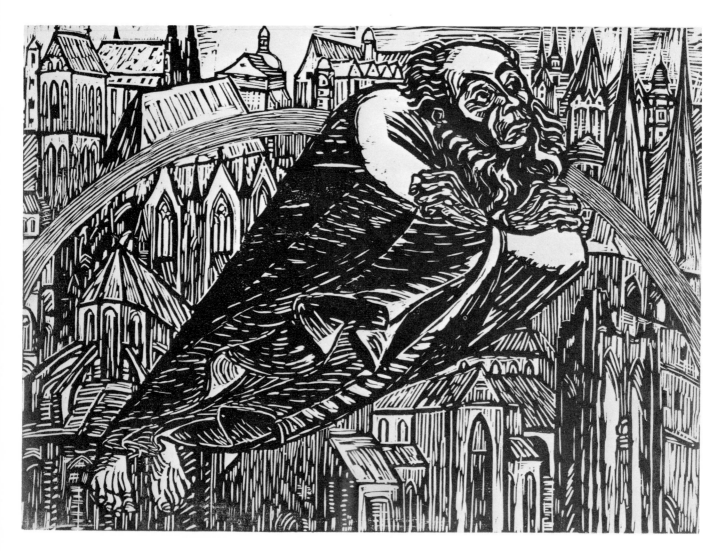

IX,5 ERNST BARLACH, *God Over the City*, 1921. Woodcut.
The Museum of Modern Art, New York

IX,6 LEONARD BASKIN, *The Anatomist*, 1952. Woodcut, black and red.
The Museum of Modern Art, New York

on the block or apply cross braces on the block for straightening. With warped blocks it is always advisable to strengthen them with cross braces.

The most generally used woods are: cherry, lime, maple, sycamore, bass, white pine, redwood, mahogany.

The end-grain blocks are very expensive; and as they are limited in size, for large prints they have to be glued together. For the huge woodcuts we are accustomed to seeing to-day, the end grain is out of the question for technical and financial reasons. In any event very few printmakers would be foolish enough to attempt to stretch a medium suited for miniature work into mural proportions.

For engraving, boxwood blocks are the best. The finest come from Turkey, but boxwood is quite expensive. Here cherry and maple are good, although more uneven in texture, and therefore less suitable for extremely fine details.

If the cutting is not too deep, the wood block can be resurfaced once or twice and built up from the bottom as it is printed in the press. The end-grain blocks are cut type high, and as they are generally printed either on hand-operated or machine-driven presses they have to have a perfectly true surface. The slightest unevenness would considerably affect the print.

A woodcut is generally printed today by the rubbing or spooning method. Therefore neither the thickness nor the trueness has a vital effect on the printing.

Besides the regular woods, plywood can be used also, but it has great limitations. It is suited only to the printing of large simple areas and very shallow cutting. Because the grain of each successive layer of wood runs in the opposite direction, the cutting is unpleasant and hard to control; unless one has razor-sharp tools, the chipping of fine lines is unavoidable. Plywood is most frequently used for the underprinting of large color areas.

Masonite can be used also, but mainly for color printing. It lacks the life and quality of wood, and in many respects is comparable to the linocut. Masonite comes in two grades—hard- and soft-tempered. The hard-tempered grade is better suited for detail work and withstands the printing better. For the cutting, only the sturdiest razor-sharp tools are advisable. I have ruined Japanese gouges on Masonite because of the softness of their steel. The soft-tempered Masonite has a tendency to tear if cut with a dull tool, and fine details would easily crumble under the printing pressure.

I have found one of the best sources for wood in old furniture. Sometimes one can pick up, for very little money, an old cabinet or a chest of drawers that yields well-seasoned fine planks far surpassing in value the cost of the furniture.

For the collage type of woodcut, veneers can be used. The veneers can be purchased in sheet form. After the desired shapes are cut out, they can be glued to the most suitable support—cardboard, Masonite, plywood, and so on. Finer details are generally cut after

宝永山
出現

IX,7　KATSUSHIKA HOKUSAI (1760–1849), *Storm,* from *The 100 Views of Fuji,* Volume I. Woodcut.
The Metropolitan Museum of Art. Gift of Howard Mansfield

the veneer is glued on the support. This method, within its limitations, offers interesting possibilities—for instance, the availability of a great variety of grains within one block, as well as the maneuverability of the direction in which the grain is running in relation to the faults.

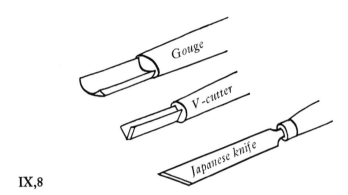

IX,8

TOOLS FOR WOODCUTTING

SCRIVE: V-shaped hollow burin, top edge set back slightly.

ASSORTED HOLLOW ROUNDED GOUGES: it is handy to have at least 3 sizes—a fine (about ⅛″), medium (¼″), and large (⅜″). For making very large cuts it is good to have one or two extra-large rounded and V-shaped gouges used by wood carvers.

JAPANESE KNIFE with a cutting point at approximately 30° angle (Fig. IX, 8).

Besides the tools, a BENCH HOOK is also needed. This can be easily constructed by the printmaker. Take plywood, the size depending on the dimension of the woodcut; attach a piece of 1 by 2 with screws on one end. Then turn the plywood over and attach another 1 by 2 on the opposite end and side of the plank. When the bench hook is placed on the working table, the 1 by 2 placed on the bottom hugs the edge of the table. This helps to keep your wood block securely in place while cutting without holding or the use of clamps (Fig. IX, 9).

METAL CLAMPS can be used also, but they are less handy, as they must be taken off and put on every time you change the direction of your cutting. If metal clamps are to be used, always place a piece of cardboard between the clamp and your wood block, as the clamp has a tendency to crush the wood and leave a mark that would show in printing.

Here I wish to add that most of the woods are much more sensitive and soft than is generally realized, and they have to be handled carefully in order not to injure their surface.

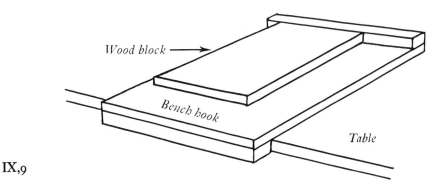

IX,9

The slightest scratch or knock may leave an indentation that will show in the print. Even in tracing a drawing on wood, if a hard pencil is used, it may leave a mark that will show up clearly as a white line on the print.

Wooden Spoons for Rubbing

It is advisable to go over the spoon surface with fine sandpaper in order to have a completely smooth surface. It is also good practice to saturate the rubbing surface with linseed oil in order to harden the surface.

Inking Rollers

It is important to have a number of rollers of assorted dimensions and qualities. Hard rubber rollers are good only if the wood surface is completely true. I have found gelatin rollers much better, as the color can be rolled on the block with less pressure, and also the quantity of ink deposited on the wood block can be better controlled.

SHARPENING OF THE TOOLS

In order to cut with any degree of control, the woodcutting tools have to be kept in razor-sharp condition. While dull tools are hard to manage on metal, on wood they become destructive. They slip, chip, tear, and are totally unmanageable cutting cross-grain. When you look down the edge of a tool, it should not show any reflection of light. You

should always have a piece of wood handy for testing purposes. The testing should be done cross-grain.

For sharpening, a combination Norton India oil stone can be used, the same type of stone that is recommended for burins. For Japanese tools, a softer wet stone is advisable, as their steel can very easily be overground. Correctly to sharpen round hollow gouges on a flat stone requires practice. The trick is to roll the tool between your fingers as you pass it over the stone in order to grind the whole curved surface and not just one point. The difficulty is to keep the gouges at a steady angle, yet achieve coordination between the rotation and the rolling.

The V-shaped gouge is sharpened on its two sides with a push-and-pull motion. It is very important to retain the set-back cutting point profile while sharpening this tool. Otherwise it won't behave properly. The V-gouge is designed to be pushed while held at a sharp angle to the wood. A distorted profile would either make the tool go too deep and undercut the grain, or slip out if the depth of the cut is checked. The meeting point of the two side blades is ground up in the manner of a fine hollow gouge. This is the critical point that inexperienced hands generally ignore, sharpening the wide blade and leaving the penetrating point of the tool dull. This will make the V-gouge tear the wood when used cross-grain.

The Japanese cutting knife is sharpened in the same manner as any knife blade.

I wish to say a few words about some of the woodcutting tools that are available in sets. Several companies offer sets of assorted woodcutting tools. The best known are the Millers Falls tools. They have two sets, one with short round handles and the other with long handles. One set costs a little more than the other. I could not find a great deal of difference between the tools except their handles and the boxing. The type of handle one might use depends upon personal preference; each type of handle is a compromise. I have found the Japanese knife with the round handle especially difficult to manage, as this type is totally unsuited for the way this tool should be held when cutting. Therefore I think it is a good idea, if one has any of these sets, to readjust the handles to his own grip by filing and sanding where necessary, or by padding with tape.

In recent years a great number of Japanese tools have been imported. They are much cheaper than American or European tools; and, although their steel is inferior, I consider them excellent buys for the money. But, as I have mentioned already, they have to be sharpened with some care and their handles have to be strengthened with friction tape because they have a tendency to split under pressure.

One of the annoying aspects of buying assorted sets is that one always ends up with some tools that one does not need. This is especially true of the Japanese sets, which are generally loaded with knives and chisels instead of gouges. I received a very elaborate set

of Japanese tools, sent to me directly from Japan by a friend, that had such strange tools in it that up to today I haven't figured out what they are good for.

The fact is that for woodcutting one does not need too many tools. With the half-dozen I have mentioned, kept in good shape, one can do anything.

WORKING ON THE WOOD BLOCK

As I have already mentioned in a previous paragraph, it is a good idea to saturate your wood block with oil before the cutting begins if this is practicable (saturation with oil should be done at least a few weeks before the wood is used), or put a couple of coats of light shellac on the wood in order to seal its pores and make the surface a little harder. The shellac should be thin, cut about 50 per cent with alcohol in order to let it sink into the wood deeper.

After the first coat is dry, sandpaper the block and put on the second coat. After the second coat, sandpaper again. Use extremely fine paper or an extremely fine steel wool.

Drawing on the Wood Block

The working method on the wood block is very personal. It depends a great deal on the working habits and temperament of the artist. The choice is to draw directly on the block, to trace a drawing, or to cut without any drawing at all. If a drawing is used, there are two choices: either to draw with black ink on the light wood, in which case the wood is cut away from the positive image, or to blacken the wood surface approximately as it would appear in print before it is cut and then draw on it with white paint. In this case the drawing is cut out as a negative image. If one prefers to work directly in the wood without any drawing at all, the wood surface should be blackened so that you can clearly see the cuts as they are made.

In making your drawing on the block (this is especially important if you are not an experienced printmaker), keep in mind the medium and use a drawing method at least approximately of its character. In other words, instead of using a fine pen or pencil that would be too linear, it is better to use a brush with poster paint or India ink. The woodcut should be bold and simple, developed in terms of large masses of light and dark areas with fairly coarse lines and textures used as a change of pace.

Going back to the choice of whether one works on a light or dark background, my ex-

perience has been that on a light background generally the whites dominate and on a black background the darks.

The drawing should function more as a quide than as something you want to follow slavishly in your cutting process. I feel very strongly that the artist should let the medium express itself in the process of work. The feeling of cutting is so totally different from that of drawing that it is impossible in the drawing stage to foresee how every detail is going to work out.

The cutting technique in itself is very simple and does not take too much practice to develop good control.

The first step is to put the block in position for cutting on the bench hook. The use of clamps is not advisable in the beginning, as the block most probably will have to be

IX,10 *Cutting with Japanese knife*

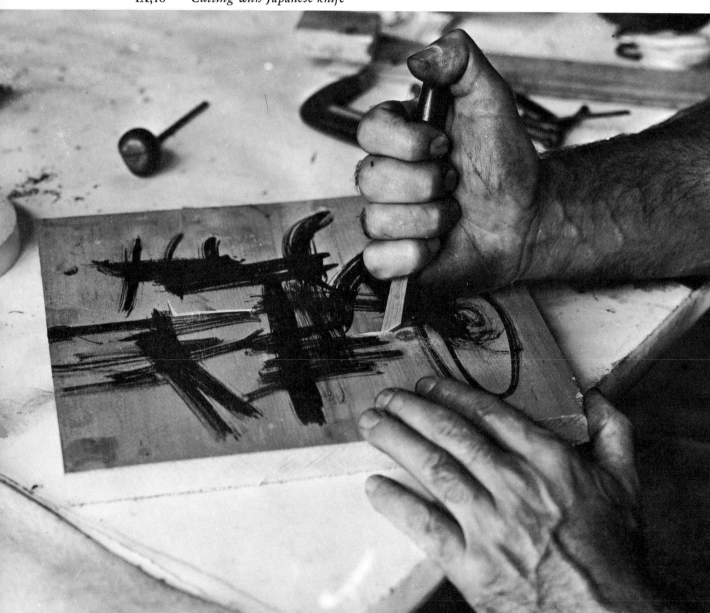

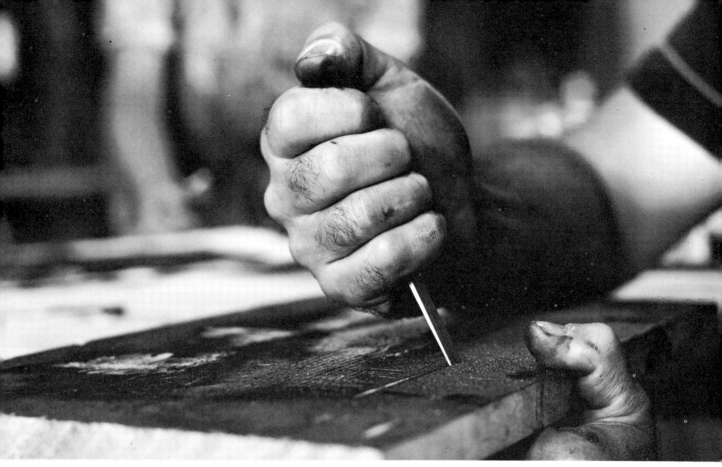

IX,11 *Cutting a line with a broad base*

turned around a great deal and the constant manipulation of the clamp is an awkward procedure. Without a bench hook it is better to hold it with one hand while you cut with the other.

One safety measure has to be kept in mind continuously: never hold a block in front of the cutting tool. It is especially dangerous with gouges, as the wood, being uneven in texture and in resistance, may easily cause you to slip.

How to Use the Japanese Knife

For definition of forms and lines when a really sharp, clean edge is desirable, use the Japanese knife. Hold the knife exactly as you would hold a dagger, gripping it firmly in your fist. Sink the point of the blade in the wood and draw it toward you, exerting pressure with your whole body and not with the arm alone (Fig. IX, 10). The blade should be slightly tilted, as the base of a line in woodcut should always be broader than the top. In other words, the line should have pyramidal shape. This gives added strength to withstand the printing pressure. An undercut line would easily chip (Fig. IX, 11, 12).

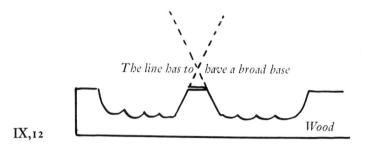

The line has to have a broad base

Wood

IX,12

Gouging the Wood

After the line is defined with two V-shaped cuts, the rest of the wood can be taken out with the various gouges. In using the gouges to cut out a large area, consider very carefully in which direction you are going to do your gouging. Generally, when the wood is superficially cut away, a great deal of texture remains, and the direction in which these textures are running has a very important effect on the composition. The general tendency is to cut with the grain, as this is the easiest; but it would result in a very dull and monotonous surface quality if all the textures on a wood block ran in the same direction.

The basic principle to follow in determining the direction is to relate it to the general dynamic intent of the form itself (Fig. IX, 19). In other words, the textures should move in the same direction as the form.

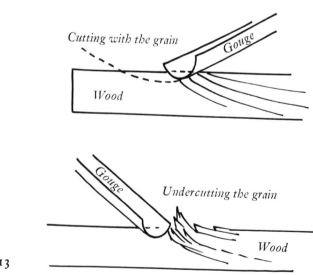

Cutting with the grain

Gouge

Wood

Gouge

Undercutting the grain

Wood

IX,13

The Danger of Overcutting

One of the most important things to keep in mind in the first stages of cutting a wood block is that you can always cut more wood away but you can't put the wood back. Therefore, don't try to finish the cutting before the block is printed. The wisest thing is to print as soon as there is enough work on the block to fix the general sense of the composition, and to keep on printing as the work progresses. The look of a wood block is very misleading. Even if you work against a darkened background where you think that you see the effect, the print will be totally different. You have to keep in mind that the woodcut is a bas-relief where the shadows and light are playing a very important role. Add to

IX,14 *Cutting with a large gouge*

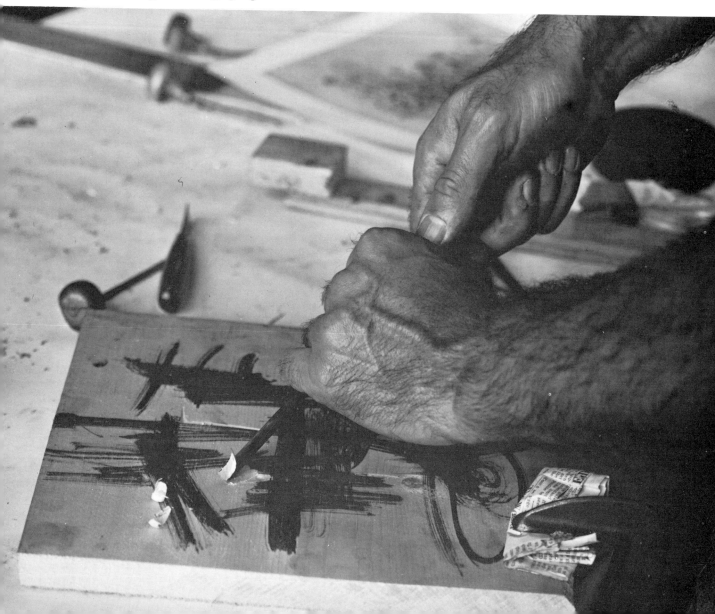

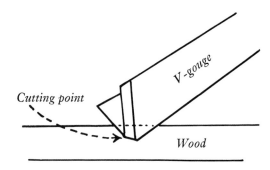

Cutting point

V-gouge

Wood

IX,15

this the color and the texture of the wood, and you realize that the cuts flattened out on the white paper will have a different impact.

Beginners have a tendency to overcut their first block. As a matter of fact, it never seems to fail, no matter how much I warn my students of this danger; they always end by cutting more wood than they should have.

One of the problems is the general reluctance to print, partly from laziness, partly because they are afraid that by rolling up the block they lose the drawing. I personally consider the obliteration of the sketch desirable after the basic structure of the composition has been cut into the wood. This way the artist is forced to create his image by spontaneous cutting instead of by copying the drawing.

The Depth of Cutting

On using the gouges (Fig. IX, 14), the choice of size depends on the area and the quality of the texture desired. A wide gouge would give a broader, coarser texture than a fine gouge. In many instances a mixture of different types of cuts is desirable on one area. The variety of textures an inventive artist can achieve with a limited number of tools is practically infinite. The cutting does not have to be very deep. As a matter of fact, it is better to keep the cutting shallow for several reasons. First, it is much easier to control a shallow cut. If the gouge is too deep in the wood it has a tendency to undercut the grain and lift it (Fig. IX, 13). The result may be splintering. Second, if any correction is needed (resurfacing an area), it is much more difficult if the cuts are too deep. Third, deep cutting is not necessary where you have close textures—only in wide-open areas where the roller does not have enough support.

Clearing Between Lines

In using the gouge, you have to be particularly cautious when clearing the wood between two lines, especially if the direction of the gouging is not parallel with them. As it is very easy to slip and cut into a line, you should never cut toward them, but always in the opposite direction. Start from the line, proceed about halfway toward the other, then turn the block around and repeat this procedure, meeting the other cut in the center.

The cleaning out of the completely white areas should be left to the very last.

TEXTURING

Besides cutting with conventional tools, many other techniques can be used to achieve interesting texture effects. As I mentioned before, the wood is more sensitive than is generally believed; therefore it is quite easy to press or hammer textures into it. For instance, a wire mesh can be very easily pressed or hammered into any of the softer woods like pine or bass. Nails or any pointed instrument can be used to punch or scratch fine textures into the wood. The only disadvantage of these fine or shallow textures is that they fill up easily with printing ink and the blocks have to be cleaned continuously during the printing of an edition.

Heightening the Grain

Artists often like to exploit the natural grain of the wood (Fig. IX, 29). If the grain is not high enough to print clearly, it can be heightened with steel wool, sandpaper, or a wire brush. If you rub the wood, using fairly coarse material, parallel with the grains, it will wear out the softer part of the wood and let the hard grain stand in relief (Fig. IX, 16). At times I use the wire brush on an electric drill to do the same thing. This, however, has to be used with caution, for the wire brush has a tendency to cut into the grain, thus creating a fairly mechanical light gray texture.

In making a surface print, it is also possible to build up on the wood as well as to cut into it. In other words, various materials can be glued on top of the block in order to get their textural effect and print it. If the material is too soft or absorbent for proper printing, it can be hardened by a generous coat of shellac or plastic spray. These effects have been used a great deal recently in experimental printmaking. They are, in a sense, the equivalent of the textural effects used in soft-ground etching.

CORRECTING THE WOOD BLOCK

Correcting a wood block is not an easy matter because in most cases it means the resurfacing of a whole area.

The simplest procedure is to plane down the section to be corrected, but in order to avoid difficulties in printing it must be done with a gradual incline. Therefore it always involves the destruction of a fairly large area.

IX,16 *Heightening of wood grain with wire brush*

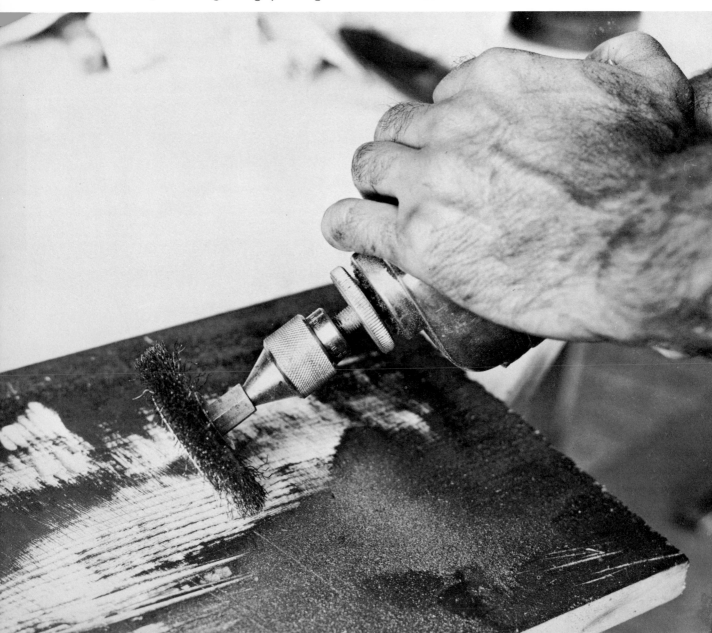

After the block is planed down, it has to be sandpapered and steel-wooled very carefully, as it is practically impossible not to leave some plane marks on the wood. This procedure is only possible if the block is to be printed by hand rubbing, where a slight deviation of the surface level does not matter. If the block is to be printed on a press, the only possible way to correct it is to chisel out the whole section; then set it in another wood block and carefully level it off. This has to be done so perfectly that it is advisable to take the block to a woodworking shop where they have large planing and sanding machines. They can do a perfect job in a fraction of the time it would take anyone attempting the same work by hand.

In inserting a wood block, it is practically impossible to have a perfect fit. Therefore any cracks that show can be filled up with plastic wood. Plastic wood is also often used to fill in imperfections that occur in most of the wood cut plankwise. Because the wood filler has a tendency to shrink when it dries, make the filling slightly higher than the level of the block and then sandpaper it down when it is dry. If the imperfections in the wood are too shallow, they will not hold the filling. In this case, it is best to deepen and rough up the holes to be filled in order to provide a firm anchor for the filling.

PRINTING THE WOOD BLOCK

Wood blocks can be printed both on a press and by hand. Most woodcuts today are printed by hand rubbing. This is basically the same principle the Japanese used (Fig. IX, 25).

In order to print on a press, the block has to be perfectly true; it also imposes severe size limitations. Hand rubbing is fairly tiresome, especially with a very large block, but it is much more sensitive and it offers much greater control than mechanical printing.

The Printing Ink

There are several different types of inks that can be used for wood-block printing. They can be either water-base or oil-base colors. The advantage of the water-base colors is that they don't have the rather unpleasant shine of most of the printer's inks. On the other hand, they dry fast. Therefore they don't lend themselves so well to the printing of large blocks as oil colors do. For black-and-white prints I generally use commercial printer's ink or litho ink. The printer's ink is ground in a special varnish and dries a great deal faster than ordinary oil colors.

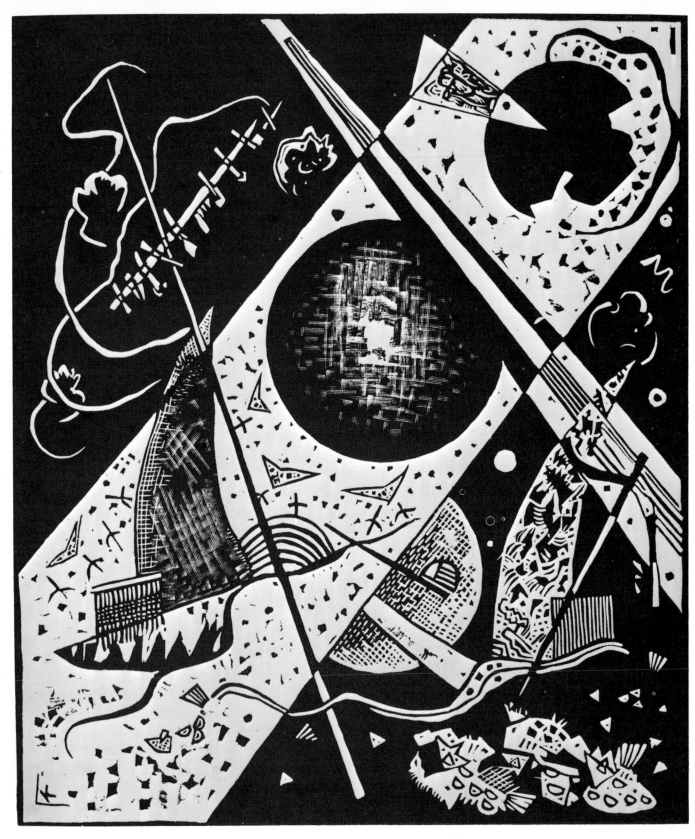

IX,17 VASILI KANDINSKY (1866–1944), *Abstraction*. Woodcut and wood engraving.
The Brooklyn Museum Collection

The Paper

In order to make a rich print with hand rubbing, one has to have a soft, sensitive paper. The Japanese rice or mulberry papers are the most commonly used. They are excellent and inexpensive, but they have to be handled carefully as they don't stand much wear. Recently a number of printmakers have used a special paper (produced domestically) which has most of the qualities of the Japanese papers but which is much stronger and therefore better suited for large prints or color prints in which the paper is subjected to multiple printing. This paper also has the advantage of coming in a roll, thereby offering much greater variety in sizes than the standard rice or mulberry paper sheets. The one I use is manufactured in Boston by the Technical Paper Corporation. It goes under the trade name Tableau.

For the first trial prints, ordinary newsprint or any cheap paper can be used, but they generally do not give you a completely true image of your wood block. If you have only a heavy, stiff paper available, a slight dampening will soften its fibers and help a great deal in printing. One has to be cautious, however, in rubbing a damp paper, as it tears easily.

The Rollers

For rolling out the colors on the block, one can use either rubber composition rollers or gelatin brayers. Hard-rubber rollers are usable only on blocks with a completely true surface. If there is the slightest unevenness, the hard roller will miss the low areas, and the result will be an uneven, spotty print; or else you will have to deposit so much ink that it may squash and close in the fine lines. I have found the gelatin rollers by far the best, although with these one has to dig out the wide white sections deeper, as these rollers have a tendency to deposit ink in the shallow areas because of their flexibility.

The Rolling of the Block

The ink has to be rolled out on glass or on a marble slab. The ink in the tube is practically always too heavy. Therefore a few drops of light linseed oil have to be added; but do not make the ink too oily because it has to have body to give a rich surface. Furthermore, an excess of light linseed oil may cause a very unpleasant-looking "bleed" of the edges of the printed areas.

The roller should never be overloaded with ink. It is always much more advisable to go over the block several times, depositing the necessary quantity of ink gradually, than to

IX,18 JOSEF ALBERS, *Encircled*, 1933. Woodcut.
The Brooklyn Museum Collection

IX,19
ERNST LUDWIG KIRCHNER,
Head of L. Schames, 1917.
Woodcut. The Museum of
Modern Art, New York

IX,20 HENRI MATISSE, *Seated Nude*, 1906. Woodcut.
The Museum of Modern Art, New York

IX,21 PABLO PICASSO, *Head*, a fragment, 1906. Woodcut.
The Brooklyn Museum Collection

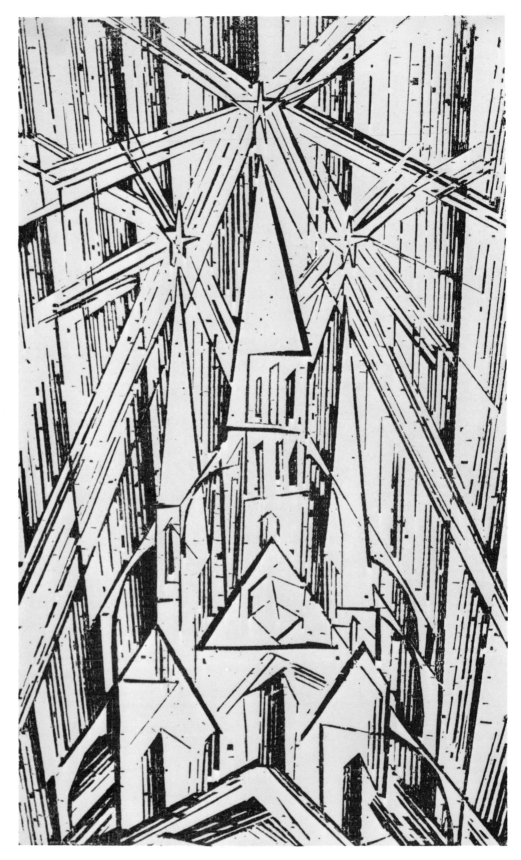

IX,22 LYONEL FEININGER, *Cathedral*. Woodcut.
The Museum of Modern Art, New York

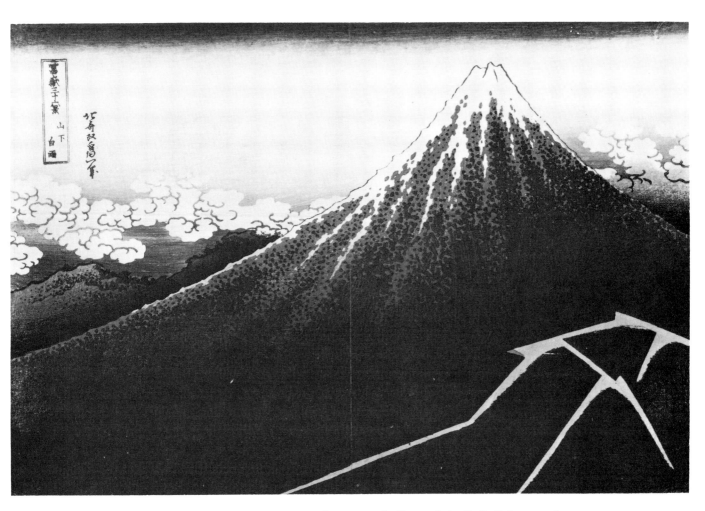

IX,23 KATSUSHIKA HOKUSAI (1760–1849), *Lightning at the Foot of the Fuji*. Color woodcut.
Courtesy of The Brooklyn Museum

IX,24 RUDY POZZATTI, *Venetian Sun*. Woodcut.
The Brooklyn Museum Collection

try to do it all at once. Too much ink on the rollers will fill in the fine lines or textures, and generally gives an uneven, unpleasant surface.

In preparing the block for printing, the first step is to clean the wood of any chips or dust that may remain in the cuts. Nothing can cause more trouble in printing than bits of wood mixed into the printing ink. They tear the paper, print white pockmarks, and ruin the gelatin rollers in no time.

As I mentioned before, the ink is then rolled gradually on the block. You can tell whether the ink deposit is sufficient by checking over the surface carefully to see whether it has an even shiny look, and also by testing it with the roller. If the block has sufficient ink on it, you cannot pull the roller up without lifting the block itself slightly. This is important because the paper should stick to the block. If you do not roll enough ink on the wood block, or if the ink is too light in body, the paper will not stick to it, and will slip and slide under the rubbing pressure, giving you a poor, blurred print.

IX,25 *Rubbing a woodcut with spoon*

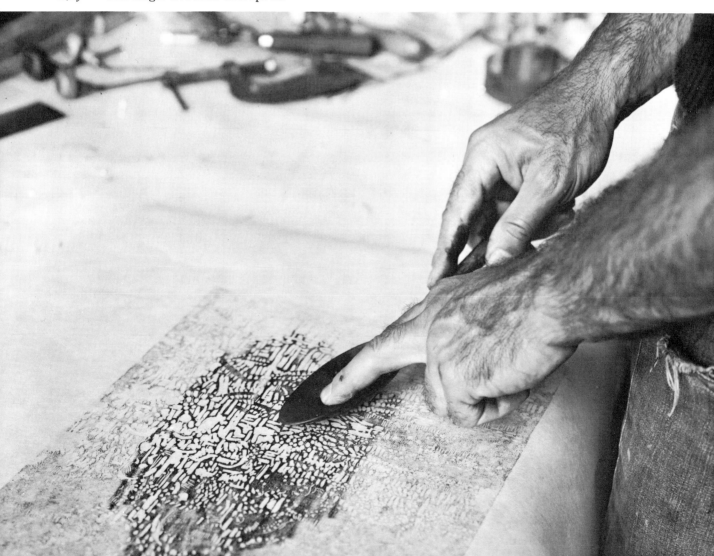

Printing by Rubbing

After the paper is placed on the block, it should be lightly pressed with the palm of the hand from the center out toward the edges. This is to make sure that the paper lies evenly without wrinkles. The rubbing with the spoon should follow the same pattern from the center out. If one is using the correct paper, the image should become clearly visible on the other side as it is rubbed (Fig. IX, 25). After some experience one can then easily judge whether the ink deposit was sufficient or not. In addition, this offers the possibility of tonal control by varying the rubbing pressure in different areas. This is, however, a procedure that few printmakers use today, as it is difficult to control through a whole edition.

Re-inking

If you feel that the block was not inked sufficiently, in order to give a solid rich color, it can be re-inked by sections with the paper on it. This is a slightly risky procedure, but with some luck one can often save the print. The procedure is to fold one-half of the paper back while the half stuck to the block holds it in position. After the uncovered part of the block is re-inked, the paper is carefully pressed back in position and the same procedure is repeated with the other half. The only danger in this procedure is that the slightest shift in the paper's position will result in blurred passages. The rubbing itself has to be done very methodically, section by section, with overlapping strokes, as an uneven, careless printing will result in a streaky, uneven print full of spoon marks.

After the print is finished, it should be tacked loosely to a board to dry. Printer's ink dries fairly fast, and twenty-four hours is generally sufficient for safe handling.

In printing a whole edition, if one does not have surface area enough—walls, tables, or special racks—the prints should be put between blotters just as etchings are.

COLOR WOODCUT

The first true color print that Western man saw was the Japanese color woodcut (Fig. IX, 1). These prints were seen at times by adventurous travelers who succeeded in penetrating the bamboo curtain of the mysterious Japan of the eighteenth century. These people looked at them more as exotic curiosities than as works of art. We can't blame them, as the Japanese themselves had hardly any idea of the meaning and significance of their prints.

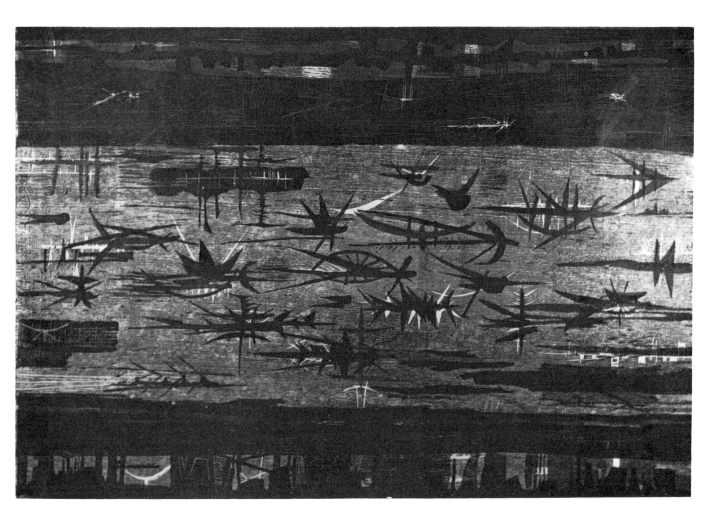

IX,26 GABOR PETERDI, *Spawning III*, 1954. Woodcut, four colors

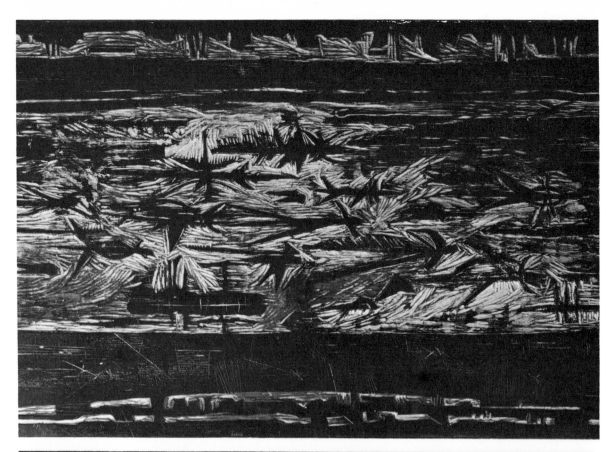

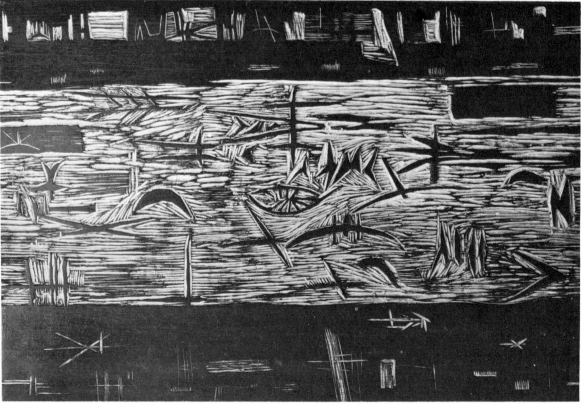

IX,27 GABOR PETERDI. Woodblocks No. II and No. III for *Spawning III*

The Japanese woodcut was made for the people. They used them and enjoyed them, but the aristocracy (the people who "knew") liked only the traditional painting influenced by the Chinese, and looked down on their own prints as something vulgar—good enough only for the common people.

A few of these prints brought from Japan by travelers got into the hands of the impressionists. We know what terrific impact the discovery of the new art form had on Toulouse-Lautrec and Van Gogh, not to mention Whistler. At the turn of the century Europe experienced a real craze for Japanese things and bought up prints as fast as they could get them. Ironically, by the time the Japanese art experts discovered what they had, practically all the fine prints were in European collections and museums and they had to go to European auctions and buy back some of their own prints for a hundred times the sums for which they had been sold.

This story has no direct bearing on my discussion of technique, but I couldn't resist including it because I feel there is a significant lesson in it for some people.

The Key Block

The principle of the Japanese color woodcut is based on using a key block. This is practically always black, sometimes blue. The color blocks are cut afterward to fit the key block.

As I mentioned once before, in the introduction, the Japanese artist did not cut his own blocks. He made his drawing on rice paper to be glued on the wood face down and cut out carefully by competent craftsmen. I mention this again because the Japanese color-printing technique was closely related to their working system and would have been impossible without the cooperation of several competent craftsmen working together.

The standard procedure was to cut a separate block for each color. In connection with this, I should like to mention a rather amazing tale that I have read in several books. It relates that the Japanese artists had such amazing visual memory that they could draw their color separations without referring to the key block. One of these anecdotes has Hokusai adding a color, by memory, to a block he had finished several months before. One of the justifications behind this strange procedure was, according to these writers, that in this fashion the artists avoided the tedious procedure of tracing their key drawing. Any printmaker would know that the hairline register the Japanese used would be totally impossible from memory—even for a genius like Hokusai. It is also obvious that the gentlemen who write these things without taking the trouble to investigate the facts do not realize that when you have a key block cut, it is not necessary to trace, for you can make as many prints of it as you wish and use them for your color separations. This is exactly what the Japanese masters did. As a key block was printed for each block, the

master indicated the different color areas; these prints were then pasted on the blocks and cut out respectively.

The Japanese printed with water-base colors. Their printing method required great skill, speed and, as I mentioned before, the cooperation of a whole workshop. For our own way of working, the method employed by the Japanese would be completely impractical.

The Japanese color print is one of the examples of a thorough understanding of how color can be used in a print without interfering with its graphic quality. Yet, strangely, they did some things that most printmakers would consider taboo. I am referring mainly to the way they used to blend different colors or tonalities by hand on the block. That's the way they printed the skies on their landscapes. This, to our standards, would put a print in the monotype category; yet their method and procedure were so highly perfected that they could repeat the same performance invariably.

The basic procedure of all color printing follows theirs in some respects. Practically every color print has a key block, not necessarily black. The key block is generally the color that will contain most of the structural and descriptive elements of the composition. Therefore it serves best as a guide for the disposition of the other colors.

The color print is not a colored print. One of the first things to guard against is making the first, or key, block too self-sufficient in itself, thus relegating the colors to a purely decorative role. The individual blocks of a successful color print seldom have any meaning in themselves and only make sense when printed together. I have found that the best method is to start the key block but not to finish it. After you have developed it enough to give sufficient indication of the general composition, the second block should be started. Then the two blocks are developed practically simultaneously. As the two proceed, you can evolve the third, fourth, or any number of them. The basic idea here is that with this procedure each color becomes organically related to the whole.

This is simply a suggestion. I realize that working procedures have much to do with temperament and personal working methods. I have found, however, in teaching, that when students have difficulties in comprehending the essence of color printing, this procedure helps them a great deal. Sometime when a student has problems because his key block is too self-sufficient, thus inhibiting him with colors, I suggest that he relegate the key block to a color of minor importance and cut different blocks for the dominant colors.

Registering the Color Blocks

The registering of wood blocks is quite simple and again follows somewhat the Japanese procedure, with the exception that instead of gluing the print from the key block onto

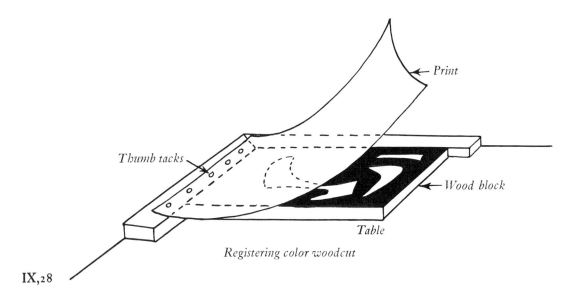

Print

Thumb tacks

Wood block

Table

Registering color woodcut

IX,28

the subsequent blocks, we simply offset the print on them (Fig. IX, 28). The simplest method is to nail a mitered corner of 1 by 2 or 1 by 3 either on your working table or on a special board to be used for printing surface. You put your key block into this corner and attach your printing paper to the strips forming your corner, making a print on a not too absorbent paper with exceptionally heavy inking. After the print of the key block is finished, the block is taken out and in its place the second block is inserted. It is self-evident that in a color print all the blocks used should be of the same size in order to have a good register.

I should also like to warn you that the blocks have to be squared properly, because the slightest deviation in a corner may be enough to throw the far end of the print completely out of register.

The wet print is folded back on top of the second block, and rubbed. Thus the image is transferred from the paper to the wood and will then serve as the guide for the register.

A number of printmakers, especially the old-timers who did not make enormous prints as we do, used to cut their registers right on the block itself. Their procedure was to select a wood block quite a bit larger than the dimensions of the print and then cut register marks and stops on the margin. I shall not go deeper into this, however, because it is so much more tedious than our method, without offering any advantages.

One of the great interests in color printing lies in the rich and exciting effects we can produce with relatively few colors if they are properly exploited. In contemporary color printing we try to exploit the combinations of overlapping transparent colors, something the Japanese printmakers used very little. In addition, we do not have to cut a separate

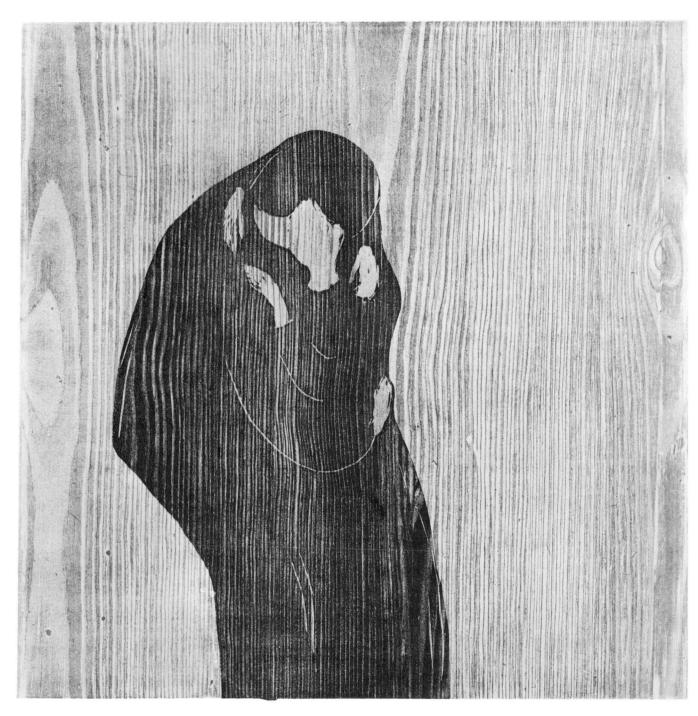

IX,29 EDVARD MUNCH (1863–1944), *The Kiss*, 1902. Woodcut.
The Museum of Modern Art, New York

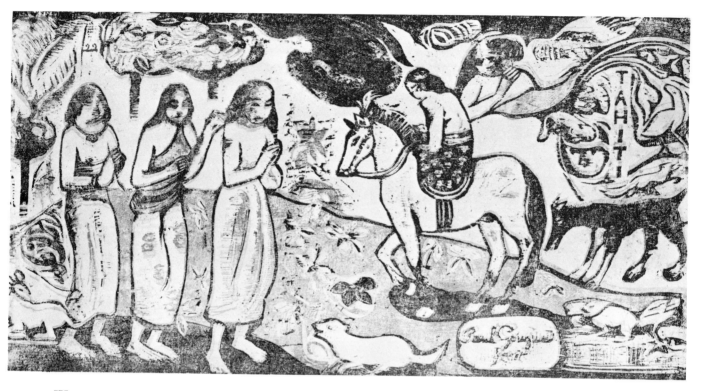

IX,30 PAUL GAUGUIN (1848–1903), *Changement de résidence*. Color woodcut.
The Brooklyn Museum Collection

block for each color; this depends on the particular problem. If we work on a large color print where well-defined color areas are far enough from one another on the block to permit a controlled rolling, any number of colors can be used on the same block.

In smaller areas some printmakers even use brushes to apply color. Although I happen not to like the printed quality of colors brushed on (generally they lack the translucence of rolled colors), I have nothing against the practice so long as the area is defined by the woodcut itself. Otherwise, it definitely enters into the monoprint category.

Movable Blocks

Movable small blocks are also used today by a number of printmakers (Fig. IX, 31). This, again, is practicable, except that it sometimes involves planning in order to print them in register with the large blocks. The easiest way is to put a light cardboard exactly the size of the key block in position. Once the small blocks are placed in the correct position to register, this can be marked on the cardboard. Then the small block should be glued down in order to avoid shifting.

Cardboard Cuts

A number of printmakers use cardboard cuts in combination with woodcuts for simple color areas. If you need a few flat color areas on a complex color print, it would be senseless to take a large wood block and cut it apart. These cardboard shapes can be put in position as suggested with the small movable blocks, or they can be temporarily mounted on the surface of a large wood block.

When printed, the cardboard has to be either shellacked or sprayed with plastic in order to harden the surface and prevent its absorption of color. As a matter of fact, cardboard in itself can be used to build up a rich and complex color print if the particular calligraphy and texture of the wood are not important.

Cardboard Prints

A young American printmaker, Edmond Casarella, makes cardboard prints with considerable complexity and richness (Fig. IX, 33). He generally uses a quite heavy laminated cardboard that can be simply peeled off at the cut-out sections. By using this procedure, he does not have to glue his shapes to a support, and he gains much more control and finer detail work than would be possible otherwise.

The complexity of some of the contemporary color woodcuts has no limit. A number

of artists have used thirty to forty colors in one print. Such prints really enter the realm of the printed painting; and although it would be silly to discuss the validity of a practice where the final justification depends solely on its aesthetic merit, I feel there is some degree of danger of losing one of the greatest assets of graphic art—the simplicity and directness imposed by its limitations.

I realize that this is a very personal point of view, and I express it as such. I suppose because I am also a painter, somehow in printing I seek a form of expression different from that of painting. To me each technique has its own place, and one compensates for the other. While I find them mutually interacting, and working on one medium often gives me ideas for the other, I have found that the fact that I work in a number of different media has kept me from intermingling them. This is in a way the answer to questions addressed to me by people wondering why my painting is so different from my prints.

I wish to emphasize again that by stating this I am simply expressing my personal attitude, and not trying to advocate anything. I know a number of fine painter-printmakers who have totally different attitudes. In the final analysis, we all have to realize that art is a domain in which it would be foolish for anyone to try to set rigid standards.

THE COLORS FOR WOODCUT

One of the great problems is the pigment to be used for wood-block printing. Most of the printmakers use commercial printing inks. These colors are brilliant, have great tinting strength, and generally possess most of the necessary qualities of good oil-based block-printing colors. There are two things, however, that make them very unsympathetic to me.

The first, and probably the most important, is that they are not very stable. Many of them, especially the reds and yellows, fade a great deal under extended exposure to daylight. I have seen a brilliant red completely fade to white within a period of four months.

The second is that these colors, ground in varnish, have a very high shine when they are overprinted several times. I find this particularly disturbing when a print is partially mat or semimat in the thinly printed areas and has a high gloss where several colors are overprinted.

The water-base colors are not so translucent, and dry too fast to be very practicable on a large color print.

Personally, I have found that a combination of fine artist's colors with some of the basic printer's inks seems to give the best compromise. I use the black, white, and the trans-

IX,31 ANTONIO FRASCONI, *Night Work*, 1952. Color woodcut

IX,32 SEONG MOY, *Classical Horse and Rider*. Color woodcut.
The Brooklyn Museum Collection

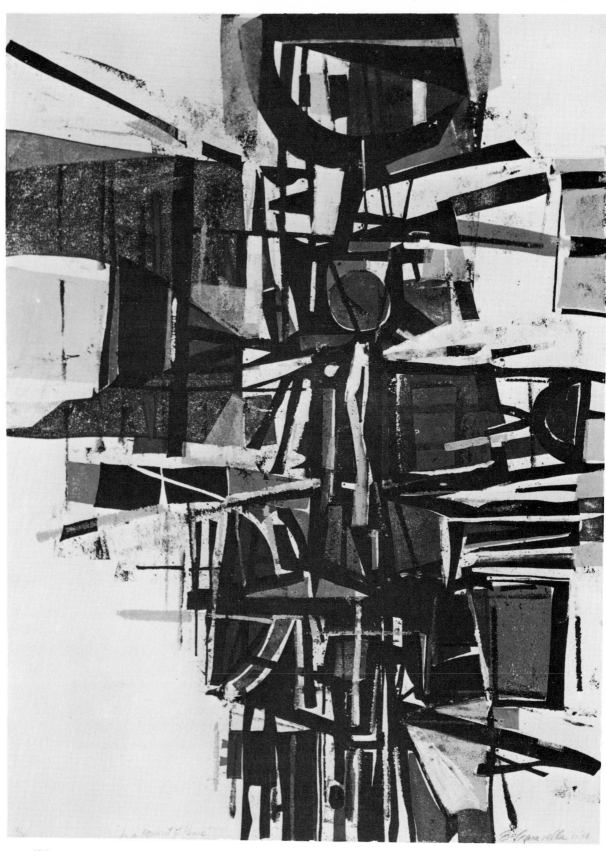

IX,33 EDMOND CASARELLA, *In a Moment of Panic*. Paper cut.
The Brooklyn Museum Collection

parent extender, some of the earth colors and permanent blues of the printing inks, and mix them with cadmiums when stable brilliant colors are necessary.

In printing, I cut my colors lean instead of oily, adding a few drops of turpentine, and printing with the minimum quantity of color deposit necessary for good coverage. In color printing, overloading with pigment is an extremely bad habit and generally produces prints with an unpleasant, cheap surface quality. As a matter of fact, these woodcuts have the same air that, to me, makes most of the silk-screen prints so unsympathetic.

In woodcut color printing, one has to consider (as in intaglio color printing) whether one can print wet on wet or whether the color print should be dry before it is overprinted again. Generally speaking, the first two colors can be printed immediately, because the first one—if the inking was not too heavy—is usually absorbed sufficiently by the paper not to affect the second printing. The third color, however, most of the time should be printed only after the first two colors have set for a couple of days or at least overnight. The time element depends on how fast your colors are drying. The same applies, naturally, to all the subsequent colors.

One of the very annoying aspects of trying to print a color over a heavily printed wet area is that instead of depositing ink on the print, generally the block picks up color from the paper, resulting in a messy-looking, mottled, uneven, printing surface.

It is also important to determine the correct order of the colors to be printed. As a general principle, just as in intaglio printing, the light colors are printed first, and you proceed toward the darker ones.

This is by no means a hard-and-fast rule. In woodcut printing, light colors over dark ones are used a great deal more than in intaglio color printing. If a cleanly printed light area is desired over a dark one, the dark color always has to be dry. Light colors would completely sink into the wet dark colors.

WOOD ENGRAVING

Wood engraving is mainly done with gravers; gouges are used sparingly as a change of pace and for the cleaning out of larger white areas. Wood engraving is generally cut on type-high end-grain wood blocks. The cross section of the tree is better suited for engraving than the wood cut plankwise because the burin can cut in any direction without lifting the fiber.

Wood engravings are generally conceived as white lines against a black background. This is the traditional look followed by most of the illustrators still influenced by Thomas

Bewick. Again, this does not apply to some of the more creative practitioners of wood engraving, like Leonard Baskin (Fig. IX, 34).

Thomas Bewick is credited with a number of innovations in wood-engraving printing. He was an exceptionally fine craftsman but a rather uninspired artist. Bewick originated the idea of printing grays by slightly lowering the wood block in areas, thus reducing the printing pressure. He also invented the overlay to print richer blacks. This is done by cutting out the dark areas from the first proofs and pasting them on the press tympan in corresponding position, thus increasing the pressure.

Wood engraving is a very much neglected graphic technique. Most of the contemporary printmakers shy away from it because of its restrictive character and also (this is my idea) because it is generally associated with the dullest book illustrations. The scratchboard technique used in commercial art to imitate the wood engraving also contributed to make this medium unpopular with fine artists.

The technique of engraving on the wood block is not hard to master. To the artists used to metal engraving it is slightly disturbing at first to miss the resistance and control offered by metals.

The gravers should be held at a flat angle to the block in order not to dig in too deeply. On a small block the thumb of the hand holding the graver is pressed against the edge of the block; this helps to control the burin. On large blocks the thumb is on the side of the graver just as in metal engraving.

THE TOOLS

Burins

The burin used for metal engraving can be used also on wood, but should be beveled to a 30° angle. Lozenge-shaped burins are preferable for wood engraving because they cut deeper, fine lines.

The Spitsticker, or Elliptic Graver

This is a graver specially made for wood engraving. It has curved sides to allow freer manipulation in the wood. It produces thick and thin lines and can be used as a substitute for regular gravers.

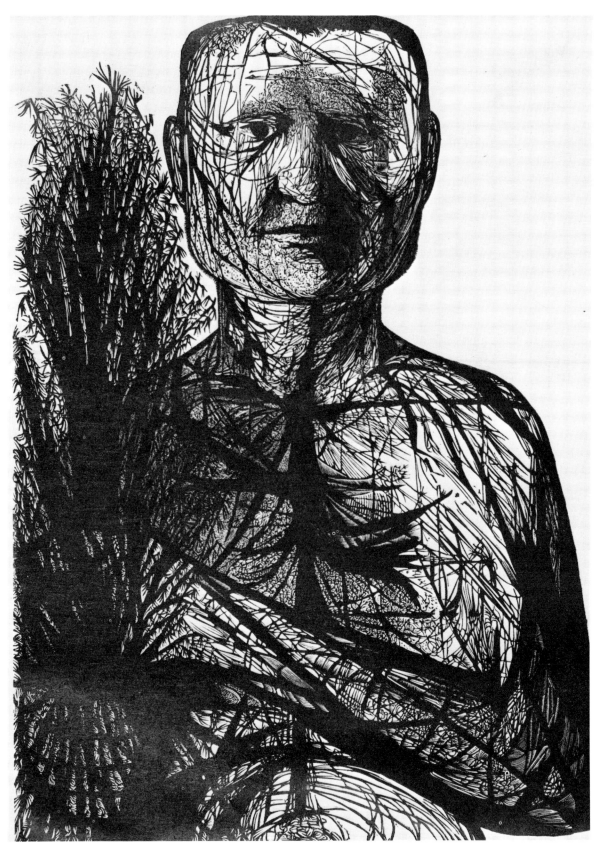

IX,34 LEONARD BASKIN, *Man with Forsythia*. Wood engraving.
The Brooklyn Museum Collection

The Tint Tool, Angle or Elliptic

To be used to cut deep, uniform lines. The angle tint tool has a flat underside to cut heavier white lines, and comes in twelve sizes. The elliptic tint tool comes with sharp edges, but the thickness of the shank varies, and it is numbered from 1 to 12 (Fig. IX, 35).

Gouges, Round or Flat

These are the same tools I described in the chapter on metal engraving, and they can be used to clean out larger white areas.

IX,35

Lining Tools, or Multiple Gravers

These are the same as those described in metal engraving, and are used to cut multiple white lines. But overuse of them is bad because it imparts a mechanical character to the work. The sharpening of these tools follows the principle described in metal engraving.

Drawing on the wood block can be done with pencil or ink. If the drawing is to be preserved through trial printing, use India ink; it won't come off when the block is cleaned. In order to see the progress of the work better, rub whiting, talcum powder, or any dry white pigment into the cuts.

The control of direction in wood engraving follows the same pattern as in metal engraving. One hand manipulates the block while the other is cutting. While cleaning out

larger white areas, avoid undercutting of the edges, for they may break down under printing pressure.

Correcting Bruise

In cutting, try to avoid bruising of the block by the belly of the gravers. Sometimes it is advisable to place a thin cardboard under the tool in order to protect the block surface. The correction of bruising is nearly impossible. Sometimes by wetting the bruise and drying it fast by exposure to flame, the grain swells up sufficiently to lift the indentation.

GESSO OR CASEIN ENGRAVING

I should like to mention in this chapter the interesting possibilities of engraving on a gesso or casein panel. Norman Gorbaty experimented with this technique at Yale, and it proved to be worth further investigation (Fig. IX, 36).

The preparation of the panel is simple. Use either soft- or hard-tempered Masonite. Rough up the smooth side of the panel with sandpaper to provide a good foundation for the gesso, or casein. The textured side of the Masonite is too rough, and generally produces a bumpy surface. The ground should be built up gradually by the application of three or four coats. After the first coat, let it dry thoroughly; then sandpaper lightly. This procedure is repeated until the gesso is at least $\frac{1}{16}''$ thick.

For the engraving, fine hollow gouges are the best, but regular engraving tools can also be used for fine details. The area to be engraved should be slightly moistened with a sponge to reduce the brittleness of the gesso or casein. In closely textured areas, the cutting does not have to be deeper than the ground. Open white areas can be gouged out of the Masonite.

Although the gesso ground does not allow the same intricacy as the end-grain block, it is much easier to control than a board cut plankwise.

After the engraving is finished, the gesso or casein should be covered with either shellac or plastic or plastic varnish to provide a hard, nonabsorbing printing surface.

LINOCUT

There is not much one can discuss in relation to the technique of linocut. It is a surface printing method and in principle similar to woodcut. Linoleum is a slightly flexible ma-

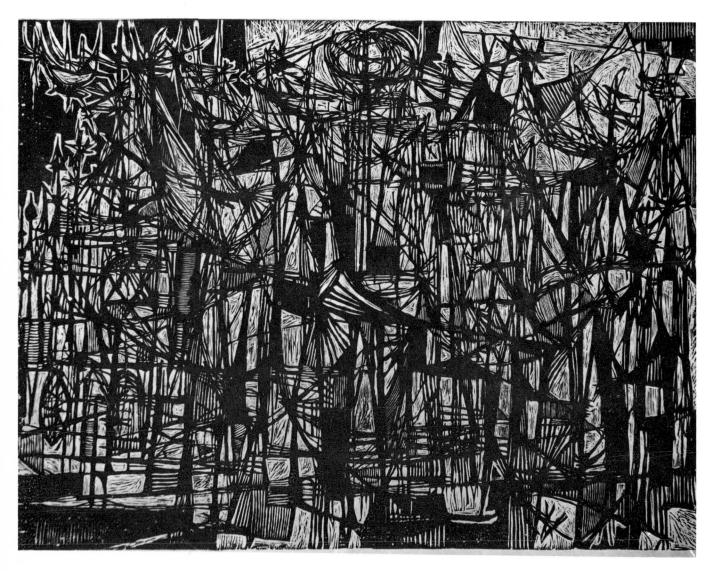

IX,36 NORMAN GORBATY, *Talmud*, 1953. Casein cut

terial so easy to cut that it is used in many junior high schools to introduce printmaking to young children. I once taught a five-year-old girl to make linocuts without any difficulty. As a matter of fact, probably because it is associated with children and hobbyists, many artists are prejudiced against linoleum.

I do not suggest that linoleum is an exciting material to work with, but within its limitations it can be quite useful. The linocuts of Picasso prove that, in the hand of a great artist, even a dull, uninteresting material can become expressive (Fig. IX, 37).

My interest in linocut is more in relation to mixed-media color printing than to its pure form. As linoleum is cheap and easy to cut, it is excellent for underprinting colors to intaglio plates or wood blocks.

Remnants of linoleum of good grade can be bought very cheaply in stores selling floor covering. Linoleum should be at least ⅛″ thick and should not be confused with the new type of Vinylite or asbestos floor coverings. Linoleum blocks sold in art supply houses are much more expensive and, except that they are mounted type high, have no particular advantages. Unmounted linoleum can be printed on an etching press with properly adjusted pressure.

To cut the linoleum, most of the woodcutting and some of the wood-engraving tools can be used. Special linocutting tools are cheap. E. C. Muller, of New York City, sells a set that can be used equally well for woodcutting. The most inexpensive set is a holder with interchangeable nibs.

In working on linoleum, one can cut freely in any direction, for it has no grain. Because linoleum is soft, and offers very little resistance to the tools, you must guard against slips, never cutting toward your hand.

PRESS PRINTING OF WOOD ENGRAVING AND LINOCUT

The printing of wood engraving is done on platen or cylinder presses.

The Platen Press

This can be a Washington-Hoe proofing press in the United States or an Albion in England. The printing is done in the following manner:

Printing with Proofing Press

The bed is rolled out from under the platen. Make sure the bed is clean. Place four wood blocks, slightly lower than the block to be printed, on the four corners of the bed. This is

to make sure that the pressure of the platen is equally distributed. Place the inked wood block face up in the center of the bed. Place the printing paper on the wood block. Lower the tympan. Roll the press bed back under the platen and press it down with the impression handle. Most of the blocks need some packing, but this can be determined only after the first proofing. Sometimes the bed has to be packed with newspapers under the block; at other times the pressure has to be increased in specific areas by pasting cut-out parts of the first proof in corresponding position on the tympan.

Some presses, like the Washington-Hoe, for instance, come with a frisket plate attached to the tympan. This makes the correct registering of the packing on the tympan much easier. It is also a great help in registering color prints.

How to Register with Frisket

To register the print with a frisket, use the following procedure. Stretch a sheet of thin but strong paper over the opening of the frisket plate. Ink the block lightly and make a print on the paper stretched over the frisket. This is to find the exact position of the block in relation to the tympan. Cut the print out. Place a printing paper on the tympan behind the frisket opening and print. With this procedure the packing and registering can be controlled with great accuracy.

The Cylinder Press

This can be a Kimbers Wood Proofing Press in England or an old Kelton Proofing Press in the United States. These presses are designed on the same principle as an etching press except that the bed passing through between the upper and lower rollers is like a tray with type-high metal sides supporting the upper roller.

The inked wood block is placed on the bed face up and is then blocked securely in position. The printing paper is placed on the block. The packing is placed on the paper or it can be attached to the tympan. The tympan is lowered, and the bed is rolled through in the same fashion as an intaglio print on an etching press. These cylinder presses are capable of printing with much more pressure than the platen press, but the pressure has to be regulated carefully. This press can apply enough pressure to crush and ruin the wood block.

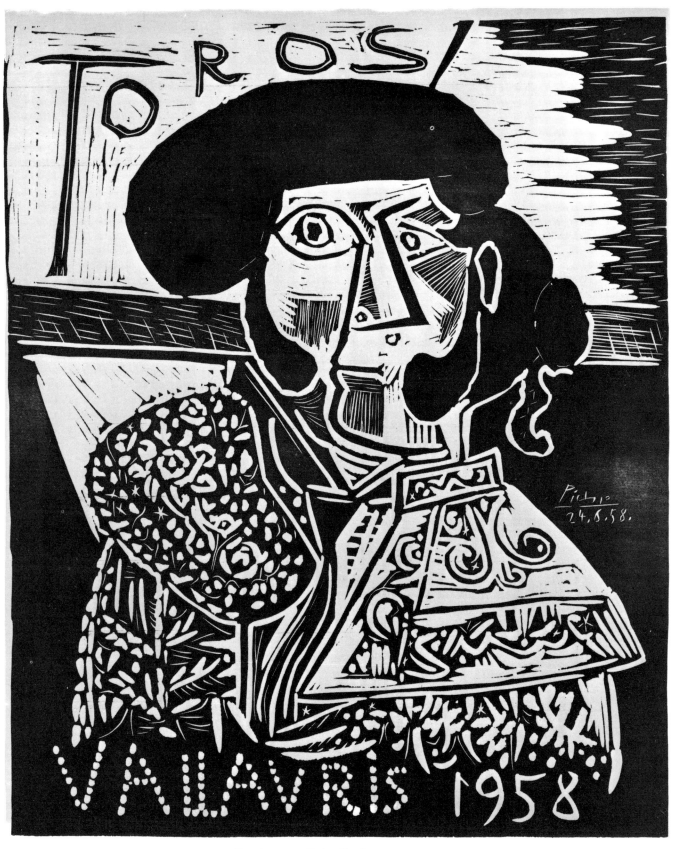

IX,37 PABLO PICASSO, *Toros Vallauris*, 1958. Color linoleum cut.
Yale University Art Gallery. Gift of George H. Fitch

IX,38 ROBERT E. MARX, *Snared*, 1953. Color linoleum cut.
The Museum of Modern Art, New York

The Papers for Press Printing

To print on presses the choice of papers is much wider than it is for spooning. Practically any paper can be used except those with coarse texture or weak, fluffy body.

Thin coated papers print exceptionally well, but their shiny surface makes them look like reproductions. Thick heavy papers should be printed damp. Printing on dampened papers also has the advantage that the block does not have to be loaded with ink to get a perfect proof.

Ten

NUMBERING AND RECORDING
AN EDITION

THE ACCEPTED TRADITION is to publish a print in limited edition. The size of the edition is determined by the artist, and is generally influenced by practical considerations. It is generally believed that a small edition will raise the value of the print. This is only partially true; the monetary value for art works does not always follow the conventional economic pattern.

It is also a fallacy to think that the size of the edition will have much effect on the quality of the print. Most of the plates and blocks can withstand at least four or five times the amount of printing that they get, without showing any deterioration.

I am sure that as popular demand increases, we are going to see more and more large editions. A few print societies are engaged in publishing large editions and are performing

313

a very useful function in popularizing fine prints. The International Graphic Arts Society (IGAS) is an excellent example of the effort to establish interest in original printmaking on a broader base.

The average edition generally varies from twenty-five to fifty prints. The number of the print, together with the edition number, usually appears under the print in the left-hand corner (for instance, 1–25). The lower right-hand corner carries the signature of the artist and the date. If the artist wishes to put the title on the print, it is written on the center of the lower margin.

The state (trial) proofs are marked with numbers to show their progression. Although these are not regularly sold, they are important to the printmaker because they represent the development of an idea. They are sometimes sold to museums and collectors.

Besides the regular edition, the artist is entitled by custom to pull five to ten artist's proofs for himself, numbered with Roman numerals.

Once the whole edition is printed, the plate theoretically is supposed to be destroyed or marked in such a manner that any further printing should be easily distinguishable from the first edition.

In some instances museums and print libraries are also interested in having some original plates in their collections for technical demonstrations and study purposes.

It is very important for the printmaker to keep an accurate record of his plates and prints, including all the relevant technical data. This is especially important if one does not print the whole edition once the plate is finished. Nothing is easier than to lose track of print numbers.

In the case of colored prints, it is particularly important to have a very accurate record kept of color mixtures, although my experience proves that it is much more advisable to print all the colors at once because, unless one uses pure colors from the tube, even with a print at hand it is practically impossible to match mixed colors accurately.

Eleven

MOUNTING PRINTS

VERY FEW PRINTMAKERS know how to present their prints properly. This is one of the constant sources of irritation for museum curators organizing large print shows. This situation is so bad that Miss Una Johnson, Curator of the Brooklyn Museum Print Department, introduced the practice of rematting every print accepted into the museum's National Print Exhibition. This is a great waste of time and money. Because smaller institutions have neither the money nor manpower to do so, they have to resign themselves to putting up badly mounted prints which ruin the overall effect of their exhibitions.

While presentation has nothing to do with artistic values, it certainly is reasonable to expect artists to respect their own work; to cut a mat correctly takes no more time than to do a bad job, and to ask artists to wash their hands before handling clean mat boards should not offend their dignity.

Most of the institutions holding large print shows specify the proportion and color of

the mounting to be used. The three or four dimensions suggested correspond to the standard frame or glass proportions available in these institutions for the presentation of graphic work. The color is generally restricted to white, past experience having indicated that without this limitation there may be entered a number of prints mounted in the colors of the rainbow. While this might appeal to individual artists, it makes the hanging of a large show impossible.

Since in the past decade a number of important printmakers have worked with un-usually large dimensions, the size restrictions have become more flexible. When museum curators and librarians realized that many artists preferred to abstain from showing rather than to exhibit their less important work, the rules were changed. Generally, printmakers are allowed to send their large prints unmatted.

To select the correct mat proportion there are a few rules that one can follow. The mat margin should not be too wide or too narrow. Generally the width is over 2½″ and under 5″. I prefer an evenly distributed mat margin if possible. Some artists like to have a slightly wider margin on the bottom than on top. If an odd-size print has to be fitted in a standard mat, try to find the best compromise by working with the plate proportion.

The opening of the mat should be cut slightly larger than the print to show at least a quarter inch, preferably a half-inch, of the printing paper. Generally, one should allow slightly more for the bottom margin in order not to cut off the signature and edition number.

The most commonly used matboard is pebbled and comes in a variety of colors. Gen-erally these boards have different colors on either side. The most practical combinations are white-cream and white-light gray. When white mats are specified in a show, an artist is allowed a choice of from cold white to a yellowish off-white, or cream color. I like to contrast the mat with the printing paper. In other words, I generally use an off-white mat-board with a cold white paper.

The standard matboard is made of pulp. This is all right for temporary presentation, but is not recommended for permanent mounting. The chemicals used in making the pulp board would "burn" the printing paper on prolonged contact. Museums always use pure rag boards for mounting, but these are very expensive.

One does not need elaborate equipment to cut mats properly. A sharp blade and a heavy steel straight-edge are sufficient to do a professional job. To cut, one can use mat-cutting knives with interchangeable blades, single-edge razors with holder, or a shoemaker's knife. To cut heavy boards I have found razor blades the most efficient, as the thinness of the blade reduces the resistance.

The first step is to prepare the cutting surface. Check its cleanliness. Nothing is more annoying than to put a white matboard on the table and find it soiled. Have enough old

cardboard pieces handy to put under the matboard. Without this cushioning, the blade will be ruined in no time.

After the board has been trimmed to the proper size, the margin is measured and marked. For marking, use a hard pencil and do it very lightly. Put the steel ruler on the marks. If you cannot rely on your strength to hold it in position while cutting, clamp it down.

The secret of a clean straight cut is to push the blade through the board and finish the cut with a single stroke. Most people have a tendency to change the angle of their knife when they go over a cut, thus producing a wobbly, uneven bevel. If the cutting is done correctly, with the whole body instead of with the arm alone, it does not require great physical strength.

In cutting one has to be extremely careful at the corners. It is easy to be carried away by the momentum of the knife, and overcut the corners.

The mat can be cut also from the back instead of from the front. This eliminates the necessity of erasing the pencil marks. In addition, it makes it easier to conceal a slight overcut at the corners. To cut from the back, the knife has to be exceptionally sharp, as the slightest imperfection on the blade would tear the mat edge.

After the mat is cut it is hinged to the backing board. For the hinging masking tape or glued paper tape can be used, but for permanent mounting a linen tape is much better.

The print should be fastened to the backing board with small paper hinges. Never fasten the print directly onto the mat opening. For the hinges one can buy specially manufactured white linen tapes; however, most museums make their own, using sheer tissue papers or Japanese woodcut papers, fastened with a paste made of rice flour. This is the safest, as it holds well but doesn't stain the paper when removed. As a rule, the paper used for the hinging should always be weaker than the printing paper itself. Thus, under strain the hinge would give without damaging the print. The print should be fastened only on top, hanging freely on the backing board. This is to allow the paper to expand or shrink as the atmospheric conditions change. If the print is fastened on all sides it would buckle or develop wrinkles as the paper changes dimensions.

For permanent mounting use only acid-free ragboard or specially manufactured acid-free board with a neutral pH. If these are not available one should use acid-free barrier paper sold by framing suppliers. Both the mat and the backing board should be lined with this paper.

Always specify to framemakers the usage of acid-free boards where they are in contact with the print. Don't take it for granted that the frame maker knows, or even cares. I was often outraged to find, on very expensive framing jobs, silk stretched on cheap pulp board for mat, and corrugated cardboard backing.

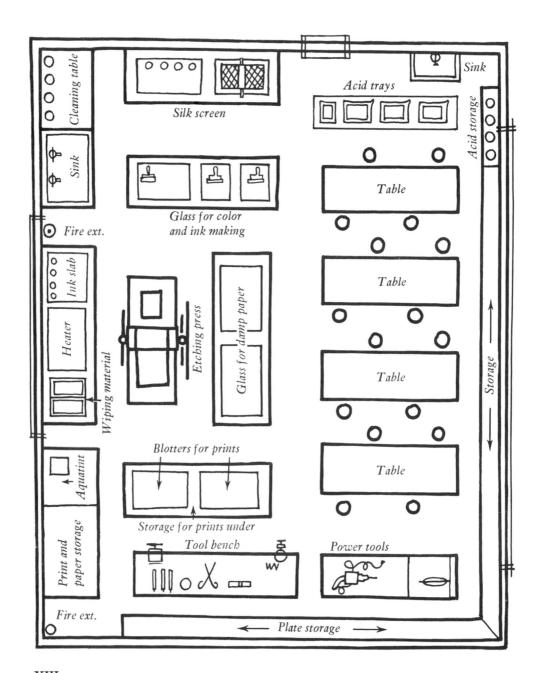

Cleaning table

Sink

Fire ext.

Ink slab

Heater

Wiping material

Aquatint

Print and paper storage

Fire ext.

Silk screen

Glass for color
and ink making

Etching press

Glass for damp paper

Blotters for prints

Storage for prints under

Tool bench

Power tools

Plate storage

Acid trays

Sink

Acid storage

Table

Table

Table

Table

Storage

XIII,1

Twelve

THE WORKSHOP

A WORKSHOP should be planned to satisfy the personal needs and working habits of the artists. In most cases it is also determined by the available space and money. Very few artists can afford to have an ideal workshop, but such a shop is by no means necessary to produce good work. I do not advocate that artists should work in romantic squalor. I think that artists should have decent and satisfactory working space, the same as any workingman. However, I am against making a fetish of buildings, tools or machines.

I take this issue up because we have a tendency to put too much emphasis on the material side of things. I have seen, many times, millions of dollars spent on fancy buildings to house underpaid teachers with indifferent students.

When I began to teach in 1948 in the Brooklyn Museum Art School, the director, Mr.

A. Peck, felt that the school should have a graphic workshop. The problem was lack of space. We had only a dark storage room available, full of heating pipes. After long debate, we decided to try it temporarily. We set it up as well as it was possible to do.

The four years I spent in this workshop teaching proved to be some of the most productive in my teaching career. I had the students and they wanted to work. We cursed the heat and the hot water dripping on our heads; but the work was full of excitement, and a number of fine printmakers came out of that little room.

First of all, we have to recognize the difference between the workshop designed to serve an artist and that of a school, for the space and equipment requirements are totally different. The two common requirements for both workshops are: adequate ventilation and water. Ventilation is very important in a graphic workshop because the constant use of acids and volatile cleaning agents causes fumes which, if inhaled excessively, can be harmful. Aside from the health hazard, I find it very depressing to work without plenty of fresh air.

Water is also an obvious necessity; it is constantly needed with graphic work. Wide, flat, industrial sinks made of cement or stainless steel are ideal, but in my studio I have a shower that I have found very useful for washing large plates and acid trays. The ideal plumbing in a workshop should be brass or steel, as quantities of acid are washed down constantly. I have found, however, that letting plenty of fresh water run down the drain after exposure to acid dilutes it sufficiently to make it harmless.

The printing area should be organized to avoid waste motion. Everything directly related to printing should be arranged around the press. On printing large editions, a few extra steps multiplied many times make a big difference. Therefore the heating unit, inking area, the damp paper, the blotters for the prints—all should be within easy reach from either side of the press (Fig. XIII, 1).

The etching and cleaning area should be arranged around the water, and, if possible, near a window or other ventilation. If necessary, a fan can be installed, with an exhaust system to draw out the harmful fumes.

Every workshop should have adequate storage area. Even this can be created with very little loss of space if racks and shelves are constructed along the walls and under tables.

There is one thing of which no workshop can have too much—table space. At times graphic work seems to require immeasurable surface area on which to work. This is especially true when working with large color wood blocks or silk screen, or combination color work. This can be solved sometimes by using folding tables. As I use my studio for both painting and printmaking, the folding table comes in handy. It can be set up when needed and put away when I paint.

Light is another important problem to consider. The working tables should be near

good daylight if possible; short of this, adequate light should be installed. For overhead lights, fluorescent fixtures with egg-crate filters are the best. In installing lights, the basic objective is to create even, diffused light and to avoid glare.

The workshop for the individual artist is always much more flexible than the one designed to serve a large group. While the individual can improvise, to do so with a group can create confusion.

It is not easy to arrive at exact figures on estimating how much floor space should be considered per individual in a collective workshop. This varies greatly, according to equipment. A workshop used for intaglio printing and woodcut only requires much less space than one also offering lithography and silk-screen facilities. Under ideal conditions the lithograph press and equipment—with it own sink—should be in a separate room. The isolation of these media is advisable not only to avoid confusion but for safety reasons as well. The stone and carborundum dust unavoidable with litho work can raise havoc with metal plates.

The number of students a workshop can accommodate depends not only on the space but also on the equipment. One press, or one heating unit, can serve only so many print-makers. Regardless of space and equipment, I find oversized workshops unsympathetic and, beyond a point, unmanageable. I don't think it is ever good to have more than twenty to twenty-four people working in a shop. This is especially true in a teaching situation. I find it very difficult to have personal contact with my students in a large group.

I consider the ideal number of students for a graphic class between twelve and sixteen. In a collective workshop, the floor space should be from fifty square feet to seventy-five square feet per student. This includes the equipment.

One press and one heating unit cannot serve adequately more than sixteen printmakers, unless part of the group works in another medium not requiring these facilities.

The furniture in the workshop should be simple and sturdy. The tables should be slightly lower than standard (approximately 26 to 28 inches). It isn't comfortable to engrave on a high table. The most practical cover for workshop furniture is stainless steel. Although it might cost more initially than other materials, in the long run its durability makes it cheaper. When covering working tables avoid protruding moldings on the edges, as they interfere with the free manipulation of plates.

Years ago it was generally believed that a graphic workshop was safe if it had good cross-ventilation. Today we know that in a workshop where acids are exposed all day, a much more efficient ventilation system is needed. The most ideal condition would be to separate the etching area completely from the workshop. If this isn't possible then the acid baths should be under a well-ventilated hood with a powerful exhaust system.

In recent years, plastic sprays have often been used to replace conventional rosin aqua-

tint. The fumes of these sprays are a great health hazard. To eliminate this danger the workshop should have a spray booth. This booth should have its own exhaust system, independent of the acids, as the mixture of fumes can be dangerous.

Inflammable cleaning fluids should be kept in metal safety cans. All the fluids and acids should have metal storage areas. Trash cans for papers and rags also should be metal.

An automatic sprinkler system is the ideal fire protection for a graphic workshop. If this isn't possible, the workshop should be equipped with a generous number of fire extinguishers.

Thirteen

MORE TECHNIQUES IN COLOR PRINTING

MULTILEVEL-VISCOSITY PRINTING

THIS METHOD is associated with S. W. Hayter's Atelier 17 in Paris, where Hayter and some of his assistants, including Khrishna Reddy, perfected it. The principle is based on the observation that, if the viscosity of colors is controlled, when they are overrolled they will either attract or reject each other. The low-viscosity lean color rejects the high-viscosity stiff color; in reversed order the stiff ink will attract the light, oily color.

Besides the viscosity control, the color areas are defined by multilevel relief etching. By using rubber or composition rollers of different density (20 durometer soft, 30 durometer medium, 40 to 70 durometer hard) to reach the various levels of the plate, com-

bined with viscosity control, one can produce rich color prints with a single pass through the press.

As a general rule the plate should have at least three levels. The lowest is inked in intaglio, the rest with rollers. Usually the ink used for the intaglio is the stiffest high-viscosity color. The highest level of the plate will carry the lowest viscosity color applied with a hard roller. The next color applied with the soft roller should be stiff, but slightly less viscous than the intaglio color. This color reaches the middle level of the plate. If the viscosity control is correct, the color on the highest level remains pure. If a mixture of colors is desired on the highest level, the order should be reversed.

In my experimentation with this method I observed but generally ignored an important factor in the control of colors. In addition to the viscosity control, the quantity of color deposited with the roller plays a significant role in the color separation. A very thin layer of low-viscosity color pollutes much more easily than a heavy deposit. This also should be tested while preparing the colors.

It is likewise very important that the rollers be of sufficient width and diameter to deposit the color in one pass over the plate. Rollers that are too small usually offset color if you go beyond one revolution with them. After each printing the rollers must be cleaned.

The procedure I described represents viscosity printing in its simplest, most direct form. It can become much more complex if more than three levels of the plate are used, and if the transitions from one level to another are refined.

Khrishna Reddy, who is one of the most sophisticated practitioners of this method, usually reworks the plate after it is etched. With gauges and scrapers he modifies the edges of the different levels. By making them slope instead of dropping abruptly he can achieve soft, blending transitions between color areas. He also uses several colors in the intaglio areas inked "à la poupée."

CHINE COLLÉ

The chine collé is a combination of collage and printing. In this method, colored and textured papers cut or torn to the desired shapes are laminated and overprinted with intaglio in one single run through the press.

The selection of papers to be used is very important, as they should have the right thickness and weight. They must always be much lighter than the printing paper support, and they shouldn't contain too much sizing, as this could cause buckling or wrinkling. Some of the Japanese colored papers like Moriki, Mingei, and Toyogami are excellent.

The next problem is the permanence of colors. Most papers are colored with cheap dyes. Exposed to light these papers bleach out completely. The safest method is to get Tableau or Japanese woodcut papers and color them yourself.

Avoid strong synthetic glues, because they affect the shrinking rate of the paper and can also burn or stain it. It is best to use thin library paste or potato starch.

To prepare them for printing, the papers to be laminated should be dampened. As these papers are sheer, they should be dampened between blotters and not by soaking and should be kept between damp blotters until the plate is ready to print. When the plate is wiped and in printing position on the press, the colored papers should be placed on a clean paper, face down, to be covered with paste. Next the papers are placed in position on the plate, with the paste-covered side up, and covered with the large printing paper. The rest is the standard procedure of intaglio printing.

Lye Wipe
(Lye, Alkaline
Solution, Sodium Hydroxide)

This is a little-known method of wiping intaglio plates. Its greatest value is in color printing, as it eliminates costly and complex procedures. It also permits the use of oil colors instead of printing inks, thus making a much wider color range available to the artist.

Lye wipe eliminates one of the greatest frustrations one can experience—when a plate inked with brilliant yellow turns out bilious green, or a bright cadmium red turns into dull brown. The crisp, pure colors of European color prints are printed from steel-faced copper plates. The steel facing protects the colors from oxidation. On bare copper or zinc plates some oxidation is unavoidable. This is a particularly vexing problem in the United States. As every printmaker knows, copper is much more expensive than zinc; its price is nearly prohibitive to art students and young artists. Zinc could be steel-faced only if it were first copper plated—an expensive and complex procedure. Disregarding the cost factor, the scarcity of steelfacing facilities alone makes this unpractical.

The lye wipe process is simple. Mix a mild solution, one teaspoonful of lye to one quart of water. Soak a fine cotton rag (synthetic fibers like Dacron or nylon are not good) in the solution; squeeze it out thoroughly so that it is only damp; wrap it around a flat, sanded wood block; and you are ready. It is advisable to test the strength of the solution first by inking only a small section of the plate. If the solution is correct the color should wipe off easily; if it takes vigorous rubbing it is too weak, and if it wipes out the delicately etched areas, it is too strong.

The feature that makes lye wipe so effective is its action on fatty substances. Lye attacks the oil and at the same time lubricates the plate. The lubrication reduces friction and protects the colors. The tightly wrapped cloth around the wood block removes the surface colors but pushes the excess colors back into the lines and crevices. This action makes it possible to use oil colors instead of printing inks.

The proportion of one teaspoonful of lye to one quart of water is the strength I use for low-viscosity oil colors. This formula works well with most oil colors, but you must keep in mind that no two colors have exactly the same viscosity. There are also great variations among different brands of paints. The solution strength should be increased in proportion to the increase in viscosity. If the viscosity is very high, it is better to reduce it by adding light oil or easy wipe compound than to use a very strong lye solution. If the color is too low in viscosity or lacks body it can be remedied with the addition of heavy oil, or dry pigment.

In handling the lye solution one has to observe a few basic safety precautions. Lye is a poison. The solution should be kept in a conspicuously labeled bottle. It should always be handled with rubber gloves. If any solution touches your skin, rinse immediately with lots of fresh water. Be particularly careful not to get it into your eyes or lips.

THE MONOPRINT (MONOTYPE)

The monoprint, as its name implies, is a unique proof. It is printed from metal, plastic, or glass plate on which the artist painted or by other means improvised the image.

"Why do it on a plate, and print it, instead of painting it directly on the paper?" is the question often asked by those who are not familiar with the special characteristics of the printed color. The quality of the color changes as it is transferred from one surface to another in the printing process. The luminosity and transparency of the printed color are unlike any painted surface. This is even more obvious on the second or third version pulled from a monoprint plate. It goes without saying that all proofs are different.

After the first proof is pulled a delicate, translucent film of color remains on the plate. This ghost has to be retouched in parts where it may be too weak. With more extensive reworking three or even four versions can be printed.

The greatest master of the monoprint technique was Degas. His inventiveness and instinct to exploit the possibilities of this method were fabulous, and his brilliant draftsmanship made this an ideal medium for him. The monoprint demands speed and spontaneity which only a secure draftsman can accomplish. Besides his black and white monoprints Degas made a series of color prints, which he often reworked with pastels. One of his most astonishing achievements was a series of landscapes heralding the lyrical abstractions of the 20th century.

XIV,1 MISCH KOHN, Untitled Engraving, 1980. Chine collé

XIV,2 MICHAEL MAZUR, His Running, My Running. First in sequence. Monotype, high-viscosity black with Thalo blue, 405 × 603 cm. All photographs by Greg Heins, Courtesy of Harcus-Krakow Gallery, Boston, Massachusetts

XIV,3 His Running, My Running. Second sequence. Worked over with a looser ink

XIV,4 His Running, My Running. Third sequence

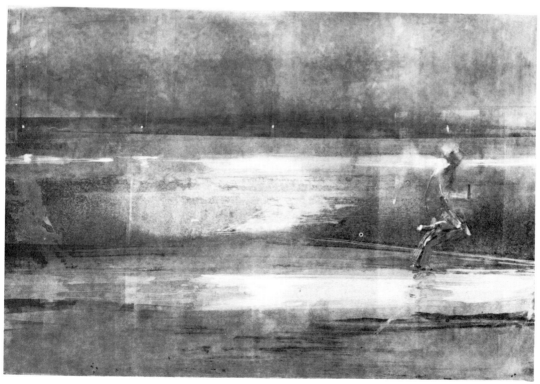

XIV,5 His Running, My Running. Fourth Sequence

There are two basic methods used in making monoprints: additive and reductive. In the first, the artist gradually builds up the image; the unpainted areas will print white. In the reductive method the artist covers the plate with colors, using brushes, rollers, or daubers, and then develops the image by removing colors gradually with rags and brushes. To dissolve colors turpentine is usually used.

Most monoprints are a combination of both methods, and one can easily determine how a monoprint was started. With the reductive method the color area is usually dominant, while with the additive method the negative, or white, areas most often dominate.

Oil-base colors are the best suited for monoprints because they don't dry fast; thus one can work on the image, and the printing, without rushing. It is possible to make monoprints with water-base colors, but one has to work extremely fast, and the printing demands thorough planning, preferably teamwork, comparable to the Japanese wood-block printing method. Also, when printing with watercolors the paper has to be prepared differently; for oil colors the paper should be merely damp, while for watercolors it should be well saturated with water.

The preparation of the paper is crucial. Too much water rejects the oil colors. If the plate is overloaded with color the water beads can make white spots, or blotched, bleeding color. This actually happened on a few Degas landscapes.

The monoprint doesn't require the same pressure as the intaglio print. Too much pressure might squash the colors and make them bleed. For the second or third printing the pressure could be increased slightly.

I have done some experimenting with monoprints in which my approach differed from the traditional procedures, as I used mostly the printing process itself to develop my images. Instead of painting directly on the plate I offset various shapes and textures onto the plate and then printed it. Thus some elements were offset two or three times before the final proof was pulled.

I made these monoprints at a time when I was involved with complex color plates using combined techniques, including insertions of cut movable plates. Initially I considered the monoprints as sketches to be translated eventually into color plates. I soon realized that the monoprint has a potential of its own, completely free from the limitations of a plate that has to be printed in controlled editions. The various ways a monoprint can be made are also excellent introductions to color printing.

I would also like to mention the importance of controlling the viscosity level of the colors in making a monoprint. It is important to understand that whenever color is used in printing, viscosity plays an important part. Color viscosity is usually associated with a printing method that originated from Hayter's Atelier 17. A high-viscosity color prints differently from one with a low viscosity. Unless this is controlled it can create

serious problems. Printing inks have high viscosity; regular oil colors have low viscosity. The high-viscosity colors are usually more intense and more opaque than the low-viscosity colors. This must be kept in mind when they are mixed in making a monoprint, otherwise the carefully worked out color relations will be lost on the print.

The Hand-Colored Print

In the past, artists often colored their prints by hand. Probably the greatest practitioner of hand coloring was Hercules Seghers, a contemporary of Rembrandt. In the 18th and 19th centuries it was common practice to hand color prints. Gauguin did it on some of his woodcuts. As the color printing techniques developed and became more and more sophisticated, hand coloring became taboo. It was looked down upon by professional printmakers and not accepted in print shows. Monoprints are also excluded from most graphics exhibitions.

As no two hand-colored prints are exactly alike, they are as unique in their way as monoprints. The argument of most printmakers against hand coloring is that the artist should accept the limitation of his medium and respect it. A print shouldn't try to be a painting. While I agree with this principle, I don't like to see it turned into a dogma. Artists should have the freedom to express themselves without restrictions. Ultimately only the quality of the work matters.

There are two hand-coloring methods; the first is a proof pulled in one color, generally black, and then hand colored either with watercolors or crayons. In the second method, the printer applies various colors on the plate by hand, so all the colors are printed. If the color distribution varies from print to print, it is considered a monoprint. A similar method, called "à la poupée," is used by French printers. They apply the color with a pointed roll of tarlatan, and their control is so consistent that these prints are never challenged in print shows.

Fourteen

HEALTH AND SAFETY
IN PRINTMAKING

Industrial workers must be protected from the hazards of their occupation by law. In spite of this, one always reads in the papers about incidents in which negligence or ignorance caused serious illness or even death. Although artists have always had a vague notion that some of the materials they use are toxic, for a long time they had no organization, no pressure group that would sponsor a thorough study on this subject and make it available to them. Finally we have such a study, thanks to Alberta Labour, and the excellent collaboration of Cherie Moses, James Purdham, Dwight Bowhay, and Roland Hosein. From their publication I selected the information I considered most important to the readers of this book.*

* Excerpts of a study on chemicals and materials commonly used by artists, published by the Occupational Hygiene Branch, Alberta Labour, Edmonton, Alberta, and reprinted with their generous permission.

EFFECTS OF CHEMICALS ON THE BODY: TOXICOLOGY

The very nature of printmaking involves the use of a variety of chemicals. When a list of chemicals used in the Printmaking Division of the University of Alberta was compiled, it became apparent that some of these chemicals were extremely toxic and the labeling on most of the products did not indicate the contents, hazards, or handling precautions associated with the material. There is a philosophy in occupational health that any material can be used or produced provided the right types of controls are used in order to minimize the exposure of workers. Controls are determined as the result of an informed investigation of the actual chemicals used, the manner in which they are used, and the environment where they are used.

In some industrial processes it is not possible to substitute toxic materials with less harmful ones, and in these cases a variety of control procedures have to be built into the operation. The same will hold true for some of the chemicals used in printmaking.

ROUTES OF EXPOSURE

Inhalation

This is the major route of entry for airborne chemicals. The chemicals can have a direct effect on the nose, upper respiratory tract, and the lungs, or they can enter the bloodstream and thus affect the blood, bone, heart, brain, liver, kidneys, or bladder.

Ingestion

This is not normally a direct route of entry from exposure except by willful or accidental ingestion. Materials can also enter the stomach through indirect means. For example, the lung has a cleaning mechanism which pushes material out of the lung where it then can be swallowed. This can result in an exposure to most of the internal organs or even in a local action on the stomach wall.

Skin Contact

Some materials are absorbed through the skin, and therefore when they enter the bloodstream they can be transported throughout the body and accumulate in, or affect, the most

sensitive areas of the body. Skin contact can also result in an allergic type of reaction, the removal of the protective skin oils, or dermatitis. In some cases chemical contact may result in a cancerous lesion.

Irritation is the result of materials which adversely affect the nasal passages, the respiratory tract, the skin, and the eyes; e.g., ozone gas from a carbon arc causes irritation to the upper respiratory tract and the lungs. Other materials have irritant effects and are also poisons, e.g., toluene. Lung sensitization, which results in an asthmatic type of reaction, can occur from inhalation of some irritant gases, vapors, or dusts. Once sensitized, a person would not be able to continue working with these materials, since any further inhalation will cause a reaction.

Contact dermatitis is caused by the irritation of a chemical upon skin contact. Although the result can be a blister, rash, or scar, it is reversible after the contact has stopped. Sometimes medical attention is necessary.

Sensitization dermatitis (*allergic dermatitis*), resulting from chemicals (such as chromic acid) which are called *sensitizers*, has a more long-term effect than contact dermatitis. It can develop upon first contact with the chemical or it may occur after repeated exposure. As we have found in the case of several printmakers, once it begins, it can become irreversible and often spreads to other parts of the body. Once sensitized, a person would not be able to work directly with the material that caused the sensitization, since further skin contact, and even inhalation, can reactivate the dermatitis. Patch testing by a dermatologist may determine the sensitizer. We cannot stress enough the need for personal protection in the studio in order to avoid this problem.

Central nervous system depression, or narcosis, is caused by a variety of chemicals which enter the body through inhalation, ingestion, or skin absorption. On continuous exposure the symptoms progress from headache, dizziness, blurred vision, incoordination, mental confusion, weakness, and fatigue to eventual loss of consciousness.

NOTES ON THE TEXT

Safety Data Tables

The first column of the Tables lists the trade names or familiar names of the materials.

The second column contains information on the chemical content which has been obtained from manufacturers, suppliers, textbooks, and, in a few instances, by actual chemical analysis in our laboratory. The entries in this column are sometimes incomplete owing to the manufacturer's request for confidentiality. For this reason general chemical groups are substituted for specific chemical names in some cases. However, the hazards

and precautions are given for the total composition. It is thought that by supplying chemical compositions, the printmaker will understand the need for controls and will also be able to use the right type of glove, barrier cream, or respirator.

The third column shows the Alberta TLV for the material and refers only to exposure by inhalation. A TLV is not always applicable as some materials do not give rise to an inhalation hazard, e.g., dilute solutions, viscous substances, or bulk solids.

The fourth column lists the hazards associated with the material. The symptoms shown should be expected only when the TLV is exceeded or when there is physical contact resulting in skin absorption and irritation.

The final column gives the precautions to be taken to minimize exposure to the material.

Toxicity Rating

A toxicity rating, based on the effects of chemicals on humans, has been given to each material whenever possible. The ratings are as follows:

Toxicity Rating	Response	Exposure Limits
1	Relatively harmless	
2	Practically non-toxic	
3	Slightly toxic	1000–10,000 ppm
4	Moderately toxic	100–1000 ppm
5	Highly toxic	10–100 ppm
6	Extremely toxic	less than 10 ppm

EXPOSURE LIMITS

The human body has a variety of defense mechanisms against most toxic materials, but beyond a certain limit the defense mechanism breaks down or is overloaded, resulting in cell, tissue, or body organ response. Animal research and human studies have defined that level of exposure where there is no adverse reaction. This level or dose is used as the basis for setting industrial exposure limits. At present, the limits are based mainly on healthy male workers and do not take into consideration the very young or old, the ill, or those who are of particularly high or low sensitivity. This is especially important in printmaking, since some people may have studios at home which can result in an exposure to a high-risk group (children, older adults, pregnant females, etc.). There are also printmak-

ing classes offered to children, but because of the chemical exposure, this practice should be discontinued unless water-based inks are used.

The Alberta government adopted set exposure limits for airborne chemicals in the working environment (most governments have similar types of regulations). These are called Threshold Limit Values (TLVs) and are set up by the American Conference of Governmental Industrial Hygienists on the basis of industrial experiences of humans, and animal research. It is thought that exposure for up to eight hours per day at or below the TLV should result in no adverse health effects. Most of the limits are based on a Time Weighted Average (TWA) concentration, and therefore some exposure above the TLV is allowed providing a pre-determined maximum limit is not exceeded for more than fifteen minutes and the average is maintained for that day. For a few chemicals, the TLV is a ceiling limit and no exposure above the limit is allowed. The TLVs are based on exposure by inhalation, but some chemicals can have direct local action on the skin or may be absorbed through the skin into the body. Special precautions have to be taken with these chemicals, since guarding against inhalation alone may still result in physiological reactions if there is physical contact.

SOLVENTS

The general solvents for printmaking are usually hydrocarbons or hydrocarbon mixtures derived from petroleum. Some exceptions listed here are the alcohols (methanol, ethanol, isopropanol), the ketone (acetone) and turpentine, which is a hydrocarbon but not a petroleum derivative.

Within the hydrocarbons are two categories: aliphatics and aromatics. Most aromatics (e.g., benzene, toluene, and xylene) are absorbed through the skin and are in general the more irritating and narcotic of the two types of hydrocarbons, although both share these properties. Aliphatics (e.g., mineral spirits, naphtha) are surface irritants, defatting the protective oily layer of the skin. This can lead to dermatitis. Varsol is mainly an aliphatic hydrocarbon mixture; however, it contains anywhere from 5% to 13% aromatics. Because the hydrocarbons irritate the skin and in some cases penetrate the skin, gloves or barrier creams are recommended.

Recently, there has been much concern over the use of benzene (benzol) by printmakers. Although it has been proven to have toxic effects on the blood, which can lead to aplastic anemia and even leukemia, it is readily available to the general public. It is also still being used by some manufacturers as a solvent in their products. As reported in "Artworker's News" (Vol. 6, #10), Hancolite Glaze Cleaner, MS 408, is one of these prod-

ucts. We recommend that benzene be removed from the printmaking studio and that xylene or toluene be substituted, as they perform the same function and are less toxic.

Many printmakers are under the impression that lithotine is not damaging to the skin. In our research, we sampled two different brands of lithotine and we found that both contain over 90% Varsol or mineral spirits. Although both these solvents may be less irritating to the skin than turpentine,* both are skin irritants and repeated or prolonged contact can cause dermatitis. In some cases, because of a small percentage of aromatics in the Varsol, skin absorption becomes an added factor. In general, gloves or barrier cream should be used when handling lithotine.

Methanol (methyl hydrate) is common to most printmaking shops. It is easily absorbed through the skin and can cause eye damage. Although it is generally used in small quantities, it would be safer to use ethanol or isopropanol, two less toxic alcohols. When you buy ethanol, it is usually denatured (made undrinkable) by the addition of a small amount of toxic materials. This addition does not significantly affect the overall toxicity of the ethanol, except by ingestion.

Odor is not an adequate measure of toxicity. Acetone, for example, has a strong odor but is one of the less toxic solvents in printmaking shops. Since it has a TLV of 1000 ppm, inhalation becomes a problem only at extremely high concentrations. On contact with the skin, acetone is irritating and defatting, and may be absorbed, but its general toxicity, even in the light of this, is low. For this reason, we suggest that you attempt to substitute acetone as a general shop solvent whenever possible. As acetone is more volatile than Varsol, it does present a greater fire hazard. Open flames and smoking should be banned in any area where solvents are used.

It is important to remember that if you are airbrushing any of these solvents, the mist created will cause a higher concentration of the solvent more quickly than if you were to brush or wipe the same solvent onto a surface. Therefore, when airbrushing the various combinations of solvent and resist, work with local exhaust ventilation (see Hazard Controls). If this is not possible, use the proper respirator in a well-ventilated area so that the vapor does not remain suspended in the working environment. Make sure that others working in the vicinity are equally protected.

Solvent misuse is a common problem in many printmaking shops. For example, too much solvent is often used for a particular job, and lacquer thinner is frequently used for general cleaning when Varsol, mineral spirits, or acetone would be sufficient.

Another problem is the use of solvents for handcleaning. There are a variety of industrial handcleaners on the market which are specially formulated to remove inks and grease. If the shop does not provide handcleaner, then this should be considered a regular part of one's own equipment.

* Lithotine is considered a substitute for turpentine in lithography.

Trade Names	Chemical Composition	TLV	Hazard	Precautions
ACETONE dimethyl ketone, 2-propanone	Acetone	1000 ppm	in very high concentrations acetone is a central nervous system depressant slightly irritating to the skin the vapor is moderately irritating to the eyes Toxicity Rating 2	Use in a well-ventilated area.

ALCOHOLS

Trade Names	Chemical Composition	TLV	Hazard	Precautions
ETHYL HYDRATE ethanol, ethyl alcohol, algrain, anhydrol, cologne spirits, ethyl hydroxide, jaysols, methyl carbinol, teosol	Ethanol	1000 ppm	relatively low toxicity if proper ventilation is maintained prolonged exposures to extremely high concentrations may produce irritation to the mucous membranes, headaches, dizziness, nausea, and narcosis (inhalation) Toxicity Rating 2	Use in a well-ventilated area.
ISOPROPYL ALCOHOL avantine, dimethyl carbinol, isohol, isopropanol, lutosol, petrohol, 2-propanol, i-propanol, sec-propyl alcohol	Isopropyl alcohol	400 ppm	defatting agent central nervous system depressant absorbed easily through the skin, but owing to its low toxicity, this is not a significant hazard (inhalation and skin absorption) Toxicity Rating 2–3	If exposure is long term, use in a well-ventilated area. Avoid prolonged skin contact.

Trade Names	Chemical Composition	TLV	Hazard	Precautions
METHYL HYDRATE, methanol, methyl alcohol, carbinol, wood alcohol, wood spirit, wood naphtha, pyroxylic spirit, pyroligneous spirit, colonial spirit, colombian spirit, methyl hydroxide, monohydroxymethane	Methanol	200 ppm	exposure to high concentrations results in symptoms such as headaches, nausea, eye irritation. Very high concentrations can result in failure of vision skin absorption is a major route of entry into the body and contributes to the above symptoms (skin absorption and inhalation) **Toxicity Rating 4**	A respirator* or local exhaust ventilation is required when airborne concentrations are high. Skin contact must be avoided. The appropriate gloves or barrier cream should always be worn when using this material. For many applications it is possible to substitute with the less toxic ethanol or isopropanol.

HYDROCARBONS

Trade Names	Chemical Composition	TLV	Hazard	Precautions
BENZENE, benzine, benzin, nitration benzene, benzol(e), benzolene, bicarburet of hydrogen, carbon oil, coal naphtha, cyclohexatriene, motor benzol, mineral naphtha, phene, phenyl hydride, pyrobenzol(e)	Benzene	10 ppm (may be lowered)	central nervous system depressant irritant to the mucous membranes causes blood abnormalities can cause aplastic anemia (inhalation and skin absorption) **Toxicity Rating 6**	If possible, eliminate the use of this substance in the workshop. Substitutes such as toluene or xylene can be used. If it is necessary to use benzene, do so only with adequate local exhaust ventilation and the proper chemical gloves.

BENZINE	Hydrocarbon mixture obtained from petroleum naphtha, distilling between 30° and 90°C. and consisting principally of n-pentane and n-hexane.	central nervous system depressant irritant to the mucous membranes n-hexane is toxic to the nervous system skin irritant and defatting agent (inhalation) Toxicity Rating 4	Use only under well-ventilated conditions. If airborne concentrations are high, local exhaust ventilation should be used. For a short exposure a respirator* may be used. Wear appropriate gloves or barrier cream.
GASOLINE	Aliphatic hydrocarbon, mostly a mixture of C_5 to C_{12} distilling between 40° and 225°C. Regular gasoline has low benzene content but contains tetraethyl lead. Unleaded gasoline has a higher benzene content.	narcotic irritating to the mucous membranes skin irritant and defatting agent tetraethyl lead is absorbed through the skin and may cause lead poisoning in unleaded gasoline, benzene exposure, with its toxic effect on the blood, becomes significant Toxicity Rating 4	Substitute the other hydrocarbon solvents such as Stoddard solvent or naphtha.
KEROSENE coal oil	Petroleum product distilling between 175° and 325°C.	central nervous system depressant irritating to mucous membranes skin irritant and defatting agent (small % skin absorption due to aromatic content, inhalation) Toxicity Rating 4	Use only under well-ventilated conditions. If airborne concentrations are high, local exhaust ventilation should be used. For a short exposure a respirator* may be used. Wear the appropriate gloves or barrier cream.

Trade Names	Chemical Composition	TLV	Hazard	Precautions
LITHOTINE	(see Stoddard Solvent and/or mineral spirits) 90–97%, pine oil, castor oil.	100 ppm	central nervous system depressant; irritating to mucous membranes; skin irritant and defatting agent (can have small % of skin absorption depending on the solvent used, inhalation) Toxicity Rating 4	Use only under well-ventilated conditions. If airborne concentrations are high, local exhaust ventilation should be used. For a short exposure a respirator* may be used. Wear the appropriate gloves or barrier cream.
MINERAL SPIRITS petroleum spirits, mineral thinner, mineral turpentine, painters' naphtha, solvent naphtha, varnish makers' naphtha, varnish makers' and painters' naphtha (VM. & P. naphtha), benzoline, canadol, ligroin	Petroleum product distilling between 95° and 175°C. Consists chiefly of C_7–C_{10} aliphatic hydrocarbons, but composition can vary widely, as any one of several fractions within this boiling range may be used.		central nervous system depressant; irritating to mucous membranes; skin irritant and defatting agent (inhalation) Toxicity Rating 4	Use only under well-ventilated conditions. If airborne concentrations are high, local exhaust ventilation should be used. For a short exposure a respirator* may be used. Wear the appropriate gloves or barrier cream.
NAPHTHA	Petroleum product distilling between 30° and 238°C. Predominantly consisting of aliphatic hydrocarbons C_5–C_{13}.		central nervous system depressant; irritating to mucous membranes; skin irritant and defatting agent (inhalation) Toxicity Rating 4	Use only under well-ventilated conditions. If airborne concentrations are high, local exhaust ventilation should be used. For a short exposure a respirator* may be used. Wear the appropriate gloves or barrier cream.

TOLUENE toluol, methyl benzene, methyl benzol, methacide, phenylmethane	toluene	100 ppm	central nervous system depressant skin irritant and defatting agent irritant to the mucous membranes (skin absorption and inhalation) Toxicity Rating 4	Use only under well-ventilated conditions. If airborne concentrations are high, local exhaust ventilation should be used. For a short exposure a respirator* may be used. Wear the appropriate gloves or barrier cream.
TURPENTINE	Distilled from pine resin, consisting of α-pinene and β-pinene. Composition varies with source.	100 ppm	central nervous system depressant irritating to mucous membranes primary skin irritant which may be more irritating than the above hydrocarbons because of impurities such as formaldehyde, phenols, and the oxidation products of the major constituents. (inhalation) Toxicity Rating 4	Use only under well-ventilated conditions. If airborne concentrations are high, local exhaust ventilation should be used. For a short exposure a respirator* may be used. Wear the appropriate gloves or barrier cream.
VARSOL, STODDARD SOLVENT	Higher boiling range of petroleum naphtha distilling between 150° and 210°C, consists of a mixture of C_9 and C_{12} aliphatic hydrocarbons with a smaller and variable content of higher aromatic hydrocarbons.	100 ppm	central nervous system depressant irritating to mucous membranes skin irritant and defatting agent (the aromatic content may be absorbed by the skin) Toxicity Rating 4	Use only under well-ventilated conditions. If airborne concentrations are high, local exhaust ventilation should be used. For a short exposure a respirator* may be used. Wear the appropriate gloves or barrier cream.

Trade Names	Chemical Composition	TLV	Hazard	Precautions
XLYENE xylol, dimethyl benzene	xylene	100 ppm	central nervous system depressant skin irritant and defatting agent irritating to mucous membranes (skin absorption and inhalation) Toxicity Rating 4	Use only under well-ventilated conditions. If airborne concentrations are high, local exhaust ventilation should be used. For a short exposure a respirator* may be used. Wear the appropriate gloves or barrier cream.
OPEX LACQUER THINNER #9	toluene methanol ethyl acetate and/or methyl ethyl ketone, isobutyl acetate and/or n-butyl acetate		narcotic irritating to mucous membranes skin irritant (methanol is absorbed through the skin) and defatting agent chronic exposure to high concentrations of methanol can result in eventual failure of vision (skin absorption and inhalation) Toxicity Rating 4	Use only under well-ventilated conditions. If airborne concentrations are high, local exhaust ventilation should be used. For a short exposure a respirator* may be used. Skin contact must be avoided. The appropriate gloves or barrier cream should always be worn when using this material.

* The normal use of a respirator is for emergencies; it is not a preferred method of control. Don't forget that a respirator only protects the wearer.

ACIDS

Health Hazards

The areas in which the printmaker normally comes into contact with acids are intaglio, lithography, and photo preparation. In general, acids are primary skin irritants. In concentrated solutions they are capable of causing chemical burns, the effects becoming less severe as the acid is diluted and more severe with prolongd contact. In addition to this, chromic acid, along with being a primary skin irritant, is also a sensitizer in dilute solution.

The major hazards associated with handling and use of acids are skin and eye contact. These are easily prevented by the use of gauntlet-type gloves and chemical safety goggles. The face and eyes can also be protected by working behind a Plexiglas shield. It is advisable to wear a rubber apron.

In addition to their effects upon the skin and eyes, many of the acids present an inhalation hazard from acid vapors and mists. Concentrated acids should be used under local exhaust ventilation. Acid vapors and mists (e.g., from hydrochloric and acetic acids) irritate the eyes, nose and upper respiratory tract. Nitrogen oxides, arising from etching with nitric acid, are deep lung irritants.

Because of the irritant properties of acids, and since chromic acid in particular is a proven carcinogen, it is dangerous to use taste as a test for acid strength, a practice still carried on by some printmakers. Acid strength is best determined with pH papers.

The hazards associated with specific acids are summarized in the accompanying table. (See the Intaglio section for precautions to be taken when diluting concentrated acids.)

Trade Names	Chemical Composition	TLV	Hazard	Precautions
ACETIC ACID	acetic acid	10 ppm	primary skin irritant concentrated liquid causes severe burns; this hazard is reduced by dilution, i.e.: 50% to 80% causes moderate to severe burns; below 50%, relatively mild injury; at concentrations below 10%, no injury should occur	Avoid skin and eye contact. Wear the appropriate gloves; use eye protection, especially when handling the concentrated material. If vapor concentration is high, then a respirator or local exhaust ventilation should be used.
			the effects of eye contact follow a similar pattern	
			the vapor is highly irritating to the mucous membranes	
			Toxicity Rating 5 (concentrated acid)	
CARBOLIC ACID	phenol	5 ppm	primary skin irritant which can cause inflammation, dermatitis, and in some cases gangrene	Avoid skin and eye contact. Wear the appropriate gloves and use eye protection. Use only under well-ventilated conditions, preferably with local exhaust ventilation.
			phenol is easily and rapidly absorbed through the skin in toxic and even fatal amounts	
			the vapor is highly irritating to the eyes, nose, and upper respiratory tract	

			can cause systemic poisoning which affects the central nervous system, lungs, liver, kidneys, and heart chronic poisoning is characterized by digestive disorders, nervous disorders, skin eruptions, and liver and kidney damage Toxicity Rating 6	
CHROMIC ACID	chromic acid	0.05 mg/m³	powerful skin irritant; the corrosive action on the skin leads to deeply penetrating, slow-healing ulcers at lower concentrations chromic acid causes eczematous dermatitis and is a sensitizer inhalation of the mist can cause perforation of the nasal septum Toxicity Rating 6	The appropriate gloves and eye protection must be worn when using this material at any concentration. If misting is possible, then local exhaust ventilation must be used.
CITRIC ACID β-hydroxytricaballylic acid	citric acid		concentrated solutions are moderately irritating to the skin has some allergenic properties Toxicity Rating 2–3	Wear the appropriate gloves and use eye protection when handling concentrated solutions.
GALLIC ACID	gallic acid (syn.) 3, 4, 5-trihydroxy benzoic acid		mild skin irritant Toxicity Rating 2–3	Wear the appropriate gloves when handling concentrated solutions.

Trade Names	Chemical Composition	TLV	Hazard	Precautions
HYDROCHLORIC ACID muriatic acid	hydrochloric acid	5 ppm	primary skin irritant; solution causes severe burns	Wear the appropriate gloves and use eye protection. For extensive use, where hydrogen chloride concentrations can rise above the TLV, local exhaust ventilation is necessary.
			emits hydrogen chloride fumes which irritate the mucous membranes of the eyes, nose, and upper respiratory tract	
			Toxicity Rating 4–5	
HYDROFLUORIC ACID	hydrofluoric acid	3 ppm	extremely irritating and corrosive to the skin	Skin and eye contact must be avoided. Wear the appropriate gloves and use eye protection. This material should be used with adequate local exhaust ventilation. In case of accidental skin contact, wash with copious amounts of water and obtain medical attention.
			produces severe, slow-healing burns; gangrene of the affected areas may follow	
			even dilute solutions can be extremely damaging to the skin	
			the vapor, hydrogen fluoride, is extremely irritating to the mucous membranes of the eyes, nose, and upper respiratory tract	
			chronic effects include loss of weight, anemia, and dental problems	
			Toxicity Rating 5	

NITRIC ACID aqua fortis azotic acid	2 ppm	solutions of nitric acid are highly corrosive and will produce severe burns to the skin and eyes nitric acid vapor is also corrosive to the skin, the mucous membranes of the eyes, nose, and upper respiratory tract and to dental enamel Toxicity Rating 5	Wear the appropriate gloves. Use eye protection, especially when handling the concentrate. With highly concentrated solutions and for etching, local exhaust ventilation should be used.
OLEIC ACID		none	None required.
OXALIC ACID	1 mg/m³	can cause severe burns to the skin, eyes, and mucous membranes either as a dust or a solution even concentrations of 5% to 10% can be irritating poison if ingested Toxicity Rating 5	Wear the appropriate gloves and use eye protection.
PHOSPHORIC ACID	1 mg/m³	a weak acid, less hazardous than nitric or sulfuric acid concentrated solutions are skin irritants Toxicity Rating 4	Wear the appropriate gloves and use eye protection, especially when handling concentrated solutions. Use in a well-ventilated area.

Trade Names	Chemical Composition	TLV	Hazard	Precautions
SULFURIC ACID oil of vitriol spirit of sulfur	sulfuric acid	1 mg/m^3	skin contact with concentrated acid causes rapid destruction of the tissue, causing severe burns; these are generally slow healing repeated skin contact with low concentrations causes drying of the skin and ulceration of the hands eye contact is particularly serious, with possible effects such as deep corneal ulceration and kerato-conjunctivitis (inflammation of the cornea and conjunctiva) vapor is irritating to the mucous membranes of the eyes, nose, and upper respiratory tract Toxicity Rating 5	Wear the appropriate gloves and use eye protection, especially when handling concentrated solutions.
TANNIC ACID	complex glucosidic polyester of gallic acid		liver toxin and suspected carcinogen of the liver non-volatile; toxicity associated with ingestion Toxicity Rating 5	Avoid accidental ingestion.

POWDERS

Health Effects

The powders used in the printmaking studio do not generally present a serious hazard to health, since they are mainly nuisance dusts. In addition, the processes involving these powders are not particularly dusty and exposure is intermittent. For some processes, such as graining the stone with carborundum or cleaning a plate with pumice, the powder is wetted and this greatly reduces the dust hazard.

A nuisance or benign dust has little adverse effect upon the lung. This is true provided that the dust is kept under reasonable control. If the amount of nuisance dust is excessive, it can cause damage by overwhelming the clearing mechanism of the lung. In most cases this damage is reversible, but exposure to certain types of nuisance dusts can give rise to benign pneumoconiosis, which causes hardening of the lung tissue or a growth. It does not usually result in shortening of life.

Talc

Some industrial talcs used in printmaking may contain asbestos (1% to 5%). Asbestos inhalation has been proven to cause lung cancer. The frequency with which talc is used, the amounts used, and the normally low concentration of asbestos in the talc serve to reduce health risks. However, certified asbestos-free talcs are available and it would be good, safe practice to use one of these. Generally these talcs are higher grades used by cosmetic and baby powder manufacturers.

Whiting

Whiting, by definition, is calcium carbonate, a pure white chalk which has been ground and washed. However, printmakers and manufacturers alike have often substituted materials such as Barytes white, French chalk, alumina hydrate, and magnesium carbonate for calcium carbonate but retained the name "whiting." For this reason we have included all the above materials in the Safety Data tables.

Controls

No controls are needed for these particular powders unless the process is particularly dusty or unless the exposure is likely to be prolonged. In such cases, a dust mask should give adequate protection. One example of a process where a dust mask would be required is when a rosin box is opened to such an extent that a great deal of dust escapes.

Trade Names	Chemical Composition	TLV	Hazard	Precautions
ALUMINA HYDRATE	aluminum hydroxide	10 mg/m³	nuisance dust only Toxicity Rating 1	If operation is dusty, use a dust mask.
ASPHALTUM (powdered) mineral pitch, bitumen	complex mixture of high molecular weight hydro-carbons	5 mg/m³	there is a continuing de-bate as to whether inhala-tion of, or skin contact with, asphalt can produce cancer in humans Toxicity Rating 4	Because of the possibility that asphalt may produce cancer, skin contact and inhalation of dust or fumes should be avoided. Wear a dust mask and use the ap-propriate creams or gloves.
BARYTES (WHITE)	barium sulfate	10 mg/m³	long or intense exposure to dust leads to a benign pneumoconiosis Toxicity Rating 2	If operation is dusty, use a dust mask.
CRYSTOLON ABRASIVE GRAIN carborundum	silicon carbide		nuisance dust Toxicity Rating 2	If operation generates excessive dust, wear a dust mask. Wetting reduces dust levels appreciably.
DRAGON'S BLOOD	wood resin		no toxicological data available	If operation generates excessive dust, wear a dust mask.
MAGNESIUM CARBONATE, carbonic acid, magnesium salt, hydromagnesite, magnesite	magnesium carbonate		nuisance dust only Toxicity Rating 1	If operation is dusty, use a dust mask.

PUMICE	complex silicates, chiefly aluminum silicate	10 mg/m³	very little toxicological information available	If operation generates excessive dust, wear a dust mask. Wetting reduces dust levels.
RED OXIDE	iron oxide	10 mg/m³	nuisance dust long or intense exposure may cause a benign pneumoconiosis Toxicity Rating 3	If operation generates excessive dust, wear a dust mask.
ROSIN	mainly abietic anhydride		may be an allergen	If operation generates excessive dust, wear a dust mask.
TALC French chalk	hydrated magnesium silicate	10 mg/m³	no short-term toxic effects chronic inhalation may lead to benign pneumoconiosis; symptoms include shortness of breath, cough, and fatigue chronic excessive exposure can lead to pulmonary fibrosis (formation of fibrous tissue in lungs) some talcs contain asbestos, which has been linked to lung cancer and peritoneal cancer (cancer of the membrane lining and abdominal pelvic walls) Toxicity Rating 3	Use certified asbestos-free talc, which is available as a high or cosmetic grade of talc. If operation generates excessive dust, wear a dust mask.
WHITING	calcium carbonate	10 mg/m³	nuisance dust only Toxicity Rating 1	If operation generates excessive dust, wear a dust mask.

PRINTING INKS

One material common to all areas of printmaking is ink. Most artists don't know the chemical nature or the toxicity of the pigments, vehicles, or solvents used in the formulation of printing inks. Unfortunately it is not uncommon to see people covering their hands and arms with ink during the mixing process.

Many pigments are, in fact, relatively low in toxicity, but several are not only highly toxic but possibly carcinogenic. There are two types of pigments to be considered: organic pigments, which are derived from carbon, and inorganic pigments, which are based on elements other than carbon.

The organic pigments are most often synthetic materials but may also be naturally occurring compounds such as indigo and alizarin. The inorganic pigments are usually metals or metal salts and are often derived from minerals (e.g., ocher, which is a clay colored by iron oxide).

The elements of inorganic pigments determine their toxicity. A great variety of metals are found in pigments, but those of greatest concern are antimony (antimony orange, Naples yellow), arsenic (emerald green, Paris green, cobalt violet), cadmium (all cadmium pigments), chromium (viridian, chrome yellow, barium yellow), cobalt (cerulean blue, cobalt violet), lead (flake white, chrome yellow), manganese (manganese pigments and umbers), mercury (vermilion, cinnabar), molybdenum (molybdate orange) and selenium (cadmium red). Almost all these metals are toxic to the central nervous system; arsenic, antimony, chromium, molybdenum, and selenium are liver toxins; cadmium, chromium, lead, molybdenum, and mercury are kidney toxins, and antimony, cadmium, and cobalt exert a toxic effect on the cardiovascular system. In addition to this, lead chromate (chrome yellow) is a suspected carcinogen.

Metal salts are also found in the driers. One of these, cobalt naphthenate, is a suspected carcinogen of the connective tissue.

A few of the organic compounds (e.g., diarylide) are of particular concern, since they are based on the compounds benzidine and dichlorobenzidine, two known bladder carcinogens. If the pigment is ingested, it may be converted by the body into these original carcinogenic compounds.

Since many pigments are toxic and may cause cancer, it is important to handle them carefully, avoiding any possibility of entry into the body. When pigments (including metallic powders, e.g., bronze, silver) are being ground or mixed, especially in the initial stages, the operation can be particularly dusty. At this time wear a respirator or work under local exhaust ventilation until the paste is completely formed.

Accidental ingestion can occur when pigment present on the skin is transferred to food

or cooking utensils. Several of these materials can be absorbed directly through the intact skin and many of them can be absorbed through damaged or abraded skin. Gloves will protect against both these routes of entry and against the possibility of dermatitis from some of the pigments, especially those that contain arsenic or chromium. Certain black pigments, based on carbon black, have been implicated as skin carcinogens. Solvents in the inks can also defat the skin and cause dermatitis.

Since the printmaker may not know the chemical composition of the pigments in the inks used in the studio, and since this information is very often difficult to obtain, it is strongly suggested that these precautions be taken when using any inks.

There are several ways to obtain information on the pigment composition. The Colour Index is a multi-volume, cross-referenced publication, dealing with the trade name of the pigments, pigment numbers, manufacturers, and chemical composition.

If the trade name of the pigment (not the ink) or the pigment number is known, then a Colour Index number can be obtained and from that the chemical composition can be found. However, if this information is not known, then the pigment number or chemical composition may be obtained from the manufacturer, although we experienced some difficulty in obtaining the cooperation of certain printing ink manufacturers. If you need assistance in obtaining this information, contact your local health and safety office.

INTAGLIO

Etching

All the acids used in intaglio etching processes are most hazardous as concentrated solutions. It is important to use care in every aspect of their handling, from the mixing of the etch, through the actual etching, to the disposal of the etch. Proper acid storage is discussed in the Acid section, along with some comments about acids in general.

When mixing an etch, wear gloves and eye protection, as the acid is being handled in its most concentrated form. Diluting an acid can be a hazardous operation, but the safer method is to begin with water and add the acid in small amounts, stirring constantly. When the acid and water are being mixed, the heat which is produced can cause the solution to splash and spit. By adding the acid to the water, any splashing that may occur would be of a dilute concentration.

The mixing as well as the etching should be done under local exhaust ventilation to prevent inhalation of the fumes. Recently, in an art college in Alberta, three staff members and two students were adversely affected by high concentrations of chlorine gas which resulted from mixing and etching with Dutch mordant. The lack of proper ventilation

was cited as the cause of the high fume concentrations in the printmaking shop. The five affected persons suffered fatigue, irritation of the eyes, nose, and throat, nausea, and difficulty in breathing. They were unable to continue working in the studio and they formally requested the safety committee of the college to take action regarding the lack of proper ventilation.

One of the best systems of protection in the etching area of a printmaking shop uses a Plexiglas enclosure for the acid trays, with a local exhaust hood above the trays. With Plexiglas shields, the eyes and body of the printmaker are protected from the splashes, and people are prevented from leaning over acid trays where fume concentrations can be high. One printmaker had, in fact, etched his front teeth from many years of working too closely to his plates as they were etching.

During the etching process it is often necessary to remove the plate from the acid to check the depth of the bite. Acid-resistant gloves should be worn when handling the plates and the plate itself should be rinsed thoroughly before it is inspected.

When disposing of an etch, use the same precautions as when mixing. If the etch is to be poured down the drain, make sure there is a constant supply of running water to dilute it.

Photo Resists

In this study we have examined two different brands of photo resists: Kodak and Christie. Both may be safely used if the proper precautions are followed.

Kodak Photo Resist, KPR, and its thinner are composed mainly of methyl cellosolve acetate, which is easily absorbed through the skin and can cause damage to kidneys and brain. It can also be inhaled. The developer is primarily xylene, a narcotic which is taken into the system through skin absorption and inhalation. The procedures for using KPR should also be used for Kodak Metal Etch Resist, KMER, as its main constituent is xylene.

The processing area for KPR or KMER should have a local exhaust hood under which the coating and developing will be done. In any communal situation, a respirator does not adequately solve the problem of fume exposure and should only be used for processes which are infrequent and short. The processing area should be set apart from shop traffic to avoid accidents. For example, one printmaker spoke of an instance where a shop did not have the proper facilities for KPR processing. The developing tray was kept on a desk in the studio and the printmaker slipped, knocked the developing tray, and splashed the developer into his face and eyes.

During every phase of the processing, gloves or barrier cream should be used and eye protection is strongly recommended, since splashing might occur. Baking of the plates

should be done under a fume hood, since the solvents and unreacted chemicals will be released at high temperatures.

The Christie photo resist process, V 149 and V 145, uses a mixture of polyvinyl alcohol, water, and an inorganic chromate as the fixer-hardener. Although chromates are rated as extremely toxic, they can be handled safely if the precautions are followed. In a dilute solution, the main problem from the chromates is sensitization dermatitis. Mists are not usually a problem in this process, therefore general ventilation is sufficient. The best precaution in all phases of the Christie process is to avoid any skin contact with the chromate solutions.

Again, the processing area should be clearly defined in the studio and isolated from general traffic. The fixer-hardener tray of chromic acid in solution (V 145) should not be left out after the processing is complete, especially in school situations where someone new to printmaking may not know the dangers involved.

Eye protection is important when handling chromates. During the Christie process safety goggles should be worn at the mixing stages.

Some printmaking shops have discontinued the use of photo resists entirely, as they have found it simpler to use presensitized etching plates.

Trade Names	Chemical Composition	TLV	Hazard	Precautions
AMMONIA	ammonia	25 ppm	vapor is irritating to the mucous membranes of the eyes, nose, and upper respiratory tract concentrated solutions have a corrosive effect on the skin and eyes, causing burns dilute solutions are defatting agents on the skin and can lead to dermatitis Toxicity Rating 5	Use under well-ventilated conditions. Local exhaust ventilation or a respirator is required for prolonged use when vapor concentrations are expected to be high. Wear the appropriate gloves or barrier cream and use eye protection.
BURNT PLATE OIL	boiled linseed oil		can be an allergen with chronic exposure Toxicity Rating 1–2	None required.
EMPIRE RESIST REMOVER CONCENTRATE	potassium hydroxide solution	2 mg/m³	corrosive action on skin and eyes; concentrated solutions produce deep, painful destruction of tissues dilute solutions will emulsify and dissolve natural skin fats, and may lead to dermatitis mists will cause irritation to the eyes and respiratory tract and erode the nasal septum heating leads to easier formation of mists Toxicity Rating 4	Prevent skin and eye contact by wearing the appropriate gloves or barrier cream and by using eye protection. If misting can occur, local exhaust ventilation is necessary or a respirator approved for alkali mists can be worn.

ETCHES

DUTCH MORDANT	hydrochloric acid potassium chlorate water	hydrochloric acid is a primary skin irritant; the solution causes severe burns in the mordant, chlorine gas is evolved which is extremely irritating to the mucous membranes of the eyes, nose, and upper respiratory tract; the irritating properties usually prevent severe overexposure Toxicity Rating 5	Avoid skin contact during the mixing of an etch as well as throughout the etching process. Wear appropriate gloves. Use eye protection, especially when handling concentrated acid. Local exhaust ventilation should be used for the etching area.
FERRIC CHLORIDE ETCH	ferric chloride water	ferric chloride hydrolizes in solution producing hydrochloric acid which is irritating to the eyes and skin Toxicity Rating 4	Skin and eye contact should be avoided with undiluted solution. Wear eye protection and gloves.
NITRIC ACID ETCH	nitric acid water	solutions of nitric acid are highly corrosive and will produce severe burns to the skin and eyes the vapor is also corrosive to the skin, to the mucous membranes of the eyes, nose, and upper respiratory tract, and to dental enamel Toxicity Rating 5	Avoid skin contact during the mixing of an etch as well as throughout the etching process. Wear gloves. Use eye protection, especially when handling the concentrate. Local exhaust ventilation should be used for etching.

Trade Names	Chemical Composition	TLV	Hazard	Precautions
GROUNDS				
SENELITH ASPHALTUM	mineral spirits and xylene gilsonite/asphalt	100 ppm	may cause photosensitization of the skin both solvents, mineral spirits and xylene, are central nervous system depressants; both are skin irritants and defatting agents xylene is absorbed through the skin Toxicity Rating 4	Avoid skin contact. Use under well-ventilated conditions. If use is either long-term or in large quantity, local exhaust ventilation is necessary. Wear the appropriate gloves or barrier cream.
SOFT BALL GROUND	gilsonite beeswax, crisco, beckapol (phenolic resin)		may cause dermatitis may cause photosensitization of the skin Toxicity Rating 3	Avoid skin and eye contact.
ULTRAFLEX LIQUID HARD GROUND	gilsonite turpentine	100 ppm	gilsonite may photosensitize the skin turpentine is a primary skin irritant, a central nervous system depressant, and is irritating to the mucous membranes (see Solvents for more information)	Avoid skin contact. Wear the appropriate gloves or barrier cream. Avoid long exposures without adequate ventilation.

NON-ETCH DESCUM SOLUTION	water sulfuric acid		heating this material causes high vapor concentrations of solvent Toxicity Rating 4 concentrated solutions cause severe skin burns repeated skin contact with low concentrations causes drying of the skin and ulceration of the hands eye contact is particularly serious with possible effects such as deep corneal ulceration and inflammation of the cornea and conjunctiva the mist is irritating to the mucous membranes of the eyes, nose, and upper respiratory tract Toxicity Rating 4	Wear the appropriate gloves and eye protection.

PHOTO RESISTS

KMER KODAK METAL ETCH RESIST	xylene light-sensitive polymer	100 ppm	xylene is a central nervous system depressant, a skin irritant, a defatting agent, an irritant to the mucous membranes, and is absorbed through the skin Toxicity Rating 4	Use only under well-ventilated conditions. Local exhaust or respirator should be used in areas where general ventilation is inadequate. Use appropriate gloves or barrier cream.

SCREENPRINTING

Inks, Bases, Thinners, Retarders

In screenprinting, the main hazards lie in the large amounts of solvent used in the inks, bases, thinners, retarders, and general screen solvents. The inks may contain anywhere from 40% to 60% solvent; the bases, around 80% solvent; and the thinners and retarders, 100% solvent. Two families of inks commonly found in screenprinting shops are the Flat Finish Inks and the Plasti-Vac Gloss Inks and their respective thinners and retarders.

The Flat Finish Inks are the most commonly used inks in fine art screenprinting shops. Basic good housekeeping methods as well as some personal protection are necessary when mixing the inks, printing, and cleaning up. Through all these procedures, gloves or barrier creams should be used, since skin contact is considerable.

The Plasti-Vac Gloss Inks, thinners, and retarders are more toxic than the Flat Finish Inks owing to the types of chemicals used as solvents. These inks should not be regularly used in studios where there is inadequate ventilation. In some instances where large amounts of inks are to be mixed and printed, local ventilation will be necessary. When handling any of the Plasti-Vac materials, gloves or barrier cream must always be used, as butyl cellosolve acetate and the aromatic hydrocarbon solvent are easily absorbed through the skin.

When mixing inks avoid leaving cans open or large amounts of ink on the palette for long periods of time. All through the mixing, printing, and drying stages, solvent is constantly evaporating from the inks into the atmosphere at concentrations which are much higher than those found in intaglio or lithography. When the mixing is complete, clean up the area entirely, i.e., don't leave unused ink or solvent-soaked rags lying around. The rags should be immediately placed in a safety disposal container.

During printing, avoid letting the screen dry out to the point where an excessive amount of clean-up solvent will have to be used. Screens and squeegees covered with ink and left to dry are not only indicative of poor printing habits, they also require more solvent in the cleaning process than would normally be used if the equipment was cleaned immediately after printing. At no point in the clean-up of the Flat Finish Inks should lacquer thinner be necessary, as the materials used in these inks are easily dissolved with Varsol.

If a stronger solvent is needed at any time, acetone is efficient and is less toxic than lacquer thinner or Varsol. It may be possible to substitute acetone as a general clean-up solvent in the shop, bearing in mind that it presents a greater fire hazard. In all clean-up

situations, wipe the solvent residue off the tables and palettes, etc., rather than letting it evaporate.

Screenprinting inks dry through solvent evaporation and therefore a drying rack full of fresh prints is a source of solvent contamination if the area is not well ventilated.

Blockouts

Two commercially prepared blockouts were sampled in this study. Although both are used for the same purpose, their compositions vary considerably. Super Blox contains a high percentage of methylene chloride and a smaller percentage of methanol. For this reason it is rated as moderately toxic and requires special handling procedures (see the Safety Data Tables). Ulano Blockout, on the other hand, has a relatively harmless composition and requires no special handling precautions.

Trade Names	Chemical Composition	TLV	Hazard	Precautions
BINDER VARNISH	resins plasticizers solvents: mineral spirits, denatured ethanol, terpene, aromatic hydro- carbon solvent	100 ppm 1000 ppm 100 ppm	mineral spirits, terpene, and aromatic hydrocarbons are all central nervous system depressants they are irritating to the mucous membranes of the eyes, nose, and upper respiratory tract they are skin irritants and defatting agents and may cause dermatitis upon prolonged or repeated exposure aromatic hydrocarbon solvents are absorbed through the skin into the body Toxicity Rating 4	Use only in a well-ventilated area. Wear the appropriate gloves or barrier cream.
BLOCKOUTS				
LEPAGES LIQUID STRENGTH GLUE	water hide glue protein extract urea preservative		toxicity unknown (animal glues are often allergenic)	
SUPER BLOX	methylene chloride methanol methyl cellulose water	200 ppm 200 ppm	methylene chloride is a central nervous system depressant; it is metabolized to carbon monoxide, and exposure to high concentrations will give symptoms of carbon monoxide poisoning which are associated with reduced availability of oxygen to the	Use only in a well-ventilated area. Avoid skin contact. Wear the appropriate gloves or barrier cream. A respirator or local exhaust ventilation is necessary for high concentrations.

			tissues; this is of particular concern to people who may be predisposed to heart attack	
			exposure to high concentrations of methanol results in symptoms such as headaches, nausea, eye irritation and damage; it is easily absorbed into the body through the skin	
			Toxicity Rating 4	
ULANO BLOCKOUT	confidential	none		None required.

INKS AND THINNERS

Trade Names	Chemical Composition	TLV	Hazard	Precautions
FLAT FINISH INKS	resins pigments solvents: mineral spirits, denatured ethanol, terpene, aromatic hydrocarbon solvent	100 ppm 1000 ppm 100 ppm	mineral spirits, terpene, and aromatic hydrocarbons are all central nervous depressants	Use only under well-ventilated conditions. If airborne concentrations are high, local exhaust ventilation should be used. For a short exposure a respirator* may be used. Wear the appropriate gloves or barrier cream.
			they are irritating to the mucous membranes of the eyes, nose, and upper respiratory tract	
			they are skin irritants and defatting agents and may cause dermatitis upon prolonged or repeated exposure	
			aromatic hydrocarbon solvents may be absorbed through the skin into the body	
			Toxicity Rating 3–4	

365

Trade Names	Chemical Composition	TLV	Hazard	Precautions
FLAT FINISH THINNER	mineral spirits	100 ppm	central nervous system depressants	Use only under well-ventilated conditions. If airborne concentrations are high, local exhaust ventilation should be used. For a short exposure a respirator* may be used. Wear the appropriate gloves or barrier cream.
FLAT FINISH RETARDING THINNER	aliphatic hydro-carbon solvent		irritating to the mucous membranes of the eyes, nose, and upper respiratory tract	
FLAT FINISH FAST THINNER	aliphatic hydro-carbon solvent		skin irritants and defatting agents Toxicity Rating 3–4	
PLASTI-VAC GLOSS INKS	pigments resins solvents: butyl cellosolve, isophorone, cellosolve acetate, diacetone alcohol, aromatic hydro-carbon solvent	50 ppm 5 ppm 25 ppm 50 ppm 100 ppm	BUTYL CELLOSOLVE irritating to the eyes, nose, and upper respiratory tract only mildly irritating to the skin surface but is easily absorbed through it in toxic amounts injurious to the blood, liver, and kidneys ISOPHORONE highly irritating to the mucous membranes of the eyes, nose, and upper respiratory tract; it is also a central nervous system depressant	The following precautions apply to the Plasti-Vac Gloss Inks, Plasti-Vac Thinner, and Plasti-Vac Retarder Thinner: Avoid skin and eye contact. The appropriate gloves or barrier cream should always be worn when handling these materials. Use eye protection. Local exhaust ventilation is necessary; a respirator may be worn if others would not be affected in the environ-ment and if there is general ventilation.
PLASTI-VAC THINNER and PLASTI-VAC RETARDER THINNER	butyl cellosolve, isophorone, cellosolve acetate, diacetone alcohol, aromatic hydro-carbon solvent (same as for ink solvents, except % differs)			

DIACETONE
ALCOHOL
defatting agents which
may cause dermatitis
upon prolonged or fre-
quently occurring
contact

irritating to the eyes, nose,
and upper respiratory tract

CELLOSOLVE
ACETATE
not irritating to the skin
surface, but it is easily
absorbed through it into
the body

can cause central nervous
system depression and lung
and kidney injury

OVERPRINT CLEAR	alkyd resins driers additives aromatic hydro- carbon solvent	the significant hazard here is with the aromatic hydrocarbon solvent: central nervous system depressant skin irritant and defatting agent; may cause dermatitis upon prolonged or frequent contact aromatic hydrocarbons are absorbed through the skin into the body Toxicity Rating 3–4	Use only in a well-ventilated area. Wear the appropriate gloves or barrier cream.

Trade Names	Chemical Composition	TLV	Hazard	Precautions
SCREEN WASH 70-184	toluene butyl acetate isopropanol	100 ppm 150 ppm 1000 ppm	toluene is a central nervous system depressant, an irritant to the mucous membranes of the eyes, nose, and upper respiratory tract, and an irritant to the skin; may cause dermatitis upon repeated or prolonged contact; it is absorbed through the skin into the body butyl acetate is a central nervous system depressant, and an irritant to the mucous membranes of the eyes, nose, and upper respiratory tract Toxicity Rating 4	Use only under well-ventilated conditions. If airborne concentrations are high, local exhaust ventilation should be used. For a short exposure a respirator* may be used. Wear the appropriate gloves or barrier cream.
SCOTCH BRAND SANDBLAST FILLER #2	naphthenes and paraffins aromatics olefins		central nervous system depressant irritating to the mucous membranes of eyes, nose, and upper respiratory tract skin irritant and defatting agent the aromatic content will be absorbed by the skin Toxicity Rating 3-4	Use only under well-ventilated conditions. Avoid breathing the fumes; use a respirator if necessary. Wear the appropriate gloves or barrier cream.
TOOSH GLUE & LACQUER RESIST	mineral spirits inert pigments vehicle solids		the significant hazard here is mineral spirits: central nervous system depressant	Use only in a well-ventilated area. Wear the appropriate gloves or barrier cream if skin contact is expected.

irritating to the mucous membranes

skin irritant and defatting agent

Toxicity Rating 3–4

TRANSPARENT BASE 5530	resins plasticizers thickeners solvents mineral spirits	the only significant hazard is with the solvent mineral spirits is a central nervous system depressant, an irritant to the mucous membranes, and a skin irritant and defatting agent Toxicity Rating 3–4	Use only in a well-ventilated area. Wear the appropriate gloves or barrier cream.
AROMATIC HYDRO-CARBON SOLVENT		high concentrations are irritating to the eyes, nose, and upper respiratory tract central nervous system depressant skin irritant and defatting agent; may cause dermatitis upon prolonged or frequent contact aromatic hydrocarbons are absorbed through the skin into the body several of these chemicals will cause severe eye irritation on direct contact Toxicity Rating 5–6	

Trade Names	Chemical Composition	TLV	Hazard	Precautions
LACQUER FILM ADHERENT GS-51	aliphatic acetates others (unidentified)		high concentrations can cause central nervous system depression irritating to the eyes, nose, and upper respiratory tract defatting agent (inhalation) Toxicity Rating 4	Use in a well-ventilated area. If airborne concentrations are high, use local exhaust ventilation or a respirator.* Wear the appropriate gloves or barrier cream.
TSP CLEANER	tribasic sodium phosphate		strongly alkaline and therefore a primary skin irritant; irritation may eventually lead to dermatitis eye contact with dust or solution will cause severe eye damage Toxicity Rating 4	Avoid skin and eye contact.
ULANO HI-FI PART A DEVELOPER PART B	organic acid peroxide-forming compound		Part A is an acidic powder; Part B is alkaline; the powders can be irritating to the skin and mucous membranes the solution gives rise to hydrogen peroxide which in low concentrations is mildly irritating eye contact can cause damage	Wear the appropriate gloves or barrier cream. Avoid splashing.

* The normal use of a respirator is for emergencies; it is not a preferred method of control. Don't forget that a respirator only protects the wearer.

BIBLIOGRAPHY

The Art of Aquatint, by B. F. Morrow. G. P. Putnam's Sons, New York, 1935.

The Art of Etching, by E. S. Lumsden. J. P. Lippincott Co., Philadelphia, 1926.

The Art of the Print, by Fritz Eichenberg. Harry N. Abrams, Inc., New York, 1976.

Atelier 17, Wittenborn, Schultz, Inc., New York, 1949.

Cahiers d'Art, Juin, 1953, "Rolf Nesch," by Will Grohman.

The Caprices of Goya, by Jean Adhemar. Fernand Hazan, Paris, 1951.

Care and Repair of Japanese Prints, by Carl Schraubstadter. Idlewild Press, New York, 1948.

The Complete Printmaker, by John Ross and Clare Romano. The Free Press, Collier Macmillan Ltd., 1972.

Degas Monotypes, by Eugenia Parry Janis. Harvard University Press, Cambridge, Massachusetts, 1968.

Etching, by Leonard Edmondson. Van Nostrand Reinhold Co., New York (n.d.).

Etching, by Earl H. Reed. G. P. Putnam's Sons, New York (n.d.).

Hercules Seghers, by Leo C. Collins. The University of Chicago Press, 1953.

Incisioni Fiorentine del Quattrocento, by Lamberto Donati. Istituto Italiano d'Arte Grafiche, Bergamo, 1944.

Master Prints from the Museum Collection, William Lieberman. Museum of Modern Art Bulletin, Vol. XVI, No. 4, 1949, New York.

The Memorial Exhibition of Hiroshige, by S. Watanabe. Ukiyoye Association, Tokyo, 1918.

New Ways of Gravure, by Stanley W. Hayter. Pantheon Books, New York, 1949.

The Origins of Printing and Engraving, by André Blum. Charles Scribner's Sons, New York, 1940.

Print People, by A. Hyatt Mayor. The Metropolitan Museum of Art, New York, 1971.

Prints of the Twentieth Century, A History, by Riva Castleman. The Museum of Modern Art, New York, 1976.

Printmaking, by Ronald Saff and Deli Sacilotto. Holt, Rinehart & Winton, Inc., New York, 1978.

Printmaking Today, by Jules Heller. Second ed. Holt, Rinehart & Winston, Inc., New York (n.d.).

Saturn: An Essay on Goya, by André Malraux. Phaidon, London, 1957.

Screen Process Printing, by Albert Kosloff. Sign of the Times Publishing Co., Cincinnati, Ohio, 1950.

Ten Years of American Prints 1947–1956, by Una E. Johnson. The Brooklyn Museum, New York, 1956.

A Treatise on Etching, by Maxime Lalanne. The Page Co., Boston (n.d.).

Wood-Block Printing, by F. Morley Fletcher. John Hogg, London, 1916.

SOME POPULAR
PRINTING PAPERS

American Etching. 38 x 50, 100% rag, machine made. White. Not much sizing. Prints well, good for large prints.

Arches Cover. 22 x 30, 29 x 41, 90% rag, mold made. White, buff. Prints well but on the light side. Exposed to light yellows.

Copperplate Deluxe. 20 x 32, 30 x 42, 75% rag, mold made. Fragile. Don't soak, spray. Prints well, best suited for small prints.

Domestic Etching. 26 x 40, 50% rag. White. Doesn't need long soaking. Ideal for schools.

German Etching. 22 x 30, 30 x 42, 75% rag, mold made. Handsome, soft white. Prints well.

Milbourn 140 lb. 22 x 30, 100% rag, handmade. Rich, handsome. P. expensive.

Mulberry. 24 x 30, part Kozo, handmade. Thin woodcut paper. Fragile. No wet strength.

Murillo. 27 x 39, 33% rag, machine made. Off-white. Strong, prints rich. Needs long soaking. Good for heavy embossment.

Rives BFK. 22 x 30, 29 x 41, 100% rag, mold made. One of the best standard papers. Buckles easily.

Strathmore Artist. 100% rag, machine made. Strong. Mechanical text. Prints with texture.

Tableau. 40″ rolls, machine made. Tough filter paper. Good for woodcuts. Wet strength. Slight discoloration with age.

SOURCES OF GRAPHIC SUPPLIES
AND EQUIPMENT

General Supplies

Arthur Brown
2 West 46th St.
New York, N.Y. 10036

Craftools, Inc.
1 Industrial Ave.
Woodbridge, N.J.
(Equipment, presses)

Sam Flax
25 East 28th St.
New York, N.Y. 10016
(Also in Chicago, Los Angeles,
and San Francisco)

Graphic Chemical & Ink Co.
728 North Yale Ave., P.O. Box 27
Villa Park, Ill.
(Printing inks, presses)

W. C. Kimber
25 Field St.
King's Cross Road
London WC 1, England

Kimber Etching Supplies
44 Clerkenwell Green
London EC 1, England

Harold M. Pitman Co.
515 Secaucus Rd.
Secaucus, N.J.
(Chemicals, plates, acid trays, etc.)

Rembrandt Graphic Arts Co., Inc.
1 River Rd.
Stockton, N.J. 08559
(Equipment, supplies, presses)

Acids, Chemicals

(Most large chemical companies and
graphic supply companies sell acids.)

Amend Drug & Chemical Co., Inc.
83 Cordier St.
Irvington, N.J. 07121

Engravers' Tools

Commercial Art Materials Co.
165 Lexington Ave.
New York, N.Y. 10016
(Imported tools)

Foredom Electric Co., Inc.
Bethel, Conn. 06801
(Miniature power tools)

E. C. Lyons
16 West 22nd St.
New York, N.Y. 10011

Frank Mittermeier, Inc.
3577 East Tremont Ave.
Bronx, N.Y. 10465

E. C. Mueller
3646 White Plains Rd.
Bronx, N.Y. 10467
(Burins, scrapers, burnishers)

Felts, Tarlatan

A. S. Textile Co., Inc.
236 West 27th St.
New York, N.Y. 10001

Aetna Felt Co., Inc.
204 Center St.
New York, N.Y. 10013

Beckman Felt Co.
120 Baxter St.
New York, N.Y. 10002
(Tarlatan)

Continental Felt Co.
22-26 West 15th St.
New York, N.Y. 10011

Gross-Kobrick
370 West 35th St.
New York, N.Y. 10013

Charles W. House and Sons, Inc
Unionville, Conn. 06085

Pacific States Mfg. Co.
843 Howard St.
San Francisco, Calif. 94103

Framing Supply

S and W Framing Supply Inc.
1845 Highland Ave.
New Hyde Park, N.Y. 11040

Inks

California Ink Co.
2839 East Pico Blvd.
Los Angeles, Calif. 90052

California Ink Co.
501 15th St.
San Francisco, Calif.

F. Charbonnel
13 Quai Montebello
Paris V-em, France

Cronite Co.
Hudson Blvd. at 88th St.
North Bergen, N.J. 07047
(Also heavy plate oil)

E. I. Du Pont DeNemours & Co.
Pigments Dept.
Wilmington, Del. 19899
(Dry pigments)

Interchemical Printing Corp.
16th and Willow
Oakland, Calif. 94615

IPI (Interchemical Corp.)
636 Eleventh Ave.
New York, N.Y. 10036

Lorileux & Lefranc Co.
16 Rue Suger
Paris VI-em, France

Daniel Smith Ink Co.
6500 32nd Ave. N.W.
Seattle, Washington 98117

F. Weber Co.
Wayne and Windrim Aves.
Philadelphia, Pa. 19144

C. K. Williams Co.
Emeryville, Calif. 94608
(Dry pigments)

Leather

A. Heller Leather Co.
101 Gold St.
New York, N.Y.

Linen Tape

Ross & Co.
529 Fifth Ave.
New York, N.Y.

Papers

Aiko's
714 North Wabash
Chicago, Ill. 60611

Andrew-Nelson-Whitehead Paper Corp.
7 Laight St.
New York, N.Y. 10013

Chicago Cardboard Co.
1240 North Homan Ave.
Chicago, Ill. 60607
(Matboards)

Crestwood Paper Co., Inc.
263 Ninth Ave.
New York, N.Y. 10013

Lindenmeyer Paper Corp.
53rd Ave. at 11th St.
Long Island City, N.Y. 11101
(Georgian-Strathmore)

Miller Cardboard Co.
80–82 Wooster St.
New York, N.Y.

Saxon Paper Corp.
240 West 18th St.
New York, N.Y. 10013
(Blotters)

Standard Corrugated & Case Corp.
686 Grand Ave.
Ridgefield, N.J. 07657

Technical Paper Corp.
729 Boylston St.
Boston, Mass. 02116
(Tableau woodcut paper in rolls)

Wilson Rich Paper Co.
60 Federal St.
San Francisco, Calif.

Plastics

Commercial Plastics & Supply Corp.
630 Broadway
New York, N.Y. 10013

Plates

J.W. Feinstein, Distributor
Revere Copper & Brass Inc.
Edes Mfg. Div.
726 Harrison St.
San Francisco, Calif. 94101

The C. George Co.
40 Ellish Parkway
Spring Valley, N.Y. 10977
(Unpolished copper plates)

Harold M. Pitman Co.
(See General Supplies)

Presses

Glen Alps
6523 40th Ave. N.E.
Seattle, Wash. 98115

Bottega d'Arte Grafica
6 Via degli Artisti
Florence, Italy

Claude Boulanger
17 Rue Emil-Dubois
Paris XIV-em, France
(Neckar press)

Charles Brandt
84 East 10th St.
New York, N.Y. 10003
(Litho, etching, also
hot plates, large rollers)

American-French Tool Co.
Route 117
Coventry, R.I. 02816

Meeker-McFee
309 Parkway
Madison, Wisc. 53703

Martech
P.O.Box 36
Northport, N.Y. 11768

Graphic Chemical & Ink Co.
Sturgis Press
(See General Supplies)

Rembrandt Graphic Arts Co.
(See General Supplies)

Hydraulic Press
Product Design Corp.
18 Marshal St.
Norwalk, Conn. 06856

Steel Facing

Anderson & Lamb
28 Fulton St.
Brooklyn, N.Y. 11201

Armco Steel Corp.
Int. Div.
270 Park Ave.
New York, N.Y. 10017

INDEX

"A la poupée," 324, 331
Abrasives, 83
Acetate, 196
Acetic acid, 83, 86, 146, 346
Acetone, 338, 339, 362
Acid-resistant, 154
Acid trays, 83, 138, 140
Acids, safety and, 345–350, 355–356
Adam, H. G., 35
Adhering liquid, 221
Agate burnisher, 11
Albers, Josef, 280
Albion proofing press, 307
Alcohol (grain), 161
Alcohol (Methylated), 83, 113, 133, 158, 215
Alcohols, safety and, 339–340
Aliphatics, 337
Alumina hydrate, 351, 352
Aluminum, 5, 75, 82
Aluminum mordant, 158
Amber, 97
American Conference of Governmental Industrial Hygienists, 337
American roulette, 67, 70
Ammonia, 83, 86, 358
Anglet graver, 304
Aquatint, 12, 37, 49, 67, 86, 126–137, 148, 149–154, 168, 170, 199
Arches, 174
Arkansas stone, 5, 11
Aromatic hydrocarbon solvent, 369
Aromatics, 337
Ars Pictoria, 97
Asbestos, 90, 307, 351, 353
Asphaltum (powder), 89–90, 95, 97, 113, 154
Asphaltum varnish, 14, 89, 113, 137, 142, 149, 154, 158, 352
Avanti, Mario, 71

Axle grease, 83, 114, 183
Azuma, Norio, 224

Baking soda, 138
Barlach, Ernst, 262
Barytes white, 351, 352
Bas-reliefs, 246
Baskin, Leonard, 263, 302, 303
Becker, Frederick G., 31
Beckmann, Max, 46, 52
Bed (press), 164, 181, 203
Beeswax, 83, 89, 113
Belt sanders, 85
Bench hook, 266, 270–271
Benzene, 89, 337–338, 340
Benzine, 83, 89–90, 91, 113, 154, 215, 222, 341
Beveling, 83–85
Bewick, Thomas, 301–302
Binder varnish, 364
Birmelin, Robert, 112
Bits, 88, 161
Black manner, 65, 68
Black pitch, 95
Blake, William, 30, 154, 160, 194
Blankets (felts), 172–173, 232
Bleeding, 182
Blending, 136, 137
Blockouts, safety and, 363, 364–365
Blotching, 182
Blotting paper, 69–70, 173, 183, 288, 320
Bonnard, Pierre, 117, 194
Bosse, Abraham, 95
Bowhay, Dwight, 333
Boxwood blocks, 264
Brayer (gelatin roller), 208, 209, 230, 267, 279
Bresdin, Rudolphe, 81
Broad manner, 22
Brooklyn Museum Art School, 319

Brooklyn Museum Print Department, 315
Browne, Alex, 97
Burgundy pitch, 95, 97
Burin, 5, 7–8, 9, 18–22, 128, 236, 302
Burlap, 127
Burnisher and burnishing, 5, 11–13, 42, 46, 48–49, 68–69, 82, 137, 195
Burnt plate oil, 358
Burr, 11, 20, 22, 38, 45, 46, 48, 49
Butt joints, 215
Butyl cellosolve, 366

Calcium carbonate, 350, 353
Caliper, 40
Callot, Jacques, 76, 91, 97
Campagnola, Giulio, 26, 56
Candles, 105
Carbolic acid, 346–347
Carbon paper, 106
Carborundum powder, 175, 243
Cardboard mat, 221, 264
Cardboard print, 296–297
Casarella, Edmond, 296, 300
Casein, 305, 306
Cellocut, 239–241
Cellosolve acetate, 367
Chagall, Marc, 46, 135
Chalk roll roulette, 57, 67, 69
Cheese cloth, 90, 127, 170
Chesney, Lee, 29
China marking pencil, 14
Chine Collé, 324–325, 327
Chinese art, 291
Chromic acid, 345, 347
Cimabue, Giovanni, 196
Circular scraper, 11
Citric acid, 347
Cleaning of plate, 146, 182
Coated paper, 221
Collage, 233

Collagraphy, 241, 243–244
Colophony (rosin), 83, 89, 90, 97, 110, 126, 127
Color printing, 193–256, 323–331
Colored inks, 182, 196
Colors for silk screen, 223
Colors for woodcut, 297, 298, 299, 301
Common pitch, 97
Contact dermatitis, 335
Copper amalgam, 42
Copper bath, 138
Copperplate, 5, 13, 14, 46, 49, 61, 74, 75, 95, 128, 133, 145, 149, 212, 325
Cordo, 232, 238
Corinth, Lovis, 55
Correcting woodblock bruise, 305
Corrosion, 183
Cotton, 70, 170
Creeping bite, 149–150
Crevé, 68, 144
Criblé, 60, 61–62, 154
Crosshatching, 23, 108, 258
Crystolon abrasive grain, 352
Cutting drill, 196
Cutting wood, 274, 275
Cylinder press, 308

Dauber, 48, 95, 171, 177, 178
Degas, Edgar, 111, 326, 330
Dermatitis, 337, 338
Deshaies, Arthur, 241, 254
Diacetone alcohol, 367
Diamond point needle, 47, 48
Double run, 182
Dragon's blood, 352
Draw tool, 84
Drawing with acid, 149
Drawing on soft ground, 114
Drawing on wood block, 269–271
Drill press stand, 88
Dropping out, 196
Drum roulette, 57, 67, 69
Dry point, 12, 46, 47, 48, 49–55, 168
Du Pont DeNemours, E. I., & Co., 239
Dürer, Albrecht, 21, 22, 23, 24, 44, 46, 258
Dust bag, 126, 127
Dust box, 126, 127

Dutch mordant, 128, 145–146, 149, 359
Duvet, Jean, 23, 27

Earlom, Richard, 64
Eberhard, Denver, Col., 167
Echoppe, 91
Egyptian asphaltum, 83, 113
Electric drill, 86, 88, 236
Electric motor, 88, 167
Electrical engravers, 48–49, 88
Elliptic graver, 302
Elmer's Glue, 243
Embossment, 182, 196, 239, 244
Emery paper, 11, 13
Empire resist remover concentrate, 358
Enamel, 222
Enamel spray can, 133, 136
End grain, 264
Endlap joints, 215
Engraver's charcoal, 5, 40, 83, 137
Engraving, 1–5, 7, 13, 17, 18, 20, 22, 23, 37, 38, 49, 118, 304, 305
Ensor, James, 115, 130
Etches, safety and, 359
Etching, 73–162
Etching, safety and, 355–356
Etching ground, 67, 73, 89, 90, 95
Etching needle, 87–88, 106
Etching papers, 174, 175
Etching press, 162, 163–165
Ethyl hydrate, 339
European tools, 268
European woodcut, 1
Evaporation of ground, 110
Exposure limits to chemicals, 336

Fabriano papers, 70
Feathering (tickling), 144
Feininger, Lyonel, 284
Felt, 172, 239; washing, 173
Ferren, John, 184, 186
Ferric chloride, 75, 83, 146, 359
Ferric crystals, 161
Filing, 85
Film stencils, 220
Fine manner, 22
Finiguerra, school of, 22
Flat finish inks, 362

Flat gravers, 37, 38
Flat scraper, 68
Flexible shaft, 88
Flower of sulphur, 133
Foul bite, 143, 161
Frankfurt black, 175
Frasconi, Antonio, 298
French chalk, 350, 353
Fumes, 320

Gallic acid, 347
Gasoline, 341
Gauguin, Paul, 295, 331
Gauze weave, 219
Gears, 164
Gelatin, 208
Gelatin roller, 208, 230, 267, 279
German copperplate, paper, 70, 174
German masters, 22
German woodcuts, 258
Gesso, 43, 305, 306
Gilsonite, 83, 89, 113
Glass plate, 20, 175, 186
Gloves, 90
Glycerin, 215
Gorbaty, Norman, 305, 306
Goggles, 84, 161
Gomez-Quiroz, Juan, 249
Gouges, 5, 39, 195, 266, 272, 274, 304
Goya, Francisco, 77, 118, 129
Grain of wood, 275
Greek pitch, 97
Grien, Hans Baldung, 259
Grinders, 88
Grinding colors, 204
Grinding the ink, 177
Ground, 73, 88, 97, 110
Grounds, safety and, 360–361

Hamaguchi, Yozo, 66
Hammerton's transparent ground, 97
Hand cleaners, 338
Hand-colored print, 331
Hand rest, 137
Hand rubbing, 277
Hand vise, 105
Hand wipe, 179, 180
Handling acids, 137–138
Hard ground, 88, 91, 95, 104, 105, 136

Hartung, Hans, 54
Hayter, Stanley William, 23, 37, 116, 123, 154, 185; facing 198, 207, 212, 323, 330
Health and safety in printmaking, 333–370
Heating box, 82
Hokusai, Katsushika, 258, 265, 285, 291
Holbein, Hans, 258
Hopper, Edward, 78
Hosein, Roland, 333
Hot plate, 82, 91, 169–170, 181
Huile de grasse, 91, 97
Hydrocarbons, 340–344
Hydrochloric acid, 75, 83, 145, 146, 158, 348
Hydrofluoric acid, 348
Hydrogen bubbles, 144

IGAS. *See* International Graphic Arts Society
India ink, 14, 151, 304
India stones, 5, 11
Ingestion of chemicals, 334
Ingres, Jean Dominique, 196
Inhalation of chemicals, 334
Inking the plates, 177
Inking the roller, 171
Inks, toxicity of, 354–355, 362, 363, 365, 366
Intaglio color printing, 195–205, 212, 236
Intaglio printing, 62, 161, 181, 239, 244
 safety and, 355–357
International Graphic Arts Society (IGAS), 314
Iron trichlorate, 161
Isophorone, 366
Isopropyl alcohol, 339
Italian engravers, 22
Ivory black, 175

Japanese knife, 266, 271
Japanese rice paper, 174
Japanese tools, 266–271
Japanese woodcuts, 39, 194, 258, 288, 291–292
Jewelers' rouge, 40, 83
Jigsaw, 196, 236
Johnson, Una, 315
Jones, John Paul, 131

Kandinsky, Vasili, 278
Kelmscott paper, 174
Kelton Press, 308
Kemtone rollers, 171
Kerosene, 83, 215, 222, 341
Key block, 291–293
Key plate, 196
Kimbers Wood Proofing Press, 308
Kinetic prints, 233
Kirchner, Ludwig Ernst, 281
Klee, Paul, 94
Kleenex, 170
Kmer Kodak metal etch resist, 361
Kochi paper, 70
Kohn, Misch, 327
Kraver, Ronald T., 247
Krylon, 189

Labour, Alberta, 333
Lacquer film adherent GS-51, 370
Lacquer thinner, 221, 222
Lacquers, 133, 136, 221, 222, 244
Lake black, 176
Lalanne's lift-ground formula, 151
Lampblack, 175, 222
Lasansky, Mauricio, 32, 198, 202
Leather printing, 191
Leno weave, 219
Lepages liquid strength glue, 364
Lift ground, 136, 150–154
Line engraving, 1–43
Line etching, 73–106, 118, 195
Lining tools, 38, 304
Linocut, 227, 305, 307
Linoleum cut, 227, 307
Linseed oil (light), 69, 91, 204
Liquid hard ground, 89–90, 91, 113
Liquid soap, 158
Lithography, 150, 223, 246, 321
Lithotine, 338, 342
Lozenge engraver, 304
Lucite, 239, 241, 243, 254
Lung sensitization to chemicals, 335
Lye wipe, 325–326

Magnesium carbonate, 351, 352
Magnesium plate, 5, 82

Magnifying lenses, 18
Mantegna, Andrea, 19, 22, 196
Marcoussis, Louis, 147
Margo, Boris, 239, 240
Marx, Robert E., 310
Masonite, 241, 264, 305
Master E. S. of 1466, 22
Mastic, 97
Mat board, 316
Mat knife, 215, 316
Matisse, Henri, 101, 282
Matting, 315–317
Mauling, 204
Mazur, Michael, 157, 328, 329
Mercury, 42
Metal clamps, 266
Metal clips, 173
Metal engraving, 1–39
Metal graphic, 232–235
Metal mat, 200
Metal trays, 138
Methanol, 338
Methyl hydrate, 340
Methyl violet dye, 113
Methylated spirit, 113
Mezzotint, 12, 64–70
Micrometal, 143
Milton, Peter, 119
Mineral spirits, 342
Miró, Joan, 46, 100
Miter joints, 215, 293
Monoprint, 326, 328–331
Monotype, 326, 328–331
Morandi, Giorgio, 96
Mordants, 106, 142
Mortar, 42
Moses, Cherie, 333
Movable blocks, 296
Movable superimposed plates, 238–239
Moy, Seong, 299
Mulberry paper, 279
Multilevel-viscosity printing, 323–324
Multiple gravers, 37, 38, 304
Munch, Edvard, 51, 294

Naptha, 222
Needles, 47–48
Nesch, Rolf, 232, 233, 235
"New Look" in printing, 244–248
Nitric acid, 75, 83, 87, 128, 142, 158, 349, 359

Nitrogen oxides, 345
Nolde, Emil, 261
Non-etch descum solution, 361
Norton India oil stone, 8, 268
Nylon, 190, 215, 219

Offset printing, 205–207, 228, 230
Offsetting linoleum, 228, 230
Oleic acid, 349
Opex lacquer thinner, 344
Orbital sanders, 86
Oscillating sanders, 86
Overcutting wood, 273–274
Overprint clear, 367
Oxalic acid, 349

Packing the plate, 168
Papers, 174, 175; for woodcutting, 279; for chine collé, 324, 325
Parallel ruler, 165
Parisian school, 194, 207
Peck, Augustus, 320
Pelliot Expedition, 257
Perchlorate of iron, 75, 83
Perf-a-Tape, 243
Pestle, 42
Peterdi, Gabor, 16, 17, 36, 74, 92, 93, 103, 104, 124, 141, 155, 156, 159, 206, 211, 213, 214, facing 214, 229, 231, 242, facing 246, 253, 255, 289, 290
Phonograph needle, 88
Phosphoric acid, 349
Photo resists, safety and, 356–357, 361
Photography, 248, 252
Picasso, Pablo, 7, 15, 46, 80, 98, 99, 121, 134, 283, 309
Pierce, Danny, 11, 34
Pierre Matisse Galleries, 186
Pigment, 204
Piranesi, Giambattista, 108, 109
Plain weave, 219
Planing wood, 276, 277
Plank, 260
Plaster of Paris, 186
Plaster print, 183–189
Plastic, 20, 241
Plastic spray, 153, 188
Plastic wood, 277
Plasti-Vac gloss inks, 362

Plate oil (heavy), 69, 204
Plate oil, making of, 176–177
Platen press, 307
Plexiglas, 5, 14, 20, 241
Plywood, 215, 264
Polishers, 88
Pollaiuolo, Antonio, 4, 5, 22
Polymer Glue, 317
Ponce de León, Michel, 233–234, 237
Pot, 90
Potassium chlorate, 83
Potassium dichlorate, 158
Poussin, Nicolas, 196
Powders, safety and, 351–353
Pozzatti, Rudy, 286
Press bed, 164, 181, 203
Pressure gauges, 165
Pressure setting, 165
Printers' knives, 175
Printing, 181–183; and the "New Look," 244–252
Printing ink for wood, 277
Printing inks, etching, 175, 176, 181
 toxicity of, 354–355
Printing on leather, 191
Printing paper, 200
Printing press, 163–167
Printing pressure, 168
Printing temperature, 182
Printing on textile, 189–191
Process plates (films), 220
Proofing press, 307–308
Pulp papers, 174
Pumice powder, 40, 83, 353
Purdham, James, 333
Pyrex tray, 140

Racz, André, 41
Rag wipe, 179
Raimondi, Marcantonio, 23
Raphael, 22
Rayo, Omar, 187
Razor blades, 88, 107, 316
Red oxide, 373
Reddy, Krishna, facing 230, 323, 324
Reduction gear box, 167
Re-etching, 105, 108
Registering color, 165, 199, 200, 202–203, 292–293, 296
Registering with frisket, 308
Relief etching, 13, 74, 154, 233

Rembrandt van Rijn, 46, 72, 89, 107, 108
Rembrandt's ground, 97
Repoussage, 40
Resin, 97, 154, 260
Retroussage, 180
Rives paper, 174
Rocker, 67, 68
Rogalski, Walter, 33
Roller, 91, 95, 208, 230
Rollers (etching press), 164, 167–168
Rollers (for inking), 168, 267
Rolling colors, 209–210, 230, 287
Rosin (colophony), 83, 89, 97, 110, 126, 127, 132, 133, 350, 353
Rosin bag (dust bag), 127
Rotary files, 88
Rotten stone, 83
Roualt, Georges, 79
Roulette print, 69
Round graver, 38, 304
Routers, 161
Rubber blanket, 232
Rubber cast, 232
Rubber gloves, 138
Rubber roller, 226, 267, 279
Rubber trays, 140
Rubbing, 264
Ruysdael, Jacob, 125

Safety cans, 321
Safety in printmaking, 333–370
Salt, 83, 136
Salt method, 136
Sand, 243
Sand ground, 136
Sandpaper, 86, 243
Sandpapering, 241, 277
Saw (bench, band, jigsaw), 84
Sawdust, 243
Saw-edge burr, 48
Schongauer, Martin, 6, 22
School of Finiguerra, 22
Schrag, Karl, 120,
Scotch brand sandblast filler #2, 368
Scotch tape, 317
Scraper, 5, 10, 11, 20, 40, 46, 82, 85, 128, 137
Scraping, 11, 38, 40, 68, 69, 195
Scratching, 241
Screen wash, 368

Screenprinting, safety and, 362–370
Screw press, 260
Scrive, 266
Sealers, 243–244
Seghers, Hercules, 122, 154, 190, 194, 197, 331
Senelith asphaltum, 360
Sensitization dermatitis, 335
Setting the pressure, 167–168
Sharaku, Toshusai, 256
Shellac, 113, 188, 215, 222, 243
Shellacked paper, 220
Shrinking of ground, 110
Silk mesh, 215
Silk screen, 212, 215, 218, 223
Skin contact with chemicals, 334–335
Smoked hard ground, 104, 105
Snake slip, 5, 83
Soap, 154, 222
Soft ball ground, 360
Soft ground, 37, 67, 86, 90, 114, 116
Soft iron, 61
Soft steel mordant, 158
Solid hard ground, 91, 95
Solvents, 89, 215; safety and, 337–338, 362, 363
Spatula, 186, 188
Spirit ground, 133
Spit bite, 149
Spitsticker, 302
Spooning, 264, 287
Spoons (wooden), 267
Spray boot, 136
Spraying, 133, 244
Squeegee, 215, 218
Stainless-steel formula, 161
Stapler, 215, 219
Stasik, Andrew, 245
Stearic acid, 222
Steel facing, 47
Steel punches, 61
Steel wool, 277
Steg, J. L., 250
Stencil, 205, 207, 209, 210, 220, 221
Stencil paper, 207, 215
Stenciling, 59, 208
Stipple engraving, 57, 62
Stippling burin, 57, 58
Stoddard solvent, 343
Stop-out varnish, 110, 113, 126, 149

Stopping out, 110, 113, 137
Storing the plate, 183
Stretching the screen, 219
Sturgis etching press, 165
Sugar bite, 150, 151
Sulphuric acid, 158, 350
Super Blox, 363, 364–365
Surface materials, 243
Surface print, 232, 241
Surface rolling, 232
Sword scraper, 68
Synthetic rubber, 95, 232

Talc, 351, 353
Talcum powder, 304
Tallow, 83, 114
Tannic acid, 350
Tao, 196
Taper, 105
Tarlatan, 48, 170, 171, 243
Textiles, printing on, 189–191
Texture, 22, 38, 73, 114, 116, 118, 136, 146, 195, 199, 274, 275
Thalo Blue, 176
Thinners, safety and, 366–367
Threshold Limit Valves (TLVs), 337
Tickling the plate, 144
Tint tool, 304
Todd, Ruthven, 154
Toluene, 343
Toosh glue and lacquer resist, 368
Toulouse-Lautrec, 194, 291
Tovil paper, 174
Toxicity rating, 336
Tracing paper, 207
Transferring drawing, 105–106
Transparent base, 369
TSP cleaner, 370
Turpentine, 83, 183, 215, 222, 337, 343
Tusche, 215
"Tusche-and-glue" method, 222–223
Tusche crayons, 223
Tympan, 308

Uccello, Paolo, 196
Ulano Blockout, 363, 365
Ulano Hi-fi Developer, 370
Ultraflex liquid hard ground, 360

Umbria, 174
Undercutting, 144, 271
Upholsterer's pliers, 215

V-cutter gouge, 266, 275
Van Gogh, Vincent, 291
Van Leyden, Lucas, 22, 23, 28
Varnish, 110, 113, 137, 158, 183, 211
Varsol, 337, 338, 343
Vasarely, Victor, 217
Vaseline, 114, 183
Venetian red, 176
Venice cerus, 97
Ventilation, 320
Vermeer, Jan, 196
Villon, Jacques, 23, 46, 53, 65, 102
Vine black, 176
Vinegar, 83, 86
Vinylite, 307
Vinyon, 219
Virgin wax, 89, 95, 97
Viscosity printing, 323–324
Von Wicht, John, 216

Washing the screen, 220
Washington-Hoe proofing press, 307
Water-base colors, 292
Wax, 97
Wax crayon, 14, 18, 68, 226–227
Wax intaglio, 226–227
Wax proofing, 42–43
Weimar, 174
Whatman paper, 174
Wheel roulette, 57
Whistler, 46, 152, 291
White chalk, 106
White ground, 97
White waxed carbon paper, 18, 106
Whiting, 83, 180, 304, 351, 353
Wiping, 170, 179–181
Wiping materials, 170
Wire mesh, 215
Wood: cherry, lime, maple, bass, sycamore, white pine, redwood, mahogany, 260, 264
Wood engraving, 257–293
Wood filler, 277
Woodcut, 257–304
Woven wool (felt), 173

Xylene, 344

Youkeles, Anne, 251

Ziemann, Richard C., 139

Zinc alloy, 13
Zinc bath, 138
Zinc plate, 5, 13, 14, 49, 61, 75, 82, 95, 113, 128, 143, 144, 146, 149

Zomo, 143